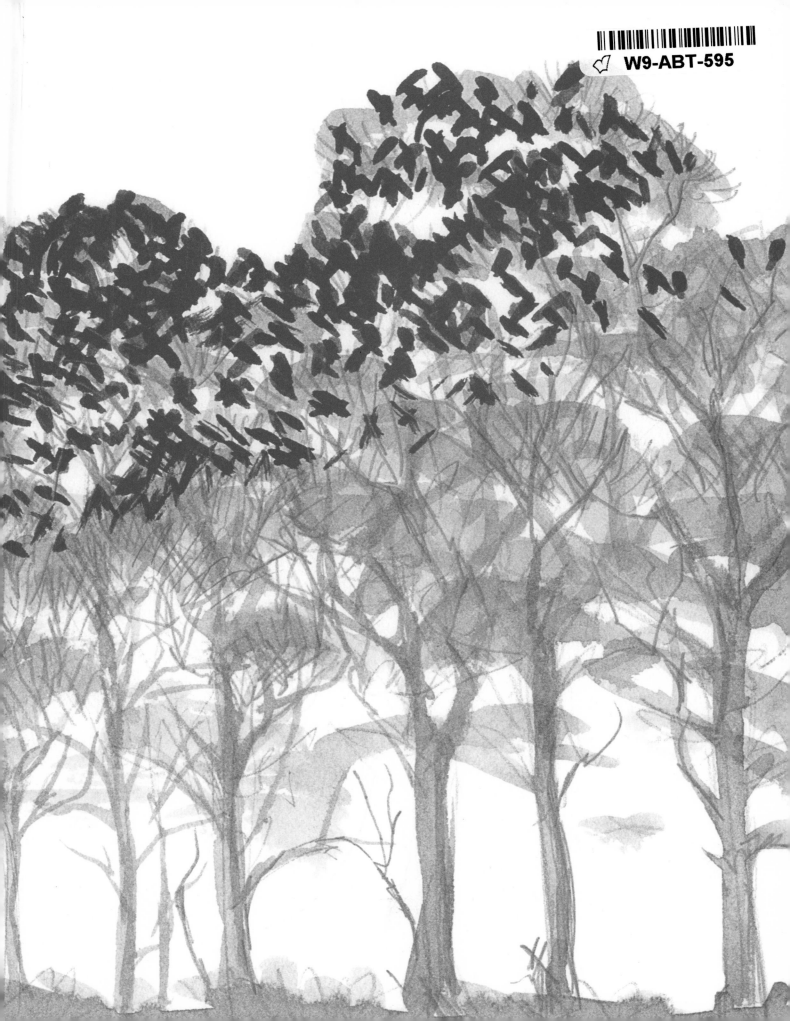

WHAT IT'S LIKE
TO BE A BIRD

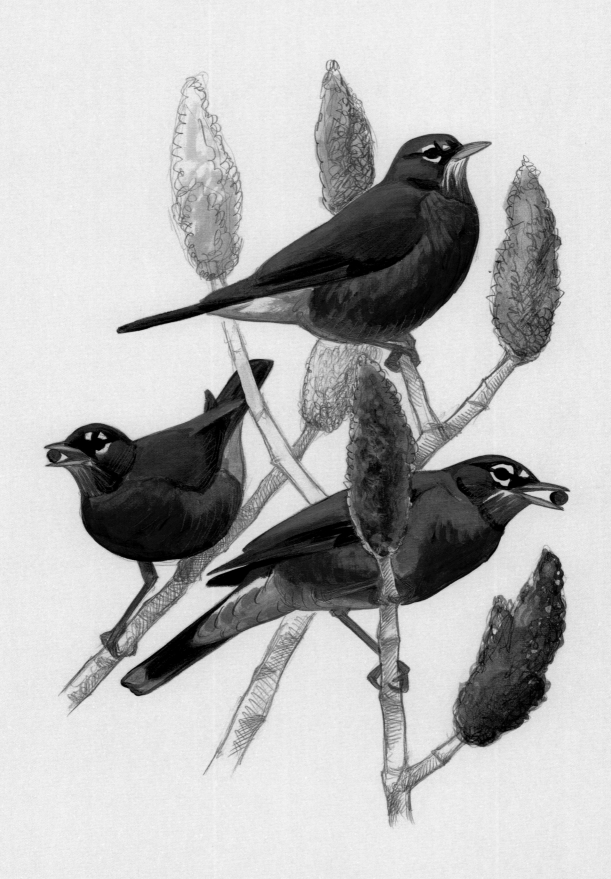

WHAT IT'S LIKE TO BE A BIRD

From Flying to Nesting, Eating to Singing—
What Birds Are Doing, and Why

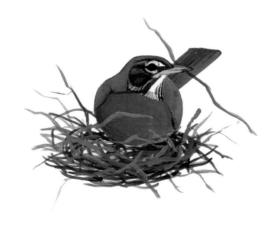

WRITTEN AND ILLUSTRATED BY

David Allen Sibley

 ALFRED A. KNOPF · NEW YORK · 2020

THIS IS A BORZOI BOOK
PUBLISHED BY ALFRED A. KNOPF

Published in the United States by Alfred A. Knopf,
a division of Penguin Random House LLC, New York, and distributed
in Canada by Penguin Random House Canada Limited, Toronto.

www.aaknopf.com

Knopf, Borzoi Books, and the colophon
are registered trademarks of Penguin Random House LLC.

Library of Congress Cataloging-in-Publication Data
Names: Sibley, David, [date] author, illustrator.
Title: What it's like to be a bird : from flying to nesting, eating to singing—what birds are doing, and why/
written and illustrated by David Allen Sibley.
Description: New York : Alfred A. Knopf, 2020.
Identifiers: LCCN 2019015980 (print) | LCCN 2019019218 (ebook) |
ISBN 9780307957894
Subjects: LCSH: Birds—Popular works.
Classification: LCC QL676 .S57 2020 (print) | LCC QL676 (ebook) |
DDC 598—dc23
LC record available at https://lccn.loc.gov/2019015980
LC ebook record available at https://lccn.loc.gov/2019019218

Cover illustrations by David Allen Sibley
Cover design by Linda Huang

Manufactured in China
Sixth Printing, April 2021

Contents

Preface

The creation of this book has followed a meandering path over the last fifteen years. My original idea, in the early 2000s, was to produce a bird guide for kids. Then I started thinking about it as a bird guide for beginners of any age. But having created a comprehensive North American bird guide, the concept of a "simplified" guide never clicked for me. Instead, I wanted to make it a broader introduction to birds.

My plan to make this volume more than an identification guide led to the idea of adding short essays about some of the more interesting and amazing things birds do, to try to give readers a deeper appreciation of the birds they are identifying. The more I worked on those essays, the more I learned, and the more interesting those essays became. Eventually those essays became the entire book.

My hope now is that these pages will give readers some sense of what it's like to be a bird. Each essay focuses on one particular detail of bird biology; they are meant to be read individually, not necessarily in sequence—everything is interconnected, and there are frequent cross-references suggesting which essay to read next. Although each essay treats a single topic, I hope that the sum of the book will get at something bigger and deeper and give an appreciation of the larger concepts of evolution, instinct, and survival.

One of the themes that impressed me throughout my work on this book is that a bird's experience is far richer, more complex, and more "thoughtful" than I'd imagined. And if that was news to me after a lifetime of watching birds, it must be surprising to other people as well.

Birds are making decisions all the time. Nest building, for example, is instinctive: a one-year-old bird with no instruction can choose materials and build a complicated nest that looks and works like every other nest of its species. Amazing. But that bird can also change its approach to nest building depending on the local conditions, using different materials, building a nest more quickly, adding more insulation in cold weather, and more. And the decision of exactly where and when to build a nest is based on a multifactored decision-making process.

The chickadee that flies to your birdfeeder and grabs a seed is making choices about which seed to choose, and whether to hide it or eat it. Jays hide food, but if they think another jay saw where they hid their food they will return a few minutes later and move it to a safer spot. The appearance of the male Wood Duck has probably evolved simply because females find it attractive. Birds' lives are rich and complex.

I think the word "instinct," to most people, implies a kind of blind obedience. We think of instinct as a set of instructions written in DNA, passed down through generations, controlling a bird's behavior. The most extreme reading of this is that birds are a bunch of zombie-like automatons. In this scenario longer days simply trigger the program to build a nest and raise a family. That's part of what goes on, but it is grossly oversimplified. When they feel the urge to raise a family birds choose a mate and a territory based on many factors, carefully select the location for a nest, build a nest that matches the local conditions, and so on.

Instinct can't be blind obedience. It has to be subtle, to allow flexibility and choices. My growing sense as I worked on this book is that instinct must motivate a bird by feelings—of satisfaction, anxiety, pride, etc. I realize this is enormously anthropomorphic, but how else do we explain the complex decisions that birds make every day, balancing competing needs such as finding food while minimizing effort and risk?

Maybe the feeling an oriole has when looking at its finished nest is similar to the feeling human parents get when we look at a newly painted and decorated nursery. Maybe the chickadee "sleeps well" after a good day of gathering and storing food for the winter.

I believe that the male and female Canada Goose are "attracted" to each other, that the parent Tree Swallow feels "satisfaction" when it is able to bring high-quality food to its young, and that Yellow Warblers feel a sense of "pride" in their territory and their family. Instinct provides the instructions and a suggestion, and the bird makes a decision based on all of the available information. We describe these feelings with words, but underneath the language they are all just feelings, and we often qualify them with descriptions like "stirring deep within." I'm not suggesting that Yellow Warblers talk to each other about feeling proud and fulfilled. I am suggesting that these feelings in us could be the stirrings of instinct.

This book is about what it's like to be a bird, and that can best be explained in terms of how it compares to being human. In my researching and writing I have been surprised many times to learn which things we share with birds, and just as surprised at other times to learn how different we are. I hope these essays will inform and inspire you, the reader, to be a more engaged and active observer of the natural world, and lead to a deeper understanding and appreciation of birds and our shared planet.

Deerfield, Massachusetts

How to use this book

Scope

This book is a guide to the science of birds, but it's an incomplete guide that barely scratches the surface of their world. It is not designed to be read straight through; it is designed to be browsed casually, so that different topics will spark connections and perhaps even a sense of discovery.

The species of birds included here are a selection of the most common and/or familiar in the continental US and Canada. Much of the science described here applies to birds anywhere in the world.

Organization

The heart of this book is the Portfolio of Birds. In this section, eighty-seven large paintings of birds appear *roughly life size* on the left-hand page, featuring ninety-six species of familiar birds. (More information about these species can be found in the section Birds in This Book.) The right-hand page is devoted to short essays describing various subjects of interest and featuring additional species. Each essay is illustrated by smaller paintings, sketches, or diagrams of the featured species or some close relatives.

The sequence of species generally follows the current taxonomic sequence; that is, beginning with geese and ending with blackbirds, but with some exceptions, so that all water birds come before all land birds.

The arrangement of topics is essentially random, and a broad topic such as bird vision is discussed in multiple essays scattered throughout the book. Some of these are cross-referenced to allow you to jump from one essay to a related essay on a different page, but all of it is related and most of the connections are not listed. The topics chosen for the essays on each page are related to the species shown, but many topics could apply to any species (e.g., all birds have a similar respiratory system).

The Introduction is designed to help you find related essays, and to function as a sort of annotated index. It groups the individual essays and their page numbers into a logical sequence of categories. In the introduction you can quickly find all of the essays related to vision, for example.

The Birds in This Book section includes a paragraph introducing the species featured in each of the life-size portraits. This paragraph gives a little more information about that species and its habits and relatives, and in many cases digresses into other topics related to the action in the painting.

Many of the essays rely on specific research and those sources are listed at the end of the book.

DISCLAIMER

This book is a very selective and incomplete review of bird science, covering the topics that I found most intriguing during my research over the last few years. Many of the topics involve recent discoveries and tantalizing possibilities, and are still being actively studied and debated by experts. I have attempted to point out uncertainty and verify the accuracy of everything in this book, but writing such brief summaries requires simplification and leaves little room for nuance. This can lead to unintended errors or misleading statements, which are my responsibility. Use these essays as an introduction, and follow the sources at the end of the book for more information.

Introduction

The Diversity of Birds

Birds are dinosaurs [p. 81 bottom]. Some dinosaurs grew feathers more than 160 million years ago and gave rise to true birds. The meteor impact 66 million years ago wiped out more than two-thirds of all terrestrial species on earth, including all dinosaurs and all but a few bird species [p. 81 middle]. The general consensus is that there are about eleven thousand species of birds on earth today, and about eight hundred are found regularly in North America north of Mexico. These species are incredibly diverse, and a sampling of their remarkable adaptations and abilities are presented in this book.

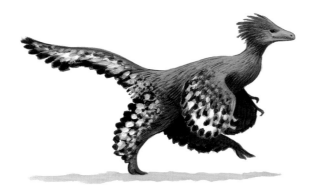

EVOLUTION—NATURAL SELECTION AND SEXUAL SELECTION

The incredible diversity of birds is the product of millions of years of evolution. Evolution operates by selection on individual birds, similar to the way breeders of roses or dogs select the characteristics they want to enhance in future generations. In nature, mortal threats like disease, weather, predators, and others remove the "less fit" individuals from the population. At the same time, members of the opposite sex select characteristics that are appealing. All of this affects which individual birds survive and reproduce, which then influences the characteristics of the next generation. Over the course of hundreds of millions of generations, this process leads to the entire diversity of life on earth. Natural selection is mediated by survival, Darwin's classic "survival of the fittest." This leads to the wide range of bill shapes, wing shapes, nesting habits, and so on, as birds with the best adapted features are stronger and healthier, raise more

young, and pass along their traits to more offspring. Sexual selection is driven by mate choice, as each sex selects a mate for particular features. This can lead to extravagant plumage, as we see in the male Wood Duck [p. 177, Wood Duck].

Feathers

THE FUNCTION OF FEATHERS

When asked "What does a feather look like?" you probably think of an oval shape, a central shaft, and many barbs on each side (like the one shown here), but feathers are extremely diverse in structure and size. Similarly, when asked "What are feathers for?" you might think of flight or insulation, but feathers have adapted to serve a myriad of different functions. Feathers keep birds warm and dry, streamline the body, provide color and ornamentation, allow birds to fly, and more. Two of the key properties of feathers are very light weight and incredible strength.

- Feathers did not evolve from scales. The precursors of feathers were bristle-like and hollow, and gradually evolved more complex structures [p. 33 right].
- The precise multibranched structure of feathers makes possible many of their remarkable properties [p. 11 bottom].
- Feathers resist breakage because fibers run continuously from the tips of the smallest barbules to the base of the feather shaft [p. 11 middle].
- Feathers have evolved many different forms, even on an individual bird, specialized for each part of the bird's body [p. 107 bottom].
- Owls' feathers have several adaptations to make them silent during movement [p. 65 middle].
- Bristle-like feathers around the mouth apparently function to protect the eyes [p. 97 bottom].

Feathers as waterproofing

- Feathers are water resistant because of the precise spacing of the barbs; water can neither flow through nor stick to the surface [p. 17 middle].
- Water birds have feather barbs closer together, making it harder for water to penetrate, and also more and stiffer feathers than land birds, [p. 17 bottom].
- Feathers wrap around the underside of a swimming bird to create a waterproof shell [p. 11 middle].
- Cormorants' body feathers have waterproof centers but get wet on the margins [p. 27 middle].
- Owls' feathers are less water repellent than other birds', which may be why so many owls seek sheltered roost sites [p. 180, Eastern Screech-Owl].

Feathers as insulation

- Down from ducks and geese is still the most efficient insulation known, natural or synthetic [p. 9 middle].
- Feathers insulate birds from heat as well as cold [p. 107 middle].

Feathers for flight

- The large feathers of the wings and tail form a broad flat surface that makes flight possible [p. 69 top].
- Details of shape and structure ensure that wing feathers have the right combination of strength and flexibility [p. 103 bottom].

Feathers as ornamentation

Feathers have evolved a myriad of colors and patterns (see coloration, below), and feathers also create three-dimensional shapes.

- The "ears" or "horns" of some owls are tufts of feathers, for display and for camouflage [p. 63 top].
- The crest of a jay or a cardinal is simply feathers, and can be raised or lowered at will [p. 147 top].
- Highly modified feather tips in waxwings have a hard, smooth texture, just for decoration [p. 185, Cedar Waxwing].

HOW MANY FEATHERS DOES A BIRD HAVE?

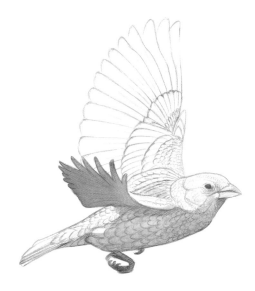

The number of feathers depends partly on the size of the bird, and also on how much it needs waterproofing.

- Small songbirds generally have about two thousand feathers, fewer in summer and more in winter. Larger birds like crows mostly have larger feathers, not more [p. 161 middle].
- Water birds have more feathers than land birds, especially on the parts of the body that are frequently in contact with water [p. 17 bottom].
- A swan's long neck is covered with a dense coat of feathers, with more than twenty thousand feathers on the neck alone [p. 7 middle].

FEATHER MAINTENANCE

Feathers are critical for a bird's survival, so birds spend a lot of time on feather care. Preening is the most obvious and frequent feather-care activity, and involves using the bill (for body feathers) and claws (for head feathers). Preening effectively combs the feathers into place, cleans out any dirt or debris that might be stuck there, removes parasites like feather lice, and applies protective oil to the feathers. Many other activities are also related to feather care.

- Birds spend at least 10 percent of each day preening their feathers, and there is a routine to it that is similar in all species. Preening is so important that some details of bill shape have evolved specifically for that activity [p. 145 middle].

- A bird can't preen its own head with its bill, so it must use its feet; some species get around this by preening each other [p. 183, Common Raven].
- Birds bathe frequently, most likely because water helps to rejuvenate their feathers [p. 137 right].
- Dust bathing is common in some species, though the reason is unclear [p. 161 bottom].
- Sunning and anting are two behaviors that are often confused by observers, and neither is well understood; sunning likely has to do with feather maintenance, anting with food [p. 109 bottom].
- Vultures often spread their wings in the sun; here, too, the reason is unclear [p. 59 top].
- The wing-spreading behavior of cormorants is still not fully explained, but probably helps dry the feathers after swimming [p. 27 top].

GROWING NEW FEATHERS

Feathers wear out and have to be replaced periodically—generally once a year— and this process is called molt. Since feathers are so critical to survival, most birds have evolved a very orderly process to molt gradually without hindering their ability to fly or to keep warm and dry.

- Feathers grow from follicles in the skin, rolled up in a cylinder; the tip emerges first [p. 15 bottom].
- The same feather follicle can grow feathers with entirely different colors and patterns at different times, triggered by hormones. Many species take advantage of feather replacement to change their color. They molt twice a year, once to acquire a drabber nonbreeding plumage, and again for a bright plumage for the spring-summer breeding season [p. 165 top and p. 186, Scarlet Tanager].

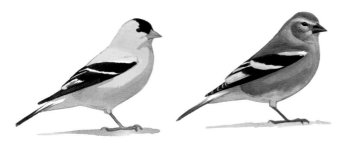

- Once a feather is grown it is "dead," like our hair, and can only be changed through wear, fading, or staining [p. 47 middle].
- Each feather only grows a few millimeters a day, so even small birds take at least six weeks to go through a complete molt. Large birds can take much longer. Faint dark and light bars indicate each day and night of growth in a feather [p. 175 middle].
- Growing new feathers requires a lot of energy, and makes flying and keeping warm more difficult, so molt generally happens during a warm season and doesn't overlap with any other demanding activities like nesting or migrating [p. 165 top].
- When replacing wing feathers, most species use a gradual process so the bird can continue flying [p. 99 top].
- Geese and ducks molt all of their flight feathers at the same time, becoming flightless for a few weeks in late summer, putting the birds at higher risk but for a shorter time [p. 5 middle].
- On rare occasions, a bird will molt all of its head feathers at once, with no apparent negative effects [p. 147 right middle].

Bird Coloration

The appearance of birds is striking and incredibly diverse. This is partly because the birds rely on vision, so the way they look is an important signal to other birds and has been influenced strongly by selection. The color of a bird's feathers can be produced in two fundamentally different ways: as a result of pigments; or as a result of the nanostructure of the surface.

Pigments

Pigments are molecules that interact with light energy electromagnetically, reflecting certain wavelengths while absorbing others. The structure and electron placement of the molecule determines the range of wavelengths that are reflected. There are two common pigment groups in birds: *carotenoids* produce most red to yellow hues, and *melanins* produce colors ranging from black to gray and brown to buff.

- Carotenoid compounds come only from a bird's diet, and brighter carotenoid-based plumage color is thought to be a sign of health and fitness, but confirmation of this has been elusive [p. 163 middle].
- In North America recently, an introduced plant with a novel carotenoid molecule has been throwing off the yellow color of Cedar Waxwings and a few other species [p. 139 middle].

- Bright color involves more than just pigment; reflective white feathers beneath the bright yellow to red of many species essentially act as a backlight to make the color glow [p. 165 middle].
- Much of what we call greenish in birds is a combination of yellow (carotenoid) and gray (melanin) pigments [p. 121 bottom].
- Bright colors on birds are even more striking when they are set off against black patterns and the blackness of feathers colored with melanin depends on feather quality [p. 186, Warblers].
- Besides being a pigment, melanin adds strength to a material. This is one reason for darker colors on birds. Dark wingtips are a common feature of many species, as wingtips are subject to more wear and tear, and melanin strengthens the feathers [p. 47 middle]. Other uses of melanin include dark spots and streaks on eggs, which strengthens the shell and reduces the need for calcium [p. 109 middle]; and darker bill color in winter, which could help protect against a more abrasive winter diet [p. 137 bottom].
- Melanin also helps to resist bacteria that attack feathers, which is especially important in more humid climates [p. 159 bottom].
- Sometimes an individual bird grows feathers with little or no melanin. This can have many different causes and effects.
 - Melanin can be reduced or absent, leading to birds that are paler than normal, showing patches of white, or all white [p. 173 middle].
 - The reduction of melanin can reveal other pigments and create unexpected colors and patterns [p. 85 top].

Structural colors

A much wider range of colors is produced structurally, without pigments. Structural color relies on the interaction of light waves with the microscopic structure of the feather so that only certain wavelengths are reflected. The multicolored sheen produced by oil on water is an example of the basic principles: oil and water have little or no color themselves, but the interaction of light waves with the thin film of oil on water produces a very colorful display.

- The brilliant jewel-like colors of hummingbirds are produced by the nanostructure of the feathers [p. 77 middle].

- The throat feathers of male hummingbirds are especially refined, and not only produce an intense reflection of a pure color, but also reflect that color in only one direction [p. 77 top].
- There is no blue pigment in birds. The blue colors of the Eastern Bluebird and other species are produced by a structure that reflects blue light in all directions [p. 127 top].
- There is no green pigment in North American birds. Bright green can be entirely structural, as in hummingbirds, or a combination of blue structural color and yellow pigment [p. 85 top].

Color patterns

The wide range of color patterns on birds' feathers has evolved to serve many different functions. The most colorful patterns are usually a signal to members of the opposite sex. Intricate patterns provide cryptic coloration for camouflage. Bold and contrasting patterns can be for camouflage (to disrupt the outline of the bird) or to startle potential predators or prey.

- Patterns on individual feathers can be incredibly intricate and develop as the feather grows [p. 15 bottom].
- Such intricate patterns within a single feather are created with melanin pigments (black to brown), while carotenoid colors (yellow to red) are generally applied to entire feathers [p. 186, Warblers].
- The intricate patterns of individual feathers are only part of the picture—a bird's whole coat of feathers, arranged in an organized way, creates an incredible tapestry of subtle colors and transitions [p. 71 bottom].
- Flashes of bright color, such as a white rump, can help startle potential predators [p. 93 bottom] or potential prey [p. 135 middle].

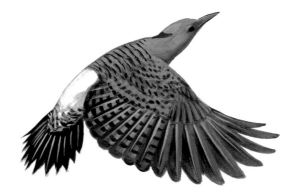

🐦 Many species have color patterns that suggest a face, presumably to deter predators [pp. 61 top, 119 right bottom].

Variation in Birds

Despite the wide range of variation in birds, the appearance of each age or sex within a species is generally very consistent. For example, adult males of any species all look similar to each other, but males can look very different from females. Immatures can look different from adults, and the same adult can look very different in summer and winter.

Differences between males and females

🐦 In many birds, the male and the female look alike, but it is still possible to distinguish the sexes by behavior [p. 3 bottom].

🐦 In other species, the male and the female look very different, and this sexual dimorphism often evolves with migration [p. 186, Buntings].

🐦 Male and female nuthatches differ mainly in the color of their crown [p. 119 bottom left].

🐦 In most species males and females are about the same size, with the males usually just slightly larger. In hawks, owls, and hummingbirds, females are significantly larger than males; the reason for this is unclear [p. 51 right bottom].

Variation with age and season

Coloration often differs between immatures and adults, but size does not vary with age.

Birds grow to full size around the time of their first flight and remain that size for their whole life. The mature adult size is pretty much the same for all members of the species, whether they are one month or ten years old, male or female, and size is a valuable clue for identification. A smaller bird at your bird feeder is not a baby, it is a different species.

🐦 In general, birds show off their brightest colors when they are courting. Drabber colors are generally worn in the nonbreeding season, and on immatures all year [p. 21 bottom].

🐦 Very young Northern Cardinals have dark bills and drab plumage; they develop their adult color over a period of a few weeks just after leaving the nest [p. 147 left middle].

🐦 Immature crows can be distinguished from adults by the color and quality of their wing and tail feathers [p. 105 bottom].

🐦 Some species molt to replace their feathers twice each year and dramatically change their appearance at different seasons [p. 165 top].

🐦 In some species, males and females, adults and immatures, each have different migratory habits and tend to winter in different regions [p. 155 bottom].

Regional variation and subspecies

Birds populations are constantly evolving, adapting to new challenges and opportunities. In the ongoing process of evolution, regional populations can diverge from their neighbors. When these differences are detectable by us, but don't seem to matter to the birds, those populations are classified as subspecies.

🐦 The evolution of new species is ongoing, and we can see the intermediate stages in some birds like Dark-eyed Junco [p. 187, Dark-eyed Junco].

🐦 In many cases, regional variation follows some general trends related to climate [p. 159 bottom].

🐦 Northern Flickers from different parts of the continent have either red (West) or yellow (East) pigment on their wings and tail [p. 93 middle].

🐦 Bill shape evolves quickly in response to new feeding opportunities [p. 161 top].

🐦 Several species of hawks show strikingly different color morphs, regardless of age or sex, each more successful at hunting in certain conditions [p. 51 top].

Bird Senses

Birds experience the world largely through sight and sound, much as we do. In the senses of vision, hearing, touch, and smell, many species of birds have abilities that surpass humans, and they can also sense the earth's magnetic field.

SIGHT

Birds generally have excellent vision, surpassing humans in many ways. They can see a wider range of wavelengths

(including ultraviolet), track fast motion better, and see as much as 360 degrees at once in peripheral vision with multiple focal points. Some have the ability to see clearly underwater, some see more detail, some have excellent night vision or color vision. But visual ability varies greatly between species. Many see less detail than we do, but make up for it with a wider field of view and better motion tracking.

Color vision

🖋 Eagles see about five times more detail than we do, and about sixteen times more color [p. 57 top].

🖋 Many birds can see ultraviolet wavelengths, and have also evolved ultraviolet plumage markings [p. 184, Chickadees].

Night vision

🖋 Owls are active at night and have excellent hearing, but still rely principally on vision for hunting and socializing. Color vision is not helpful at night, so they see mainly in black and white. [p. 63 right bottom].

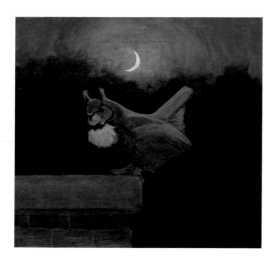

🖋 Birds with relatively large eyes tend to have better low-light vision, which also allows them to be more active earlier and later in the day [p. 131 bottom].

Visual field

Human eyes focus straight ahead on a single small point of detail, but birds see multiple separate areas of detail. Most birds have very little binocular vision (where both eyes overlap and see the same image), and generally it is not very sharp. This means that they have a very limited view of their own bill, in exchange for a wider view of their surroundings.

🖋 Many birds can see a full 360 degrees around, and 180 degrees overhead, at the same time, and see detail in a wide horizontal band along the horizon [p. 45 bottom].

🖋 Eagles see four separate focal points, two on each side [p. 57 middle].

🖋 Because their sharpest vision is to the side, birds need to tilt the head sideways to look up or down with one eye [pp. 57 top, 127 right top].

🖋 Birds that have eyes oriented forward to see more detail in front of them lose the ability to see behind and have to turn their head more often to scan behind them [p. 167 bottom].

🖋 Owls' eyes are aimed forward, leaving a large blind spot at their back, which is one reason they need the ability to turn their heads more than three-quarters of the way around [p. 63 left bottom].

Visual processing

🖋 Birds process visual information more quickly than we do, which is critical for tracking fast-moving prey and for scanning their surroundings during fast flight [p. 55 middle].

🖋 A newly discovered type of cone cell in the eyes of flycatchers is probably specialized for tracking fast motion, one of several adaptations that help these birds see and catch tiny flying insects in midair [p. 97 middle].

Underwater vision

🖋 Some birds need to see in both water and air, and have evolved flexible lenses to do so [p. 27 bottom].

🖋 Some birds hunt fish underwater at night or dive so deep that there is essentially no light. How do they find the fish? Nobody knows [p. 25 bottom].

🖋 Herons and egrets are able to correct for refraction at

the water's surface when they take aim at their prey [p. 33 left top].

Other visual adaptations

🖋 When birds are walking, they bob their heads to stabilize their view of the surroundings [p. 75 top].

🖋 Birds have a remarkable ability to hold their head at a fixed position in space while hovering, to keep their vision fixed on a target [p. 83 top].

🖋 Birds have a nictitating membrane—an extra eyelid—that protects the eye from damage [p. 149 bottom].

HEARING

Birds' ears are small openings on the sides of their head below and behind the eye, usually covered by feathers and surrounded by clusters of specialized feathers that help channel sound. Birds' hearing varies a lot in different species, but generally surpasses ours in sensitivity and processing, but not in the range of frequencies heard. Birds also have some adaptations for reducing their own noise so that they can hear their surroundings better.

🖋 Barn Owls can catch a mouse in total darkness, guided only by hearing [p. 65 bottom]; modifications of ear placement and structure allow them to pinpoint the location of the sound [p. 65 top].

🖋 Birds' brains process sound more than twice as fast as we do, so they hear much greater detail; in general, however, humans hear a wider range of frequencies [p. 157 middle].

🖋 The loudness of many birds' calls, so close to their own ears, would damage their hearing, but several adaptations help prevent this [p. 109 top].

🖋 The streamlined ear covering of nearly all birds presumably helps them hear their surroundings while they are flying or on a windy day [p. 107 bottom].

🖋 Owls have evolved soft, specialized feathers that muffle all noise of the bird's movement [p. 65 middle].

TASTE

🖋 Birds can taste their food, and they have taste buds inside their bill all the way out to near the tip [p. 19 middle].

🖋 Many birds that are generally said to hunt by feel are probably also using taste buds in the tips of their bills [p. 35 top].

SMELL

All birds can smell, in general at least as well as we do, and some species have an extraordinary sense of smell.

🖋 It's been known for decades that a few species, like the Turkey Vulture [p. 59 middle] and the American Woodcock [p. 179], hunt largely by smell.

🖋 Many birds can smell well enough to distinguish family from strangers, tell males from females, detect predators, find plants that are infested with insects, and more [p. 137 top].

🖋 Recent research has shown that all kinds of birds are guided by all kinds of smells. Pigeons and other species can use smell in some way for navigation [p. 73 middle].

TOUCH

Many species have abundant nerve endings in the tip of the bill, making it very sensitive to touch. The Roseate Spoonbill [p. 179] and some other species hunt almost entirely by feel.

🖋 The tip of a sandpiper's bill is sensitive enough to detect tiny differences in pressure when they probe the mud, and to sense things nearby before even touching them [p. 43 middle].

🖋 Ibises hunt by sight and by touch [p. 35 top].

🖋 Filoplumes growing at the base of every feather allow birds to feel the movements of individual feathers [p. 141 middle].

OTHER SENSES

Birds have an excellent sense of balance, which is essential because they have only two legs (and often rest on just one leg) and have to balance all the time.

🖋 Birds' remarkable ability to balance is made possible because they have a balance sensor in their inner ear (like us) and a second balance sensor in their pelvis [p. 149 top]!

- Birds can balance on a tiny twig while they sleep [p. 121 top].
- Balancing on one leg is easy for birds, thanks to their extra balance sensor and some adaptations of leg structure [p. 35 bottom].

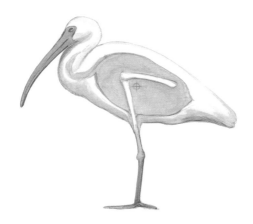

- Birds can sense the magnetic field [p. 73 middle], and it's possible that they can "see" it in some way [p. 141 top].
- Birds can sense changes in air pressure [p. 47 bottom].
- By tracking the sun's movement, birds have an excellent sense of time [p. 186, Scarlet Tanager].

BIRD BRAINS

Other than owls, birds don't have a reputation for being smart, but experiments and observations have shown that birds are very intelligent. Ironically, owls are among the less intelligent birds.

- When we think of smart birds, the pigeon is probably not the first one that leaps to mind, but pigeons are quite intelligent and understand abstract concepts [p. 73 top].
- Most parrots are left-footed, and performing tasks with only one side of the body is associated with better problem-solving ability [p. 85 middle].
- Crows are unusually clever and curious, and they even understand the concept of fair trade [p. 183, American Crow].
- Birds can recognize individual humans [pp. 105 bottom, 135 top].
- Crows are able to solve puzzles, in some cases demonstrating an understanding equal to a five-year-old human [p. 107 top].

- Jays have an awareness of the intentions of other jays [p. 111 middle].
- Some birds can remember thousands of hiding places, and key things about each item stored [p. 113 bottom].
- Groups of birds (like groups of humans) are better at problem solving than a single bird alone [p. 187, House Sparrow].

SLEEP

- Birds can sleep with one eye open, resting one half of their brain at a time [p. 75 middle].
- Some birds spend the entire winter in the air, and even sleep while flying [p. 183, Chimney Swift].

Movement

FLIGHT

Much of the evolution of birds has been shaped by the requirements of flight: to lighten and streamline their bodies, and to concentrate weight in a compact central mass. Feathers are, obviously, a key to flight (see "Feathers for flight" above), as is reducing weight at the extremities—and these are just the beginning of the ways that birds have adapted for an aerial lifestyle. Even if humans had extremely large wings, we would not be able to fly like birds; we are simply too heavy and too ungainly.

- Instead of heavy jaws and teeth, birds have a lightweight bill [p. 7 bottom].
- A bird's muscles are concentrated in a compact central mass, with lightweight tendons to control the extremities [p. 69 middle].
- The large muscles required for flapping are balanced below the wings; even the muscles for raising the wings are on the underside of the body [p. 69 top].
- Birds excrete concentrated "urine" so they don't have to carry the weight of extra water [p. 173 bottom].
- Eggs allow a female bird to continue flying while her offspring develop in the nest [p. 157 bottom]
- Even egg shape is apparently influenced by the constraints of flight [p. 169 top].
- Wing shape is determined by the relative lengths of bones and feathers. It is related to flight style, and has evolved to match the needs of each species [p. 99 middle].

- Species with larger wings relative to body mass are more buoyant and fly more easily. Species with a smaller wing area require higher airspeed to stay aloft [p. 99 bottom].
- Most birds have just one flight mode: traveling. Hawks use several different modes depending on conditions [p. 51 left bottom].
- Only hummingbirds can truly hover [p. 79 bottom]; kingfishers and other "hovering" birds require some wind to hold their position in the air [p. 83 top].
- A long, forked tail provides aerodynamic advantages to some species; others use a long tail to sweep insects [p. 97 top].
- Adult birds, of course, don't seem to be afraid of heights [p. 145 top].
- Most water birds require a long running start to take off from the water [p. 21 top].
- A few species of ducks have evolved a technique for taking off directly from the water, by pushing their wings against the water [p. 11 top].

Efficiency

Flying is a lot of work—using up to thirty times as much energy as resting, for example—so birds have evolved many structural adaptations and have developed behavioral tricks to increase efficiency.

- Birds fly in V formations to take advantage of rising air currents from the wingtips of the birds in front, and to make this work they must be amazingly sensitive to air movement and lift [p. 5 top].
- Species that fly with their wings in a dihedral (raised in a V) sacrifice a little lift in exchange for more stability [p. 59 bottom].
- Soaring birds can use warm air rising from the ground to gain altitude without flapping [p. 61 bottom].
- The undulating flight path used by most small birds is not the most efficient mode, according to calculations, but is so widely used it must have other advantages [p. 163 top].

SWIMMING

Birds that swim face many specific challenges. The first is just staying dry, and many adaptations of feathers allow this (see "Feathers as Waterproofing").

- When swimming along the surface, all birds paddle with their feet; most have webbed feet, but some have lobed toes [p. 19 top].
- Many species submerge completely and swim underwater in search of food [p. 21 upper middle].
- When swimming underwater, most birds use their feet to paddle, but a few species use their wings [p. 25 bottom].
- Birds that dive underwater can reduce their buoyancy by compressing their feathers to trap less air, and also by exhaling air from their air sacs [p. 23 middle].
- Murres can dive to more than six hundred feet deep in the ocean—but how they survive, and how they find food there, is unknown [p. 25 bottom].

WALKING

- Some species of birds walk and others hop, and the reason for this difference is unknown [p. 153 top].

- The head-bobbing motion of pigeons and many other species is all about seeing [p. 75 top].
- Woodpeckers cling to the bark with their feet and use their tail as a brace [p. 91 top].
- Nuthatches often climb trees head-down or sideways [p. 119 middle].

RECORD HOLDERS

- The fastest animal in the world is the Peregrine Falcon, clocked at 242 miles per hour [p. 61 middle].
- The fastest runner among North American birds is probably the Wild Turkey, at about 25 miles per hour. The fastest-running bird in the world is the ostrich [p. 81 top].
- Fastest wingbeats goes to the hummingbirds, at over seventy wingbeats per second in the smaller species [p. 181, Blue-throated Mountain-gem].

Gulls may be the most versatile birds: they are very good at flying, running, and swimming [p. 179, Ring-billed Gull].

Physiology

SKELETAL AND MUSCULAR SYSTEMS

The skeleton of birds has evolved dramatically for flight, becoming simpler and stiffer, but actually not lighter than mammals of the same size [p. 101 bottom].

Standing on one leg requires almost no effort, aided by an adaptation of bone structure [p. 35 bottom].

Most of what we call a bird's "leg" is actually the foot bones [p. 37 middle].

Adaptations of the neck vertebrae, and of the arteries supplying blood to the brain—among other things— allow birds extreme neck flexibility [p. 63 left bottom].

Adaptations of the bill and skull help woodpeckers avoid concussions [p. 87 left top].

Birds do not automatically grip their perch when they sleep; they simply balance their bodies [p. 121 top].

The tendons in a bird's toes have a mechanism (similar to a plastic cable tie) that keeps the toes tightly closed with very little effort [p. 121 middle].

CIRCULATORY SYSTEM

Birds have relatively large hearts and a very fast pulse; small birds have a heart rate more than ten times faster than the average human's [p. 125 top].

RESPIRATORY SYSTEM

The respiratory system of birds is utterly different from ours, and much more efficient.

The lungs of a bird do not expand and contract. A system of air sacs controls airflow, and fresh air passes through the lungs in one direction on both inhale and exhale, continuously supplying oxygen [p. 151 middle].

Birds can fly over Mount Everest and are essentially never out of breath. They only pant from overheating [p. 151 top].

Singing in flight is a challenge, but the efficient lungs of birds help make it possible [p. 167 top].

Migration

Migration is extremely variable. Some birds live their entire lives within a few acres; others migrate every year from one end of the earth to the other. We say birds go south for the winter, but relatively few birds have a simple north-to-south migration from a summer home to a winter home. Both within species and between species there are differences in strategy, route, distance, and timing. Each species has evolved a unique schedule and route that matches its physical abilities and meets its needs for food, water, and shelter. Over millennia, as climate and ecosystems change, the birds' migration strategies and physiology evolve to match the new conditions.

Not all birds migrate—only about 19 percent of species worldwide. Migration gives birds access to better food sources, which offsets the energy used in migrating [p. 186, Rose-breasted Grosbeak].

Migration as a strategy has apparently been abandoned and readopted multiple times across all birds, and many species that now inhabit the tropics evolved from migratory ancestors [p. 188, Baltimore Oriole].

In many species migration is flexible. They can speed up or slow down, or even reverse direction, based on current weather and food conditions [p. 177, Snow Goose].

Many ducks and geese leave their breeding grounds in late summer and fly north a thousand miles or more to molt before making the autumn journey south to their wintering grounds [p. 5 middle].

Many species have a strong eastward or westward component to their movements—for example, flying from Alaska to eastern Canada [p. 143 top].

In some species, males, females, adults, and immatures each have different migratory habits, and tend to winter in different regions [p. 155 bottom].

Waxwings and some other species simply wander in search of food, sometimes moving east and west across the continent rather than north and south [p. 185, Cedar Waxwing].

Some species are nomadic, breeding when and where conditions are good and then wandering elsewhere when that food source fails [p. 165 bottom].

Most small songbirds migrate at night; deciding which night to fly is a complex choice based on many factors [p. 187, White-crowned Sparrow].

On finding themselves in an unfamiliar place at sunrise, migrant birds use the local resident birds as an information source on resources and dangers [p. 113 top].

You can help migrating birds by providing native shrubs and trees for cover and food, and water for drinking and bathing [p. 141 bottom].

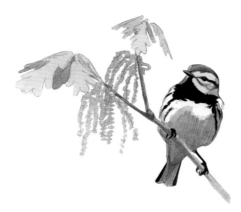

Some species travel back and forth between a small summer territory and a small winter territory, year after year [p. 185, Wood Thrush].

Many of the species we consider "our" nesting birds in the United States spend more than half of the year in the tropics [p. 184, Red-eyed Vireo].

Extreme migrants

An individual Arctic Tern can travel 60,000 miles every year from the Arctic to the Antarctic and back [p. 49 bottom].

The Eared Grebe makes an amazing transition, not flying at all for many weeks and then making one nonstop flight for hundreds of miles [p. 23 top].

Some Blackpoll Warblers migrate from Alaska to Brazil and back every year, more than 7,000 miles each way, including 2,500 miles nonstop over the ocean [p. 143 top].

Bobolinks migrate from southern Canada to Argentina [p. 188, Bobolink].

NAVIGATION

Studies of pigeons have revealed much of what is known about birds' navigation and orientation abilities. Birds can navigate by the stars, by tracking the sun's movements and position, by ultra-low-frequency sounds, and even by using smell [p. 73 middle].

Birds have some extraordinary senses that help them navigate, such as an ability to sense the magnetic field and polarized light [p. 141 top].

A magnetic sense is obviously useful for navigating long distances, but can also be extremely helpful for navigating smaller territories and finding stored food [p. 141 top].

BIRDS AS TRANSPORTERS

Nesting colonies of birds bring nutrients from a wide area and concentrate them in the immediate vicinity of the colony [p. 25 top].

Birds transport seeds by eating fruit, and either regurgitate or defecate the seeds in areas far from where they were eaten, sometimes hundreds of miles away [p. 145 bottom].

Salmon swimming upstream deliver nutrients from the ocean to the forest, and this fertilizes plants, which then helps birds [p. 125 bottom].

Food and Foraging

With their high metabolism and high body temperature, birds need a lot of energy, and that means a lot of food. Most of their day is devoted to finding, catching, and processing food.

Birds lose 10 percent of their body weight overnight, every night [p. 125 middle].

If you "ate like a bird" you might eat more than twenty-five large pizzas each day [p. 184, Golden-crowned Kinglet].

A single robin can eat about fourteen feet of earthworms in a day [p. 185, American Robin].

HANDLING FOOD

With no hands and no teeth, birds have developed some clever tricks to handle their food. (The expression "as scarce as hen's teeth" refers to the fact that hens, like all birds, have no teeth.)

Food is manipulated with the bill, generally swallowed whole, and processed inside the body by the digestive system [p. 5 bottom].

Birds are capable of swallowing very large food items; a heron can swallow a fish equal to more than 15 percent of its body weight [p. 71 top].

Bills

The bill is the first and primary food-handling structure, and it has evolved into a myriad of forms to fit specialized feeding habits. Browsing through the species illustrated in this book will give you a sense of the diversity of bill shapes and how each is adapted to certain foraging habits.

- Most birds handle their food using only their bill, and swallow it whole [p. 83 bottom].
- The bill is a lightweight framework of bone with a thin covering of keratin [p. 7 bottom].
- Not all birds' bills are rigid, and many long-billed species can open and close just the tip of their bill [p. 41 bottom].
- Bill shape evolves quickly in response to new feeding opportunities [p. 161 top].
- Some details of bill shape have evolved specifically for feather care [p. 145 middle].
- Birds that need to crack hard seeds require stronger jaw muscles, which necessitates a reinforced jaw and a larger and heavier bill to withstand the extra force [p. 149 middle].
- Jays that hammer acorns with their bill have evolved a reinforced lower jaw [p. 111 top].
- Despite pointed bills, herons and other birds do not spear their prey; they catch it between the tips of their bill [p. 31 top].
- Flycatchers snap flying insects with the tip of their bill; they do not "scoop" with their open mouth [p. 97 bottom].
- Pelicans use their huge bill and expandable pouch to engulf fish [p. 29 top].
- Sandpipers can use water to transport food up into their mouth [p. 43 bottom].

Tongues

We don't think much about birds' tongues, partly because we rarely see them. Tongues are very important to birds, and have evolved many specialized forms.

- Many species use their tongues to manipulate food in their bill [p. 85 bottom].
- The tongue of hummingbirds is adapted to capture a drop of liquid and carry it into the bill [p. 79 middle].
- Woodpeckers have a long, flexible, sticky, and barbed tongue to reach into crevices and extract food [p. 91 top].
- Long tongues such as those of woodpeckers are

"stowed" in a sheath that wraps all the way around the back and top of the head [p. 91 bottom].

Feet

Most species don't use their feet to handle food. Only parrots use their feet to actively handle food—and most parrots are left-footed [p. 85 middle].

- Raptors like Bald Eagles capture and hold prey with their large talons, then tear it with their bill [p. 180, Bald Eagle].
- Chickadees and jays use their feet to hold food while they pound it with their bill [p. 111 top].

FORAGING METHODS

Birds have evolved a tremendous variety of foraging methods and strategies. Most birds find their food by sight, but touch [p. 43 middle], taste [p. 19 middle], smell [p. 59 middle], and hearing [p. 65 bottom] are also important for some species (see "Senses" above).

- Robins tilt their heads as if they are listening, but they are actually looking for signs of worms and other prey [p. 127 middle].

Tricks to help find food

- Quail, like chickens, scratch the ground with one foot at a time to uncover food [p. 71 middle].
- Some sparrows uncover food by scratching the ground with both feet at once [p. 153 middle].
- Sanderlings take advantage of the ocean's wave action, which exposes invertebrates in the sand [p. 179, Sanderling].
- Egrets actively lure prey with bait and other tricks [p. 33 bottom].
- Woodpeckers excavate small holes in wood to reach insects there [p. 87 right].

- Birds take advantage of the "looming" response to startle prey into the open [p. 135 middle].
- Some species use a long tail to sweep insects into view [p. 95 top].
- Eastern Meadowlarks use their bill to open a gap in matted grasses, to see potential prey underneath [p. 167 bottom].

Adaptations to help catch food

- Some birds make a habit of stealing food from other birds [p. 29 bottom].
- Plunge diving is a common technique for catching fish in open water [p. 49 middle].
- Some hawks have evolved great agility in flight, as well as long legs, allowing them to fly in quickly and grab small birds in the air [p. 55 bottom].
- Hummingbirds and flowers have coevolved: bill shapes match flower shapes, and flowers have features that attract hummingbirds and not insects [p. 181, Rufous Hummingbird].
- Flycatchers feed almost entirely on insects captured in flight and have many adaptations of vision that make this possible [p. 97 middle].
- Many birds dive underwater for food [pp. 21 middle, 25 bottom]; some ducks simply tip forward to reach food underwater [p. 177, Mallard].

DIGESTIVE SYSTEM

Once swallowed, food is stored in the crop, then moves through to the gizzard (stomach), where it is crushed and ground up, and on to the intestines, where nutrients and water are extracted and waste products concentrated.

- It's normal for birds to regurgitate a lot [p. 35 middle].
- The crop is a food storage organ near the beginning of the digestive tract. The gizzard is where powerful muscles crush and "chew" food; many species swallow gravel and sand to help grind food [p. 5 bottom].
- Some birds can swallow whole clams, which are then crushed and digested in the gizzard [p. 178, Surf Scoter].
- The bacteria that thrive in a vulture's gut help it digest rotting meat and are toxic to most other animals [p. 180, Turkey Vulture].
- In some species indigestible parts of their food are formed into a pellet and regurgitated [p. 95 bottom].

- The white and black droppings of birds contain very little water [p. 173 bottom].

QUALITY OF FOOD

Birds are keenly aware of the nutritional quality of their food, and they seek out higher-quality food for themselves and/or for their young.

- Even chickadees, among the most dedicated bird feeder customers, get at least 50 percent of their food in the wild. Adult chickadees make special efforts to seek out spiders to feed to their young, for the nutrient taurine [p. 113 middle].
- Adult gulls may feed themselves from the garbage dump, but they will catch fresh fish for their offspring [p. 47 top].
- Birds select food carefully, weighing the pros and cons [p. 115 top].
- Some birds pick one seed and fly away from the feeder to eat it, and this makes their choice even more important [p. 115 middle].
- A need for calcium causes some birds to eat paint chips [p. 109 middle].
- Eating acorns provides calories, but leads to a net loss of protein, so birds that eat acorns must have an additional source of protein [p. 111 top].

STORING FOOD

Most birds simply eat food as soon as they find it, but some invest great effort into storing it for later use.

- A group of Acorn Woodpeckers can store thousands of acorns for later use [p. 89 top].

Jays store food for use later in the winter, and are careful to keep their hiding places secret [p. 111 middle].

A single chickadee can store up to eighty thousand food items in a season and can remember not only where each item is stored but also some key details about its quality [p. 113 bottom].

DRINKING

Birds can drink their body weight in water in a day, or they can get by with almost none [p. 153 bottom].

Birds in hot and dry climates have many adaptations and strategies to conserve water [p. 186, Canyon Towhee].

Some birds have salt glands (like extra kidneys) on their forehead, which allow them to drink saltwater as needed, and easily switch from saltwater to freshwater and back [p. 17 top].

To conserve water, birds' urine is concentrated to a white solid with almost no liquid [p. 173 bottom].

Survival

BIRDS AND WEATHER

Birds have to live outdoors in all kinds of weather. They rely on their feathers for protection, and use other tricks to survive, but severe weather can be a big challenge.

Birds survive storms by stocking up on food and then sheltering through the worst of the storm [p. 47 bottom].

Swallows rely on flying insects for food, and a period of inclement weather can be a severe challenge [p. 183, Tree Swallow].

Keeping warm

With relatively small bodies and a high body temperature, birds in cold climates often struggle to keep their bodies warm. Feathers are the first line of defense.

Down is the most effective insulation known, by weight [p. 9 middle].

Birds grow more feathers in winter [p. 161 middle].

During extreme cold, birds reduce their activity and stay in sheltered areas. Fluffing the feathers creates a thicker coat; tucking in legs and bill reduces heat loss [p. 125 middle].

Grebes sunbathe by fluffing their feathers to allow the dark gray skin to absorb heat [p. 178, Eared Grebe].

A swan's long neck must be especially hard to keep warm, and is covered with a remarkably dense coat of feathers [p. 7 middle].

Many small birds are capable of entering "torpor," a sort of temporary hibernation, to save energy on cold nights [p. 77 bottom].

Birds use countercurrent circulation to avoid losing body heat through their uninsulated legs and feet [p. 15 top].

Birds in colder climates tend to have smaller bills and feet to reduce exposure [p. 159 bottom].

How does the Atlantic Puffin stay warm with such a large bill in Arctic water? Nobody knows [p. 25 middle].

Keeping cool

Birds are well insulated, and—just like us—they heat up when they exercise. Imagine wearing a down jacket all the time, even when you exercise! It turns out that birds have to be careful to avoid overheating.

Dark plumage can actually be cooler than white plumage [p. 107 middle].

Nests are also important for insulation, keeping the eggs and young from getting too hot or too cold [p. 117 bottom].

Birds don't sweat; they generally cool off by panting [p. 143 middle].

The behavior of desert birds has evolved to avoid exertion during the hottest part of the day [p. 186, Canyon Towhee].

AVOIDING PREDATORS

Birds are hunted constantly by a multitude of predators, and much of their appearance and behavior has developed in response to that threat. This response generally falls into three categories: be inconspicuous; be alert; and—as a last resort—create a distraction.

Be inconspicuous

Many birds rely on not being seen, and have various forms of cryptic coloration for camouflage.

- Killdeer and other species have bold patterns that camouflage by disrupting the outline of the body [p. 179, Killdeer].
- Many species have complex patterns that blend in with their surroundings [p. 180, Eastern Screech-Owl].
- Many species are able to conceal colorful plumage as needed [pp. 143 bottom, 175 top].
- Nests are generally carefully placed so that they are hard to see, and the parent birds are very discreet on their approach to and departure from the nest [p. 12 middle].
- Many ground-nesting birds have camouflaged eggs, and select a nest site that matches the colors of their eggs. And they have evolved odorless preen oil which hides their scent from predators during the nesting season [p. 39 top].
- Nuthatches instinctively wipe the entrance of their nest hole with aromatic or sticky material, presumably to deter predators, although the true function is unknown [p. 119 top].
- Most birds try to stay hidden in vegetation and avoid coming into the open; they weigh the risks and benefits of feeding opportunities [p. 115 top].
- To maximize their ability to escape predators, sparrows delay feeding until later in the day, staying light and quick until the last possible hour [p. 159 top].

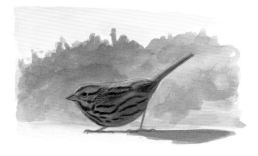

- When birds sleep or rest they generally choose an inconspicuous place that is hard for predators to reach. Forest songbirds roost on twigs well above the ground [p. 121 top].
- One hypothesis to explain the nocturnal migration of many small songbirds is that they are avoiding predators [p. 187, White-crowned Sparrow].

Be alert

Predators generally require surprise to capture their prey, so they target birds that seem slow or inattentive. To foil a predator, birds give loud alarm calls to tell the predator it has been seen, and to alert any other birds nearby. They also use tricks to signal alertness.

- Alarm calls are understood by many species, and, in some, even the whistling sound of wings on takeoff can alert other birds to danger [p. 75 bottom].
- Crows communicate complex information about danger [p. 105 bottom].
- Many birds have plumage markings that create the illusion of eyes—a false face—presumably to make a predator think it has been seen [p. 61 top].
- Tail-wagging and tail-flicking behavior is apparently meant to send a signal of alertness to any potential predators [p. 95 top].
- Many birds literally sleep with one eye open [p. 75 middle].
- Birds in a flock rely on flock mates for vigilance [p. 173 top].
- Migrant birds in a new location can learn about predators from the local resident birds [p. 113 top].

Create a distraction

When all else fails, a bird will try to confuse, harass, or startle a predator.

- Smaller birds are generally quicker and more agile than their predators, so they can be very bold and aggressive about harassing and chasing potential predators. Some species, like the Western Kingbird, are known for this [p. 182].
- Small birds often boldly and loudly gather around to harass, or "mob," a predator [p. 123 left bottom].
- Many birds protect their nests by pretending to be injured and luring predators away [p. 39 right].
- Large flocks of birds can fly in confusing swirls, and though their movements can seem to be choreographed, they are really just reacting to other birds in the flock, like a "wave" in a stadium [p. 43 top].
- Flashy color patterns, like the white rump of the Northern Flicker, may help to startle a potential predator in the midst of an attack [p. 93 bottom].

🖋 Some threat displays show off startling patterns, such as eye spots [p. 119 bottom].

Social Behavior

All birds have complex social lives, and because birds communicate mainly through sight and sound we can study and appreciate their interactions even from a distance. Some species are very social, traveling in flocks all year or nesting in colonies. Other species are essentially solitary and associate only with their mate and only during the nesting season.

COMPETITION AND COOPERATION

Birds generally work hard to find a safe territory with enough food, and often have to defend those resources against other birds. In other circumstances there are advantages to living in large groups and cooperating.

🖋 Threat displays often involve movements or postures that make the bird look larger [p. 7 top].

🖋 The little Downy Woodpecker may have evolved to look like the much larger Hairy Woodpecker to garner more respect [p. 182, Downy Woodpecker].

🖋 Flocking is an advantage where food is concentrated in scattered patches [p. 173 top].

🖋 When suitable nest sites are limited (such as islands) and food is patchy (as in the ocean), then nesting in colonies is the best strategy [p. 49 top].

🖋 Small groups are better at problem solving than individuals [p. 187, House Sparrow].

🖋 Food storage by Acorn Woodpeckers requires the cooperative work of a small group of birds [p. 89 top].

🖋 Crows have a rich and complex social life, and usually travel in groups including parents and their offspring from two or more recent nesting seasons [p. 105 top].

🖋 In some species, birds preen each other [p. 183, Common Raven].

🖋 Chickadees are inquisitive and social and often form the core of mixed-species flocks [p. 113 top].

Courtship

Most species of birds have a prolonged and intricate courtship process. This almost always involves both audible and visible displays.

🖋 Cranes are among the most conspicuously social birds, with dancing and other displays [p. 37 bottom].

🖋 Groups of male Mallards gather to court any female with choreographed displays and sounds [p. 12 top].

🖋 Red-tailed Hawks perform intricate flight displays, and exchange prey and nest materials, as part of their courtship [p. 52 top].

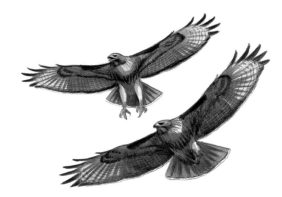

🖋 The male Northern Cardinal shows off his bright red plumage and singing ability, and presents the female with food [p. 186, Northern Cardinal].

🖋 Wild Turkeys use a lek mating system [p. 67 top].

🖋 Northern Flickers fan their tails and sway back and forth in a "dance" [p. 93 top].

🖋 A singing performance often includes visual display of some bright or contrasting color, which ideally is kept hidden at other times [pp. 143 bottom, 175 top].

🖋 Most birds mate for life, but in the smaller species there is only a slight chance that both members of the pair will survive to nest together a second time [p. 169 bottom].

SOUNDS AND DISPLAYS

Birds sing to advertise to potential mates and rivals, and to claim their territory and mark the boundaries.

🖋 Birds practice their songs and vary their performance for different audiences—for example, one type for mates and another for competitors [p. 143 bottom].

🖋 Changes in day length trigger hormonal changes that prompt a bird to sing [p. 147 right bottom].

🖋 Many songbirds inherit a sort of song template, but they must hear the song of their species in order to copy it. Most species of songbirds learn one or a few variations of songs when they are young, and sing those for their entire life without changing [p. 157 top].

- A single Northern Mockingbird can have well over two hundred different songs in its repertoire [p. 185, Northern Mockingbird].
- The Carolina Wren knows up to fifty song phrases, and a single male Marsh Wren might know more than two hundred different songs [p. 184, Carolina Wren].
- Birds produce sound with their syrinx, and can sing two different sounds simultaneously—one from each side of the syrinx [p. 131 middle].
- The pitches in some birdsongs are related mathematically, like a musical scale [p. 131 top].
- Some birds sing at night, mainly to take advantage of the quiet to send their messages [p. 135 bottom].
- A bird's song is like an elaborate gymnastics routine, combining strength, speed, and precision [p. 157 middle].
- Many birds sing in flight, both for the visual display and to broadcast their song over a wide area [p. 167 top].
- The muscular tongue of parrots may play an important role in sound production [p. 85 bottom].

Sounds can be nonvocal.

- Some birds, like snipes, produce sound with specially modified feathers [p. 45 top].
- The wings of many species make a whistling sound in flight [p. 75 bottom].
- American Woodcocks perform a spectacular flight display, creating sound mostly or entirely with their wings [p. 179, American Woodcock].
- Most woodpeckers use their bill to produce a rapid drumming on wood in place of song [p. 87 right].

FAMILY LIFE

The central activity in a bird's life is reproduction: finding a mate and selecting a territory or a nesting site, preparing a nest, laying eggs, incubating those eggs, then feeding and protecting the young. This whole process can take as little as one month in smaller species, up to four to six months in many larger species, and over a year in a few species.

Territory

Most species defend a breeding territory that will provide food, water, and a suitable nesting site, and they remain on that territory for the entire breeding season. Resident species might stay on their territory all year.

- Most migratory birds return to the same small territory every summer, usually near where they were hatched [p. 103 top].
- Some migratory species also defend winter territories, and return to the same one every year [p. 185, Wood Thrush].
- Birds defend their territory against intruders, and disputes can lead to brief scuffles. Territorial birds are sometimes confused by their reflection in a window or a car mirror [p. 187, Song Sparrow].

NESTING

After courtship and territory establishment, birds get down to the actual work of raising young. Many different strategies have evolved. In this book, the full nesting cycle is shown for three species with three different strategies: Mallard [pp. 12–13], Red-tailed Hawk [pp. 52–53], and American Robin [pp. 128–129].

Timing of nesting

In general, birds seem to time their nesting efforts so that the chick-rearing stage happens at a time when there is abundant food available. For most songbirds this is the spring and early summer, when insect abundance is high.

- The nesting cycle of waxwings is timed to take advantage of the peak of fruit abundance [p. 139 top].
- Most species of birds have a very brief nesting season; some, like Mourning Doves, can nest almost year-round [p. 181, Mourning Dove].
- A recent study of nest timing found that many species have shifted earlier as the climate has warmed [p. 111 bottom].
- Some birds nest in two different places in the same year [p. 139 bottom].

Nest building

Each species has its own style of nest building, including the location, materials, construction method, and shape. Some birds build extraordinary nests for their eggs, others build no nest at all, and others don't even raise their own young. All of this is instinctive, but adaptable to local conditions.

Nest building generally takes four to seven days for the Red-tailed Hawk [p. 52 middle] and the American Robin [p. 128 top], but up to fifty days for the Bushtit [p. 117 left].

Woodpeckers excavate nesting holes in trees [p. 87 right].

Some species use mud to build shaped nests, and the shape is distinctive for each species [p. 101 top].

Bushtits instinctively know two different nest styles [p. 117 top].

Nests are important for insulation, keeping the eggs and young from getting too hot or too cold. There is evidence that birds build thicker nests in colder locations [p. 117 bottom].

Species that nest in cavities (such as old woodpecker holes) rely on a steady supply of holes. In many areas such holes are scarce, and birdhouses are a good substitute [p. 133 middle].

Some birds don't build a nest at all; they simply lay eggs in a depression on the ground, and have many adaptations to help them succeed [p. 39 top].

Species that nest on the ground on sandy beaches have to coexist with humans, our dogs and vehicles, and other threats [p. 39 bottom].

Nest defense

Birds can be very aggressive in defense of their nest, even if at other times they are timid [p. 135 top].

One potential advantage of nesting in colonies is that all nests are defended by an "army" of birds [p. 49 top].

Eggs

An egg is a major investment.

A single egg can be up to 12 percent of the body weight of the female bird, and she might lay one egg a day for multiple days [p. 157 bottom].

Eggshells require a lot of calcium, which birds must get from their diet. Some birds try to get calcium by eating paint chips from houses [p. 109 middle].

One of the effects of DDT is to reduce birds' ability to process calcium, leading to thin eggshells and no reproduction [p. 29 left middle].

Eggs of each species have a characteristic shape, color, and pattern.

Subtle differences in the egg shape of different species are apparently influenced by the requirements of flight [p. 169 top].

Dark spotting on eggs is mainly for added strength [p. 137 bottom].

The number of eggs in each nest varies by species. Four eggs is a typical number for many species of songbirds, and a pair of adults can usually provide enough food for that many offspring [p. 128 middle].

Species with precocial young can lay more eggs because the chicks are more fully developed at hatching and can find their own food—often ten eggs or more in a nest, as in Mallards [p. 12 middle].

Some species lay only a single egg. Some usually lay two or three eggs, as in Red-tailed Hawks [p. 52 middle].

During the egg-laying stage, before incubation starts, the nest is not defended. The female visits every day or two to lay an egg [p. 12 middle].

Broken pieces of eggshell on the ground indicate predation or an accident; an empty eggshell neatly split in half indicates hatching [p. 133 bottom].

Parental roles

The roles of males and females vary greatly between species. Overall, females do more parenting than males.

Species in which males and females look alike generally share parenting duties equally [p. 3 bottom].

Migration is linked to sexual dimorphism and also to diverging roles for males and females, with the female handling more of the nest building and parenting [p. 186, Indigo Bunting].

In most ducks, the female is responsible for all of the nesting duties [p. 12].

In hummingbirds and grouse, including species with a lek display system, no pair bond is formed and the male takes no part in nesting or raising young [p. 67 top].

- Grebes share parenting duties in an unusual way [p. 23 bottom].
- Crow parents often have helpers, usually one- or two-year-old offspring from the same parents in previous years [p. 105 top].

Incubation

Incubation is when the parent bird sits on the eggs to warm them so the embryos begin to develop. Once development begins, the embryos are very sensitive to temperature, and the adults spend up to twenty-three hours a day incubating.

- In most species, the parents begin incubating after the last egg is laid, so all eggs develop and hatch together (synchronous hatching) [p. 12 middle].
- In some species, incubation begins with the first egg, and chicks hatch on different days in the order that the eggs were laid (asynchronous hatching) [p. 52 bottom].
- Incubation times are generally longer in precocial birds and shorter in altricial birds [p. 3 top].
- Communication between eggs and parents in the last few days before hatching has been documented in several species [p. 23 bottom].
- The length of time it takes for an egg to develop and hatch has evolved, at least in part, under the pressure of sibling rivalry—a race to hatch [p. 115 bottom].
- In the Red-tailed Hawk, incubation is mostly by the female, and takes four to five weeks [p. 52 middle].
- In the Mallard, incubation is entirely by the female and takes about four weeks [p. 12].
- In the American Robin, incubation is entirely by the female and takes less than two weeks [p. 128].
- Incubation is the most dangerous time for a bird [p. 12 middle].

Chick development

- Precocial young hatch fully feathered, with their eyes open, and instinctively know how to feed themselves and avoid danger [p. 3 top].
- Precocial young find their own food, but depend on the parent for warmth and mentoring, especially in the first week or so [p. 13 bottom].
- Altricial young are born naked and helpless, and require care for many days. There are pros and cons to being precocial or altricial [p. 103 middle].

- Some birds use an intermediate strategy, between precocial and altricial—young birds hatch fully feathered and mobile, but still depend on the parents for food [p. 19 bottom].
- In species with asynchronous hatching, such as Red-tailed Hawks, the strongest (usually oldest) chick gets fed first, and the others are fed only if there is enough food [p. 53].
- Young birds instinctively imprint on a parental figure [p. 3 middle].

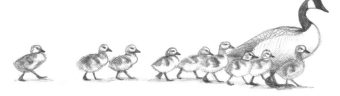

- Young loons often climb onto their parent's back to rest, which is warmer and safer than swimming [p. 21 middle].
- On short trips to feed their young, a parent bird carries food in its bill. On longer trips, birds store food in their crop and carry it back to the nest to regurgitate it for their young [p. 35 middle].
- Birds will select highly nutritious and natural food for their young, often different from what they eat themselves [p. 47 top].
- Chickadees seek out spiders (high in the essential nutrient taurine) for the first week or so that they are feeding young [p. 113 middle].
- The waste produced by young birds in the nest is managed by an adaptation called the "fecal sac" [p. 87 bottom].

Fledging

The length of time that young birds spend in the nest before they fledge varies a lot between species. Precocial young leave the nest just hours after hatching, long before they can fly. At the other extreme, altricial young are completely dependent on the parents and remain in the nest for weeks, until they can fly.

- Baby birds often leave the nest before they are fully able to fly, but generally do not need your help [p. 105 middle].
- To enable fledging sooner, many young birds leave the nest with a complete set of relatively flimsy feathers,

which are replaced within weeks by a stronger, more adult-like set [p. 147 left middle].

- Birds do not "learn" to fly, any more than humans "learn" to walk. They simply develop the feathers, muscles, and coordination necessary [p. 53].
- American Robins fledge about two weeks after hatching [p. 129].
- Red-tailed Hawk nestlings fledge at about six weeks, but continue to get food from their parents for several more months [p. 53].
- Loons become independent about twelve weeks after hatching [p. 21 middle].
- Mallards leave the nest within hours, become gradually more independent, and fly about eight or nine weeks after hatching [p. 13].

Post-fledging care and independence

In most species young birds continue to be fed and defended by the parents for days or weeks after they leave the nest.

- In most songbirds, parental care continues for up to two weeks after fledging [p. 129].
- In larger species like the Red-tailed Hawk, the young stay close to the nest for several more weeks and continue to be fed for at least eight weeks (and up to six months) after leaving the nest [p. 53].
- Precocial young, like ducks, receive no food from their parents [p. 13].
- Most birds disperse individually in winter and do not stay together as a family [p. 155 bottom].
- In some flocking species, pairs or groups might travel together for months or even years [p. 37 bottom and p. 188, Lesser Goldfinch].

Renesting

- Most species nest only once each year. If a nest is lost early in the season, they might be able to make another attempt, but they do not have time for two complete cycles in one season [p. 13].
- Many smaller species with shorter nesting cycles can nest successfully two, or even three, times in a single season, and generally build a new nest each time [p. 129].
- Some species will reuse a nest [p. 95 middle].

Brood parasitism

Some species do not build a nest or care for their young. Cowbirds use a nesting strategy called *brood parasitism,* laying their eggs in the nests of other species and leaving all of the work to the unwitting foster parents.

- Cowbird eggs hatch more quickly than their host species' eggs, and chicks grow faster and larger, so the baby cowbird has an advantage over its nest mates [p. 171 bottom].
- The female cowbird monitors the eggs that she has laid, which might be a key to the young cowbirds in being able to recognize their own species a few weeks after fledging [p. 171 middle].

Birds and Humans

Interactions between birds and humans fall into a few main categories: birds' influence on human culture; birds in commerce; and birds' lives altered by the human population.

BIRDS AND HUMAN CULTURE

Birds feature prominently in folklore, and their shapes, habits, and sounds have inspired writers, musicians, and scientists for millennia.

- There are similarities between birdsongs and human music [p. 131 top].
- The structure of feathers and other details of bird anatomy continue to inspire scientists [p. 103 bottom].
- People mark the changing seasons by the migrations and songs of birds [p. 147 right bottom].
- The snipe is a real bird, but a "snipe hunt" is a practical joke [p. 45 middle].
- Hawks have been persecuted, unfairly, for centuries [p. 55 top].

Bird names

The names we use for familiar birds can be based on their sounds, habits, or appearance.

- Phoebes get their name from their song [p. 182, Black Phoebe].

- Chickadees are named for their calls [p. 184, Black-capped Chickadee].
- Nuthatches are apparently named for their habit of "hatching" (like a hatchet) nuts [p. 184, White-breasted Nuthatch].
- The name *titmouse* comes from two Middle English words, both meaning "small bird" [p. 184, Oak Titmouse].
- The American Robin is named for its resemblance to the distantly related European Robin [p. 185, American Robin].

BIRDS IN COMMERCE

The earliest humans hunted wild birds for food. Until around 1900 wild birds were hunted and widely sold for food and for fashion. Now we raise domesticated birds for food.

- Market hunting in the 1800s was responsible for the extinction of several species, including the Passenger Pigeon [p. 73 bottom].
- Outrage over the slaughter of birds for women's hats around 1900 led to the formation of Audubon societies, national wildlife refuges, and new laws protecting wild birds [p. 179, Snowy Egret].
- Only a few species of birds have been domesticated by humans [p. 177, Muscovy Duck].
- Among the most important domesticated birds is the Graylag Goose, raised for meat, eggs, feathers, and vigilance [p. 9 bottom].

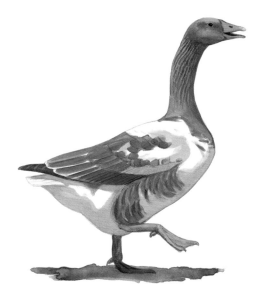

- Domestic turkeys originated in Mexico, and reached the United States via Europe [p. 67 middle].
- The domestic chicken is the most numerous bird in North America [p. 69 bottom].
- For hundreds of years feathers were the preferred implement for writing [p. 9 top].
- Each of the different types of feathers from a goose is used for different products [p. 9 middle].
- Parrots worldwide are now threatened by capture for the pet trade [p. 182, Monk Parakeet].
- Painted Buntings are threatened partly by trapping for use as cage birds [p. 151 middle].
- Bird feeding is big business. The food that we feed to birds must be grown somewhere, of course, and must be protected from birds during the growing process [p. 175 bottom].

BIRDS AND THE HUMAN ENVIRONMENT

The increasing human population has a broad impact on birds, mainly by usurping the birds' natural habitat and transforming it into human habitat. Some species adapt and benefit from these changes, but most do not.

- Rock Pigeons adapted readily to nesting on the ledges of buildings instead of on cliffs, and now thrive in cities worldwide [p. 181, Rock Pigeon].
- House Sparrows apparently adapted to take advantage of the beginnings of human agriculture about ten thousand years ago, and have continued a close relationship to humans [p. 161 top].
- House Finches have adapted very well to suburban life, and often nest on window ledges and other structures [p. 187, House Finch].
- Barn Swallows [p. 101 top] and Chimney Swifts [p. 99 bottom] nest almost exclusively in human structures.
- Bluebirds nest in cavities such as old woodpecker holes, and might be limited by that if people didn't provide birdhouses for them [p. 133 middle].
- As human noise changes the soundscape, birds are changing their sounds [p. 159 top].
- In urban areas, more birds sing at night, likely to take advantage of the quiet [p. 135 bottom].
- Sandy beaches are scarce and in high demand for human use, which leads to conflicts with the birds that have adapted to nest there [p. 39 bottom].

AGRICULTURE AND BIRDS

An increase in industrial farming methods, especially the reduction of weeds and insects with chemicals, has been bad for birds.

- Birds that thrive in hedgerows have declined as farm fields have become larger and more sterile [p. 71 top].
- Modern hay-farming methods, with more frequent cutting, don't allow enough time for birds to complete a nesting cycle between harvests [p. 167 middle].
- Some species, like grackles and crows, benefit from human agriculture, and their increased population has an unnaturally large impact on the ecosystem [p. 188, Common Grackle].

BIRD FEEDING

In most places, all it takes to attract birds to your yard is a little food. If you offer seeds or other quality food, the birds will find it and appreciate it.

- Hummingbirds (and other species) can be attracted to sugar water [p. 79 top].
- Birds generally prefer natural food over a bird feeder [p. 155 top], and never rely on feeders for more than 50 percent of their food [p. 133 middle].
- Birds do not become dependent on feeders. Feeders do not keep birds from migrating or make them more vulnerable to predators [p. 155 top].

Ecology and Bird Conservation

Ecology is the study of the interactions among living things as well as between them and their environment. Everything is connected, and birds demonstrate these connections.

- It goes without saying that birds need a clean and healthy environment [p. 178, Common Loon].
- The sap wells created by sapsuckers are an important food source for many other species [p. 182, Yellow-bellied Sapsucker].
- Nest holes created by Northern Flickers and other woodpeckers provide nesting and roosting sites for dozens of other species [p. 182, Northern Flicker].

- Salmon are critical to the survival of many birds, simply because they deliver nutrients upstream [p. 125 bottom].
- Fruit has evolved to attract birds so that the birds disperse seeds [p. 145 bottom], and flowers have evolved to attract hummingbirds for pollination [p. 181, Rufous Hummingbird].
- Great Blue Herons benefit from the habitat that beavers create [p. 31 bottom].
- Fear is a powerful ecological force. Predators cause changes in the behavior of their prey species, which creates opportunities for those lower in the food chain [p. 180, Cooper's Hawk].
- The human habit of transporting animals and plants across the globe and releasing them in different ecosystems has sometimes devastating consequences. Some species thrive but have a negative impact on other species, and are called "invasive" [p. 185, European Starling].
- The swan species seen by most people in North America is a nonnative species often considered invasive [p. 177, Mute Swan].
- American Robins are native to North America but have benefited from such invasive species as earthworms, bittersweet, and buckthorn [p. 127 left top].

HABITAT

- In the competition for resources, each species has adapted to a niche where it can succeed alongside other species [p. 41 top].
- Many species of birds are very sensitive to details of their habitat—foliage, insects, moisture, temperature, light levels, and many other factors [p. 185, Black-throated Blue Warbler].
- Red-tailed Hawks and Great Horned Owls occupy similar habitats and take similar prey, but the hawk hunts in daylight and the owl at night [p. 180, Great Horned Owl].

BIRD POPULATIONS

- The most numerous species of wild bird in North America is the American Robin, and even that is outnumbered by humans; the domestic chicken is the most abundant bird in the world [p. 69 bottom].

🖋 The total population of a species can be limited by one aspect of its life cycle [p. 83 middle].

🖋 Some species are tied to "boom-and-bust" cycles of seeds or other food. Populations increase when food supplies are good, and decrease in poor years as birds are forced to wander in search of food [p. 165 bottom].

Winners and losers

🖋 The Canada Goose has gone from a rare species needing protection in the early 1900s to being abundant and widespread today [p. 177, Canada Goose].

🖋 The Wild Turkey was nearly extinct around 1900, and is now common again [p. 181, Wild Turkey].

🖋 As farmland has regrown into forests across much of the eastern United States, the Pileated Woodpecker has benefited [p. 182, Pileated Woodpecker].

🖋 Barn Swallows have benefited from civilization—barns provide nesting sites, and the surrounding fields are ideal foraging areas—but may have trouble thriving if insect populations continue to decline [p. 183, Barn Swallow].

🖋 American Robins have benefited from development, and thrive around suburban lawns and plantings [p. 127 left top].

🖋 Northern Cardinals have adapted well to suburban habitats and expanded their range north in the last century [p. 186, Northern Cardinal].

🖋 The American Kestrel is declining; possible causes include habitat loss, contamination, loss of nesting sites, and the decline of insects [p. 180, American Kestrel].

🖋 Chicken-like birds in the grouse and pheasant family are hunted around the world wherever they live, and many species are now very rare; a few are extinct, including the Heath Hen of the northeastern United States [p. 181, Greater Prairie-Chicken].

🖋 Grassland birds have declined because of habitat loss and changes in farming practices [p. 167 middle].

🖋 Widespread declines of Northern Bobwhites are unexplained [p. 71 top].

🖋 Several species of birds have gone extinct in North America in the last one hundred years; the last Passenger Pigeon died in 1914 [p. 73 bottom].

Threats to Bird Populations

The primary threat facing most bird populations is habitat loss (see "Winners and losers," left). Other major threats include house cats, window collisions, pesticide use, and climate change. A recent study found that the total number of birds in North America has dropped by 25 percent in the last fifty years.

🖋 We rarely find dead birds, and when we do there is usually a human-related cause [p. 123 right bottom].

🖋 Most songbirds don't survive their first year, and once they are adult they have about a 50 percent chance of surviving each year [p. 169 bottom].

HOUSE CATS

House cats are serious predators and are not native to North America. It is estimated that cats kill more than a billion birds a year in North America (and even more small mammals)—more than any other human-related mortality. Feral cats living in the wild are responsible for most of those bird deaths, but even well-fed pets kill hundreds of millions of birds every year.

Colonies of outdoor feral cats are particularly devastating to surrounding bird populations. Despite all of the evidence, including the fact that cats in these colonies live brutal and short lives, such colonies have been allowed, and even supported, in many places. If you own a cat, keeping it indoors is one of the best things you can do for birds. An indoor cat won't kill birds, and it will live a longer, healthier life.

WINDOW COLLISIONS

Window collisions are one of the most serious human-related causes of death in birds, estimated to kill hundreds of millions of birds every year in the United States alone. Even though collisions are common, they happen so infrequently at any one building that they can be easy to ignore. The basic issue is that birds think they can fly into the open sky and trees that they see reflected in the glass. Hitting a solid pane of glass at full speed is often fatal.

This issue is distinct from the usually nonlethal problem of territorial birds attacking their reflection in a window (p. 187, Song Sparrow, and see below). This is also separate from the issue of migrating birds being attracted to and crashing into lighted city office buildings at night. In that case the solution is simply to turn off lights so that the birds are not attracted.

How to prevent window collisions

In order to prevent birds from crashing into the windows at your home, you must make the birds understand that they can't fly through the window. One of the simplest and most effective solutions is to hang strings or place vertical strips of tape a few inches apart on the outside of the window. This creates a visual barrier with gaps too small for a bird to fly through, but doesn't interfere much with your view from inside the house. The widely used decals of falcon silhouettes are not effective, since they leave too much of the window unobstructed and birds simply try to fly around them. Commercial products are available, or you can make your own.

CLIMATE

Climate change due to greenhouse gasses will have dramatic and far-reaching impacts on bird populations in the future. Its effects are already being seen in changing migration times and a generally disruptive effect on natural cycles. Rising sea levels are a serious threat to coastal birds.

- The timing of annual cycles of plants and insects is shifting with climate change; some birds are able to adjust, but others are not keeping pace [p. 111 bottom].
- Many species have been spreading north for at least a century [p. 89 middle].
- Robins now winter farther north, at least partly due to a warmer climate but also because of more abundant fruit [p. 127 left top].

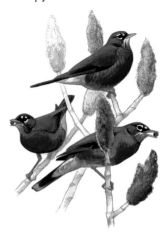

- If projections for future climate in the desert Southwest are accurate, many birds will find it impossible to survive there [p. 186, Canyon Towhee].

CONTAMINANTS

Birds depend on us for a clean environment, and they require healthy populations of insects, fish, and other food sources. Species affected by DDT in the 1960s have mostly recovered since that chemical was banned in the United States, but overall pesticide use has increased since then and some of the newer chemicals are known to cause harm to birds.

- Contaminants like DDT accumulate as they move up the food chain [p. 29 left top].
- The Bald Eagle, now recovering, was one of many species decimated by DDT [p. 180, Bald Eagle].
- Lead poisoning, caused by human products, is an insidious and serious threat to many species [p. 57 bottom].
- Widely used new pesticides are implicated in broad declines of insect-eating birds [p. 101 middle].

DISEASE

Disease is rarely seen in the wild, as sick birds tend to hide and are also more vulnerable to predators.

- Conjunctivitis is an eye disease frequently seen in House Finches [p. 163 bottom].
- West Nile Virus has had a significant impact on bird populations (p. 183, California Scrub-Jay)

WHAT IT'S LIKE
TO BE A BIRD

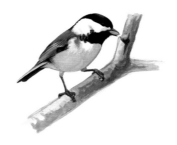

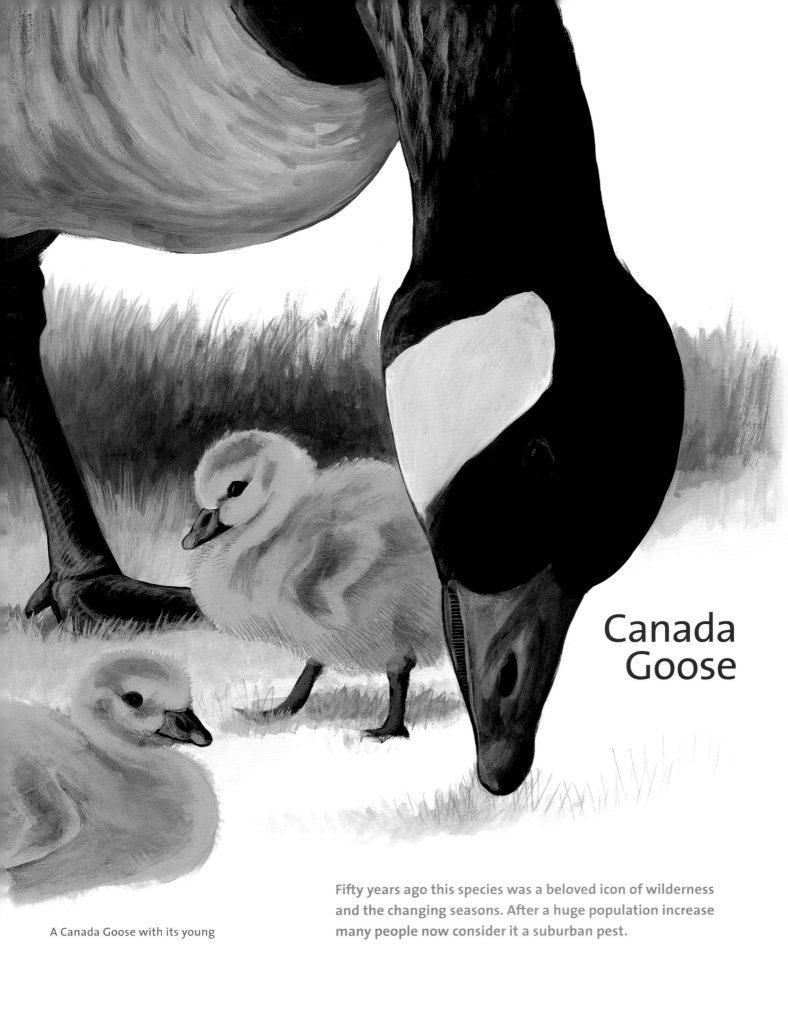

Canada Goose

Fifty years ago this species was a beloved icon of wilderness and the changing seasons. After a huge population increase many people now consider it a suburban pest.

A Canada Goose with its young

■ Geese, like ducks, sandpipers, and chickens, have *precocial* young—hatched with eyes open, fully feathered, capable of walking, swimming, feeding, and maintaining their own body temperature within a few hours after they hatch. Most of their behavior is instinctive, and geese hatched in a mechanical incubator with no parents can care for themselves and grow into healthy adults. The adult goose in the wild protects the young from predators and other dangers, and leads them to good feeding areas, but does not feed them. Songbirds, in contrast, have *altricial* young, hatched naked and helpless with eyes closed, requiring two weeks or more of constant care and feeding to survive (see p. 103 middle).

A baby Canada Goose, just a few days old

■ Young geese instinctively form an attachment to, or imprint on, the first plausible parent they see. In geese the critical period is about thirteen to sixteen hours after hatching. Newly hatched geese are not very discriminating, and can imprint on other species, including a human, or even on an inanimate object like a toy train. This instinctive behavior has obvious value in species like geese, in which the precocial young leave the nest soon after hatching and must be strongly attached to their parents to have the best chance of survival.

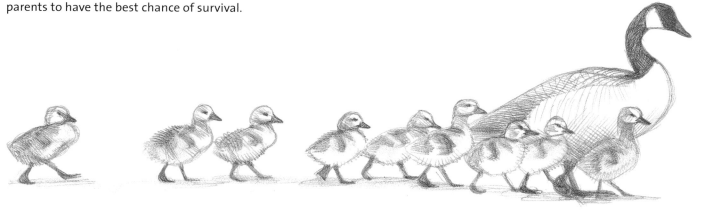

A family of Canada Geese

■ Male and female geese are similar in appearance, typical of species in which both sexes share the work of tending the nest and young. It is still possible to distinguish male and female geese by careful observation of their behavior. In a family of geese, the male is usually the largest individual, and tends to stand taller, acting as sentry and defender. Unlike most birds, family groups of geese stay together throughout the fall and winter. The male is called a gander, and the female is a goose.

A Canada Goose pair—male on left, female on right

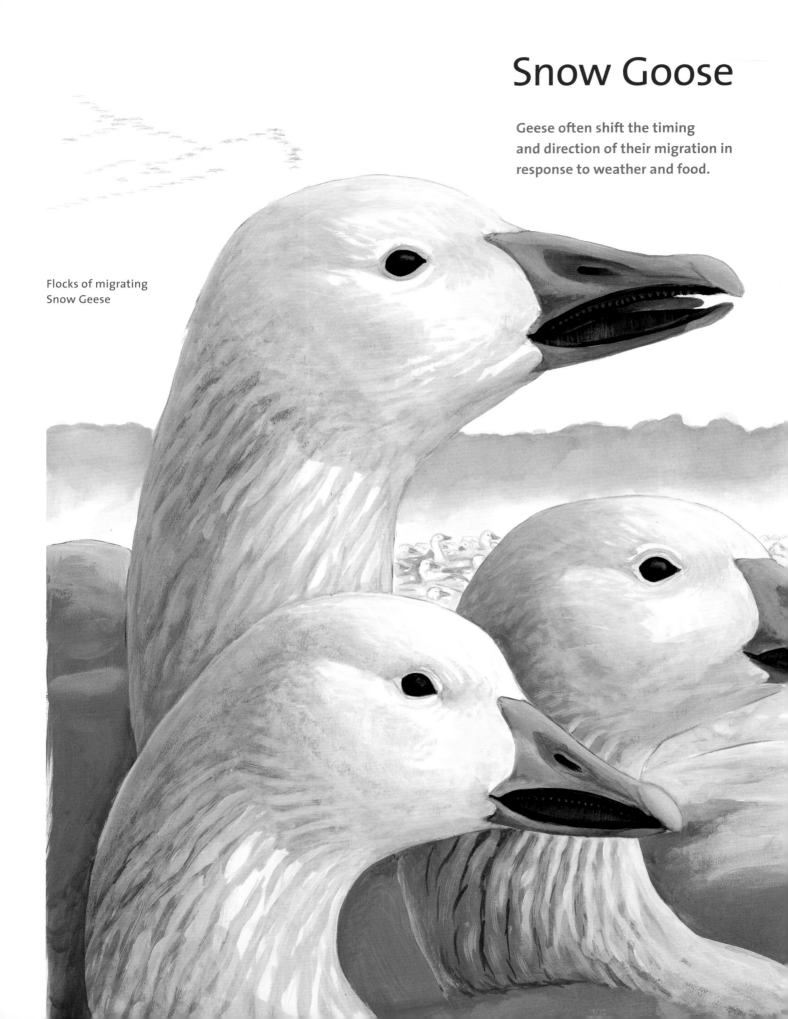

Snow Goose

Geese often shift the timing and direction of their migration in response to weather and food.

Flocks of migrating Snow Geese

■ Flying in a V formation allows birds to reduce their energy use and increase their flight range. It also enhances communication within the flock by allowing birds to maintain visual contact with all of their flock mates. Birds in a V save energy by flying through rising air currents left by the bird in front of them. Each flying bird leaves behind a "wake" of swirling air. Air flowing across the curved airfoil shape of the wing creates higher pressure below the wing and lower pressure above, and this difference in pressure keeps the bird aloft. Most of the wing pushes air down—a downwash; but the high pressure below the wing spills off the wing tip and creates an upwash there. Trailing birds shift to the side to avoid the downwash, and adjust their position so that one wing passes through the upwash left by the bird ahead. They even adjust their wing beat rhythm and their distance from the bird in front so that their wing beats are in phase, with their wing tip following the same path through the air to remain in the upwash from the leading bird's wing beats. To accomplish this, they must have a remarkable sensitivity to air movement, lift, and drag, to find the most efficient path through the air.

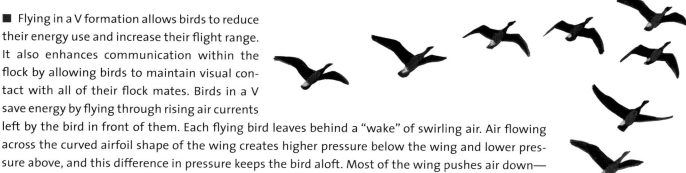

Geese flying in a V

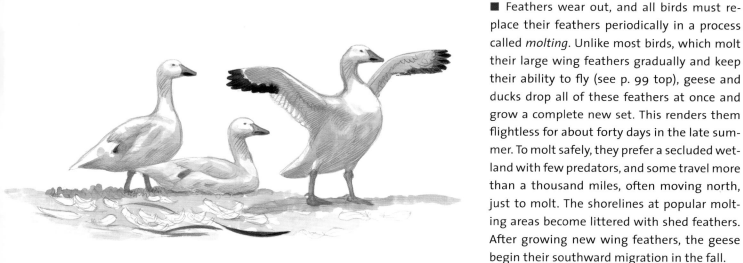

Molting Snow Geese

■ Feathers wear out, and all birds must replace their feathers periodically in a process called *molting*. Unlike most birds, which molt their large wing feathers gradually and keep their ability to fly (see p. 99 top), geese and ducks drop all of these feathers at once and grow a complete new set. This renders them flightless for about forty days in the late summer. To molt safely, they prefer a secluded wetland with few predators, and some travel more than a thousand miles, often moving north, just to molt. The shorelines at popular molting areas become littered with shed feathers. After growing new wing feathers, the geese begin their southward migration in the fall.

■ Birds have no teeth. Food can be broken up a little by the bill, but most of the work of crushing food is performed by the very muscular gizzard. Food is stored in the crop, an expandable pouch at the front of the body, and then passes through the proventriculus into the gizzard. There, powerful muscles squeeze and grind the food. The gizzard is remarkably strong; for example, a Wild Turkey can crush whole walnuts in its gizzard, and the Surf Scoter can crush small clams. Snow Geese eat mostly plant material, so they swallow small rocks as well to provide a hard grinding surface that helps pulverize food in the gizzard.

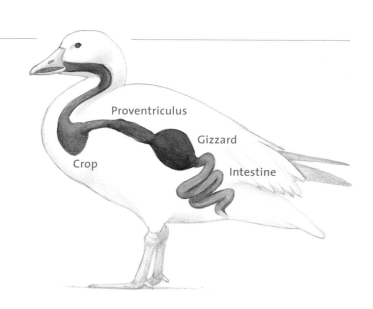

Proventriculus

Gizzard

Crop

Intestine

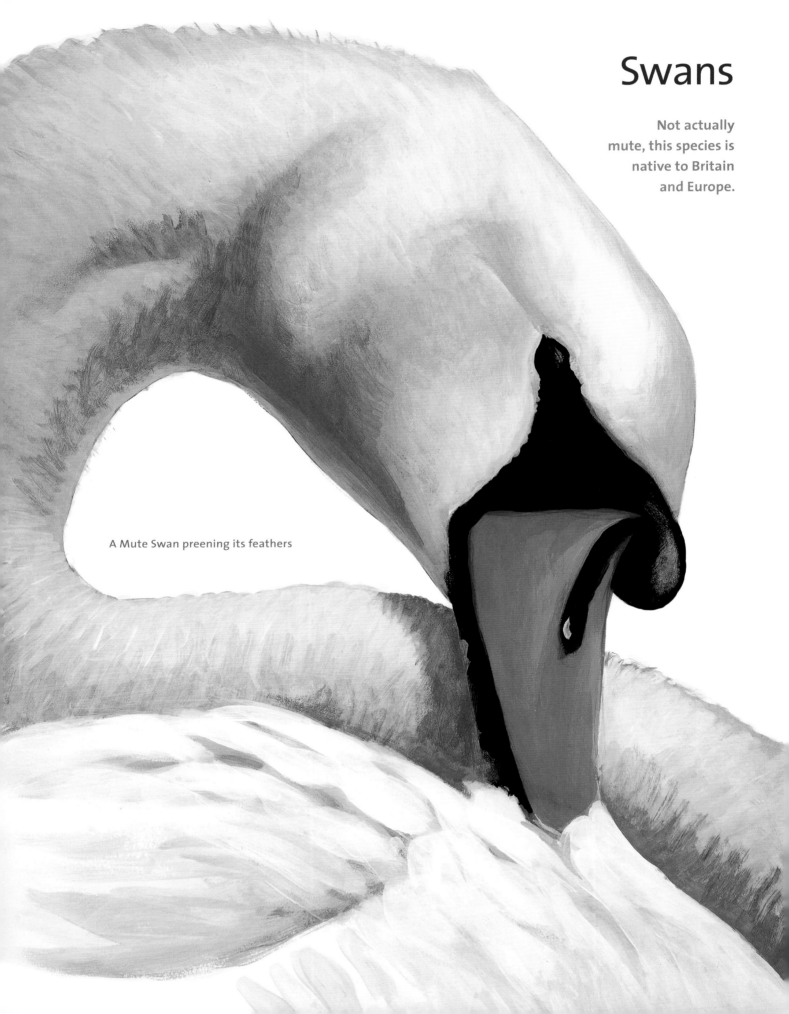

Swans

Not actually mute, this species is native to Britain and Europe.

A Mute Swan preening its feathers

The aggressive display of a Mute Swan

■ Many aggressive displays are designed to make the bird look larger. The threat display of the Mute Swan is a prime example. The swan lifts its wings up above its back, fluffs out the tiny feathers on its neck, and surges forward across the water. This is accompanied by some fearsome hissing. In most cases, birds are bluffing when they threaten a human like this, but the Mute Swan, at about twenty pounds, can deliver a powerful blow with the bony leading edge of its wing or with its bill, and you should give it a wide berth.

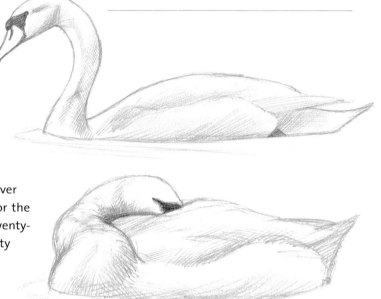

■ Swans and geese have long slender necks that must be kept warm in any weather, and especially when exposed to freezing wind and submerged repeatedly in water. To reduce exposure and retain heat, long-necked birds coil their necks tightly against the body when they can. The countercurrent circulation birds have in their legs (see p. 15 top) is not practical in the neck, because the brain requires a steady supply of warm oxygenated blood. So these species have evolved a dense coat of tiny downy feathers over their entire neck. In fact, a Tundra Swan holds the record for the most feathers ever counted on an individual bird—just over twenty-five thousand in all, with 80 percent of those (about twenty thousand feathers) on the head and neck.

A Mute Swan curling its neck to keep warm

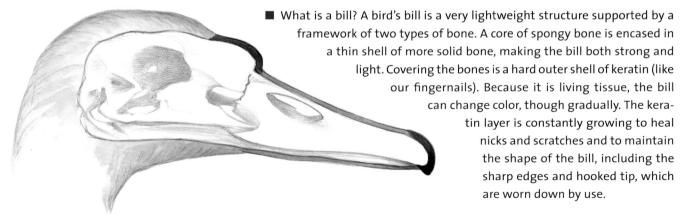

■ What is a bill? A bird's bill is a very lightweight structure supported by a framework of two types of bone. A core of spongy bone is encased in a thin shell of more solid bone, making the bill both strong and light. Covering the bones is a hard outer shell of keratin (like our fingernails). Because it is living tissue, the bill can change color, though gradually. The keratin layer is constantly growing to heal nicks and scratches and to maintain the shape of the bill, including the sharp edges and hooked tip, which are worn down by use.

A Mute Swan's bill structure, with the bones in gray and the thin covering of keratin in orange and black

Domestic Ducks and Geese

These are just two examples of the wide range of different breeds and hybrids of these domesticated species.

Domestic varieties of Muscovy Duck (top) and Mallard (bottom)

■ For more than a thousand years, from the 600s to the 1800s, feathers were the ultimate writing implements. The tubular structure of a feather shaft, and its combination of stiffness and flexibility, worked perfectly for a pen. Simply cutting diagonally across the shaft of the feather creates a delicate pointed tip with a hollow tube to hold ink, while trimming the barbs from the sides of the feather allows room for a comfortable grip. The large wing feathers of birds such as geese and crows were the right size, and readily available, especially where geese were raised for food. In fact, Saint Petersburg, Russia, exported 27 million goose quills annually in the early 1800s. Artists still use delicate "crow quill pens," though they are no longer made from bird quills. The modern word "pen" comes from the Latin word *penna*, for "feather," and a "pen knife" was a small folding knife carried in a pocket and used to make and maintain feather pens.

The large wing feathers of a Graylag Goose, trimmed to form a pen

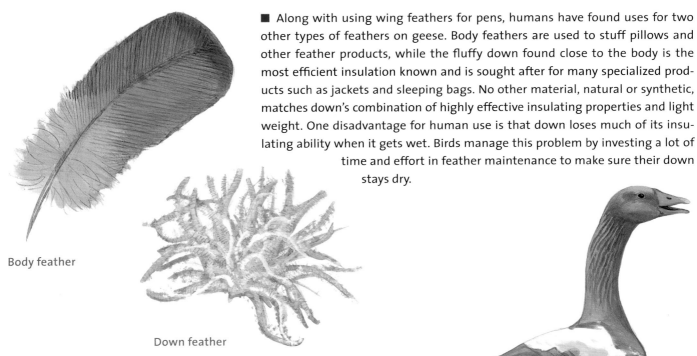

■ Along with using wing feathers for pens, humans have found uses for two other types of feathers on geese. Body feathers are used to stuff pillows and other feather products, while the fluffy down found close to the body is the most efficient insulation known and is sought after for many specialized products such as jackets and sleeping bags. No other material, natural or synthetic, matches down's combination of highly effective insulating properties and light weight. One disadvantage for human use is that down loses much of its insulating ability when it gets wet. Birds manage this problem by investing a lot of time and effort in feather maintenance to make sure their down stays dry.

Body feather

Down feather

■ In past centuries geese were among the most important domesticated birds. The Graylag Goose of Europe was raised for meat and eggs and also provided feathers for down and pens. They can even provide security, as their vigilance and loud calls make them functional "watchdogs."

A domestic Graylag Goose

Dabbling Ducks

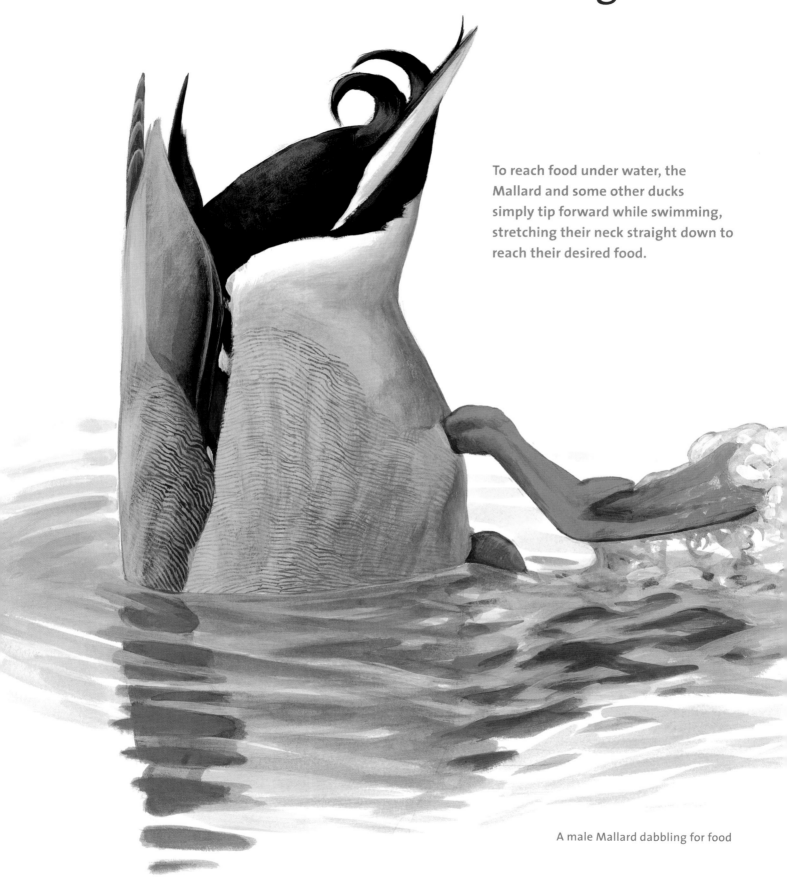

To reach food under water, the Mallard and some other ducks simply tip forward while swimming, stretching their neck straight down to reach their desired food.

A male Mallard dabbling for food

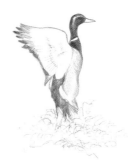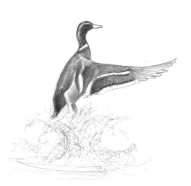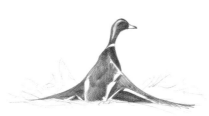

A Mallard taking off from the water

■ Taking off from water presents special challenges, since the water doesn't provide a solid surface for launching. Most species (see p. 21 top) need to run across the surface to reach takeoff speed. Dabbling ducks like the Mallard are unusual in being able to launch directly into the air from the water. They do this by using their wings to push against the surface of the water. Their first wing beat is in the water, not the air. Once clear of the water, with a few vigorous flaps in the air, they climb and accelerate to normal flying speed.

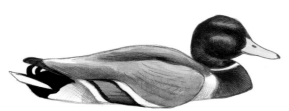

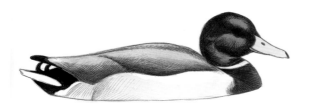

■ What happens to a duck's wings when it is swimming? The wings fold against the side of the body, and the flank feathers wrap around from the belly to cover the wings. Feathers of the breast, belly, and flanks form a complete waterproof shell, like a boat, that holds the body and wings afloat. When the back feathers spread out to cover the folded wings from above, they fit under the flank feathers, and this forms a waterproof seal to protect the entire body from the water.

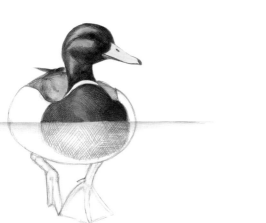

A magnified part of one feather showing the barbs and barbules

Shaft

Barbule

Barb

The top image shows a duck's normal posture, with the wing hidden behind the flank and back feathers. In the middle image, the wing is exposed. The bottom image shows how the flank feathers wrap around both sides to form a complete waterproof shell.

■ All birds have feathers, and no other living thing does. The typical feather has a single central shaft, with angled barbs on either side of the shaft. Each barb is lined with many tiny barbules. The barbules on one side of the barb have tiny hooks, or barbicels, that latch on to grooved barbules extending back from the next barb, sticking them together like Velcro. This forms a flat surface that is lightweight, strong, flexible, and water repellent. One reason feathers have such remarkable resistance to breakage is that fibers run continuously from the base of the feather along all of the branches right to the tips of the barbs and barbicels (the orange line shows a single fiber).

The Nesting Cycle of a Mallard

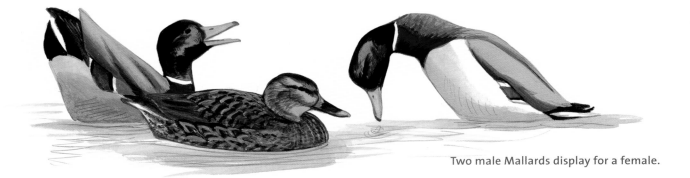

Two male Mallards display for a female.

Courtship begins as early as November and continues through the winter, as males vie for females' attention. Once a pair bond forms, the male and female will stay together through spring migration and during the nest-building and egg-laying stages, but the male departs when incubation begins.

The female alone builds a nest, on the ground, often far from water. She begins by roughly shaping a cup, arranging dried grasses and other material around the edge. The nest is often under a small shrub or grass tussock, sometimes using grasses to form a canopy. The site and the materials are carefully selected to camouflage the nest. When egg laying begins, the female still spends her time mostly with the male on a nearby pond or marsh, and only returns to the nest quickly and quietly about once a day to lay an egg. During most of this time the nest is unattended, and the female does little to defend it. After incubation begins, the female lines the nest with downy feathers plucked from her breast, and continues to add plant material and down to the nest throughout incubation.

Survival
A nesting attempt has only a 15 percent chance of fledging any young. Once hatched, fewer than half of all ducklings survive the first two weeks, and only about a third of those survive the next six weeks to fledging. Incubation is the most dangerous phase for the adult female, as she spends almost all of her time sitting on the eggs, relying on camouflage to avoid predators. In several studies, up to 30 percent of adult females did not survive the four weeks of incubation.

Once the clutch is complete—containing, on average, ten eggs—the female begins to incubate, sitting on the eggs to warm them. She sits roughly twenty-three hours a day for about twenty-eight days, relying on camouflage, stealth, and luck to avoid detection. When incubation begins and the female is spending all of her time on the nest, the male's responsibilities are over; he travels, often hundreds of miles, to a food-rich wetland, where he will stay for the summer.

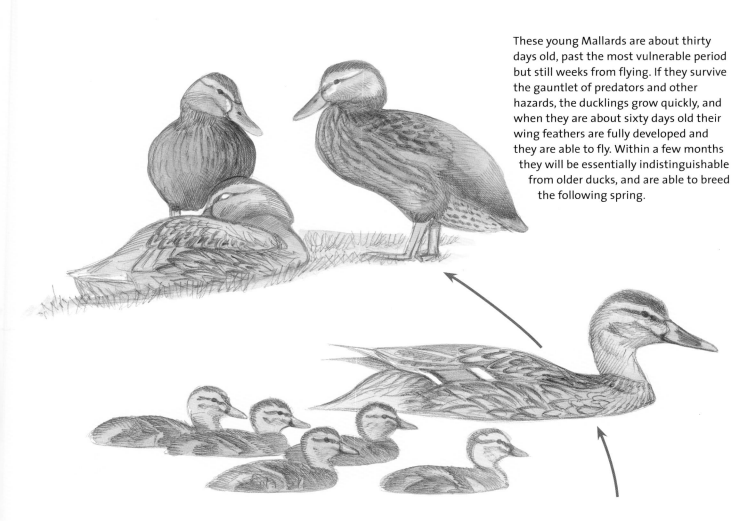

These young Mallards are about thirty days old, past the most vulnerable period but still weeks from flying. If they survive the gauntlet of predators and other hazards, the ducklings grow quickly, and when they are about sixty days old their wing feathers are fully developed and they are able to fly. Within a few months they will be essentially indistinguishable from older ducks, and are able to breed the following spring.

Soon after hatching, the precocial chicks are mostly self-sufficient—able to walk, swim, and find their own food—and the female leads them away from the nest. The ducklings still depend on the adult female for warmth, and in colder climates require regular and nightly brooding for up to three weeks. The adult also provides critical vigilance and guidance to find good feeding areas and avoid predators. At this stage the ducklings are extremely vulnerable, and many are taken by predators: foxes, cats, hawks, gulls, crows, predatory fish such as largemouth bass and pike, snapping turtles, and even bullfrogs.

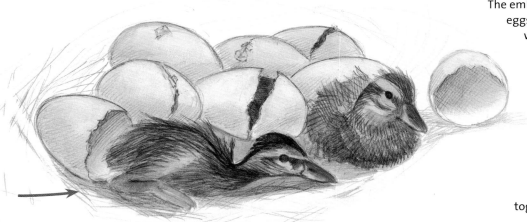

The embryos all begin to develop inside the eggs when they are triggered by the warmth of incubation, so even though the eggs were laid over many days, they will all hatch within a few hours. The young start peeping and clicking inside the eggs about twenty-four hours before hatching, and this may help synchronize hatching. It is usually just a few hours from the time the first egg hatches until the entire family is ready to leave the nest together in search of good feeding areas.

Wood Duck

The male Wood Duck is a product of
evolution and female choice. The male
plays no role in raising the young, so a
female chooses a mate based largely
on his attractiveness. Over millions of
generations, as females continually choose
males that stand out from the flock, the
process can lead to strikingly beautiful
birds like the Wood Duck.

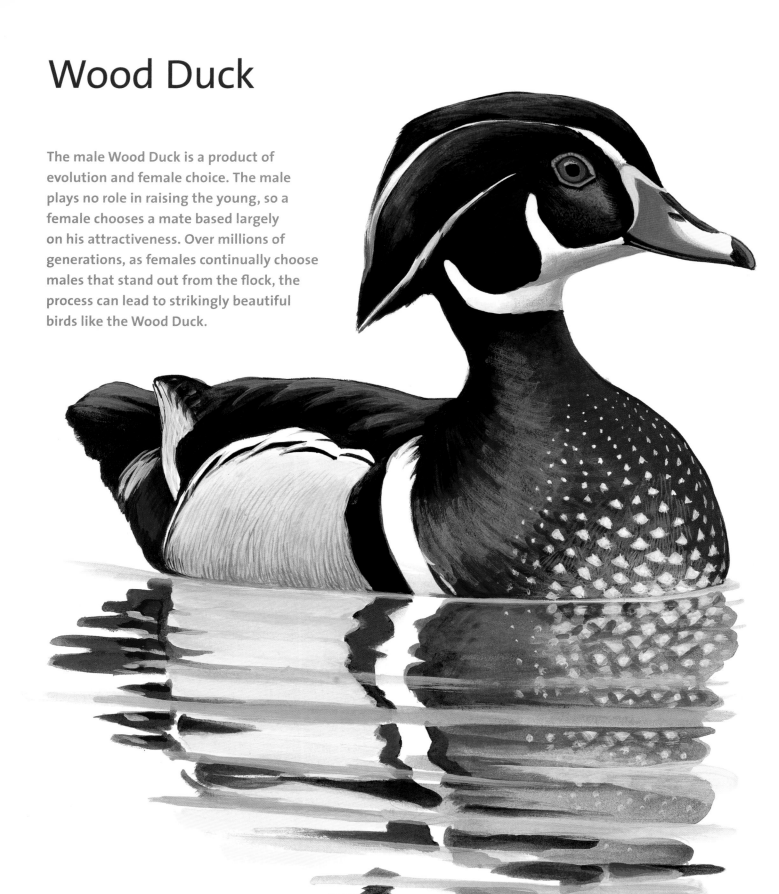

A male Wood Duck looking his best

■ Birds' bodies are well insulated, but they have no insulation on their legs and feet, which are often exposed to extreme cold. Birds' feet can handle being cold, and they don't need much blood flow because they have very little muscle tissue (see p. 121 middle). The bigger problem is that any blood that does go to the feet comes back into the body cold—but birds' systems have a solution for that. A process called *countercurrent circulation* is used to transfer heat and warm up the blood coming back into the body. The major veins and arteries in the legs split into multiple smaller blood vessels at the top of each leg, intertwining to allow more heat to transfer from the warm outgoing blood to the cold incoming blood. This system is so efficient that as much as 85 percent of the outgoing blood's heat is transferred to the incoming blood. Countercurrent heat exchange is widespread across the animal kingdom: birds also have it in their wings, and we humans have a rudimentary version of it in our arms. The same principle is also important for chemical transfer—in salt glands (p. 17 top), for example.

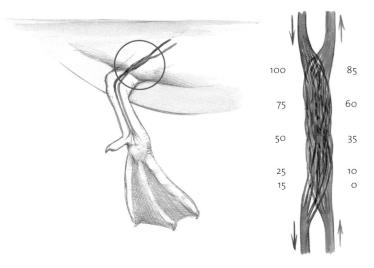

Outgoing blood in the artery (red) intertwines with incoming blood in the vein (blue); outgoing blood remains warmer than the incoming blood at every point (numbers indicate the percent of available heat), so heat is transferred through the entire length of the system.

■ Female choice may control the appearance of males, but the appearance of females is driven mainly by classic natural selection, such as the need for cryptic coloration—camouflage—to avoid predators. This leads to extreme sexual dimorphism in some species. At the same time, the female's selection of certain features in males does have consequences for her female offspring. Sexual differentiation doesn't begin until the embryo has been growing for about a week, so features that develop before that, like bone structure, patches of skin without feathers, and to some extent the length of individual feathers, are shared by males and females. The adult female Wood Duck has an utterly different color pattern from the male, but shares the same bill shape, a ring of bare skin around the eye, and a small crest.

A female Wood Duck

■ The variety and complexity of colors and patterns in bird feathers is truly mind-boggling; at the same time, the pattern of each feather is remarkably consistent across a species. How are these patterns controlled with such precision? Since a feather (like human and other mammal hair) is a dead structure once it emerges from the follicle, the only chance to create a pattern is as the feather grows. This can be roughly likened to the way a sheet of paper comes out of an ink-jet printer: color is deposited on the feather before it emerges, beginning with the tip. Unlike the sheet of paper, which remains flat as it passes through the printer, the feather is rolled up around its central shaft, and fans out as it emerges. In this way, patterns like dark spots, streaks, and bars can be created by "turning on" black and brown pigment briefly on different parts of the feather as it grows. A single feather follicle can produce multiple patterns and shapes of feathers, switching between them based on hormones as the bird matures or the seasons change (see p. 165 top).

One flank feather of a male Wood Duck emerging from the tubular sheath and unfurling as it grows (top), and fully grown (bottom)

Diving Ducks

Scoters are diving ducks, submerging completely to
find food in deep water. They swallow whole clams,
which are crushed in their powerful gizzard.

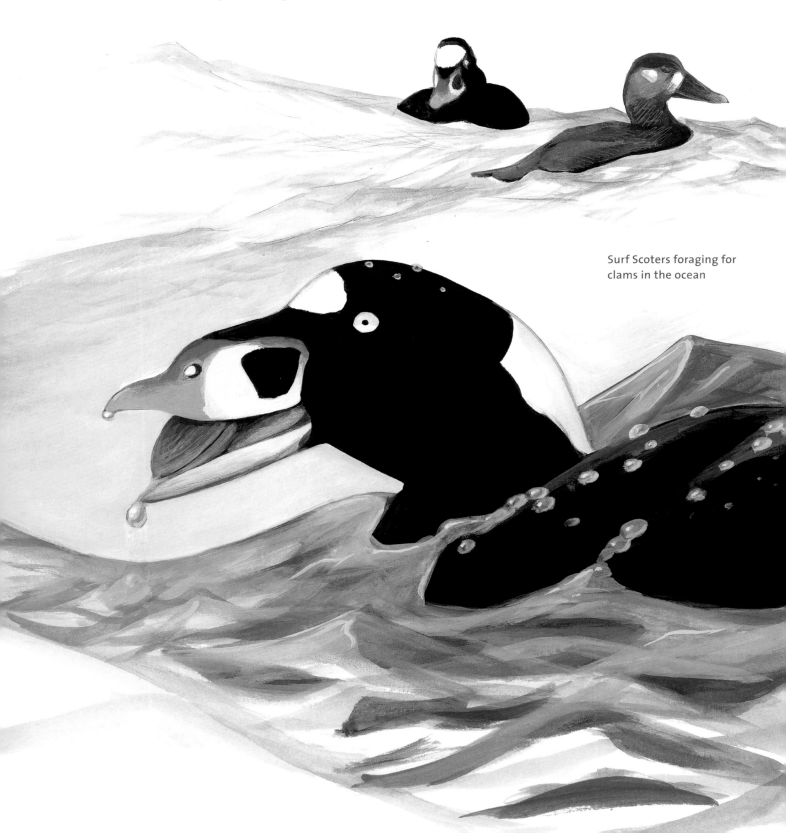

Surf Scoters foraging for
clams in the ocean

The head of a Surf Scoter, with the salt gland in blue

■ We rely on our kidneys to remove excess salt and other contaminants from our bodies. In addition to kidneys, birds have salt glands, located above the eyes on top of the skull, which concentrate salt from the blood and excrete it. This highly concentrated salt solution drips out of their nostrils. The glands use counter-current circulation to transfer salt from blood to water (see p. 15 top), like our kidneys, but they are much more efficient. In one experiment, a gull was given saltwater amounting to nearly 10 percent of its body weight, and all of the excess salt had been cleared from the body within three hours, with no ill effects. (Don't try this at home!) Salt removal is especially challenging for birds like scoters that feed on clams and other invertebrates in the ocean, since those animals have body fluids as salty as the water they live in (unlike fish, which maintain a salt concentration in their bodies lower than that of seawater). The salt gland shrinks when scoters spend the summer on freshwater lakes, and grows larger when they move to the ocean in the winter.

■ Feathers are waterproof mainly because of their structure. The surface tension of water causes water droplets to maintain their shape, and the overlapping and linked barbs of feathers leave openings too small for liquid water to flow through (the same concept as GORE-TEX fabric). The hooked barbules are needed not just to keep the barbs from being pulled apart but also from being pushed too close together, keeping them all at the correct spacing. That spacing has evolved differently depending on a species's habits. Birds that dive underwater have barbs very close together to keep water from being forced through under pressure. But while it prevents water penetration, the closest barb spacing allows water to make contact across the barbs and soak the surface of the feather. Land birds have barbs farther

Like water off a duck's back—a drop of water resting on the barbs of a feather

apart, which maximizes water repellency and prevents water from soaking the surface. But this allows water to penetrate through the spaces under pressure (for example, if a songbird ever tried to dive underwater). Ducks such as scoters have compromised with medium barb spacing. They enhance their water repellency with preen oil, and limit water penetration by having many overlapping feathers that provide several layers of protection.

■ In water birds like the Surf Scoter, each feather is very stiff and strongly curved so that its tip is pressed tightly against the feather behind it. Feathers grow close together and overlap to provide multiple layers of water resistance, all forming a firm but flexible shell that keeps water out and traps a layer of dry insulating down underneath. Land birds such as crows have fewer, straighter, more flexible feathers, forming a shell that is very water repellent but not good enough for swimming.

A cross-section of the body, showing the feathers of a scoter (left) and a crow (right)

Coots

Coots share some similarities with ducks, but are more closely related to cranes.

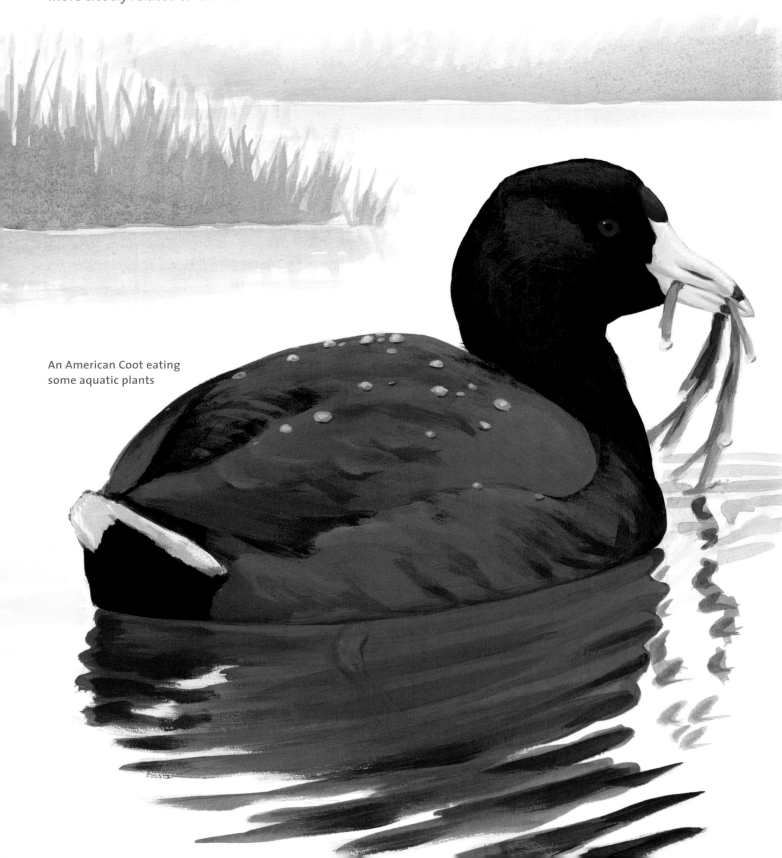

An American Coot eating some aquatic plants

■ Swimming birds propel themselves across the water using their feet. Most species have evolved simple webs between their toes to create a broad surface for efficient paddling. A few species, including coots, have evolved flaps along the sides of the toes, making the toes wider and providing more surface area to push against the water. These are called "lobed toes" and have also evolved in grebes, phalaropes (in the sandpiper family), and finfoots (a tropical group).

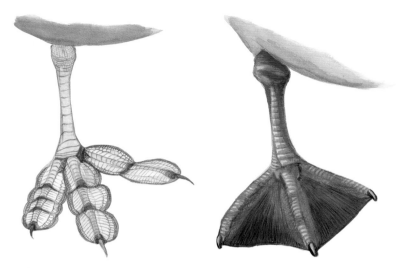

The lobed toes of a coot (left) and the webbed toes of a duck (right)

■ Birds have a well-developed sense of taste and birds experience all four of the main tastes that humans do, although they have far fewer taste buds. The coot shown here is tasting the plants in its bill. Birds' taste buds are generally not on their tongue, but in the roof and floor of the mouth. And they have at least a few taste buds close to the tip of their bill, so they can make a quick assessment of a food item as soon as they pick it up.

Green stippling shows the approximate position of taste buds (inside the bill).

■ Young coots hatch fully covered with downy feathers, with their eyes open, and are able to swim and follow their parents from about six hours after hatching. However, unlike the fully precocial young of geese and ducks (see p. 13 middle), they do not find their own food. Young coots are fed by the parents until they are several weeks old. This strategy is also shared by grebes and loons.

An American Coot offers food to its chick.

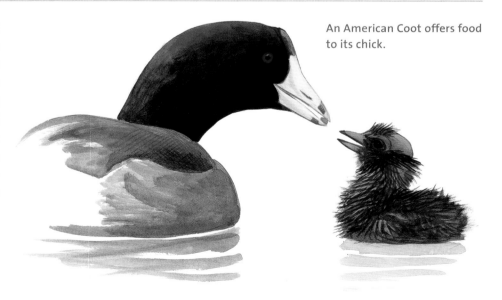

Loons

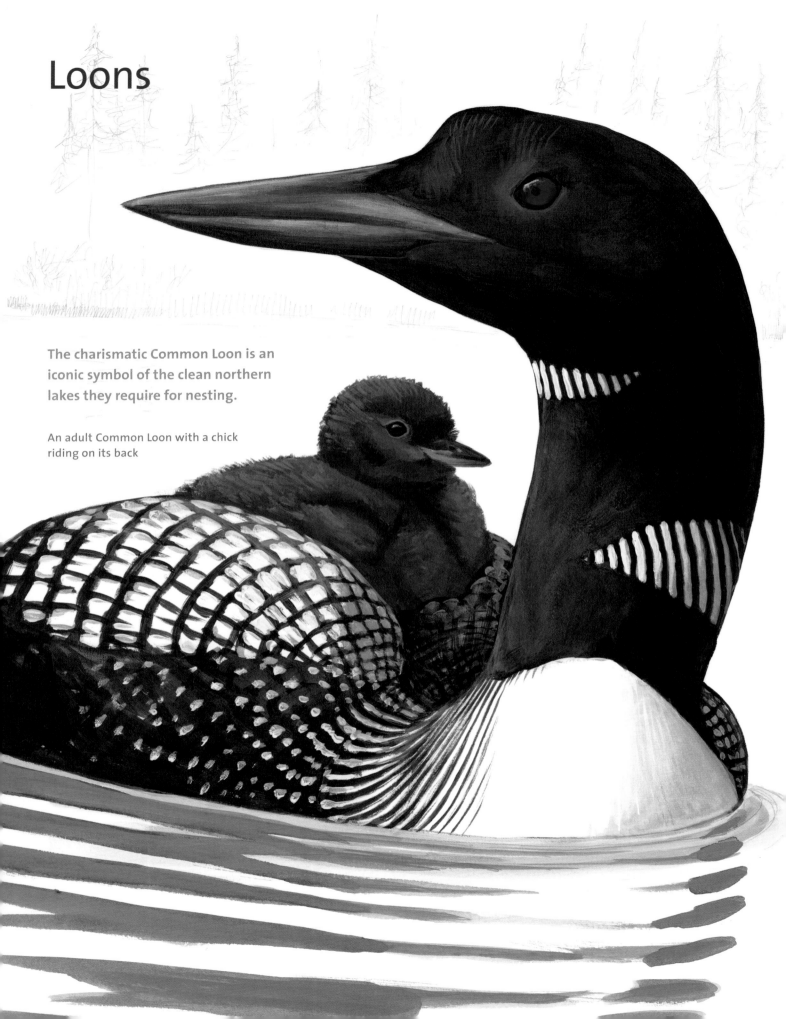

The charismatic Common Loon is an iconic symbol of the clean northern lakes they require for nesting.

An adult Common Loon with a chick riding on its back

■ Loons need a large expanse of open water to take off. They take a long running start, using both their wings and legs, to build up enough speed to become airborne. A headwind helps by increasing the speed of air across the wings, so they always prefer to take off into the wind. They can become trapped if they land on a pond that is too small. Their legs are adapted for swimming and are set so far back on their body that walking is difficult, and taking off from land is impossible. (See Mallard, p. 11 top.)

A Common Loon taking off

■ Loons forage by diving completely underwater and pursuing fish. Before they dive, they often put their head underwater to look for

potential prey. To begin a dive, they thrust with both feet and slide underwater head first. Using their feet to swim around, they try to get close enough to a fish to strike, heron-like, grasping it (not spearing) with their dagger-shaped bill, and returning to the surface to swallow it. Loons can stay underwater for up to fifteen minutes, and travel more than two hundred feet deep, but their average dive is under forty-five seconds and within forty feet of the surface.

A Common Loon peering underwater and diving

■ Loon chicks can swim within hours of hatching, but they depend on their parents for food for almost three months; when they are young, they often ride on their parents' backs in the water. At three weeks old, they are able to pursue fish a distance of up to a hundred feet underwater, but their fluffy down makes them slow and they only catch fish on about 3 percent of attempts. At eight weeks, they have grown adult-like feathers and can catch 50 percent of their own food, and at twelve weeks they are independent, able to fly and to catch all of their own food.

A Common Loon with chicks on its back

■ All birds molt to replace all of their body feathers at least once each year. Loons and many other species molt twice a year, and loons transform from the striking black and white of breeding season to a plainer gray-brown and white in the winter. Immature loons, until they are more than a year old, also have drab gray-brown plumage that is very similar to winter adults.

A Common Loon in immature plumage

Grebes

Despite their similarity to loons and other water birds, recent DNA research shows that the grebes' closest relatives are flamingos!

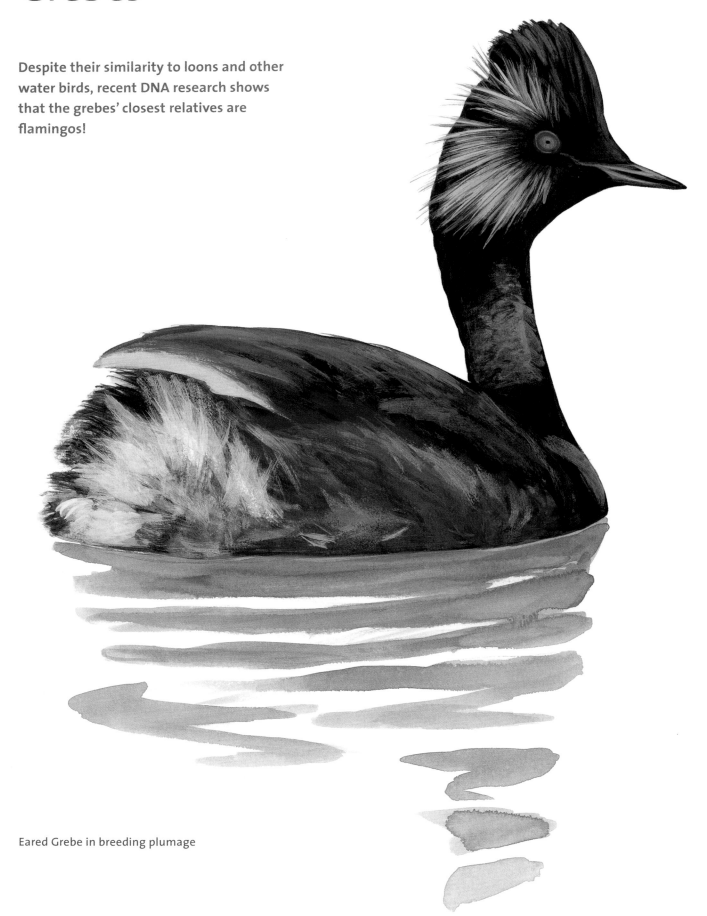

Eared Grebe in breeding plumage

Eared Grebes spend most of the year not flying at all, but each spring and fall they make an arduous nonstop flight of hundreds of miles. In the early fall, more than 99 percent of the entire American population of Eared Grebes gathers in two places—Mono Lake and Great Salt Lake—with more than a million birds at each lake, feasting on brine shrimp and gaining weight. Their entire focus shifts to processing food, as digestive organs grow and flight muscles shrink to the point of flightlessness. When their body weight has doubled with stored fat, and food supplies in the lake dwindle, they stop eating. Now the digestive organs shrink to one-quarter of their peak size and become nonfunctional, and the grebes exercise their wings so that flight muscles grow in preparation for one big flight. The stakes are high, since they are now unable to eat. Their flight muscles must get strong enough while they still have enough stored fat to make the flight. They only have enough fuel for one attempt, and on optimal evenings in October hundreds of thousands of birds take off together for their overnight nonstop flight over the desert to the Pacific Ocean, where they will spend the winter.

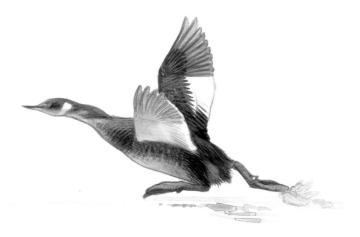

An Eared Grebe running to take off from the surface of the water

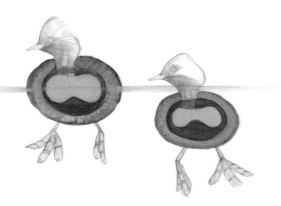

Diving birds have some ability to control their buoyancy, and grebes often hide underwater by sinking below the surface so that only their head is exposed. They do this by compressing their feathers to release some of the air that is trapped there, and also by exhaling air from the air sacs inside their body. When filled, the air sacs occupy a large part of the body cavity, and they can be compressed to reduce buoyancy. One study of diving ducks found that feathers and air sacs are equally important in reducing buoyancy.

An Eared Grebe sinking under the water by squeezing air out of its feathers and air sacs

An amazing communication occurs between the unhatched chicks of Eared Grebes and the incubating adults through a vocalization called the "care-soliciting signal." In the last few days before the chicks hatch, faint peeping sounds from the eggs prompt the adult Eared Grebes to turn the eggs more often, build up the nest mound, bring food to the nest, and spend more time incubating.

Once the chicks have hatched, they ride on the backs of their parents for the first week. After about ten days, each adult grebe will take half the brood and the family parts ways.

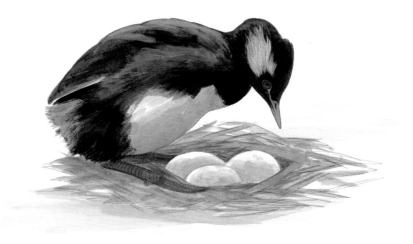

An Eared Grebe tending its eggs

Alcids

Alcids are the Northern Hemisphere equivalent of penguins, but they are not related. They have developed similar solutions to the challenges of finding food in a frigid ocean, an example of convergent evolution.

An Atlantic Puffin feeding its chick in the nesting burrow

■ Colonies of nesting seabirds are critical to the ecology of their region in many ways. By gathering fish from the ocean and carrying them onto land, the birds concentrate nutrients and move them uphill, essentially fertilizing the area around their colony. The increased plant growth provides a home for many other species of animals. One study even found that ammonia particles released from the guano of seabird colonies in the Arctic are an important component of cloud formation there, essentially "seeding" clouds and helping to cool the region.

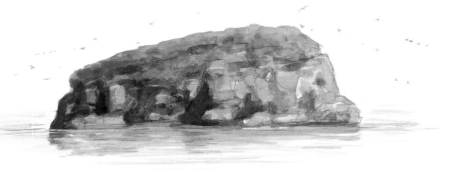

A seabird colony on a small rocky island

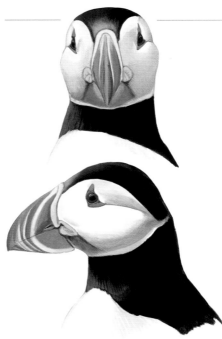

■ The large colorful bill of a puffin is a strange and wondrous thing, and has earned it nicknames like "sea parrot." But why do puffins have it? The color is probably for show, a flashy pattern that looks good to other puffins, but the shape and size of the bill is harder to explain. Most species with large bills, such as toucans, live in hot climates, where their bill helps radiate heat out of the body. But puffins live in very cold water; how do they survive with such a large bill? In addition, a tall bill is streamlined for moving forward but not as good for moving sideways underwater. One possible advantage is that the extra height adds stiffness and keeps the bill from bending, allowing the puffin to clamp down tightly on multiple fish.

An Atlantic Puffin, from the front and the side

■ Murres, related to puffins, feed on small fish and commonly dive to six hundred feet or more below the surface of the ocean, using their wings for propulsion (unlike loons—see p. 21 middle). At that depth, even on a bright sunny day in clear water, the light level is the same as midnight on the ground with just a sliver of moon. Murres also commonly forage at night, when their preferred prey move closer to the surface, but they still dive up to two hundred feet deep. It seems unlikely that they are using vision to locate and pursue their prey, but nobody knows what senses they are using. Similarly, no one knows how the birds withstand the pressure at those depths (for example, how they keep water from penetrating through their feathers), or how they can travel that far and fast without breathing.

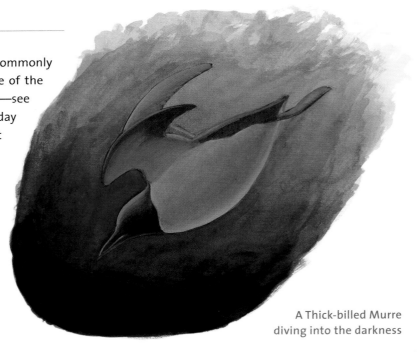

A Thick-billed Murre diving into the darkness

Cormorants

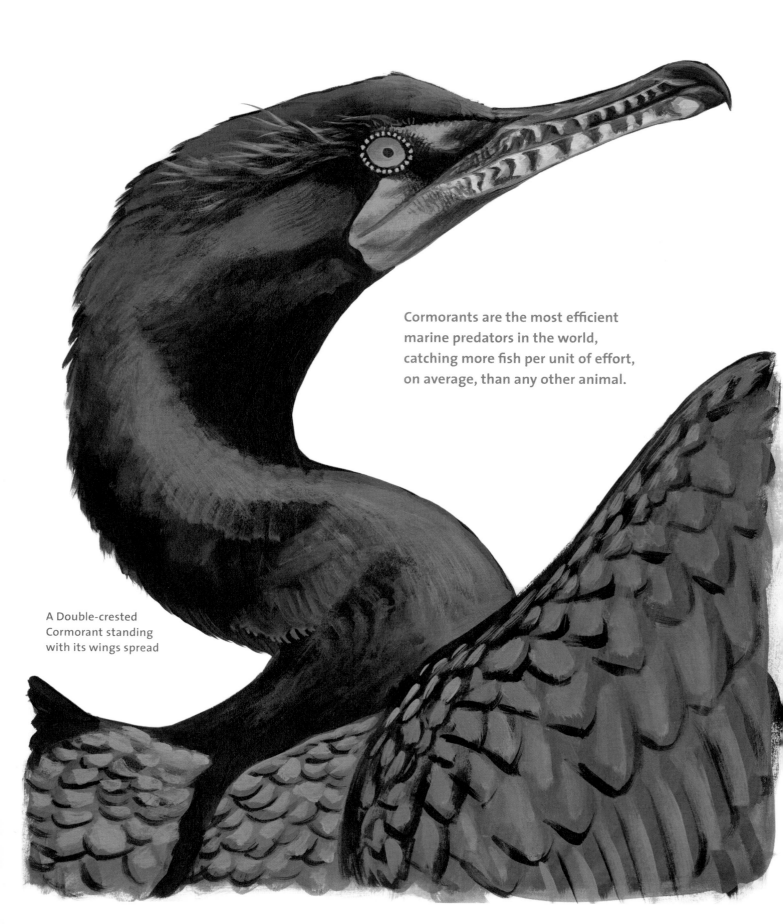

Cormorants are the most efficient
marine predators in the world,
catching more fish per unit of effort,
on average, than any other animal.

A Double-crested
Cormorant standing
with its wings spread

■ It is often reported that cormorants' feathers get wet because they lack preen oil. In fact, cormorants do have preen oil, but their feathers have evolved to get wet. The barbs at the margins of a cormorant's body feathers are free, with no barbules to hold them in place, so they get wet as water sticks the barbs together. In the center of each feather, however, barbules hold the barbs firmly in place to repel water (see p. 17 middle). These waterproof centers overlap and help keep water from reaching the skin, even though the margins of the feathers get wet. When the added weight of water in the feathers reaches about 6 percent of their body weight (in about twenty minutes), cormorants need to get out of the water. The advantage of retaining water in the feathers is that it can reduce buoyancy by nearly 20 percent, so diving requires less effort. It's also possible that trapping a film of water on the feathers might help cormorants move through the water more easily, but this needs testing.

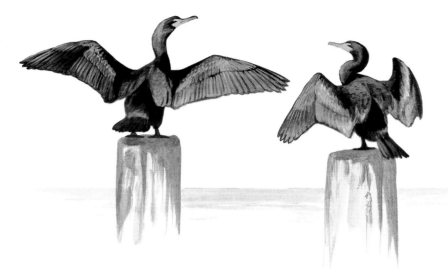

Double-crested Cormorants
spreading their wings to help dry their feathers

A cormorant body feather showing the water-resistant
central portion and wettable edges

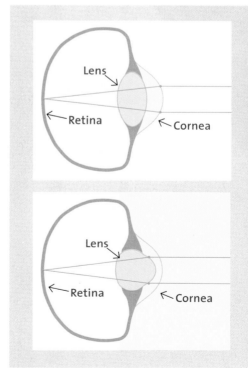

My vision is blurry underwater—how do birds see and catch fish?

To focus an image on the retina, our eye, like any lens, relies on refraction—the bending of light as it passes from a material of one density to another. The bigger the difference in density, the more the light bends. In air, most of the refractive power of the eye comes from the curved surface of the cornea, where light passes from gas to liquid (air to eyeball). The lens only makes tiny adjustments to focus on near or far objects. In water, the cornea has almost no effect as light passes from liquid to liquid (water to cornea). Our lens alone can't compensate to focus the image on our retina, so we see a blur. But cormorants and a few other water birds have evolved a much more flexible lens. To create a sharp image underwater, a group of tiny muscles squeezes the lens, forcing it to bulge out through the more rigid iris, which creates a strongly curved surface that can take over for the cornea underwater.

In the air (top), light bends at the outer surface of the eye, and not much at the lens. In the water (bottom), light barely bends where it enters the eye, and the job of focusing is taken over by the lens.

27

Pelicans

An adult Brown Pelican in a relaxed pose. Pelicans are among the heaviest flying birds in the world.

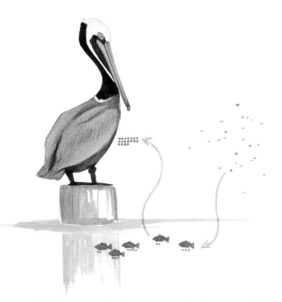

DDT (represented by orange dots) accumulating as it moves up the food chain from insects to fish to pelican

How a pelican fishes with its pouch

Contrary to popular belief, a pelican's pouch is not used as a basket to carry fish, but as a giant scoop to catch fish underwater.

Brown Pelicans fly above the water looking for fish, and when they spot a promising school they plunge headfirst into the water.

When the head plunges into the water with the bill open, the sides of the lower mandible bend outward, and the pouch stretches like a balloon, filling with up to three gallons of water—and hopefully many fish.

As soon as the head stops moving forward through the water, the sides of the lower mandible snap back to parallel, and the upper mandible closes to trap any fish inside the expanded pouch.

Resting on the water, the pelican slowly raises its head, allowing water to drain out through the narrow gap between the upper and lower mandibles, while fish stay in the pouch.

Finally, when all the water has drained, the pelican swallows any fish with a deft toss of the head.

■ The Brown Pelican nearly became extinct as a direct result of DDT poisoning. This chemical was widely sprayed in the 1950s and '60s for insect control, and was the subject of the 1962 book *Silent Spring*. It accumulates in the body fat of animals, where it can persist for years. Insects each carry a tiny amount, but fish that feed on those insects are continually adding pesticide to their bodies, and when pelicans eat those fish they gradually add to their own pesticide load. This phenomenon—toxins becoming more concentrated higher up the food chain—is known as *bioaccumulation*. DDT interferes with the body's use of calcium, and contaminated birds produce eggs with shells that break very easily. Pelicans were literally breaking their own eggs when they tried to incubate, leading to zero reproduction and a declining population. Fortunately, the trend reversed within a few years after the ban of DDT in the United States in 1972, and the Brown Pelican is once again a common sight along our southern coasts.

■ *Kleptoparasitism* is a fancy term for a strategy of stealing food. Some species of seabirds, especially gulls and their relatives, specialize in this behavior. When they see a bird that has captured a meal, they simply try to steal it for themselves. Laughing Gulls often hang around foraging pelicans, even standing on a pelican's head, hoping to grab a few fish. The gulls are looking for fish that fall out as the pelican drains its pouch, but will also take any fish they can get out of the open pouch.

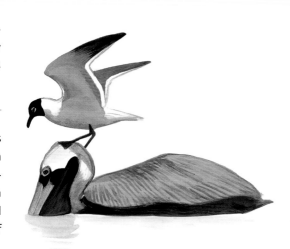

Brown Pelican and Laughing Gull

Herons

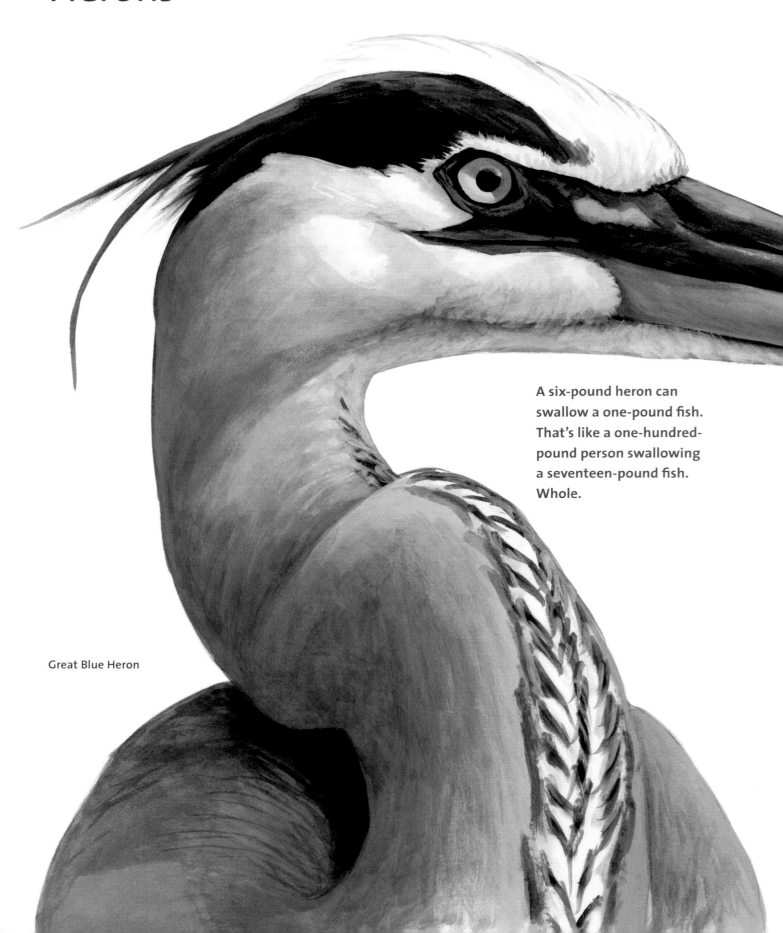

A six-pound heron can swallow a one-pound fish. That's like a one-hundred-pound person swallowing a seventeen-pound fish. Whole.

Great Blue Heron

Sequence of the foraging strike of a Great Blue Heron

Great Blue Herons are very patient hunters, watching and occasionally taking a slow step forward. When a potential prey item is sighted, they lean forward, neck slightly coiled, lining up and carefully planning for one explosive strike. In a fraction of a second they have grabbed the fish in their bill. Out of the water, they reposition the fish with a quick toss so they can swallow it—head first and whole. Smaller prey like minnows go down with no trouble. Larger prey can take up to a minute to travel the length of the neck, with a bulge visible all the way down. After a very large meal the heron may sit for several minutes to let it "settle" before going back to hunting.

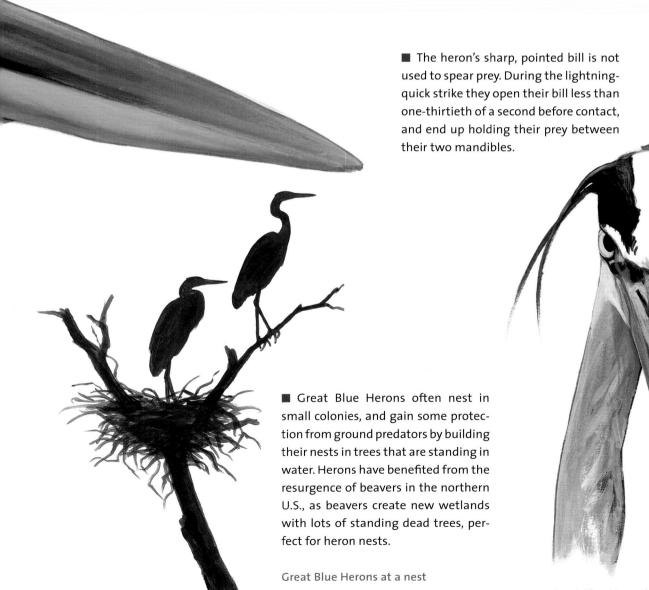

■ The heron's sharp, pointed bill is not used to spear prey. During the lightning-quick strike they open their bill less than one-thirtieth of a second before contact, and end up holding their prey between their two mandibles.

■ Great Blue Herons often nest in small colonies, and gain some protection from ground predators by building their nests in trees that are standing in water. Herons have benefited from the resurgence of beavers in the northern U.S., as beavers create new wetlands with lots of standing dead trees, perfect for heron nests.

Great Blue Herons at a nest

Great Blue Heron head-on

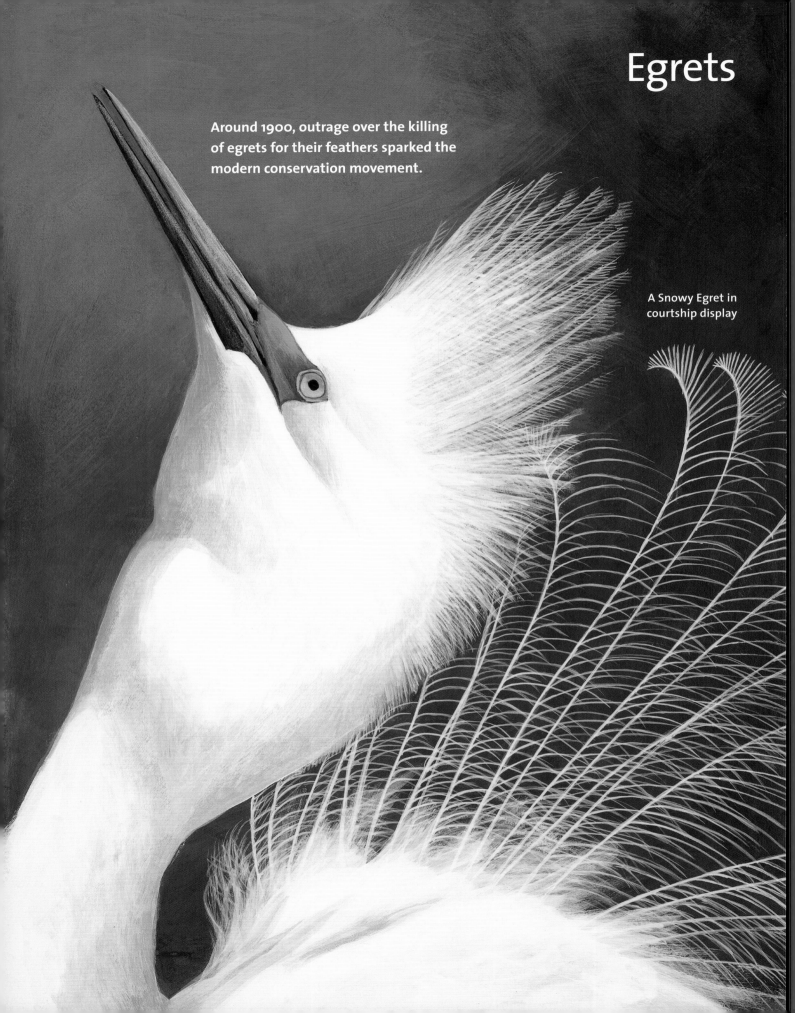

Egrets

Around 1900, outrage over the killing of egrets for their feathers sparked the modern conservation movement.

A Snowy Egret in courtship display

Light reflecting off the fish (orange line) bends at the surface, so it reaches the egret's eye from a different angle; sighting along that line (dotted line), the fish appears to be in a different location.

■ Refraction: Try dipping a pencil (or any other straight object) into some water and notice how the pencil seems to bend at the water's surface. If you had to shoot the tip of the pencil, where would you aim? This is the egret's challenge. Light reflecting off a fish bends at the water's surface, meaning that the fish is not where it appears to be. The egret must correct for the illusion and strike the real fish.

The angle of refraction changes slightly with the angle of view, and the offset due to refraction increases with depth. In the egret's range the real fish can be as much as three inches away from where it appears. Knowing where the real fish is requires a complex calculation of angle and depth. Experiments have shown that, before they strike, egrets position themselves so that the angle and depth fit a certain mathematical relationship, and this apparently allows them to correct for refraction. If their preferred angle is blocked they often miss, but if they can choose their position, and are targeting stationary prey in the laboratory, they never miss.

A Snowy Egret luring fish to the surface

■ Herons and egrets have developed a multitude of tricks to get close to fish. Green Herons have been observed placing small feathers (and even fish food pellets found in a public park) on the surface of the water and then watching for small fish that come to the bait. Snowy Egrets often dabble the tip of their bill in the water to mimic a disturbance such as an insect struggling on the surface, then catch any fish that come near. Bringing fish to the surface has the added advantage of mostly eliminating the challenge of refraction.

The evolution of feathers

Feathers did not evolve from scales, they developed in dinosaurs and are fundamentally tubular. The evolution of feathers is explained in five stages:

STAGE 1: The earliest "feather" was a simple hollow tube like a bristle. These were probably mainly for insulation, but even at this primitive stage the feathers could have been colored for display or camouflage.

STAGE 2: The simple tube divides into separate fibers from the base, similar to the down feathers of modern birds. This would create a layer of fuzz and more effective insulation than the bristly tubes of Stage 1.

STAGE 3: A branching structure develops, with a central shaft and barbs along each side. This allows more complex color patterns to be formed.

STAGE 4: Further branching produces barbules along each barb, with hooks that interlock so the barbs stick together to create a more rigid flat surface.

STAGE 5: Many specialized feather shapes and structures develop for many different functions. Some of the most complex and specialized feathers are those involved in flight, such as asymmetrical feathers for enhanced aerodynamics, suggesting that flight is a recent stage in the evolution of feathers, and not their original function.

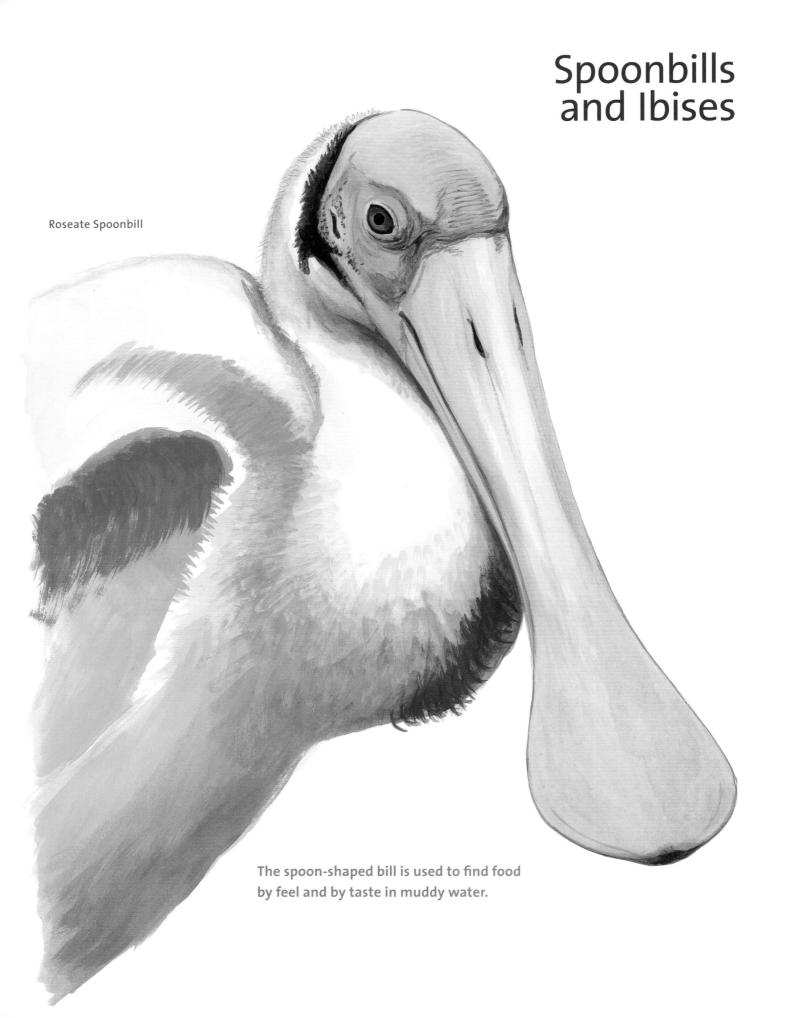

Spoonbills and Ibises

Roseate Spoonbill

The spoon-shaped bill is used to find food by feel and by taste in muddy water.

Feeding both by sight and by feel, White Ibis thrust their bills into mud or into burrows.

■ Finding food is one of the primary challenges faced by birds, and the large wading birds such as herons, ibises, and spoonbills show a wide range of strategies. Herons and egrets hunt entirely by sight (see p. 31). Spoonbills hunt entirely by touch. Ibises use both sight and touch. They often look for clues like crayfish burrows, then stick their bill in and probe around using their senses of touch and taste in the tip of their bill until they find something worth grabbing.

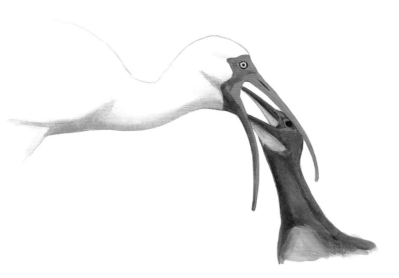

■ Regurgitation is normal and common in birds. All birds have an expandable sac at the base of their neck where the esophagus meets the body, known as the crop (see p. 5 bottom). Some digestion begins there, but it is mainly a food storage organ. Adult birds can gather a lot of food while they are out foraging, hold it in their crop as they fly back to the nest, then regurgitate it for the nestlings. Birds also regurgitate and discard indigestible parts of their food, such as seeds or shells. Some of these items are regurgitated because they are too large to pass through the intestines, others because it is helpful to remove the extra weight and bulk from the body as soon as possible.

A baby White Ibis (right) reaches in for food being regurgitated by the adult (left).

■ Why do birds stand on one leg? The short answer is: Because it's easy for them. This behavior is most conspicuous in long-legged species, but all birds do it. Several adaptations of leg structure make this a stable and almost effortless stance. The center of mass of their body is below the knee (like a squatting position), and a knob on the pelvis prevents the leg from angling any higher. Balancing on one leg requires angling that leg so that the foot is directly below the body, and with the leg essentially locked in position, and the body leaning against the leg, tiny adjustments of the toes are all that is needed to stay upright. Birds also have an extra balance sensor near their pelvis, which undoubtedly helps them stay upright on one leg (see p. 149 top).

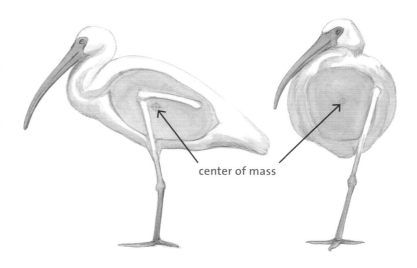

center of mass

A White Ibis standing on one leg, from the side and from the front

Cranes

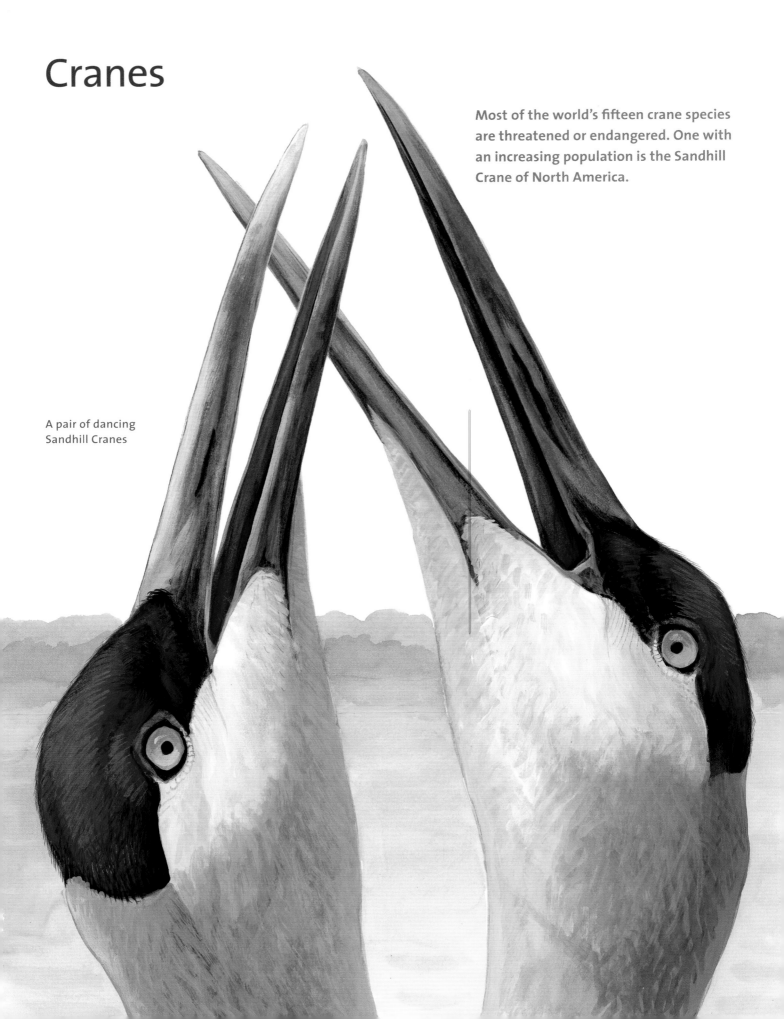

Most of the world's fifteen crane species are threatened or endangered. One with an increasing population is the Sandhill Crane of North America.

A pair of dancing
Sandhill Cranes

■ Many people use the name *crane* for any large, tall, gray bird, but in most of North America these birds are Great Blue Herons (see p. 30). Cranes and herons are superficially similar but not related, and can be distinguished by many details of appearance, habits, and voice. Cranes are almost always in pairs or flocks (not solitary) and have pleasing bugling calls. They feed by picking gently at the ground (herons hunt fish with a sudden violent lunge), and cranes have a patch of red skin on their forehead and a "bustle" of curved feathers over their tail.

Great Blue Heron (left) and Sandhill Crane (right)

■ If you look carefully at a bird's legs you'll see that the "knee" joint seems to bend the wrong way—but that's because it's actually the ankle joint. The bones that are equivalent to most of our foot (shown in yellow) are fused together into a single long straight structure that is very leg-like, and what we call a bird's foot is really just the toe bones. All of the leg muscles are close to the body, hidden and insulated by feathers, which is why the parts that we see are so spindly and skeletal, really just slender bones and tendons with a leathery covering.

A human leg (right) compared to a Sandhill Crane leg (left), with toes, foot, lower leg, and upper leg each color coded

The dance of the Sandhill Crane

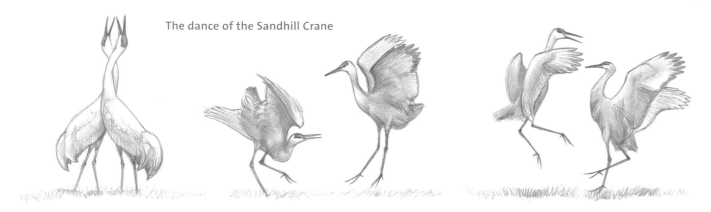

■ During the breeding season, crane pairs are territorial and do not associate with other cranes as they raise their young— usually a single chick, sometimes two. At the end of the summer all cranes, including family groups and nonbreeders, gather in flocks to migrate south. Family groups generally remain together until about March, and often include one or more young from previous years along with the parents and their most recent offspring. Within these winter flocks social displays are common, including the spectacular and intricate "dancing" unique to cranes. A dance is initiated by the male, and involves bowing, calling, flapping, running, and leaping into the air. It is thought to be a courtship display, but it occurs throughout the winter, and dancing by one pair often stimulates other pairs nearby to begin dancing.

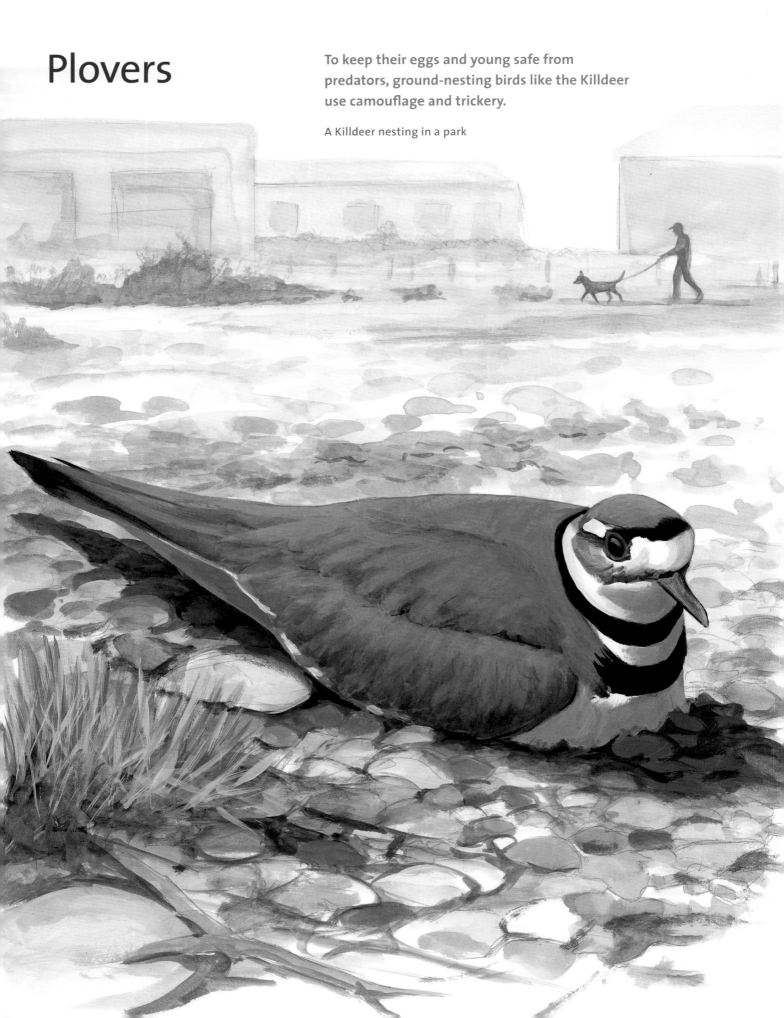

Plovers

To keep their eggs and young safe from predators, ground-nesting birds like the Killdeer use camouflage and trickery.

A Killdeer nesting in a park

■ Eggs that are simply laid on open ground are very vulnerable to predators. The primary defense strategy is for the eggs to remain undiscovered, and the birds have several adaptations for that. The eggs are cryptically colored, or camouflaged, and there is evidence that the adults choose to nest on ground that matches their eggs. The nest is simply a slight depression with no structure that might attract the attention of predators. The adult is also cryptically colored, and actively misdirects predators with distraction displays. But all of this is visual camouflage, and a major threat comes from predators hunting by smell, especially at night. To protect against this, the preen oil of Killdeer and other ground-nesting birds changes during the nesting season to a different chemical compound with no odor. This effectively masks the smell of the incubating bird and makes them less likely to be found by predators such as skunks and foxes.

I saw a bird that was obviously injured, just flopping on the ground, but when I got close it flew away.

This is all an act to protect their eggs or young, a behavior called a distraction display or a "broken-wing act." The bird pretends to have a broken wing, calling pitifully, stumbling, dragging one wing on the ground. It can be very convincing, and as you follow it you are being lured farther from the nest. When the bird feels that it has brought you to a safe distance it simply takes off and flies away. It will sneak back to the nest later.

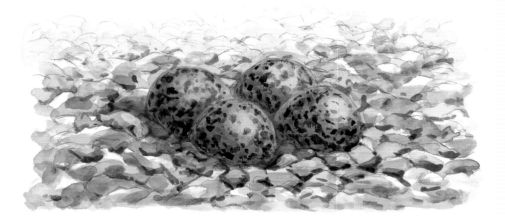

The camouflaged eggs of a Killdeer, laid in a faint depression on open ground

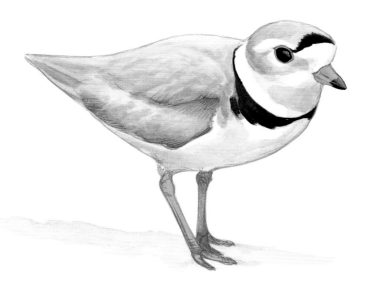

A Killdeer performing a distraction display

■ A few species of small plovers live and nest on sandy beaches just above the high tide line: the Piping Plover in the eastern U.S. and the Snowy Plover in the West. This puts them into direct competition with millions of humans who use the same sandy beaches for recreation. There are only about twelve thousand Piping Plovers in the world, and many of them nest on beaches along the eastern coast of the United States, from New Jersey to Massachusetts. On most of these beaches, the survival of the species now depends on the help of some humans to educate other humans and keep them (and their dogs, vehicles, kites, and other threats) away from the nesting plovers. If the plovers are protected from disturbance at critical times, they can nest successfully even on a popular beach.

Piping Plover

Large Sandpipers

A very large sandpiper with an impressively long bill, this species spends much of the year on dry prairie, eating grasshoppers and other insects plucked from the grass.

Long-billed Curlew picking up a fiddler crab

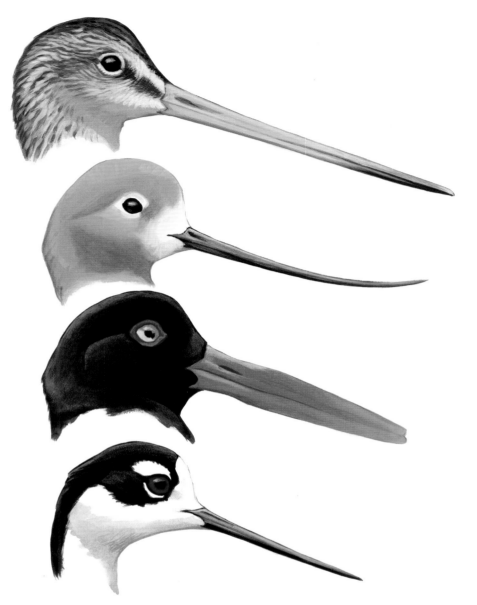

■ These four species of shorebirds all have long slender bills, but each one uses its bill in an entirely different way. The Marbled Godwit probes in mud or sand, similar to the Dunlin (p. 43 middle). The American Avocet sweeps its upturned bill sideways through the water, hunting by feel and grabbing any food that makes contact (similar to the Roseate Spoonbill, p. 34). The American Oystercatcher (which eats few oysters and doesn't need to "catch" them) uses its sturdy bill on mollusks such as snails and mussels to knock them loose and open their shells. The Black-necked Stilt uses its very slender bill to pick small food items delicately from the surface of the water or mud (similar to Wilson's Phalarope, p. 43 bottom). Each of these species is a specialist, and occupies a niche within the ecological community, so they can all forage in the same place without competing for food.

From top to bottom: Marbled Godwit, American Avocet, American Oystercatcher, Black-necked Stilt

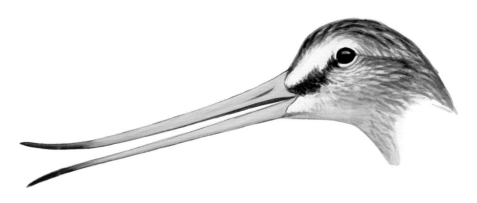

■ The tip of a sandpiper's bill is packed with nerve endings so they can sense their prey under the mud or sand, and they have taste buds inside the tip of their bill to test whatever they find. The bill has flexible "joints" near the tip, controlled by tendons connected to muscles on the skull. Even when a prey item is buried deep in the mud or sand, it can be grasped and pulled out.

A Marbled Godwit flexing its bill tip; compare the resting bill shape of the Marbled Godwit in the image above.

Small Sandpipers

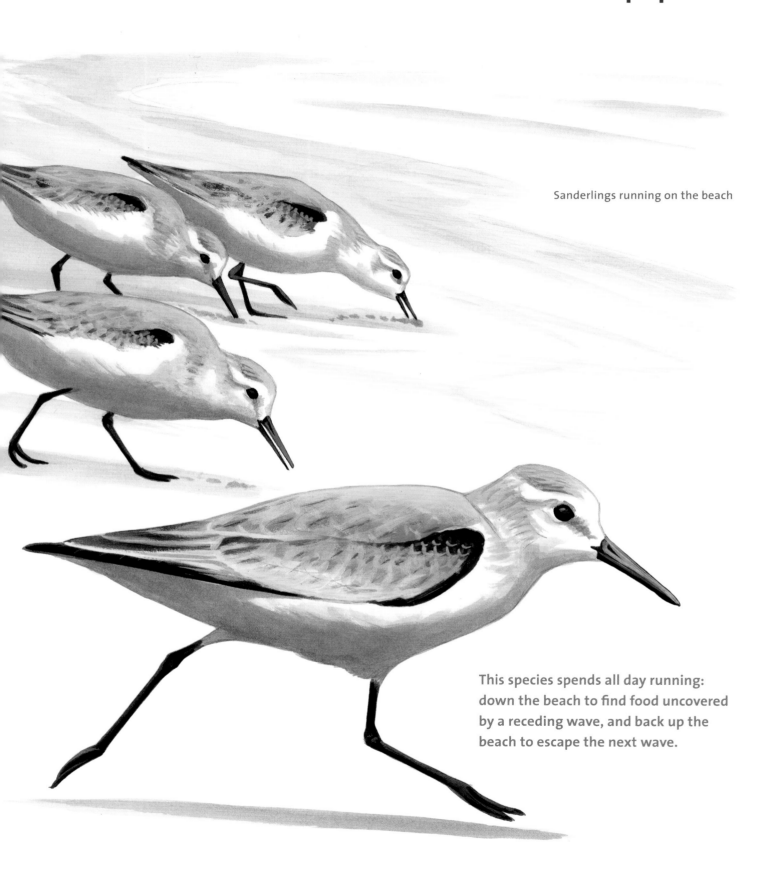

Sanderlings running on the beach

This species spends all day running: down the beach to find food uncovered by a receding wave, and back up the beach to escape the next wave.

■ The swerving movements of a flock of sandpipers in flight are among the most remarkable spectacles in nature, and recent research has provided some insight. There is no leader—any bird in the flock can suggest a turn. The other birds see the change in direction, and if they also turn the reaction is transmitted through the flock at a constant rate (much like a "wave" in a sports stadium). A flock the size of a football field can change direction in this way in less than three seconds. Each individual bird just switches to the new direction, changing their position relative to their neighbors like in a marching band. Turns are usually initiated by birds at the edges of the flock, and they usually swerve into the flock. Being at the edge gives them a better view of any potential danger, and also makes them more vulnerable to attack. Some turns are in response to actual danger, but many are likely just prompted by a desire to get away from the edge. As an edge bird gets nervous and swerves into the flock, the rest of the flock reacts. The result is a dizzying, swirling, unpredictable mass of birds that is very difficult for a predator to attack. Even if most of the turns are false alarms, frequent and sudden turns make the group safer.

A flock of sandpipers before and after a turn. The edge bird (light color) initiates the turn, all birds turn on the same radius in response, and the edge bird ends up in the middle of the flock after the turn.

■ The tip of a sandpiper's bill is very sensitive to touch, and this even allows them to sense things indirectly. When the bill is forced into wet sand or mud, water is displaced and moves away. If the flow of water is blocked by something in the sand or mud (like a small clam), slightly higher pressure builds up where the water is squeezed between the bird's bill and the clam. Sensing that pressure, the bird knows that probing in that direction might be worthwhile.

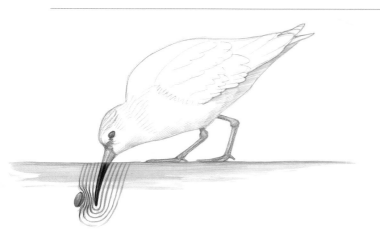

A Dunlin probing in mud

■ Observing a flock of sandpipers foraging on a mud flat, you might notice that they are constantly picking at the surface, or probing into the mud or water, but rarely lift their heads. Each one is picking up food with the tip of its bill, and getting the food into their mouth, but the bill is constantly pointed down, seeming to defy gravity. The explanation involves a simple bit of physics—taking advantage of the surface tension of water. When the bird grasps a tiny food item in the tip of its bill, a droplet of water comes along with the food. Because the droplet of water tends to hold together, the bird can move the water up the length of its bill by slightly separating the mandibles repeatedly, and the moving water carries the food with it. Once in the mouth, the water is squeezed away and shaken off, the food is swallowed, and the bird can go back for more food. High-speed video taken of Red-necked Phalaropes shows that they can transport their prey from bill tip to mouth in as little as 0.01 seconds, simply by using surface tension to pull in a drop of water. That's about thirty times faster than the blink of an eye.

A Wilson's Phalarope manipulating food into its mouth

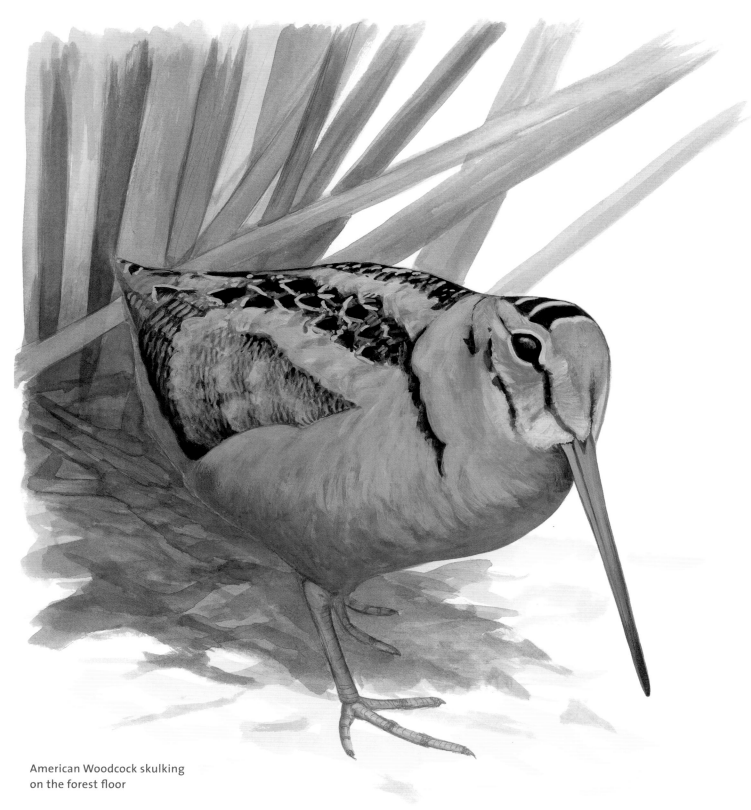

American Woodcock skulking
on the forest floor

Spending most of its time alone in
the forest, the woodcock emerges at
dawn and dusk in spring to perform a
spectacular courtship flight.

Snipe and Woodcock

■ To impress mates and rivals, the snipe does not use its voice to sing, instead it produces a humming whistle with its tail. This is easy to observe, but some of the details of how the physics work were only recently revealed by research. The trailing edge of the outermost tail feathers is lighter colored and lacks barbules (hooks) to hold the vane together, making that edge of the feather less stiff. When these feathers are extended perpendicular to the body at high speed, the trailing edge of the feather can flutter very rapidly, like a flag in high wind, and its shape and flexibility is "tuned" to vibrate at the frequency that produces the low whistling sound of the snipe's display.

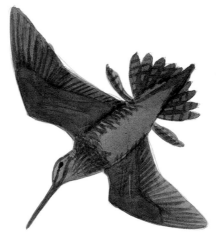

A Wilson's Snipe displaying, and a close-up of the feather that makes the noise

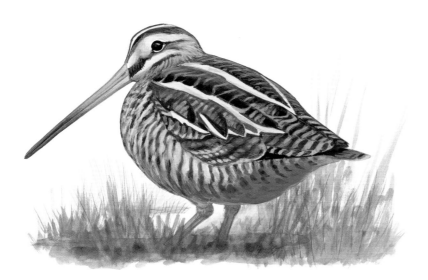

A Wilson's Snipe in the grass

■ The snipe hunt is a practical joke, popular in the United States as early as the 1840s. An unsuspecting newcomer is invited on the hunt, given a bag, and led to a remote location with instructions for catching a mysterious swamp creature called a snipe. Recommended techniques include holding the bag open and just waiting, or making odd noises to attract the snipe into the bag, especially at night. The pranksters then leave the newcomer alone in the woods, "holding the bag." There is a real bird called a snipe—a chunky sandpiper that hides in wet muddy and grassy areas, relying on its cryptic coloration for camouflage. No one has ever caught a snipe in a bag.

■ Birds generally have excellent eyesight, and one of the ways they surpass human vision is in their field of view—the spread of their surroundings that can be seen simultaneously. Human eyes are positioned to focus together on a single point, and if we hold still we can see about half of our surroundings (although we only see detail in one tiny point at the center of our vision). The snipe, like many other sandpipers and ducks, can see the entire 360 degrees around, and a full 180 degrees overhead, all at the same time. And instead of seeing a small area in fine detail, they see detail in a wide horizontal band in each eye. Imagine being able to see the entire sky and horizon, and some detail along most of the horizon, without turning your head. This is critical for birds like snipes that rely on camouflage for protection. Their first response to approaching danger is simply to crouch and freeze, and while remaining perfectly motionless they can still see everything around them. (See also p. 57 middle, and p. 67 bottom.)

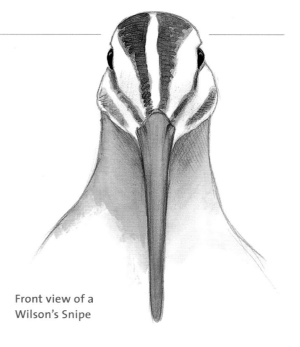

Front view of a Wilson's Snipe

Gulls

Gulls may be the most versatile birds in the world. In a bird triathlon—swim, run, fly—gulls would be among the favorites to win.

Ring-billed Gulls raiding a picnic at the beach

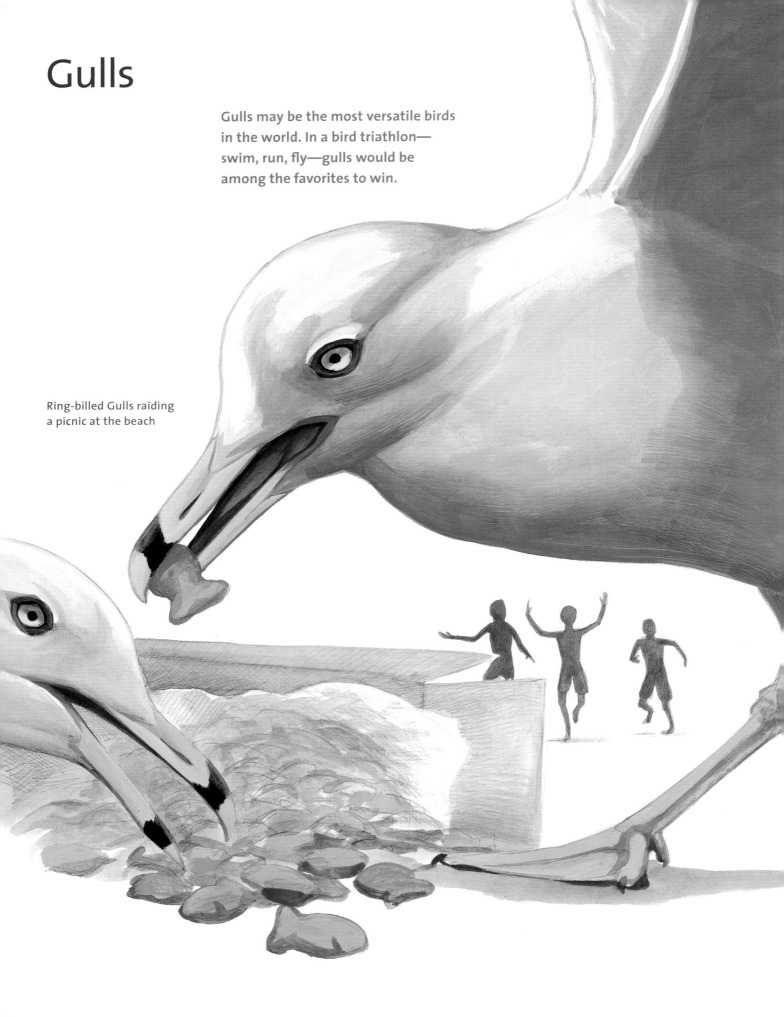

A Herring Gull regurgitating food for its chicks

■ Gulls are notorious for eating junk—literally. They flock to open garbage dumps to scavenge food, and hang around picnic sites, fast food restaurants, fishing boats, and other such places, ready to gulp down any discarded scraps. Despite this, they are careful about what they feed their chicks. Many studies have shown that when the chicks hatch they are provided with highly nutritious natural food like crabs and fresh fish, even as their parents visit the garbage dump to feed themselves. (See also p. 113 middle.)

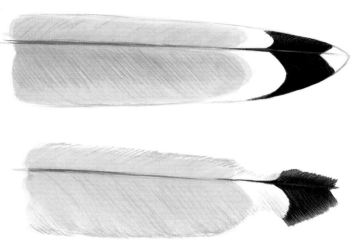

■ If you find a gull feather on the beach, it has probably been molted naturally after being used by the bird for a full year. If it's an outer wing feather like the ones shown here, look carefully at the tip of the feather. You'll see that the white parts of the feather tip are more worn, while the dark parts are mostly intact. Almost all gulls have dark pigment in their wing tips, and this is a common pattern across all families of birds. One reason is that melanin (the pigment responsible for black and brown colors) strengthens the feather, making it more resistant to wear and tear. The tip of the wing is crucial for flight, and also subject to more sun and abrasion, so making it a little stronger is important.

The outer wing feathers of most gulls are gray with a black-and-white pattern at the tip. A new feather (top) has intact white markings; an old feather (bottom) has lost most of the white parts.

■ What do birds do in a hurricane? Birds are able to sense barometric pressure, and when the pressure drops, indicating that a storm is imminent, their first reaction is to start eating more. Their strategy for riding out a storm is usually to stock up on food, find some shelter, and just sit and wait. Shelter for a gull might be a clump of grass or a log on a beach, which provide a little bit of protection from the wind. They will stand facing into the wind, with their head down for streamlining. As long as they have some fat reserves, there is no need for them to move.

Herring Gulls hunkering down in a storm

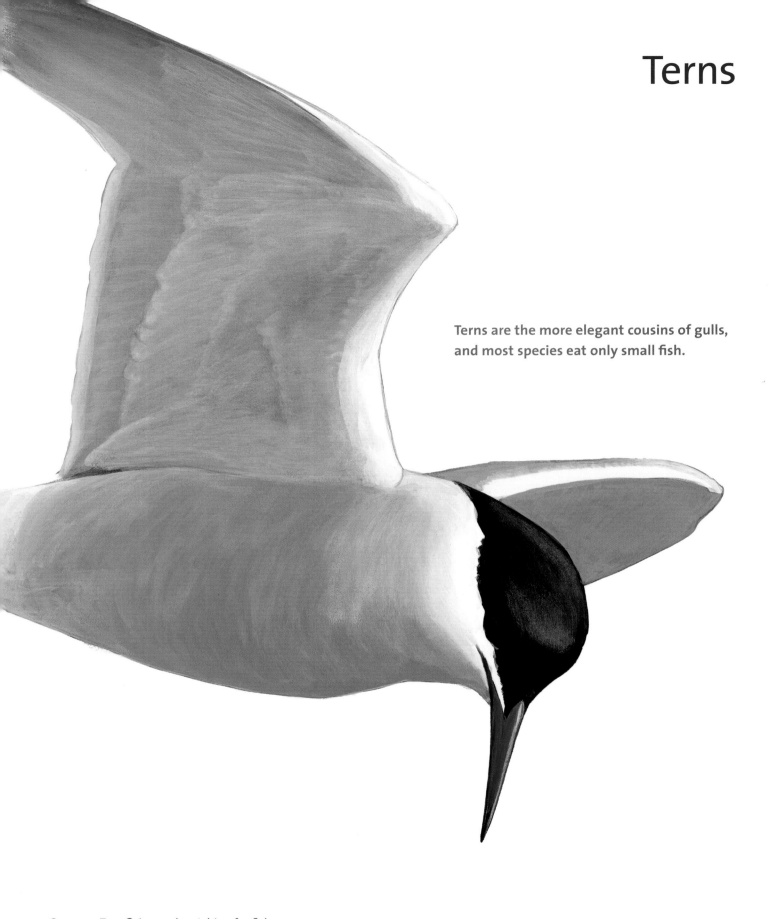

Terns

Terns are the more elegant cousins of gulls, and most species eat only small fish.

Common Tern flying and watching for fish

A colony of Common Terns: each pair defends a small space around their nest, but everything else is shared.

■ Why do some birds nest in colonies? Colonial nesting habits develop when suitable nest sites are limited and food is patchy and unpredictable across a wide area. Terns nest on small islands with no ground predators, and the schooling fish they need for food are extremely unpredictable. The disadvantages of living in crowded conditions include increased exposure to disease and parasites, and increased competition (for food, nest sites, nest materials, and mates). Advantages of colonial nesting include improved predator defense and better information about food sources. A larger and denser colony can mount a much stronger attack against a predator than a sparse colony or an isolated pair. Even when parents are absent from their own nest for long periods in search of food, the colony as a whole will still be defended by other colony members. A colony also functions as an information exchange, allowing birds to take advantage of food sources discovered by their neighbors. The chance of discovering small schools of fish is greatly increased with more birds searching, and once a school is discovered other terns can quickly join the feeding frenzy.

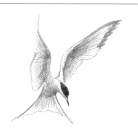
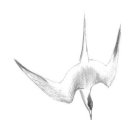

A Common Tern hovering and diving for fish

■ Finding fish in the open ocean is a challenge, and terns require small fish that swim within a few inches of the surface. The tern's strategy is patrolling at a low height, scanning for fish. When they find fish at the surface they stop and hover, about ten feet over the water, selecting their target and waiting for the right moment. Then they turn and drop straight into the water headfirst, hoping that they can close their bill around a fish. They never rest on the water; instead, they take off immediately, and if they've captured a fish they either swallow it while flying or carry it back to their nest. Along the way, they hope to avoid marauding gulls and other birds that want to steal their fish (see kleptoparasitism, p. 29 bottom).

■ Terns are exquisitely adapted for flight, and none more so than the Arctic Tern. This species nests in the Arctic, then migrates to the Antarctic and back every year. It lives most of the year in sunlight, traveling from Arctic summer to Antarctic summer, and spends most of the year near icebergs. Terns are not well suited for swimming, so they're on the wing during long stretches of migration. Their migration route is not a straight line, but takes wide loops around the ocean, and an individual bird might travel 60,000 miles in a year. (The bird migration distance record is currently held by the Wandering Albatross, which has been tracked moving an average of 114,000 miles a year, cruising around the southern oceans.)

Beginning at Arctic nesting sites, Arctic Terns migrate south (orange lines) to their Antarctic winter range (blue), then return north on a different route (green).

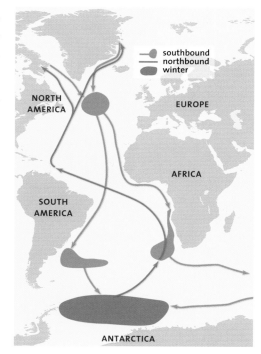

Hawks

This species thrives in the open spaces
and edges created by humans.

A Red-tailed Hawk hunting along a roadside

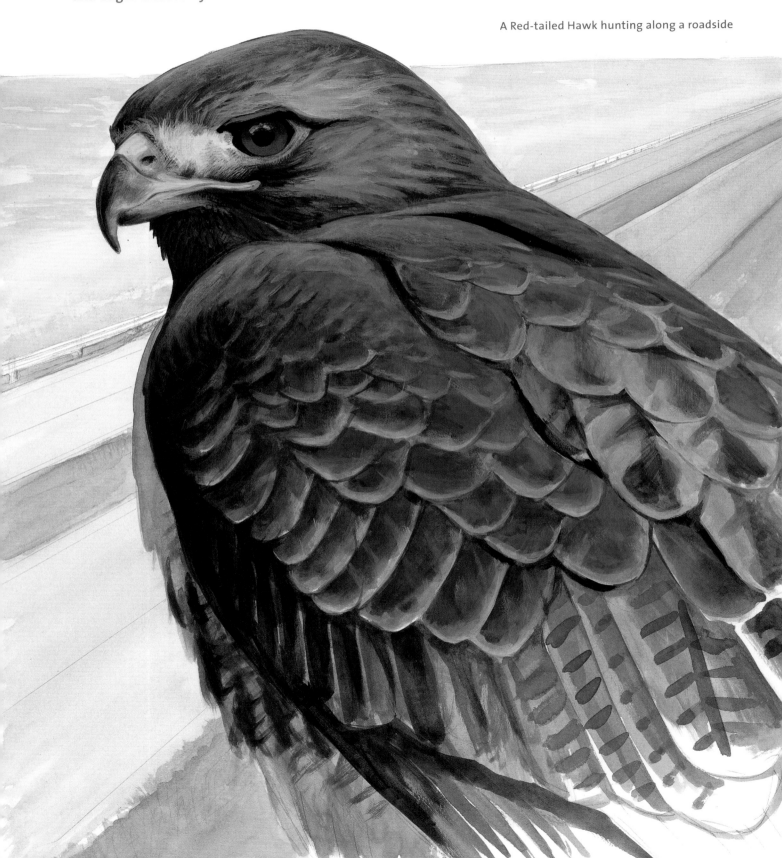

■ The overall color of birds can be quite variable, and it can change seasonally or with age, or can be different between males and females. A few species, including the Red-tailed Hawk, show color morphs. In this case an individual is either dark or light overall, and will remain that way for its whole life regardless of age, sex, or season. The reasons for this type of variation are not completely understood, but recent research supports the idea that (at least in hawks) it is related to camouflage. Dark-morph birds are less conspicuous—and therefore more successful at capturing prey—in low light (as in forests), and light-morph birds are more successful in brighter light (as in open areas). Each color morph has an advantage under different conditions, but neither has an overall advantage, so the two morphs are maintained.

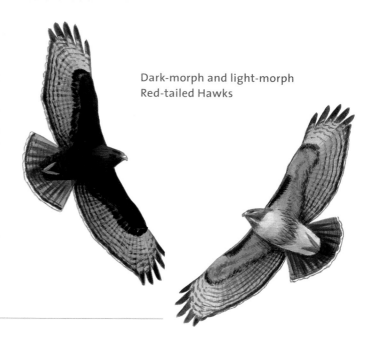

Dark-morph and light-morph
Red-tailed Hawks

Red-tailed Hawk kiting and stooping

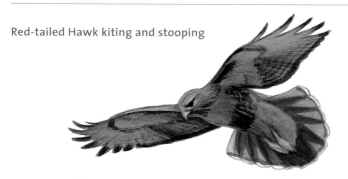

■ Most birds use flight simply to travel between points, and don't change their mode of flight very much. Species like the Red-tailed Hawk, however, spend a lot of time in the air and are incredibly versatile. They use different flight modes depending on whether they are hunting or traveling, and adjust their flight style depending on their needs and the current wind conditions. Red-tailed Hawks are patient hunters, often sitting for hours on a branch or pole where they have a good view of their surroundings, watching for an opportunity. They will also spend hours in the air—kiting (hanging stationary in the breeze with little or no flapping), soaring, or gliding over open areas, watching for prey on the ground. They take mainly small mammals like voles or ground squirrels, but any animal up to the size of a small rabbit is fair game. To capture prey, the Red-tailed Hawk stoops, folding its wings and dropping at high speed.

■ Most species of birds don't vary much in size. They reach adult size within a few weeks of hatching, and after that all individuals are similar in body size. In most species of birds, males are just slightly larger than females. In most hawks (and even more so in owls and hummingbirds), however, the opposite is true—females are larger than males. Among many different hypotheses, several potential advantages involve nesting and foraging, but none have been confirmed by research. The female does most of the incubation, and her larger body mass could make it easier for her to keep the eggs and young chicks warm. At the same time, the male's smaller size makes him quicker and more agile, allowing him to grab smaller prey—which tends to be more abundant and reliable—as he finds food for himself and the incubating female. After the eggs hatch, both male and female hunt for the family, and being different sizes might allow them to capture a wider range of prey within their nesting territory.

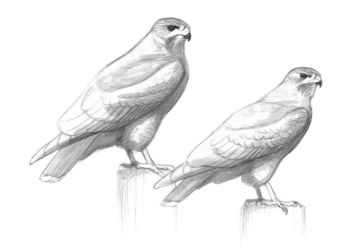

The larger and bulkier female Red-tailed Hawk (left) and the smaller male (right)

The Nesting Cycle of the Red-tailed Hawk

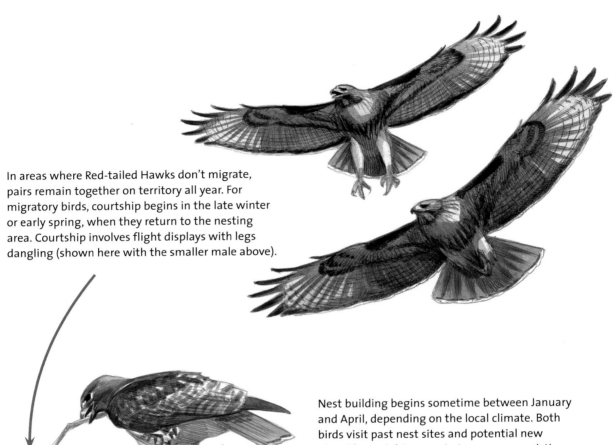

In areas where Red-tailed Hawks don't migrate, pairs remain together on territory all year. For migratory birds, courtship begins in the late winter or early spring, when they return to the nesting area. Courtship involves flight displays with legs dangling (shown here with the smaller male above).

Nest building begins sometime between January and April, depending on the local climate. Both birds visit past nest sites and potential new sites. They might renovate two or more existing nests and also build a new one before choosing which one to use. Both male and female gather materials, carrying sticks in their bill, but the female does most of the work shaping the final bowl. They work mainly in the morning, being stealthy to keep the location secret, and a nest can be completed in four to seven days.

Egg laying might not begin for three to five weeks after nest selection. Usually only two or three eggs are laid, sometimes four. Typically an egg is laid every other day, so the third egg would be laid four days after the first. Incubation begins as soon as the first egg is laid, and is performed mostly by the female. The male helps a bit with incubation, and brings food to the female on the nest. Incubation lasts from twenty-eight to thirty-five days.

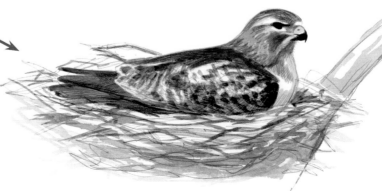

Red-tailed Hawks leave the nest (fledge) at forty-two to forty-six days after hatching, but they stay close to the nest and rely on the parents for almost all of their food for another two to three weeks. They gradually capture more of their own food over the following weeks, but continue to get some food from the parents for at least eight weeks after fledging. The chicks spend a lot of time during their last two weeks in the nest exercising their growing wings, and begin proper soaring flight about four weeks after fledging. In migratory populations adults and fledglings go their separate ways about ten weeks after fledging. In sedentary populations the family can continue associating for up to six months.

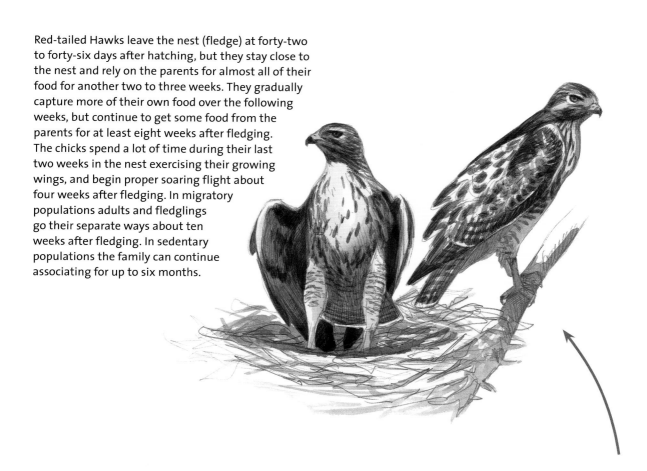

The first egg laid hatches first, and later eggs hatch with one to two days between. Because of this asynchronous hatching, the young are at different developmental stages with a range of size and strength. If food is limited, the chicks compete for it in the nest, and the strongest nestlings (usually the oldest) will get more. The weakest will starve or be eaten by their siblings. This system may seem cruel, but feeding the strongest chick first ensures the best outcome for the most chicks—it is better to raise one healthy chick than two malnourished ones.

Nestlings are able to raise their heads within twelve to eighteen hours of hatching, sit up by day fifteen, feed themselves (from prey delivered by the parents) at day twenty-one, and leave the nest at day forty-six. The adult female continues to brood her young to keep them warm and dry until they are thirty to thirty-five days old, more when they are younger. During this time the male provides most of the food for the female and their young; he brings in up to fifteen prey items a day, totaling about a pound and a half of food each day for a family of three.

Accipiters

Fear of predators can have a profound influence on the behavior of prey species.

A Cooper's Hawk on the hunt

■ Cooper's and Sharp-shinned Hawks are the menacing "chicken hawks" of earlier generations, but they are generally too small to take full-grown chickens. The related Northern Goshawk is more of a threat to chickens, but quite rare. A reflexive belief that hawks are evil, and that hawks and humans compete for the same food, led to centuries of persecution. Educational campaigns in the late 1800s and early 1900s stressed the economic value of hawks—for example, they help protect farmers' crops by eating mice—and an appreciation of the value of predators led to strict laws to protect hawks. But hawks are still persecuted in many areas, and this same thinking continues in attitudes toward wolves and other large predators.

Cooper's Hawk

Cooper's Hawk stalking a Black-capped Chickadee

■ Along with their very sharp eyesight and wide field of view, bird vision includes another adaptation that is critical to their lifestyle: they process visual information much more rapidly than humans do. Our movies are a series of still images flashing by at about thirty pictures per second. This is too quick for our vision to react, and the images blur together into a "moving picture." Birds can process images more than twice as fast as we can, so they would see one of our movies as a slideshow. This ability is critical when dodging obstacles and tracking prey during high-speed flight. Where we see signposts on the highway passing in a blur, a bird would still be able to see details and track the passing of each post.

■ Alert and quick, the Cooper's Hawk and its close relative the Sharp-shinned Hawk live on small birds. These species often hunt around bird feeders in the winter, using hedges, a fence, or even a house to hide their approach. They suddenly burst into the open near the feeder, like a gray-brown missile, at over thirty miles per hour. In that fraction of a second they look for a songbird that is vulnerable—slow, inattentive, or just unlucky. With a quick flick of wings and tail the hawk changes direction, spinning and dodging to follow the smaller bird, trying to get close enough that its long legs and needle-sharp talons can reach out and snare the prey.

Sharp-shinned Hawk with songbird prey

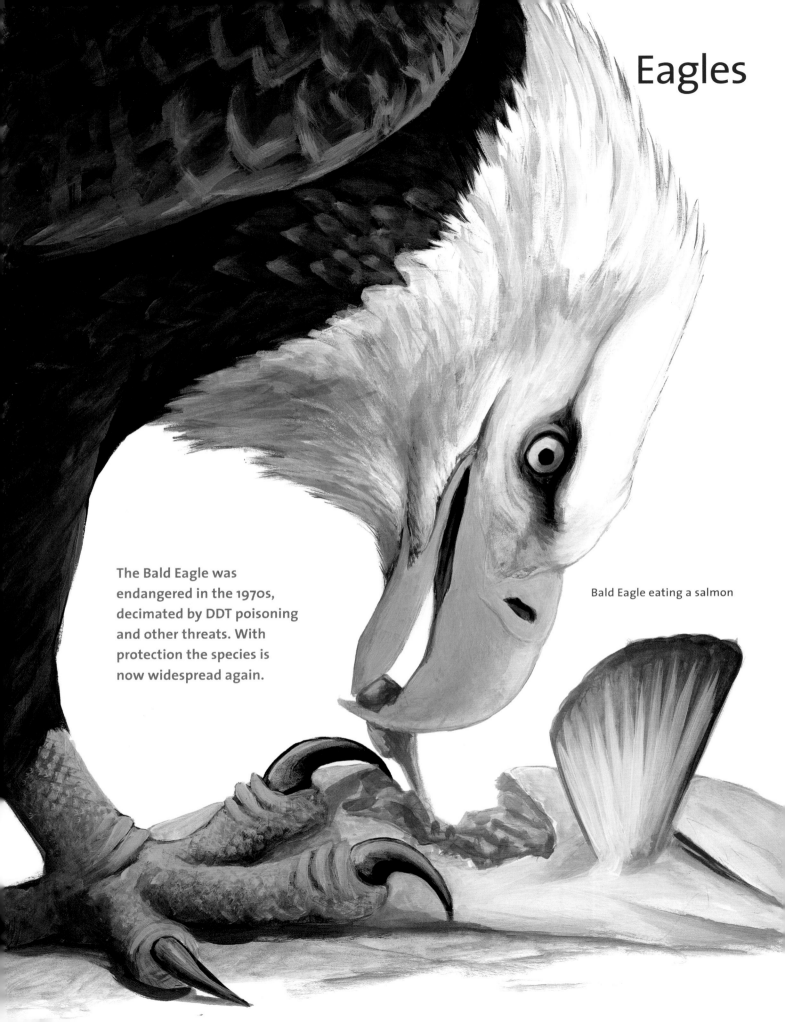

Eagles

The Bald Eagle was endangered in the 1970s, decimated by DDT poisoning and other threats. With protection the species is now widespread again.

Bald Eagle eating a salmon

■ We call someone "eagle-eyed" if they spot very distant objects. This expression was first used in the 1500s, long before the science of eagle vision was known, but anyone who watches eagles notices how they react to distant events that we can only see with the aid of binoculars, such as a rabbit loping across a hillside a mile away. Eagles have five times as many light-sensing cells packed into their eyes—five times as many dots per inch—so they can see a lot more detail than we can. And almost all of those cells (80 percent) are cones that see color. We have only 5 percent color-sensing cones and 95 percent rods for dark-light vision. In addition, each of the eagle's cone cells has a colored oil droplet that acts as a filter to block some wavelengths (colors) of light, further enhancing their color vision. We can look through 5x binoculars to approximate an eagle's visual acuity, but we have no way to simulate their color vision.

Because of the position of the fovea, this Bald Eagle is looking directly at you (with one eye).

A Bald Eagle showing the lines of sight of the four foveae

■ Look at a single word in this sentence, and then try to read the words around it without moving your eyes. That tiny area of detail in the center of your vision is because of the fovea, a small pit in the retina of each eye where light-sensing cells are more tightly packed. We have one fovea in each eye, both eyes focus on the same point, and we see one spot of detail. Most of our visual field, over 110 degrees, is viewed by both eyes (this is called "binocular vision"). Eagles, however, have two foveae in each eye, for a total of four, and they all point in different directions. Their two eyes only overlap in a narrow arc of less than 20 degrees, and they don't see much detail there. An eagle is seeing four different areas of detail at all times, as well as nearly 360 degrees of peripheral vision! One fovea in each eye is aimed almost straight ahead, and the "strongest" fovea points out at about 45 degrees. In order to look at the sky or the ground, a bird will cock its head to one side, using one fovea of one eye to study something.

■ One of the most serious threats now facing eagles and many other birds is lead poisoning. Eagles swallow lead shot and bullets embedded in prey, or eat waterfowl that have high levels of lead (from swallowing lead shot and fishing weights). Because a bird's digestive system relies on a muscular gizzard (stomach) and strong acids to pulverize and dissolve food, harder materials like rocks, seeds, bones, or metal fragments are simply ground up until they are small enough to pass through. This means that bits of lead can remain in the gizzard, breaking down and releasing lead into the body, for many days. Signs of severe lead poisoning include weakness, lethargy, and green feces. All of the lead involved in these poisonings comes from humans, and simply using lead alternatives in ammunition and fishing weights would solve this problem.

This Bald Eagle is suffering from severe lead poisoning and needs treatment to have any chance of survival.

Vultures

Among their many adaptations for eating carrion, vultures have an unusual community of gut bacteria that would be toxic to most animals.

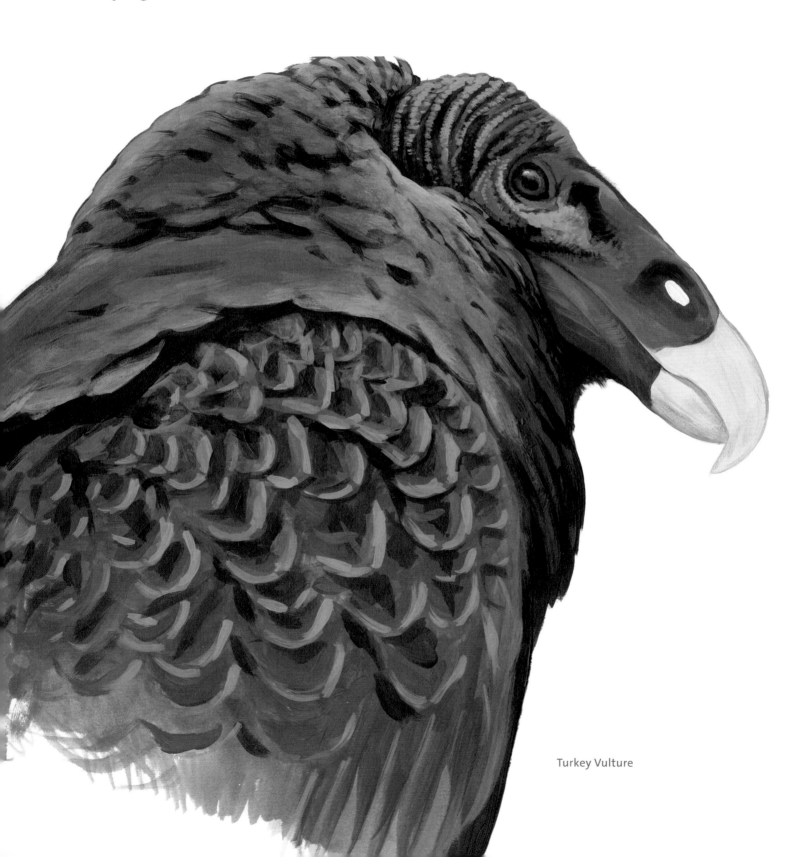

Turkey Vulture

■ Vultures spend the night roosting in large groups in trees, on pylons, or on buildings, and often stand with their wings spread in the early morning. The reason for this behavior is unknown, and it may serve several different functions. It is most often seen on bright, sunny mornings as birds prepare to leave their roost, and they tend to stand with their backs to the sun and wings spread and angled for maximum sun exposure. On cool mornings, this may help dry off any dew that collected on the wings during the night, thus reducing weight and making flight easier. One study found that vultures stand with their wings spread on cool mornings regardless of whether any dew formed, and suggested that it may simply be an automatic response to strong sunlight and the possibility that their wings are damp. One researcher has suggested that the warm sun refreshes the curvature of the large wing feathers, preparing them for another day of flight. In hot weather, wing spreading can also be used as a way to reduce body heat, by exposing the less insulated underside of the wing.

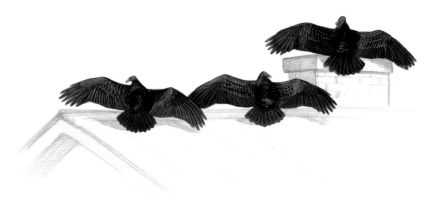

Turkey Vultures roosting with wings spread

The low and slow flight of Turkey Vultures allows them to use their sense of smell to find food

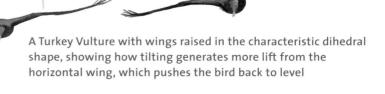

■ You might have heard that birds cannot smell, but all birds can, and Turkey Vultures have a very good sense of smell. There is debate over whether they use sight or smell more for locating their preferred food of recently dead animals, but there is no doubt that smell is important. Recent tests suggest that their sense of smell is not keen enough to pick up a faint scent from their normal soaring altitude, so they may use other clues at first, and then use smell to zero in on food (or the tests may have underestimated their smelling ability). It is common to see Turkey Vultures flying relatively low—around treetop level—presumably hunting by smell. A related species called the Black Vulture begins flying later in the morning, flies higher, and often locates food by following Turkey Vultures.

■ The flight of Turkey Vultures is distinctive—they fly with the wings raised in a V (dihedral) and constantly tilt from side to side as they react to air currents. A dihedral is more stable but generates less lift than with wings horizontal, so Turkey Vultures have relatively large wings for their weight (see p. 99 bottom). The dihedral makes flight more stable because it is self-correcting: a roll to one side puts that wing more horizontal, which generates more vertical lift, which then automatically pushes the bird back to level, without flapping. They can tilt away from an updraft that is too strong, spilling air from one wing while allowing the opposite wing to provide lift and push them back upright. In this way they can fly low and slow in search of food, staying airborne with only tiny adjustments of their wings, where other species would need to flap frequently to regain their balance.

A Turkey Vulture with wings raised in the characteristic dihedral shape, showing how tilting generates more lift from the horizontal wing, which pushes the bird back to level

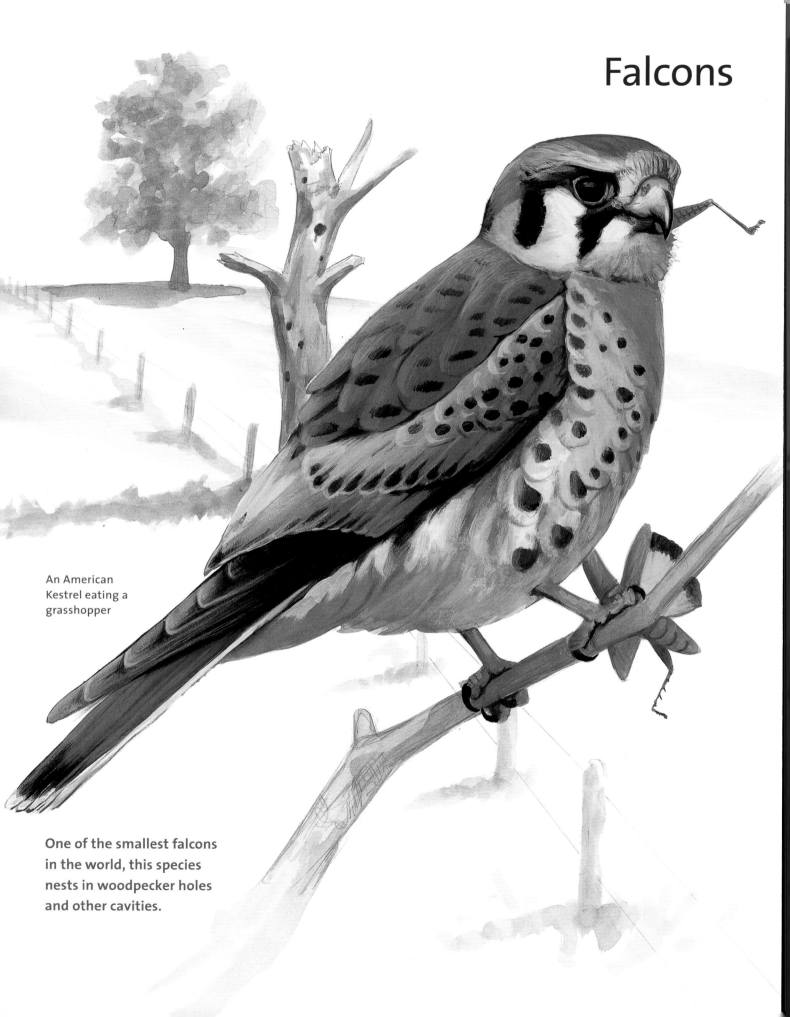

Falcons

An American Kestrel eating a grasshopper

One of the smallest falcons in the world, this species nests in woodpecker holes and other cavities.

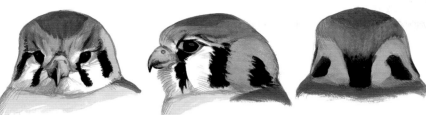

American Kestrel from front, side, and back

■ The intricate color pattern on the head of American Kestrels includes two false eye spots on the back of the head. This creates the illusion of a face and is an example of *deflective coloration*. The most likely benefit for the kestrel is that would-be predators are fooled by the false face and think they are being watched, or are uncertain about which way the kestrel is facing, which causes them to either delay or give up an attack. (Yes, small hawks and falcons can be prey for larger species.)

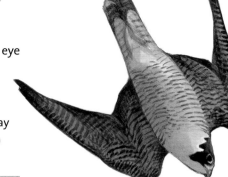

■ The Peregrine Falcon is the fastest animal in the world, capable of speeds of at least 242 miles per hour and potentially more than 300 miles per hour, and is able to make turns that generate 27 Gs (one G is the force of gravity, and humans lose consciousness at 9 Gs). Peregrines usually circle high overhead when hunting. When they see potential prey—such as a duck—they fold their wings and go into a steep dive, called a "stoop." The duck is hit from above as it flies, and often doesn't see the falcon coming. The falcon hits its prey with its feet, and the impact of being struck by a two-pound falcon traveling at over 200 miles per hour stuns or kills the duck instantly. The duck falls to the ground, and the falcon circles back to settle and feed. Adaptations for extreme speed include very stiff and sleek feathers, and a modified nostril that makes it possible for the falcon to breathe even at top speed.

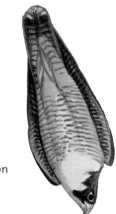

A Peregrine Falcon in a high-speed dive, or "stoop"

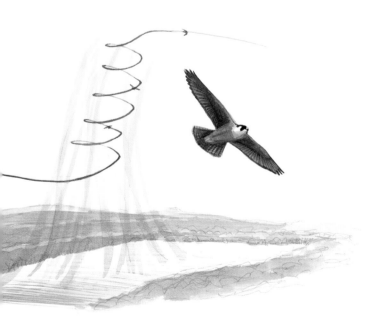

■ Birds use many techniques to save energy when they are flying, most of which are tricks to stay aloft without flapping. Riding updrafts to gain altitude is one of the most conspicuous. Bare ground such as fields or parking lots absorbs more heat from the sun, and as air near the ground warms up it rises. This creates a column of rising warm air—a *thermal*—reaching hundreds or even thousands of feet high. A soaring bird can sense the air movement and fly in circles to stay in the column. It simply fans its wings and tail and lets the rising air carry it up like an elevator. When it reaches the top, the bird bends its wings and glides in the direction it wants to travel, searching for the next thermal. All soaring birds take advantage of thermals, but some species, like Broad-winged Hawk and Swainson's Hawk, are specialists and in the right conditions can travel hundreds of miles with almost no flapping.

Blue lines show a *thermal* of warm air rising from the open field; the reddish spiral shows the path of a Peregrine Falcon entering low and circling to ride the rising air upward.

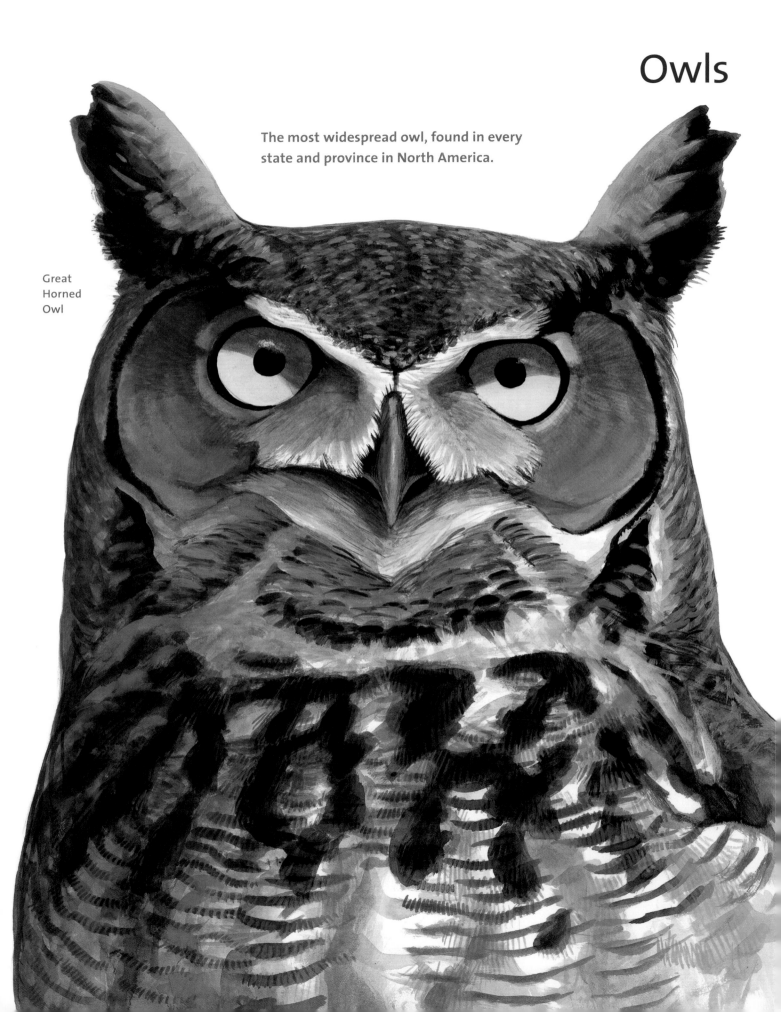

Owls

The most widespread owl, found in every state and province in North America.

Great Horned Owl

A Great Horned Owl with horns raised and lowered

■ The "horns" of the Great Horned Owl are actually tufts of feathers on their head. These resemble ears or horns, but they are formed by just a few feathers and can be raised or lowered depending on the owl's mood. The function of these tufts is debated; they certainly help to camouflage an owl by breaking up the outline of the head, and they probably also play a role in displays.

Barn Owl turning its head to hear you better

■ There's a common myth that owls can spin their heads completely around. This is not quite true, but they can turn 270 degrees in either direction, three-quarters of a full circle (and *all* birds can turn more than halfway around). An owl has twice as many vertebrae in its neck as we do, which makes their neck more flexible. (Some other birds have more than three times as many.) But twisting the head requires more than neck flexibility, as the critical nerves and arteries that travel along the neck have to be protected from pinching or kinking with such extreme movements. In owls the two carotid arteries supplying blood to the brain pass through a relatively large channel in the vertebrae, and run outside of the last few neck vertebrae below the skull, so they can move more freely to adjust to head movements. The arteries also rejoin in the skull just before they fan out to cover the brain, so if one of them is pinched closed on the neck the other can still supply blood to the entire brain.

Owls are supposed to be nocturnal—why do they call most often at dusk and dawn?

Though nocturnal, owls still rely on visual cues most of the time, and have some visual signals for display, such as the white throat of this calling Great Horned Owl. The white patch shows well in the dim light of twilight, when owls do most of their calling. There is no need for owls to be more colorful, since colors are not obvious in low light and owls' color vision is not very good (their eyes contain mainly rod cells for sensitive dark-light vision). Vision is also the reason owls are most active hunting during the twilight hours, for a few hours after sunset and a few hours before sunrise. Even if they locate their prey by sound, they need to see in order to fly around trees and other obstacles.

A Great Horned Owl calling

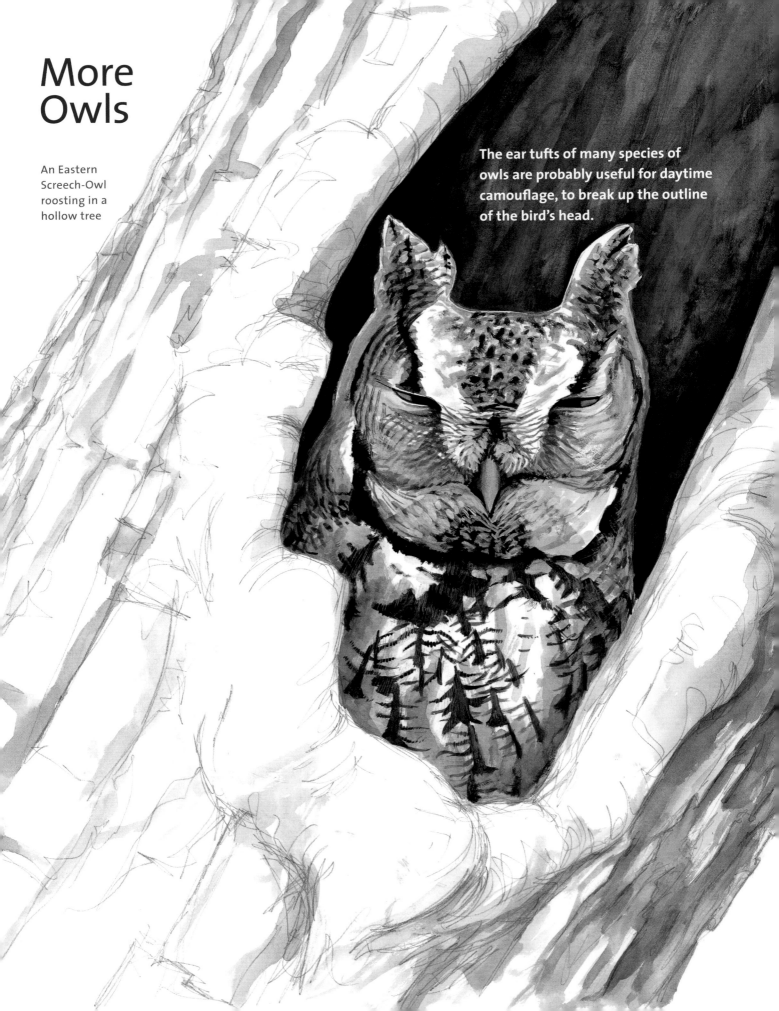

More Owls

An Eastern Screech-Owl roosting in a hollow tree

The ear tufts of many species of owls are probably useful for daytime camouflage, to break up the outline of the bird's head.

■ Owls have extremely sensitive hearing, and some owls have adaptations that improve their ability to locate sounds. In the Barn Owl, the outer ear flaps are asymmetrical: the left ear opening is higher and angled down, and the right ear opening is lower and angled up. We can locate sounds in the horizontal plane because of the tiny difference in the time the sound reaches each ear, but we have little ability to pinpoint sounds vertically. Barn Owls' ear structure means that the left ear (angled down) captures more sound from below, and the right ear captures more sound from above. They can use the difference in volume to determine the vertical angle to the source of the sound. By twisting their heads into odd positions they are turning their ears to test the sound from different angles and get a better fix on a location. Interestingly, asymmetrical ears have evolved independently in at least four different owl species, each time in a slightly different way.

A Barn Owl, showing the different position and direction of the two ears

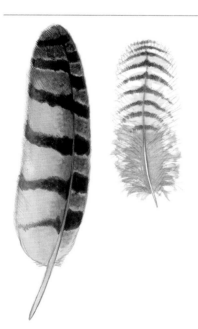

■ Owls' wing feathers have several adaptations for silent flight: delicate shaggy fringes on the leading and trailing edges, a downy or velvety upper surface, and a generally soft and flexible texture. Softer feathers with more flexible and porous edges allow air to flow more smoothly around the wing, reducing turbulence and therefore noise. These same adaptations also reduce the noise of feathers brushing against each other as the wing moves. The body feathers of owls are also soft and fuzzy. As the owl's body feathers slide across each other (when turning the head in a circle, for example), they are silent. Imagine how quiet your movements are when wearing a soft sweater instead of a nylon rain jacket. This has two advantages: it makes it harder for prey to detect the owl's presence, and it allows the owl to hear any surrounding noises more clearly.

A wing feather (left) and body feather (right) of a Great Horned Owl

■ Even with their excellent hearing, most owls still require some vision to capture prey, but Barn Owls are able to capture prey in total darkness, using sound alone. Experiments have shown that Barn Owls can pinpoint the location of a mouse from thirty feet away, strictly by sound, then fly to that exact spot even if the mouse makes no further sound. They even orient their attack based on the direction in which the mouse is traveling. Imagine walking across your bedroom in total darkness to put your finger on something that made a sound a minute earlier. Now imagine floating across your room. . . . Barn Owls can determine the precise direction to their prey because of their ear adaptations. But how do they know the distance? And once they leave their perch and begin flying—in total darkness—how do they track their progress in the air and land precisely on a tiny mouse thirty feet from their starting point? These are unanswered questions.

A Barn Owl striking a mouse

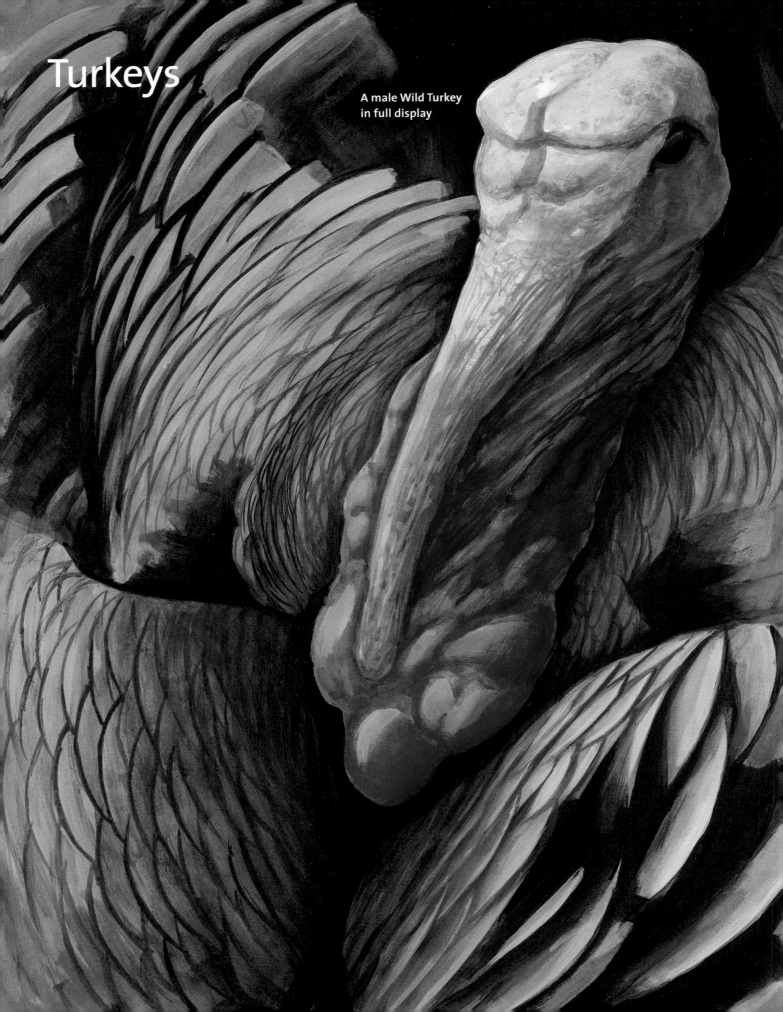

Turkeys

A male Wild Turkey
in full display

■ Wild Turkeys, like many species in the chicken family, use a *lek* display system. Males gather at a favored display area, or lek, usually in a clearing that allows females to get a good view of the display. Males hang around the lek for weeks in the spring, jockeying for the best positions. Females pass through, browsing the selection of available males and judging their displays. Females only need to mate once, and have no further contact with the male. The female alone builds a nest, lays eggs, and raises the young.

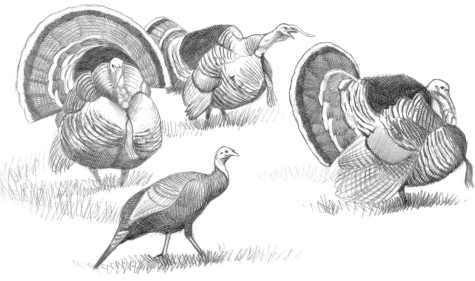

A female Wild Turkey (front) reviews three displaying males

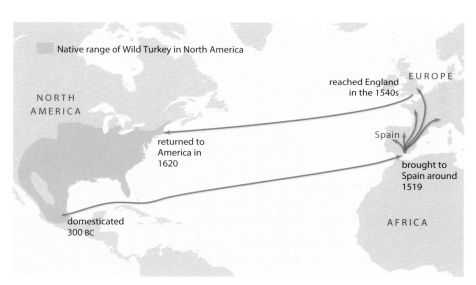

Native range of Wild Turkey in North America

EUROPE

reached England
in the 1540s

NORTH
AMERICA

Spain

returned to
America in
1620

brought to
Spain around
1519

domesticated
300 BC

AFRICA

The strange journey of the domesticated Wild Turkey

■ A bird's ears are on the side of the head behind and below the eye. In most species the ear is hidden under specialized feathers (see p. 107 bottom), but on birds like the Wild Turkey, with an unfeathered head, the ear opening is clearly visible.

A female Wild Turkey

■ Wild Turkeys were domesticated in southern Mexico at least as early as 300 BC and were brought back to Europe in 1519 by the first Spanish explorers. They were very popular, traded between towns, and spread quickly across Europe. The name *turkey* comes from the mistaken impression that these strange birds arrived in Europe from the East, in the region of Turkey. They reached England in the 1540s, less than thirty years after their arrival in Spain. When the *Mayflower* set sail for Massachusetts in 1620, several live turkeys were among the cargo, returning to the Americas after 101 years away. In fact, all domestic turkeys today are descended from those Mexican turkeys domesticated more than two thousand years ago.

Grouse and Pheasants

This subspecies of the Greater Prairie-Chicken was common in the northeastern states before 1800, including close to Boston and New York City, but went extinct in 1932.

The Heath Hen

The largest muscles in a bird's body are the breast muscles that power flight, which can account for 20 percent of a bird's total weight. There are two separate muscles involved, one for the upstroke and one for the downstroke. In most species the downstroke muscle is about ten times larger. On our bodies the muscles for bringing our arms forward (downstroke) are on our chest, and the muscles for bringing our arms backward (upstroke) are on our back. Birds have evolved to have both muscles on the front, below the wings for better weight balance in flight. This sketch shows how the larger downstroke muscles (darker red) attach to the underside of the wing to pull it down, and the upstroke muscles (lighter red) wrap over the shoulder and attach to the top of the wing as a sort of pulley system. When you carve a chicken or turkey breast for dinner, you might notice the separation of these two large muscles.

Ring-necked Pheasant with breast muscles highlighted

Birds have many adaptations that make flight possible, and weight balance is one of the most important. The heavier bone and muscle of a bird is almost all in a compact central mass that rides below the wings. Wings and legs are controlled by long tendons connected to muscles in the compact body. The neck and head are very light, with a lightweight bill instead of heavy jaws and teeth. Try making a paper airplane, then tape a coin to different parts of the plane. It will only fly properly if the extra weight is below the wings and near the center.

Ring-necked Pheasant with actual flesh and bones shown in red; the wings and tail are mostly feathers

Domestic chickens

What's the most common bird in North America? That would be the domestic chicken. The population at any given time numbers something over 2 billion birds—about 500 million egg-layers and the rest being raised for meat. That's about five times more than the human population of the continent. In contrast, the best guess for the most numerous wild bird in North America is the American Robin, at an estimated 300 million birds. That's about one-seventh of the chicken population, and slightly smaller than the human population.

Quail

Quail tend to be secretive and stay hidden in dense brush, but males often stand in the open to broadcast their call.

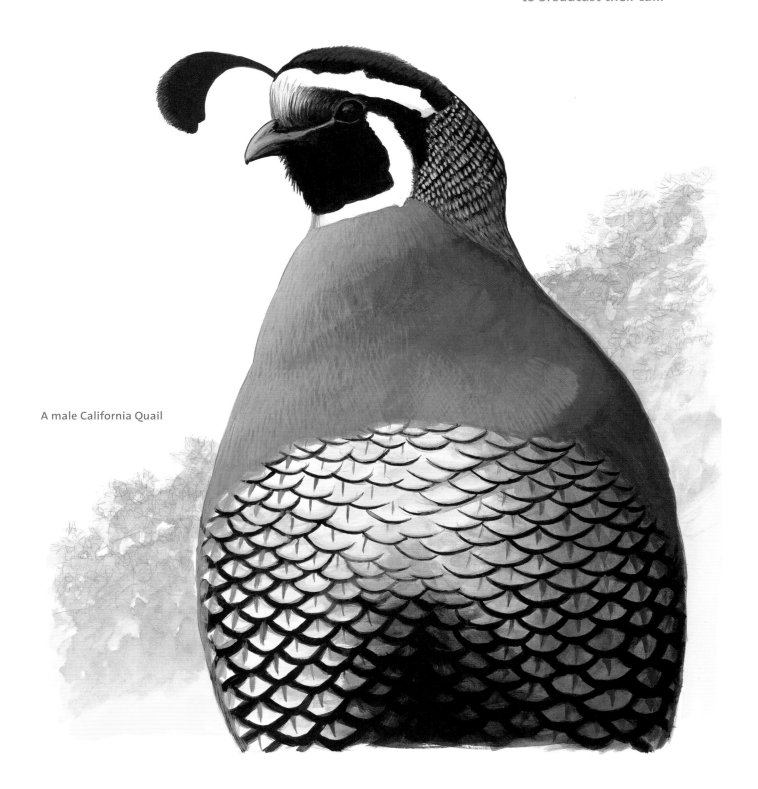

A male California Quail

■ The Northern Bobwhite is named for the male's call, a clear, cheerful whistle: *bob-WHITE*. It is the only quail native to eastern North America, and in the 1800s its call was such an iconic sound that, for example, people moving west wrote nostalgic letters about how much they missed it. As early as the mid-1800s bobwhite numbers in settled areas were severely reduced by hunting, and by the mid-1900s the gradual conversion of farmland had further reduced their habitat and numbers. That trend continues, and populations now are less than 10 percent of what they were just sixty years ago. In response to declines, beginning in the mid-1800s, millions of bobwhite were trapped and moved from areas where they were still common (such as Mexico) to areas where they were declining (such as New England), and many more have been raised in captivity and then released into the wild. Introducing birds that are genetically unsuited to the local conditions may have contributed further to local declines. The species can still be found in many states, but its long-term future in the wild is uncertain.

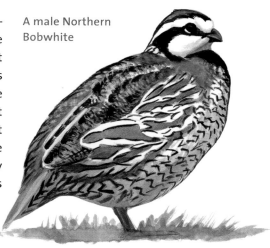

A male Northern Bobwhite

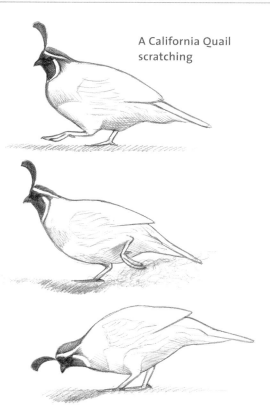

A California Quail scratching

■ Birds spend a lot of their time searching for food, and finding food on the ground often involves sifting through leaves and dirt to reveal edible treats. Quail (like their close relative the chicken) have evolved a one-footed scratch maneuver to help uncover food. They stand on one leg and kick backward with the other leg, scratching their toes along the surface and sending leaves and dirt flying backward. Sometimes they alternate legs, but they can't see what their feet are doing, so in order to look for food they have to stop scratching, take a half step backward, and study the ground.

■ Intricate feather patterns often follow a simple progression. The feathers grow in a very organized arrangement (like shingles on a roof), and because of that organization, applying some relatively simple incremental changes in each feather creates amazing color patterns. In this quail, small changes in the background color, thickness of the dark margin, and thickness and color of the shaft streak are applied both left to right and up and down to make a pattern that is extremely complex and at the same time pleasingly predictable, like a visual representation of music.

California Quail belly feathers

Pigeons

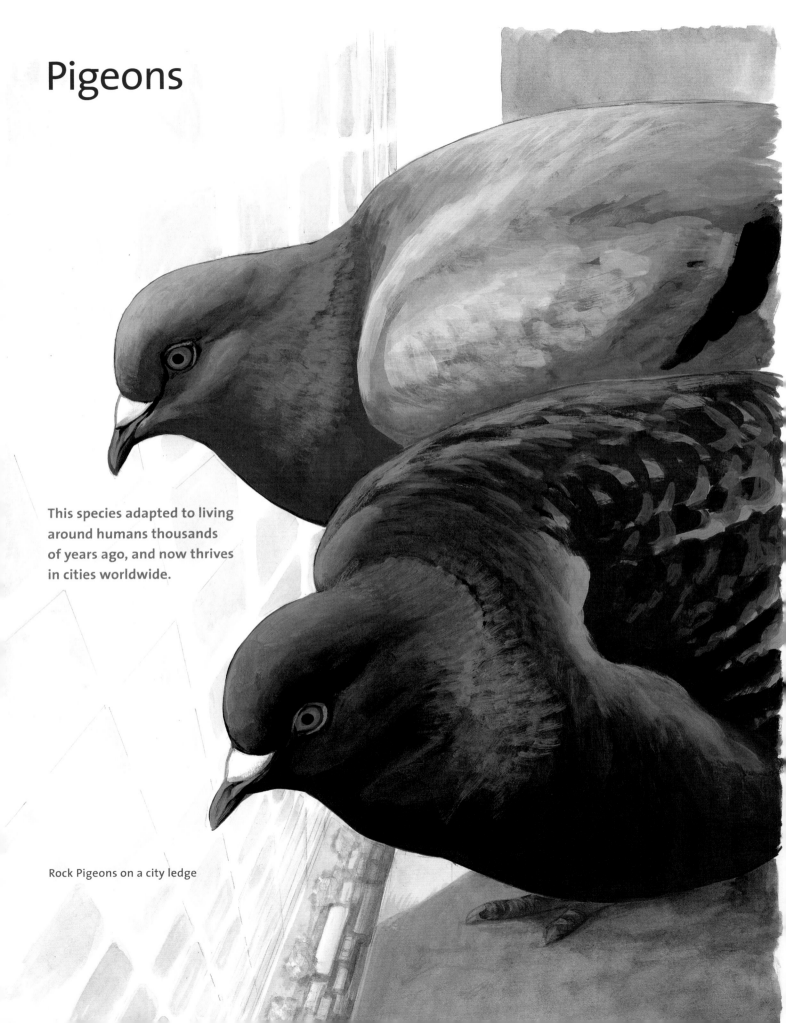

This species adapted to living around humans thousands of years ago, and now thrives in cities worldwide.

Rock Pigeons on a city ledge

■ Birdbrain, silly goose, dodo . . . these expressions and others reflect our low opinion of the intelligence of birds, but this is unfair to the birds. Crows and parrots perform as well as dogs in tests of reasoning and learning. Birds are self-aware and can learn by watching the experiences of other birds. Pigeons understand concepts like the difference between water in droplets, puddles, or lakes, and have been trained to distinguish impressionist art from other styles, and to read mammograms as well as a human can. Pigeons' success in cities around the world requires cleverness and innovation, both signs of intelligence.

Rock Pigeon

■ With their remarkable navigational abilities, pigeons have been used to carry messages for thousands of years, and pigeon racing is still a popular hobby. Pigeons can find their way back to their home loft from at least 2,500 miles away. A race involves taking a group of pigeons from neighboring lofts and releasing them together at some distant location. The winner is the first one to return home. Pigeons have been the subjects of hundreds of scientific studies, and much of what we know about how birds navigate has been learned from them. The picture that has emerged is complex. The birds must have a form of map and compass, with multiple senses and systems contributing. They sense the magnetic field, read the stars, track the sun, hear infrasound (very low frequency noises), follow smells, and more, all integrated with a precise clock. And once they have experience with a route, they can follow the same corridor using rivers, hills, roads, buildings, and other landmarks.

A Rock Pigeon's normal cruising speed is nearly fifty miles per hour

■ Upon hearing the name *pigeon*, most people frown and think of the common Rock Pigeon of cities, which has evolved to live with humans and is rarely found away from buildings. Rock Pigeons originated in Europe, but there are other species of pigeons native to North America. The most widespread is the beautiful and majestic Band-tailed Pigeon, found in the mountains of the western U.S. Another native pigeon is, sadly, extinct. The Passenger Pigeon was considered the most abundant bird in North America, traveling in flocks of hundreds of millions of birds. They nested together in huge colonies wherever food was abundant. In the mid-1800s, with growing cities in the eastern U.S., and new railroads making transportation easier, entire nesting colonies could be harvested, shipped to markets in the cities, and sold for food. The last Passenger Pigeon—Martha— died in a zoo in Cincinnati, Ohio, in 1914.

The native Band-tailed Pigeon

Doves and Pigeons

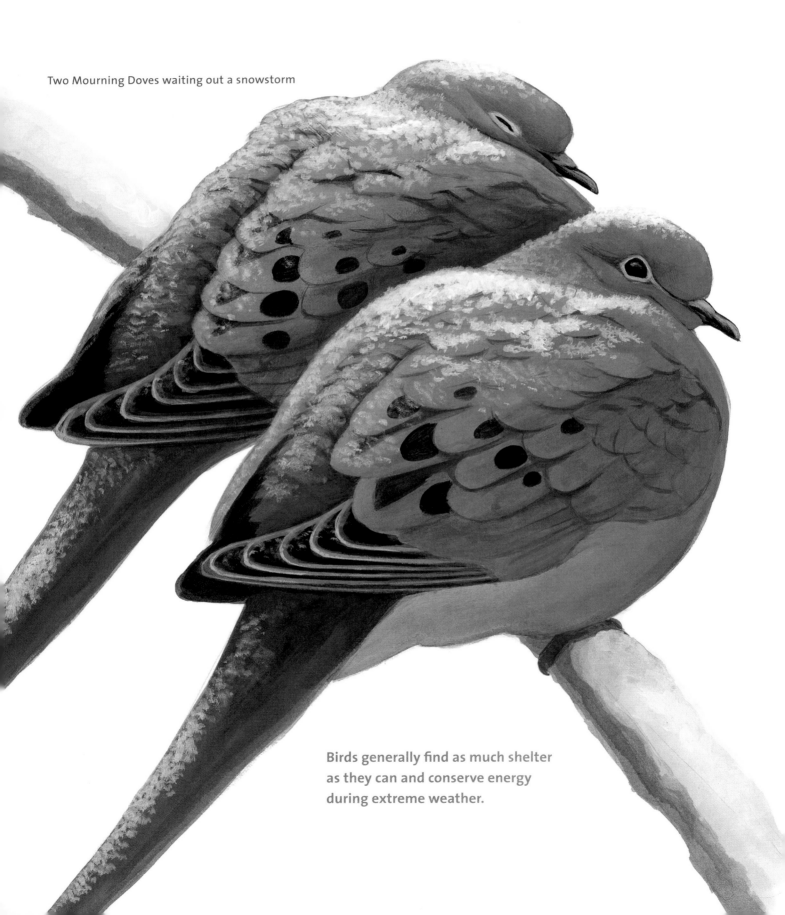

Two Mourning Doves waiting out a snowstorm

Birds generally find as much shelter as they can and conserve energy during extreme weather.

■ Many birds bob their heads back and forth as they walk, and they do it to help keep their vision fixed on their surroundings. Head bobbing is synchronized with foot movements. As one foot is picked up and moved forward, the head snaps forward and then remains nearly stationary while the body moves forward below it. As the trailing foot is picked up off the ground the head snaps forward again, and the cycle repeats. The head-bobbing motion is stimulated visually, and in experiments where pigeons walk on a treadmill or are blindfolded (so that the view does not change), they do not bob their heads.

A Rock Pigeon walking: the head remains stationary while the body moves forward

Mourning Dove partly asleep

■ Can birds really sleep with one eye open? Yes. Bird sleep is quite different from ours, and they can put half of their brain to sleep while continuing activity with the other half. We could say this dove is "half asleep," but research shows that it is really about three-quarters asleep. The side of the brain with the eye open is really in an intermediate state, resting while still monitoring the surroundings. Birds resting at the edge of a flock will often keep their "outward" eye open to watch for danger.

■ Why do the wings of Mourning Doves make a whistling sound on takeoff? Researchers tested the reactions of doves and other birds to recordings of Mourning Doves taking off, and found that the sound of a normal relaxed takeoff caused no reaction, but the sound of a panicked takeoff (higher pitched and with quicker wing beats) caused doves and other birds to flee in alarm. Clearly the wing whistle of doves is a valuable signal alerting other doves to potential danger, and can be learned by unrelated species just like the high-pitched alarm calls of many songbirds. Wing sounds are also used in the dove's courtship displays, so it's possible that the sound evolved mainly for that purpose, with the alarm function being a nice extra benefit.

Mourning Dove taking off

Hummingbirds

Male hummingbirds will fiercely defend a patch of flowers (or feeders) against all other hummers.

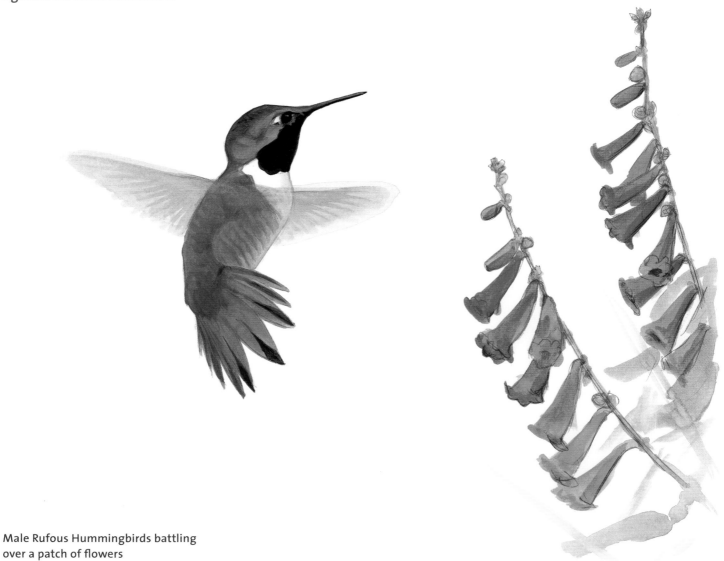

Male Rufous Hummingbirds battling over a patch of flowers

Male Ruby-throated Hummingbird in side view and front view

■ Many species of birds have iridescent colors, produced by the microscopic structure of the feathers' surface. The iridescent colors of the throat of a male hummingbird are among the most refined and spectacular colors in all of nature. The structure of the feather surface amplifies one color of light, and the surfaces are angled so that they reflect that color in only one direction—straight ahead of the bird. Even the feathers that wrap around the sides of the head have the microscopic flat surfaces angled to face forward. A male hummingbird as shown here can look black-headed most of the time, but when it turns to face you directly the throat glows with an intense beam of brilliantly colored light. This gives the male hummingbird an extremely directional signal, visible only to the object of his attention.

The glittering colors of a hummingbird's throat do not involve pigment. They are produced by the physical structure of the feather's surface, as light waves interact with precisely spaced microscopic layers. In the diagrams here, one layer of the feather's surface is shown (gray). Light of all wavelengths comes from the right (not shown). Some light reflects from the outer surface of the feather, and some passes through the layer to reflect from the inner surface. This diagram shows only one reflected wave of each color from each surface.

In the upper image, the distance through the layer is equal to one wavelength of blue light. Waves of blue light reflected from both surfaces emerge *in phase* (with crests and troughs aligned) and combine to create one stronger wave. No other wavelengths match the distance through the layer. Red light has a longer wavelength, greater than the distance through the layer, so the reflected red waves emerge *out of phase*. These red waves cancel each other out and become invisible, and all that we see is an intense blue color. The lower image shows a thicker layer, matching one wavelength of red light, so red waves are amplified while the blue waves (and all other wavelengths) are invisible. The feathers of a hummingbird's throat can have up to fifteen layers, all with exactly the same thickness to match one color of light. The only visible light reflected from such a feather is fifteen waves of the same color combined into one superwave!

(This is a simplified explanation of some of the basic principles involved, the reality is more complex.)

■ It takes a lot of fuel to keep a hummingbird going at its normal pace, and they need to feed constantly during the day. To conserve energy to get through a long night with no food, hummingbirds can slow down their body processes, becoming torpid. During torpor, the tiny bird's body temperature can drop below 60°F. The heart rate can slow from five hundred beats per minute to fewer than fifty, and breathing may briefly stop. How do hummingbirds come out of torpor? As their heart and breathing rates rise, their large flight muscles begin to shiver, and you will see their wings vibrating. The use of any body muscles generates heat. (This is also true in mammals, which is why we get warm while exercising, and shiver when we're cold.) The heat generated by the vibrating wing muscles warms the hummer's blood supply. The warmed blood circulates throughout the body, and soon the hummer's body temperature is back up to its normal toasty range of 100–104°F.

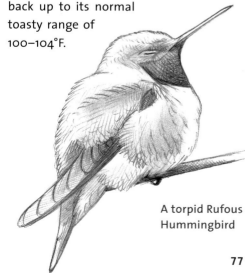

A torpid Rufous Hummingbird

More Hummingbirds

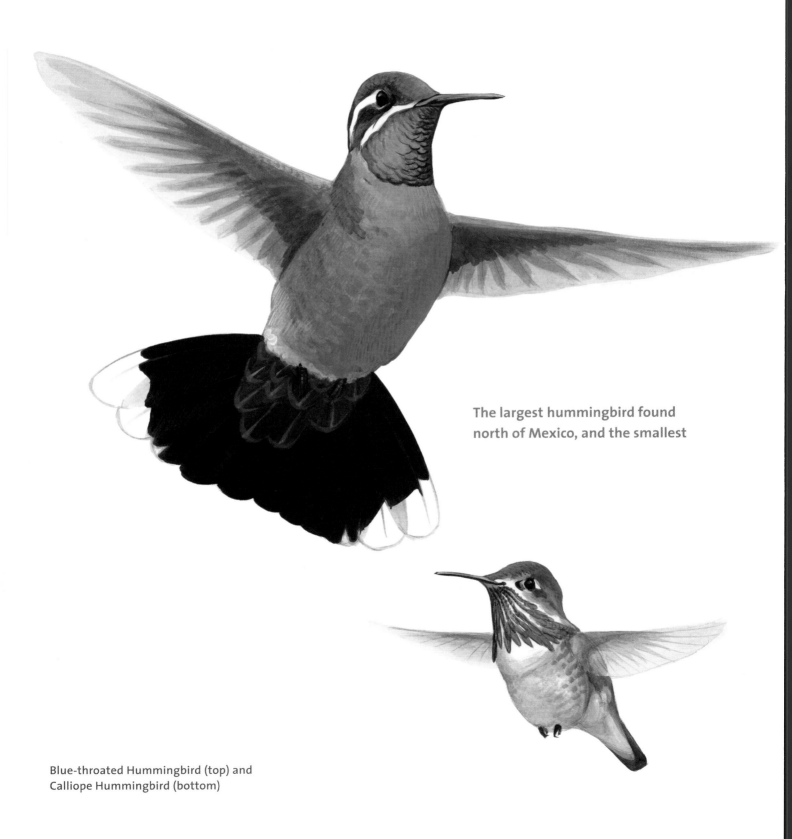

The largest hummingbird found
north of Mexico, and the smallest

Blue-throated Hummingbird (top) and
Calliope Hummingbird (bottom)

■ Feeding hummingbirds is simple, and the birds are amazing to watch. There are just a few things you need to know. Use plain white sugar, dissolved in water at a ratio of about four parts warm tap water to one part sugar. Don't use brown sugar, organic sugar, or "raw" sugar, as these can contain iron, which is toxic to hummingbirds. Don't add red food coloring—the red parts of the feeder will attract birds. White sugar is sucrose, the same as flower nectar, and anything else you add is unnecessary and can be harmful. Keep your feeders clean. Rinse them out and replace the nectar every few days (more often in warm weather) to keep mold or fungus from growing. If you have trouble with one dominant bird chasing away other hummingbirds, try putting out more feeders. A typical individual visits the feeder about once every thirty minutes, and in between it will be catching insects (which can constitute up to 60 percent of its diet) and visiting flowers. A rough rule of thumb for estimating the total number of hummingbirds using your feeder is to count the most birds you see at one time and multiply by ten.

Ruby-throated Hummingbirds at a feeder

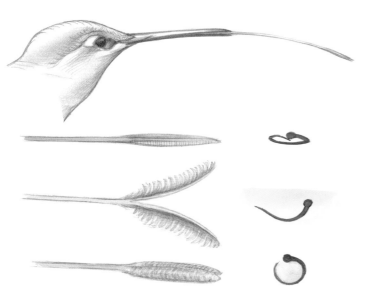

The hummingbird tongue on the left, and a magnified cross-section on the right, shown as it emerges from the bill (top), as it enters the liquid nectar (middle), and as it is pulled back into the bill (bottom)

■ Hummingbirds feed by dipping their long slender tongue into the nectar inside a flower (see p. 91 bottom). Some of the remarkable details of how this works were just recently discovered. The tip of the tongue is forked, and each fork has a fringe that forms a flexible tube designed to hold liquid. The fringe spreads out when it is submerged in nectar, and wraps securely around a drop of nectar as it is pulled back into the bill. Inside the bill the nectar is squeezed out and swallowed, and the tongue immediately dips into the flower again. This action can be repeated twenty times per second—a lot faster than you can count. All the bird has to do is extend its tongue into the flower and pull it back full of nectar, like dipping a paintbrush into water.

■ Hummingbirds can hover in place because their wings twist to generate lift on both forward and backward strokes. A helicopter's rotor blades lift the helicopter because they are angled, with the leading edge of the blade higher so that as the blades spin they create higher air pressure below the blade. Hummingbird wings work the same way, except they can't spin in a complete circle around the bird; they have to reverse direction and flap very quickly back and forth. In each direction, the wing twists so that the leading edge is higher and the movement of the wing pushes air down.

Insects have near-perfect hovering efficiency and generate an equal amount of lift on both the forward and backward wing strokes. Hummingbirds get about 30 percent of their lift from the backward stroke. Larger birds, like the Belted Kingfisher, do not truly hover. They get almost no lift from the backward stroke and generally require some wind to help keep them in place.

Traveling forward (reddish), the wing twists so that the leading edge is higher; traveling backward (bluish), the wing twists the other way so that again the leading edge is higher.

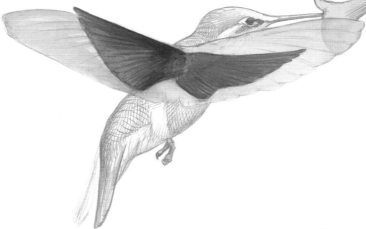

Roadrunner

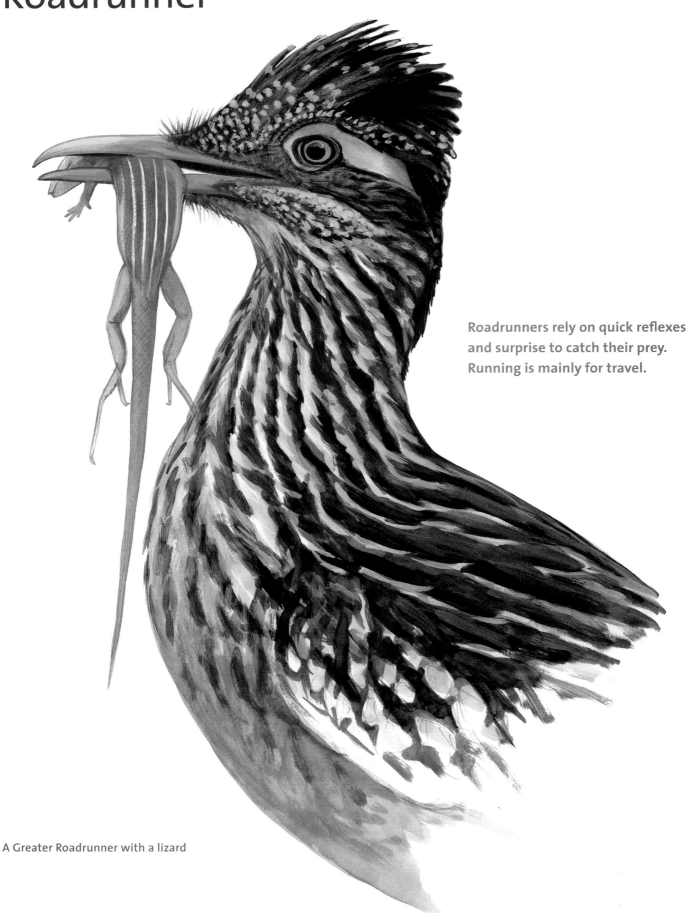

Roadrunners rely on quick reflexes and surprise to catch their prey. Running is mainly for travel.

A Greater Roadrunner with a lizard

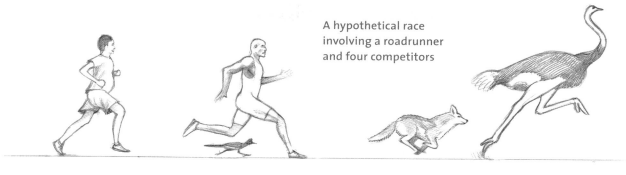

A hypothetical race involving a roadrunner and four competitors

■ In real life, a coyote is much faster than a roadrunner (even without any rockets or other accessories used by the cartoon coyote), but a roadrunner is faster than most humans. If the competitors shown here ran a 100-meter sprint, the ostrich would easily take first place, in under five seconds (with a top speed of about 60 miles per hour, and sustained 45). The coyote would be close behind, in under six seconds (over 40 miles per hour). The roadrunner and Usain Bolt would take about twice as long. A roadrunner's top speed is said to be about 20 miles per hour, which would get it across the finish line in just over eleven seconds. Usain Bolt's 100-meter record is under 9.6 seconds, or about 23 miles per hour. The average human runner finishes in fifteen seconds (under 15 miles per hour). So an elite human sprinter would beat the roadrunner to the line—but most of us would not.

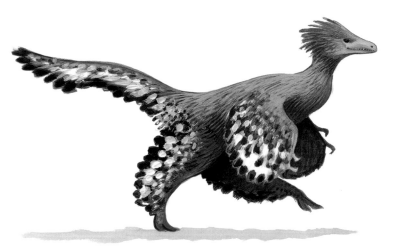

The feathered dinosaur known as Anchiornis

■ For more than a century, the link between birds and dinosaurs was debated, but recent discoveries of many dinosaur fossils with feathers and other birdlike features, and a better understanding of the evolution of feathers (see p. 33 right), has settled the debate. Modern birds are the descendants of dinosaurs. Anchiornis, shown here, was one of the "proto-birds" from about 160 million years ago; it was smaller than a roadrunner. It probably couldn't fly. Its feathers were loose and shaggy without interlocking barbules (the third stage in the evolution of feathers), and might have been useful for gliding, but were probably mainly for insulation and display. Many other feathered dinosaurs and true birds evolved in the next 100 million years after Anchiornis, but almost all went extinct after the meteor impact 66 million years ago.

■ At the time of the meteor impact that ended the Cretaceous period 66 million years ago, there was a great variety of birds on earth, including many species that lived in trees and were fully capable of flight. That event killed most of the large trees on earth as well as all of the non-avian dinosaurs, and ferns became the dominant plants for thousands of years afterward. Only about 25 percent of all species of plants and animals survived the catastrophic global changes, and among birds only a few small ground-dwelling species survived. These included one species that gave rise to the modern tinamou/ostrich group, another species that gave rise to the modern duck/chicken group, and a third species (perhaps pigeon-like or grebe-like or maybe even roadrunner-like) that gave rise to all other modern birds.

Greater Roadrunner running

Kingfishers

This species is most often seen on a
prominent perch overlooking the water.

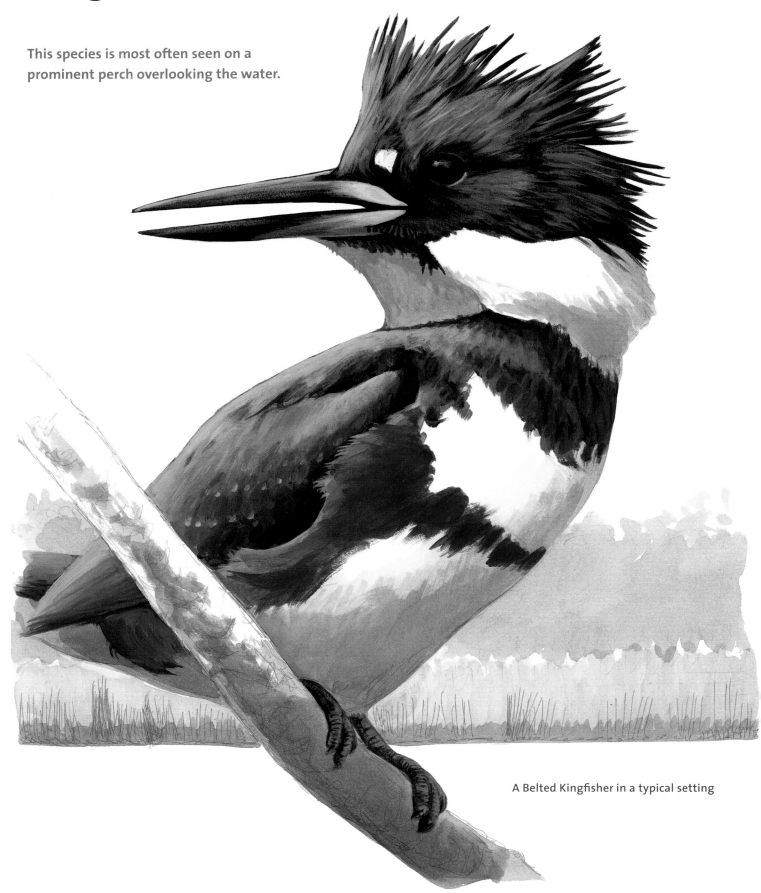

A Belted Kingfisher in a typical setting

■ Kingfishers catch fish by "hovering" (but see p. 79 bottom) and then diving headfirst into the water. If you watch carefully when a kingfisher is hovering, you'll see that the head remains stationary in the air, holding a fixed position over the water, while the wings flap, the tail adjusts, and the body shifts around, doing the work of flying. It's important to hold the head steady so that the eyes can remain fixed on a potential target below, but the senses and the control involved in this are truly remarkable. The bird has to have an exquisitely delicate sense of air movement to anticipate how changing wind currents will affect its position, and an equally delicate sense of body position so that it can adjust wings and tail to compensate for air movements. And while the body moves around in response to wind and the wings and tail flap and flare to hold position the neck has to absorb all of the body movement instantly so that the head stays still. Imagine standing on a rocking boat and keeping your head at a fixed point in space—that is just one part of what the kingfisher is doing while it hovers. (See head bobbing in pigeons, p. 75 top.)

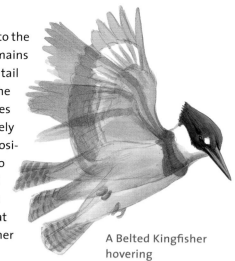

A Belted Kingfisher hovering

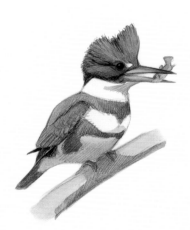

A Belted Kingfisher near its nest— the hole in the bank

■ Ecologists talk about the concept of limiting factors: that the overall population of a species can be limited by just one scarce resource. In the case of the Belted Kingfisher, that resource can be nesting sites. There are plenty of places with enough fish to feed a family of kingfishers, but for nesting they require the eroded face of a sandbank soft enough for the birds to burrow deep into it, and tall and steep enough to make it hard for predators to reach the burrow. As rivers and streams are dammed and channelized, the right kind of sandbank is getting scarcer, thus becoming a limiting factor in the population of Belted Kingfishers.

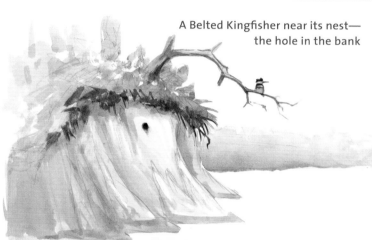

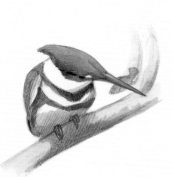

A kingfisher holds a very wiggly fish crosswise in the bill, whacks it hard against a branch to stop it from wiggling, then deftly tosses it in the air, catching it by the head and swallowing it head first.

Caught a fish . . . now what?

Birds have wings instead of hands, and use their feet for perching, so all food handling has to be done by the bill. Furthermore, they have no teeth (too heavy), so prey must be swallowed whole. Imagine if your hands were tied behind your back, and you had no teeth for chewing—how would you eat? Birds use their bill to manipulate their food, and then swallow it more or less whole, with the "chewing" stage happening in their muscular stomach.

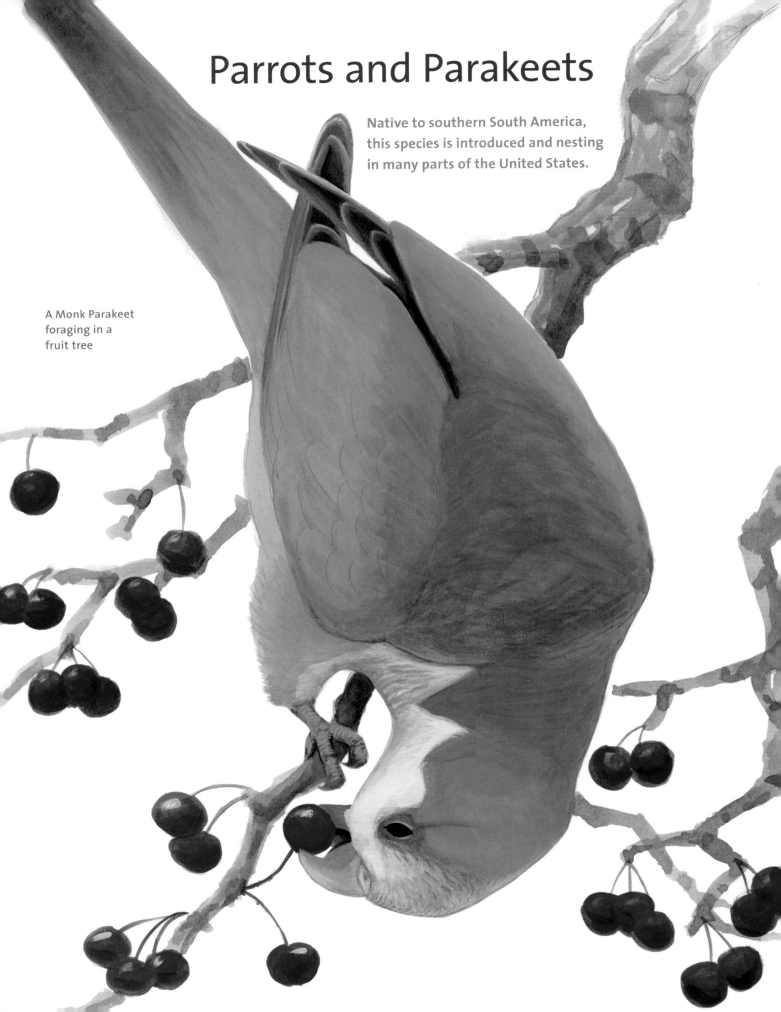

Parrots and Parakeets

Native to southern South America, this species is introduced and nesting in many parts of the United States.

A Monk Parakeet foraging in a fruit tree

■ The brilliant green color of many species of parrots is a combination of blue and yellow. The yellow is a pigment, and the blue color is a result of the microscopic structure of the feather which relies partly on the blackish pigment melanin. Combining the blue structural color with yellow pigment produces the vibrant green of these parrots. Parrot breeders have been able to produce blue and yellow variants. The blue variety simply lacks yellow pigment, and what remains are blue and gray colors produced by the feather structure and melanin. The yellow variety lacks melanin, so the bird appears white and yellow. In this case the structure of the feathers is still reflecting blue light from the surface, but without the underlying layer of melanin to absorb the other colors they are all reflected equally and the feathers appear white. Interestingly, the yellow, orange, and red colors in parrots are not based on carotenoids (see p. 163 middle) but are an entirely different class of pigments called *psittacofulvins*, found only in parrots.

Monk Parakeets: a typical bird (center) with one lacking melanin (right) and one lacking yellow pigment (left)

■ Without hands, most birds use their bill alone to manipulate food. Some species (for example, hawks, jays, and chickadees) use their feet to hold food while they pound or tear it with their bill. Only parrots use their feet actively to handle food. Interestingly, most species of parrots show a preference for one side, and most are left-footed. Parrots with a stronger preference for one side also show better problem-solving skills. Research in parrots and humans suggests that performing tasks with only one side of the body promotes multitasking and creativity because it occupies only one side of the brain, leaving the other side free to do other things. This human-like behavior is part of what makes parrots so unique and so endearing.

A Monk Parakeet holding food in its left foot

■ A bird's tongue is a very important food-handling appendage, and many species have evolved specialized tongues (see p. 91 bottom and p. 79 middle). Parrots are unique among birds in having a stubby, muscular tongue much like ours, and they use their tongue a lot to help move food around in their mouth. There is also evidence that the tongue plays a role in modifying sounds produced by their syrinx (in the same way our tongue modifies our voice), and this may be one reason that parrots are able to mimic human speech so well.

A Monk Parakeet manipulating food with its tongue

Woodpeckers

These two similar species are found across the continent. There is some evidence that the smaller Downy Woodpecker has evolved coloration to match the Hairy Woodpecker because it benefits from being mistaken for the larger, more dominant species.

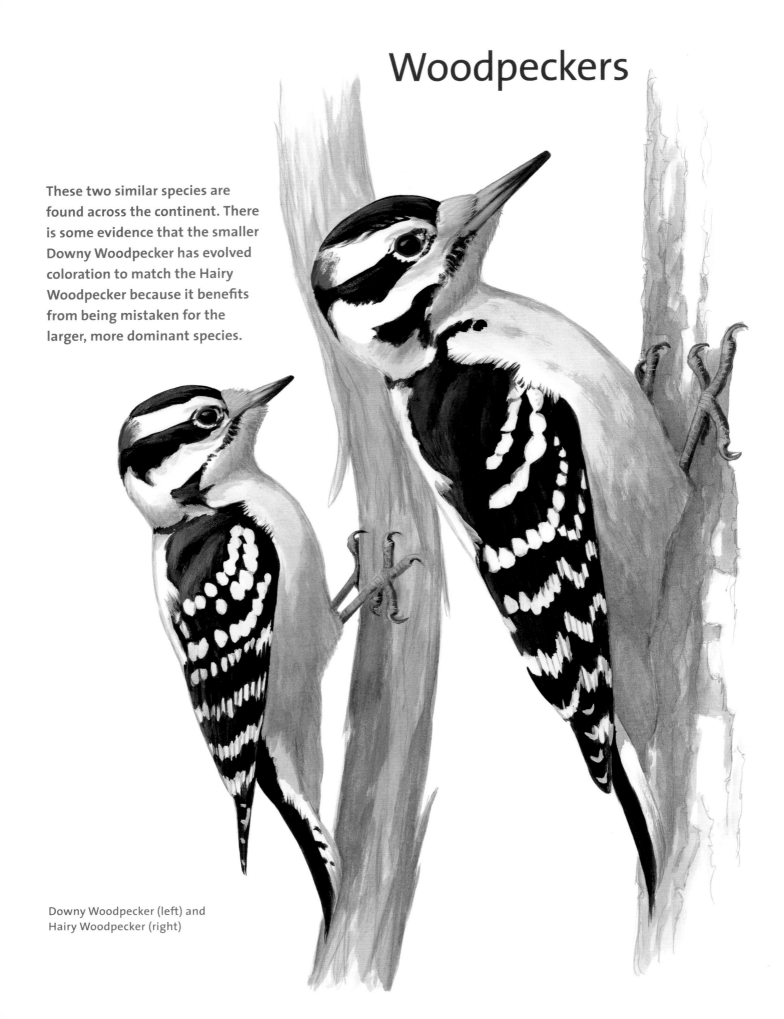

Downy Woodpecker (left) and Hairy Woodpecker (right)

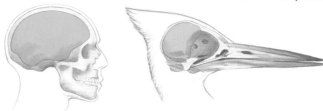

The skull and brain of a human and of a Pileated Woodpecker

■ Why don't woodpeckers get concussions? Mainly because their brains don't weigh very much and are oriented to absorb impact from the front, unlike our brains, which are more massive and oriented to absorb impact from below (like jumping). Woodpeckers have several other adaptations that reduce the impact. Their lower mandible is slightly longer, striking the wood first and transmitting the force through the lower jaw rather than into the skull. A layer of spongy bone at the base of the upper mandible helps cushion any impact there. They always hammer their bill straight into the wood, so the forces are always in the same direction.

A Hairy Woodpecker with a fecal sac

■ A nest is very close quarters for four or more young birds, and managing the waste products of those growing babies is critically important. One remarkable adaptation of nestling birds is a big help in this effort. At the end of the young bird's intestines just before defecation, a gelatinous mucous encases each white-and-black dropping in a fecal sac. The baby bird produces a neat "packet" that the adult can pick up and carry away. Newly hatched baby birds instinctively defecate immediately after being fed, and the adults instinctively wait for the fecal sac and fly away with it, scattering the evidence up to 100 feet from the nest. The primary purpose of this is probably to keep the nest clean, but scattering the droppings also helps to avoid an accumulation that could give away the location of the nest.

Woodpeckers engage in three very distinct activities that all involve banging on wood with their bill.

- Drumming is the woodpecker's equivalent of song, performed mainly in the spring. A woodpecker sits in one spot and periodically hammers its bill against the wood in one short and very rapid burst as a way of advertising to a mate or rival. This produces lots of sound but does no damage to the wood.

- A foraging woodpecker will move around, tapping and chipping, making lots of small exploratory holes as it seeks out insects in the wood. Foraging occupies a large part of each day, year-round, and produces a variety of holes, depending on the prey being sought.

- For its nest a woodpecker excavates a neat round hole leading into a large cavity inside the trunk of the tree. This takes many days, and after a few days the nest is large enough for the bird to climb inside.

Downy Woodpecker drumming (top), foraging (center), and nest excavating (bottom)

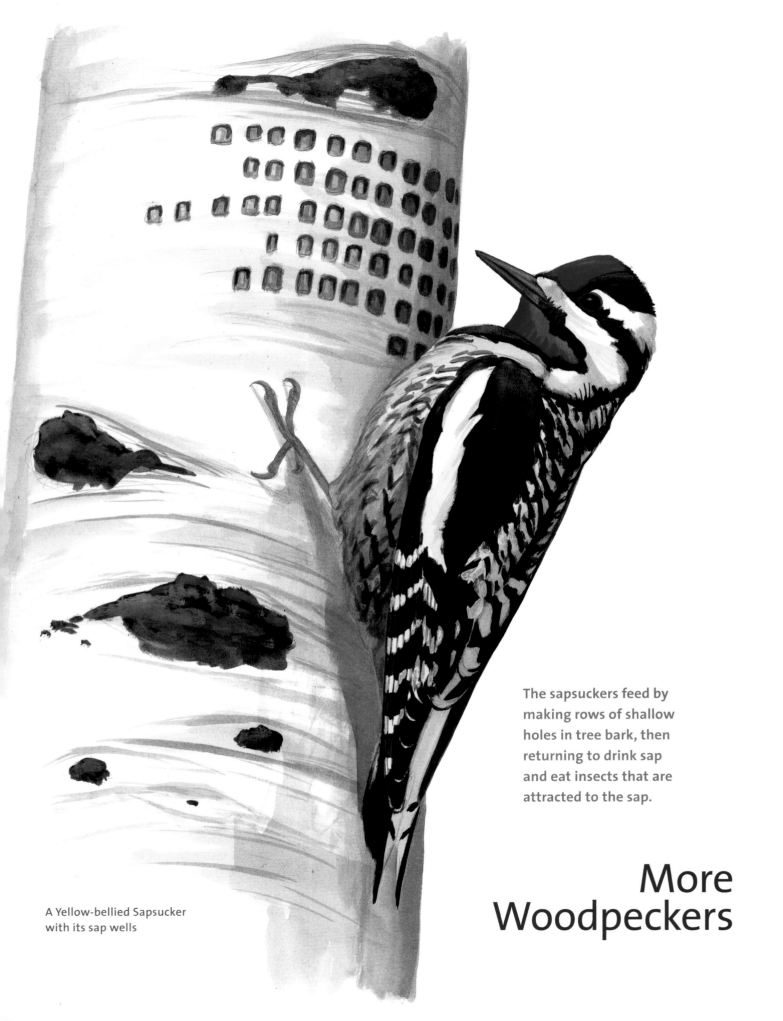

The sapsuckers feed by making rows of shallow holes in tree bark, then returning to drink sap and eat insects that are attracted to the sap.

A Yellow-bellied Sapsucker with its sap wells

More Woodpeckers

■ The Acorn Woodpecker, found in the southwestern U.S., has the unique habit of drilling small holes in trees and storing an acorn in each hole. This species (particularly in California) lives in cooperative groups that include several breeding adults with several nonbreeding helpers, and all contribute to making holes and gathering acorns. Acorns are gathered and stored in the fall to be consumed during the winter when few other food sources are available. This allows the birds to remain on their territory through the winter, and to be healthy enough to breed in the spring. The success of a breeding group is related to how many acorns they can store. Holes are drilled in dead limbs or in thick bark, so as not to injure the tree, and they are reused each year. A relatively small number of new holes are added each year, and a group of woodpeckers builds up a large storage capacity over time. A typical storage tree with four thousand holes could take over eight years to create, longer than most Acorn Woodpeckers live. The record—an estimated fifty thousand holes in one tree—probably took more than one hundred years to make.

A male Acorn Woodpecker at its storage tree

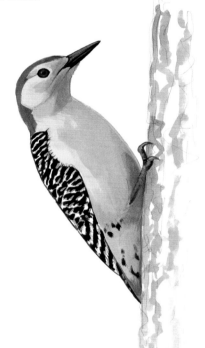

■ A general trend for more than a century has been birds' ranges shifting north. The Red-bellied Woodpecker—along with Tufted Titmouse, Northern Cardinal, Northern Mockingbird, Carolina Wren, and others—has colonized New England from the South within the last hundred years. In the Pacific Northwest, Anna's Hummingbird and California Scrub-Jay have become common in the last few decades. Some of this is attributable to climate change: milder winters allow birds to survive farther north. Another factor has been the changes in habitat associated with suburbanization: closely spaced houses and hedges creating warm microclimates; dense cover in the form of planted exotic shrubs and trees; and lots of bird feeders offering supplemental food.

Red-bellied Woodpecker

■ So small and camouflaged, the Brown Creeper is barely noticed even though it is found in wooded areas throughout most of North America and spends its time in plain sight climbing on the bark of large trees. Experienced birders can locate it by its high sibilant calls, or notice it as it flies from high on one tree to the base of another to begin climbing the bark, but most often we simply pass by the Brown Creeper without even knowing it is there. Creepers have a woodpecker-like style of climbing, using their stiff tail as a brace, but they are not related. This is an example of two groups of birds converging on the same solution to a problem, in this case the challenge of climbing trees. Even more than woodpeckers, creepers hug the bark, staying very close to the tree and leaning in to peer under bark scales and into furrows, then using their long curved and pointed bill to extract tiny spiders, insects, and eggs.

Brown Creeper, life size

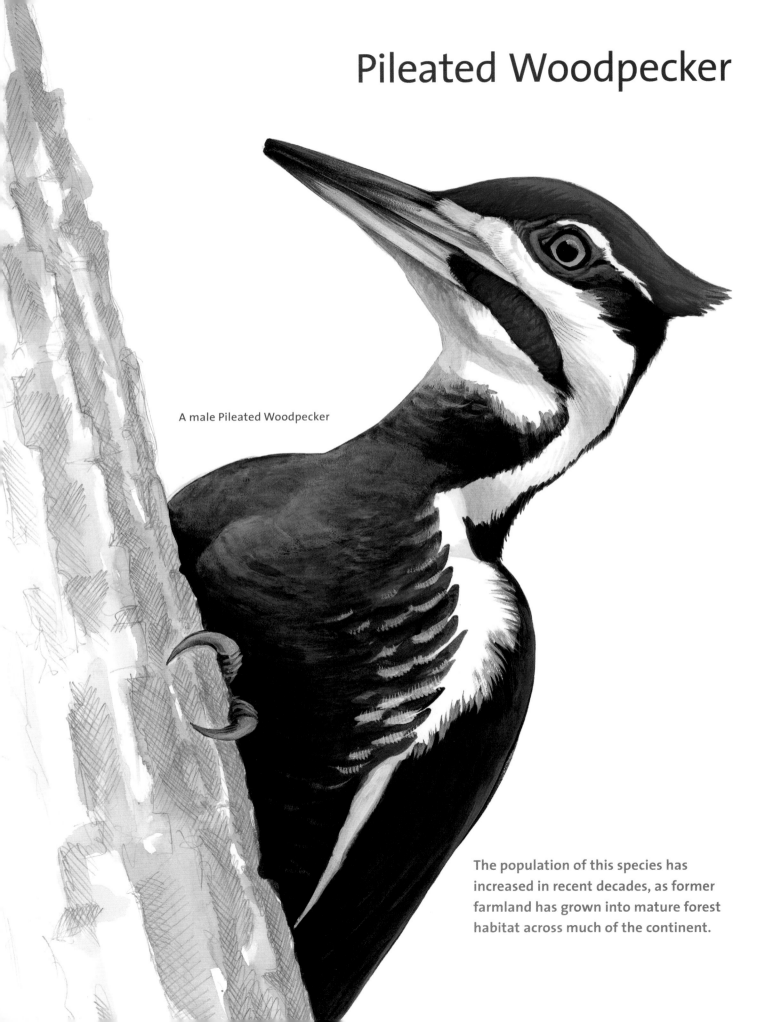

Pileated Woodpecker

A male Pileated Woodpecker

The population of this species has increased in recent decades, as former farmland has grown into mature forest habitat across much of the continent.

Adaptations for climbing and probing

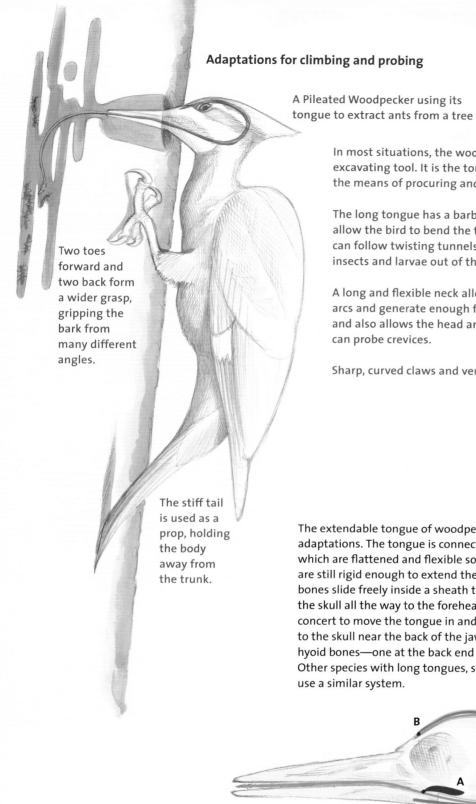

A Pileated Woodpecker using its tongue to extract ants from a tree

Two toes forward and two back form a wider grasp, gripping the bark from many different angles.

The stiff tail is used as a prop, holding the body away from the trunk.

In most situations, the woodpecker's bill is an excavating tool. It is the tongue that functions as the means of procuring and manipulating food.

The long tongue has a barbed and sticky tip, and tiny muscles that allow the bird to bend the tip of the tongue in any direction, so it can follow twisting tunnels, trap prey against the walls, and pry insects and larvae out of their hiding places deep inside a tree.

A long and flexible neck allows the head and bill to swing in wide arcs and generate enough force for excavating holes in the wood, and also allows the head and bill to maneuver so that the tongue can probe crevices.

Sharp, curved claws and very strong legs and feet cling to bark.

The extendable tongue of woodpeckers depends on some remarkable adaptations. The tongue is connected to the hyoid bones (shown in blue), which are flattened and flexible so they can curl around the skull, but they are still rigid enough to extend the tongue (imagine a plastic strap). These bones slide freely inside a sheath that wraps around the back and top of the skull all the way to the forehead. Two muscles (shown in red) work in concert to move the tongue in and out. Both muscles have one end attached to the skull near the back of the jaw, and the other end attached to the hyoid bones—one at the back end of the bones, the other in the middle. Other species with long tongues, such as hummingbirds (see p. 79 middle) use a similar system.

With muscle A contracted and B relaxed, the tongue is pulled into the bill.

When muscle B contracts and A relaxes, the hyoid bones are pulled forward and the tongue extends out of the bill.

91

Flickers

Because of the odd habits and bold markings of flickers, many people do not recognize them as a kind of woodpecker.

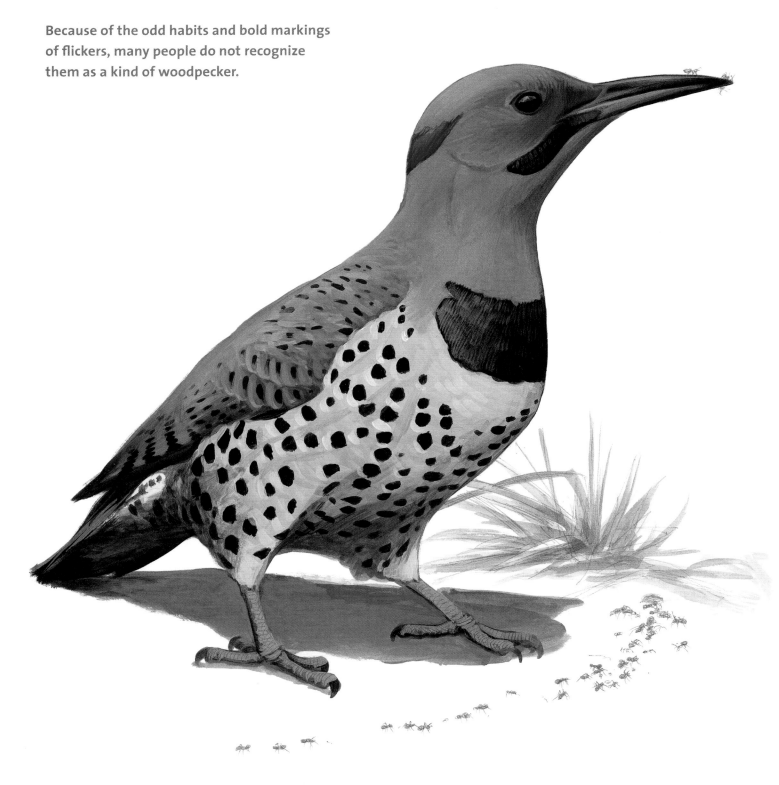

A Northern Flicker on the ground eating ants

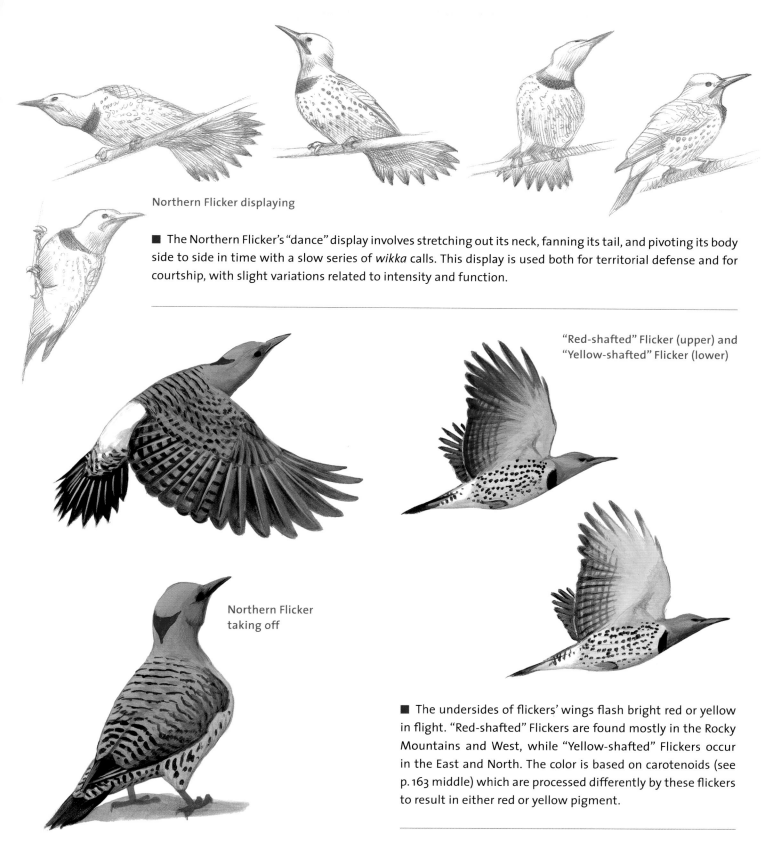

Northern Flicker displaying

■ The Northern Flicker's "dance" display involves stretching out its neck, fanning its tail, and pivoting its body side to side in time with a slow series of *wikka* calls. This display is used both for territorial defense and for courtship, with slight variations related to intensity and function.

"Red-shafted" Flicker (upper) and "Yellow-shafted" Flicker (lower)

Northern Flicker taking off

■ The undersides of flickers' wings flash bright red or yellow in flight. "Red-shafted" Flickers are found mostly in the Rocky Mountains and West, while "Yellow-shafted" Flickers occur in the East and North. The color is based on carotenoids (see p. 163 middle) which are processed differently by these flickers to result in either red or yellow pigment.

■ The bright white rump patch of flickers is hidden when they are perched but obvious when they take off, and along with their red or yellow wings probably serves to startle potential predators. This eruption of bright colors as the flicker bursts into flight might cause a momentary hesitation and increase the bird's chance of escape. In any case, the flickering white and yellow or red of the flying bird is what gives the species its name.

Phoebes

The three species of phoebes have
adapted to living around humans, often
nesting under the eaves of porches.

A Black Phoebe perched
on a lawn chair

■ Many unrelated species of birds have a habit of pumping (or wagging) their tails, and many possible explanations have been offered. A recent study found that the rate of tail pumping increased when (and only when) a predator was nearby. The explanation is that tail pumping is a simple signal, and the message it sends to the predator is "I know you're there. I'm healthy and quick, and you won't catch me, so don't even try." When we get nervous, we fidget. When phoebes get nervous, they wag their tails, and when a predator sees fidgeting or tail wagging it gets the message that this is a healthy and alert animal and may not be worth chasing. The behavior—fidgeting or twitching under stress—is universal, something we "just do" because it is hard-wired and instinctive. What varies by species is exactly what we do to send the signal. Phoebes and a few other species of birds wag their tails, other birds flick their tails up, others flick their wings, others bob their heads, others call, and so on. These are all just different ways of sending the same message.

Black Phoebe tail pumping

Eastern Phoebe on a nest on a porch

■ Phoebes like to build their nest on a protected ledge, and under the edge of an open porch they can find the perfect setting. Most songbirds will not reuse a nest. Even in the same season they will build a new nest for the second brood. Phoebes are an exception, and they often reuse a nest more than once in a season, or will reuse a nest from a previous year (with a little renovation). They sometimes even modify an old Barn Swallow nest for use. It is thought that most birds build a new nest for each brood to avoid parasites like feather mites that might come along with a used nest. Cavity-nesting birds like bluebirds and Tree Swallows often reuse nests because they have few cavities to choose from. Given a choice, they generally prefer to build a new nest in a clean cavity. Phoebes might face similar limits on potential nesting sites, and reusing an old nest might be their best option.

■ Like most birds, phoebes generally swallow their prey whole, and the work of "chewing" is done in the muscular gizzard. Many insects have hard shell-like parts that cannot be digested. Small fragments will pass through the intestines, but larger parts that can't be broken up accumulate in the gizzard and are regurgitated as a compact pellet. Hawks and owls regurgitate pellets containing the bones and fur of their prey (about sixteen hours after a meal), and gulls and cormorants produce pellets of fish bones. Unlike some other birds, these species do not ingest grit to help pulverize their food (see p. 5 bottom), partly because it would be regurgitated whenever a pellet was ejected, but also because bits of shell and bone in their diet act as grit substitutes, grinding up the softer materials in the gizzard.

Black Phoebe regurgitating a pellet

More Flycatchers

A Western Kingbird harassing a Red-tailed Hawk

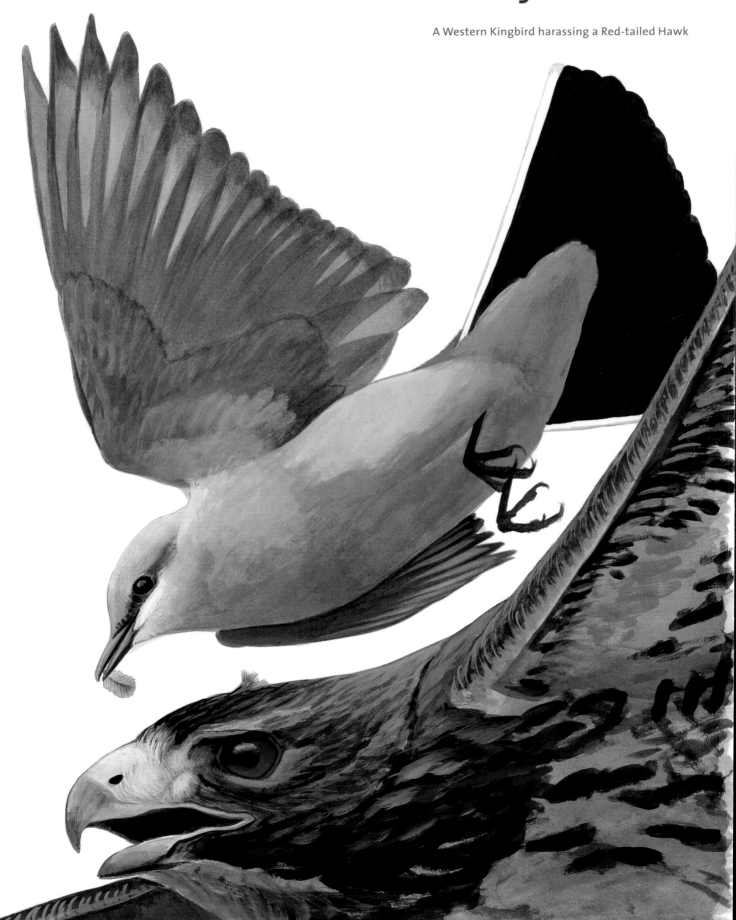

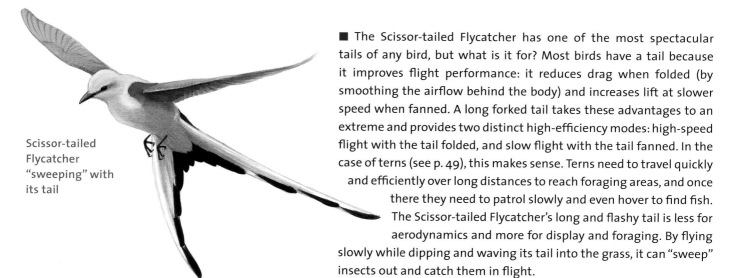

Scissor-tailed Flycatcher "sweeping" with its tail

■ The Scissor-tailed Flycatcher has one of the most spectacular tails of any bird, but what is it for? Most birds have a tail because it improves flight performance: it reduces drag when folded (by smoothing the airflow behind the body) and increases lift at slower speed when fanned. A long forked tail takes these advantages to an extreme and provides two distinct high-efficiency modes: high-speed flight with the tail folded, and slow flight with the tail fanned. In the case of terns (see p. 49), this makes sense. Terns need to travel quickly and efficiently over long distances to reach foraging areas, and once there they need to patrol slowly and even hover to find fish. The Scissor-tailed Flycatcher's long and flashy tail is less for aerodynamics and more for display and foraging. By flying slowly while dipping and waving its tail into the grass, it can "sweep" insects out and catch them in flight.

■ All birds have extraordinary vision, but the needs of flycatchers are particularly extreme. Imagine flying twenty miles per hour, swerving and dodging to follow the movements of a mosquito in flight, then grabbing that mosquito out of the air with a pair of tweezers. This requires several visual adaptations beyond human eyesight.

- Increased visual acuity detects tiny specks at a distance.
- The ability to see ultraviolet light undoubtedly helps to distinguish insects against a background of mottled foliage and shadow.
- Colored oil droplets inside cone cells in the eye act as filters to enhance color definition—for example, making it easier to pick out other colors against blue and green backgrounds.
- An ability to track very rapid movements of insects and surroundings during high-speed flight. Other birds process images more than twice as fast as we do, making high-speed motion less of a blur, and flycatchers have the fastest processing of any birds tested. A newly discovered type of cone cell unique to flycatchers may be the key to this ability.

A Black Phoebe catching an insect

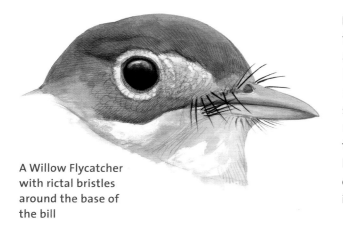

A Willow Flycatcher with rictal bristles around the base of the bill

■ Rictal bristles are a set of modified whisker-like feathers around the base of the bill. These are well developed in most flycatchers and prominent in several other families of birds. Because these birds rely on capturing small, fast-moving insects in midair, a common assumption is that the bristles function as a sort of net to help scoop up flying insects or sense the location of insects near the mouth. But flycatchers always capture flying insects between the tips of the mandibles, and the bristles are not involved. Experiments have shown that the bristles act as eye protection, a safety net that deflects insects (and their legs and wings) away from the eyes during high-speed capture.

Swifts

Some species of swifts stay in the air continuously for ten months each year.

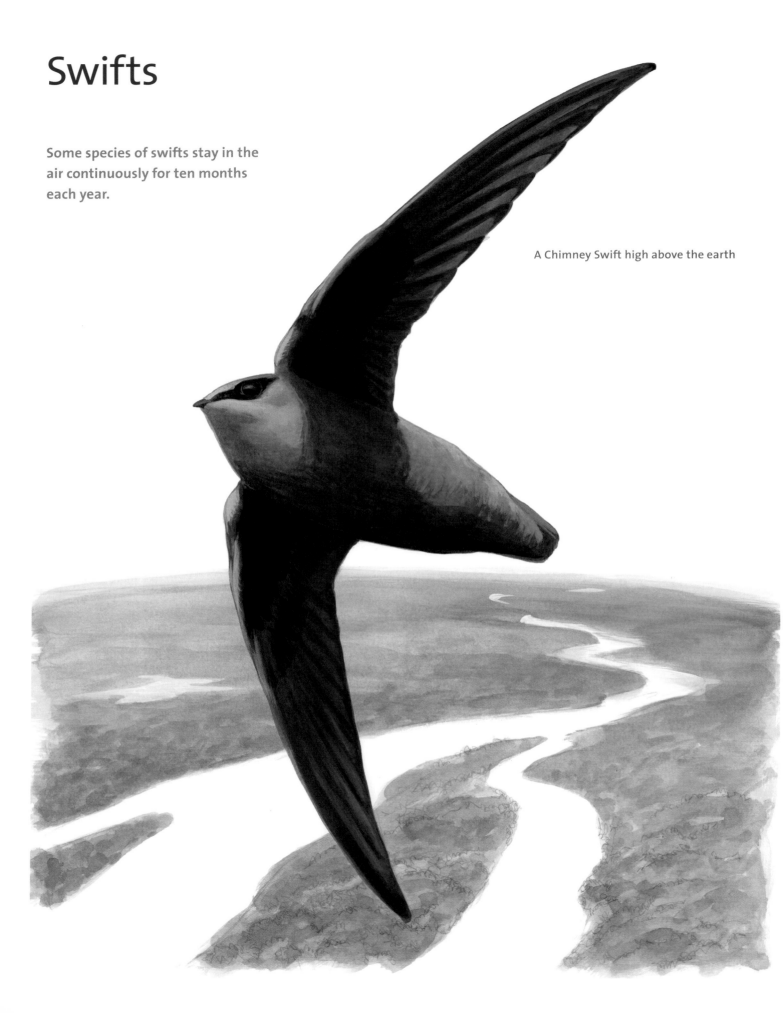

A Chimney Swift high above the earth

■ Flight is critical to most birds' survival. This is especially true for swifts, whose large wing feathers have to be in good condition. This means replacing those feathers once a year, but how can they keep flying while growing new wing feathers? Most birds replace their feathers gradually. By growing only one or two feathers at a time, the neighboring feathers overlap enough to cover most of the gap and maintain a functional wing. The next feather won't drop until the growing feather is long enough to fill in, so there is never more than a small gap, and flight is not significantly hindered. It can take more than three months for a Chimney Swift to complete the molt of all of its flight feathers. (See p. 5 middle.)

A Chimney Swift, showing the progression of new feathers (shown slightly darker) replacing old feathers, beginning with the inner feathers and moving gradually to the tip of the wing

■ The wing structure of swifts is distinctly different from that of most other birds, with much shorter "arm" bones, so that almost all of their wing surface is created by long feathers growing from the "hand" bones. In this respect, they are similar to hummingbirds, but of course the flight style is very different. The Ring-billed Gull shown here in comparison is a relatively long-armed species. This allows them to dramatically change the shape of their wings to adjust to changing conditions, simply by adjusting the angles of the wing bones. Swifts have a very limited range of possible wing shapes, and generally fly straight and very fast, which is one reason why they usually stay high in the open air.

A Chimney Swift and a Ring-billed Gull (not to scale), with arm bones shown in blue and hand bones in red

■ The closest most of us will ever get to seeing a swift perched is watching one drop into a chimney to roost. Swifts are supremely adapted to life in the sky. Their stiff, narrow wings are very efficient for high-speed travel in a straight line, but make low-speed maneuvering more difficult. Swifts have high wing-loading–high body weight relative to the surface area of their wings. To generate enough lift for flight, they must travel at high speed to increase the airflow across their relatively small wings. Gulls have lower wing-loading and their relatively large wings generate plenty of lift at lower speeds, so they appear to float effortlessly in the air. When it's time for swifts to go to roost inside a chimney they approach at high speed, stall directly over the opening, and awkwardly flutter straight down into the chimney.

Chimney Swifts dropping into a chimney

Swallows

This species nests in barns, and it is very rare to find a nest that is not on a human structure.

A Barn Swallow hunting insects over a hay field

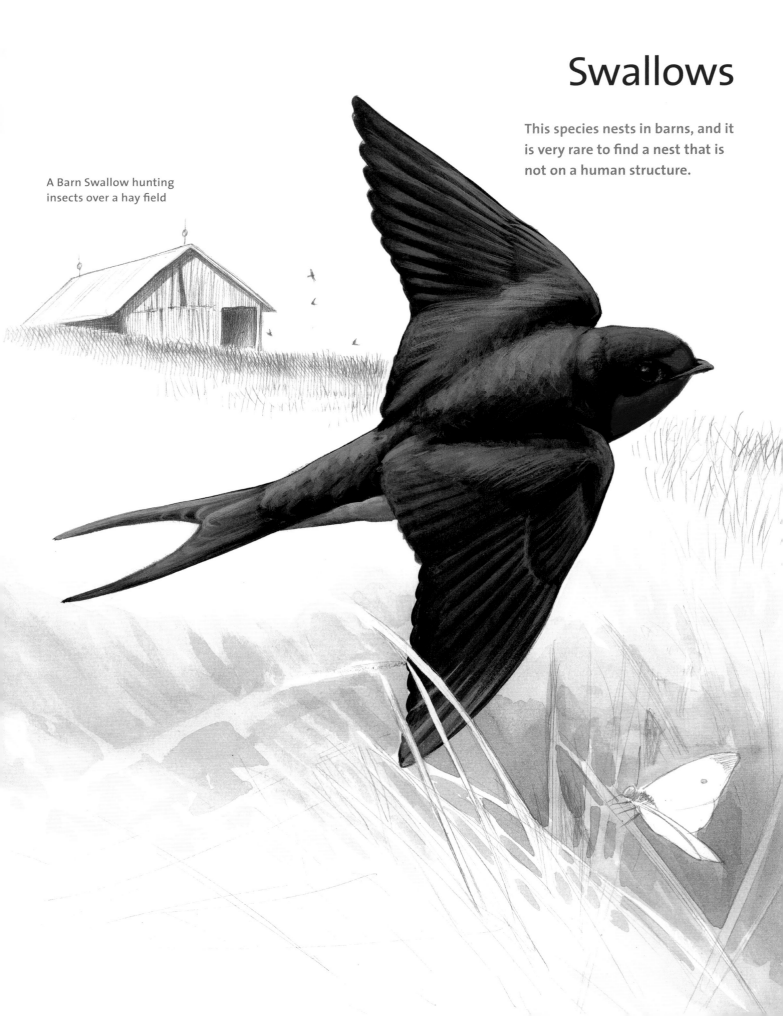

■ Birds have evolved many different strategies and styles for building nests, but these tend to be consistent within a group of related species. Swallows are unusual in having a wide variety of nest styles among closely related species. Tree Swallows use cavities like old woodpecker holes or birdhouses and build a grass nest inside. Barn and Cliff Swallows gather mud to create a structure, then build a grass nest inside that. Some other swallows (including the Bank Swallow) dig a tunnel into a sandbank and then build a grass nest at the back of the tunnel. Several species of swallows are almost entirely dependent on human structures for their nest sites, including the aptly named Barn Swallow.

The half-bowl nest of a Barn Swallow (left) and the enclosed gourd-shaped nest of a Cliff Swallow (right). Both are built on a vertical wall, just below an overhang, using small mouthfuls of wet mud carefully stuck together and allowed to dry.

Barn Swallows in flight

■ Swallows fly for hours at a time, coursing low over fields, marshes, and ponds, sometimes high in the air, catching small flying insects. This makes them part of a group of birds known as *aerial insectivores,* which also includes swifts, flycatchers, and others. Surveys in North America show that all of these species have been declining over the last fifty years. While many factors could be contributing to this, one of the biggest is probably a decline of insects. Recent studies in Europe show a significant decline in insect populations there in the last thirty years. No similar survey exists in North America, but most data point to declines. Anyone born before 1970 will certainly remember the problem of insects flying into, and then covering, car windshields, which is rarely a problem now. One possible cause of the decline of insects is the widespread use of insecticides in agriculture, on lawns, and more. Research, monitoring, and action are all urgently needed.

■ In order to fly, birds have to be lightweight, and the lighter they are the less energy is needed for flight. Much of the evolution of birds has been shaped by this requirement, and their skeletons are dramatically modified. But a bird's skeleton is not particularly lightweight, and accounts for the same percentage of total body weight as in a mammal of the same size. In many ways, birds' skeletons have evolved to be lighter—with fewer bones, hollow bones, and so on. Other changes make the skeleton stiffer and stronger to meet the demands of flight. The tissue that makes up the bones themselves is denser in birds than in mammals. This adds needed stiffness and strength, but also weight. What we should really say is that birds have skeletons that are stronger and stiffer than those of mammals of the same size—without any added weight.

A Barn Swallow with its skeleton

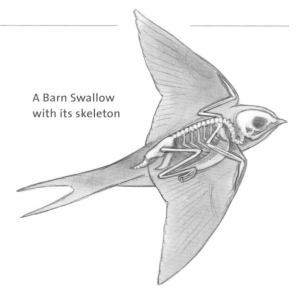

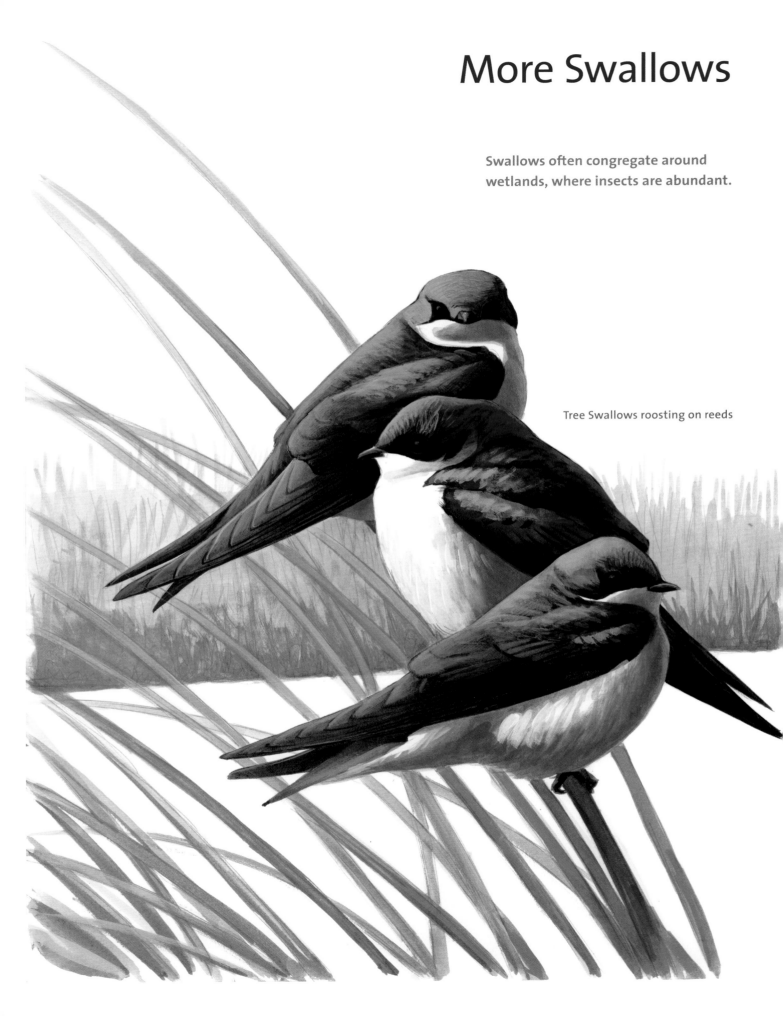

More Swallows

Swallows often congregate around wetlands, where insects are abundant.

Tree Swallows roosting on reeds

■ Will the same individual birds return to the same territory every year? Almost certainly . . . if they survive the winter (see p. 169 bottom). Most species are very faithful to their nesting site, especially if they were successful at raising young, and will return every year to the same territory. Furthermore, one-year-old birds returning to breed for the first time typically come back to the area where they were raised. One study in Pennsylvania found that Tree Swallows returned to within a few miles of the nesting box where they were raised, and made their own nesting attempts in that area. This connection to familiar places is not just for nesting sites. Many migratory species follow the same migration route and use the same winter territory each year.

A pair of Tree Swallows on a nesting box

A just-hatched Tree Swallow

■ All baby songbirds (such as this Tree Swallow) hatch naked, with eyes closed, and require constant feeding, warming, and protection by the parents to survive. These are known as altricial young. One advantage of having altricial young rather than precocial young (see p. 3 top) is that the nesting female can lay smaller eggs that require fewer resources, since the eggs hatch at an earlier stage of development. But that simply delays the work until later, and adult swallows have to invest a lot of time and energy to care for the young after they hatch. Another advantage of the altricial system is that it allows more brain growth after hatching. Precocial young like ducks and geese hatch with nearly fully developed brains and feed themselves. Altricial young are helpless at hatching, but the parents deliver a steady supply of high-protein food (see p. 113 middle), so the brains of the young birds grow substantially after hatching and adults have proportionally larger brains than in precocial species.

■ The details of an individual wing feather are amazing! Researchers exploring the precise shape and structure of feathers continue to discover new details, some of which can be applied to human engineering challenges. The shaft is a foam-filled tube— a structure that provides high strength and stiffness with very low weight. The tube is formed by layers of fibers oriented in different directions, just like modern high-tech carbon fiber tubes. The changing shape of the feather shaft, from round at the base to rectangular and then square, gives it different properties of stiffness and flexibility at each point. The shape of individual barbs is oval, with more material at the top and bottom. This makes each barb very resistant to flexing up or down but more flexible from side to side. When locked together with other barbs, they form a strong flat surface for flight. But if a feather hits something, the individual barbs simply twist, disengage from their neighbors, and bend to absorb the impact.

Cross-sections of different points on a typical wing feather

Cross-section of a feather barb

103

Crows

Crows are among the most intelligent
birds, and even understand the
concept of fair trading.

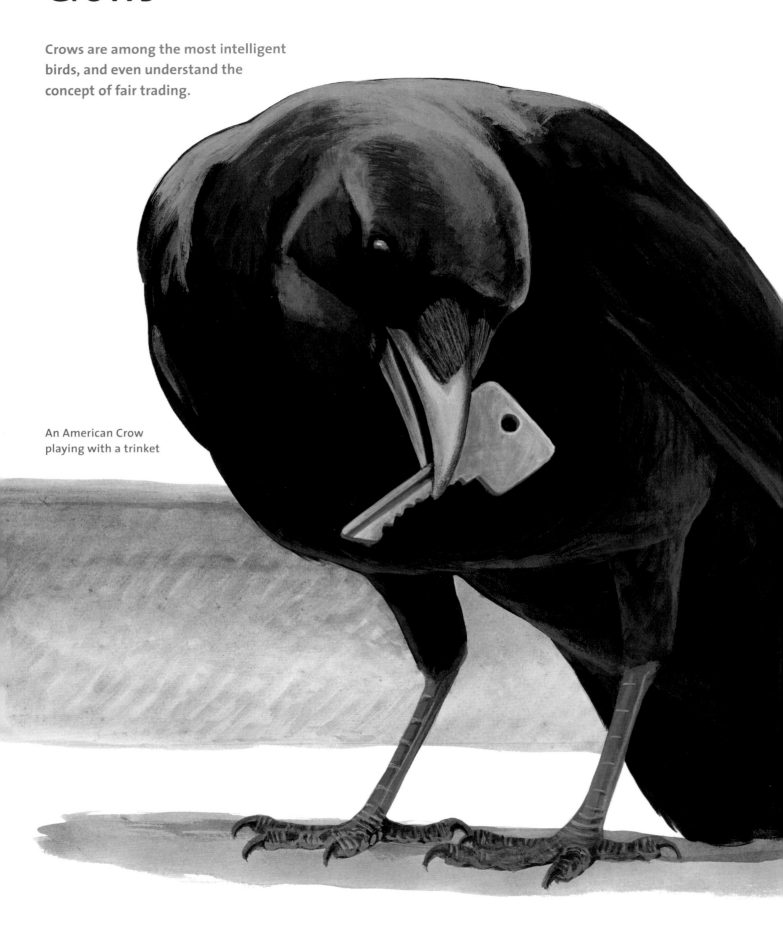

An American Crow
playing with a trinket

■ Crows usually travel in small groups year-round, and their inquisitive and sometimes destructive behavior (like opening trash bags in search of food) can make them seem like malicious vandals—but these are generally family groups in search of food, not trying to cause trouble. A typical group includes a breeding pair with their most recent offspring, as well as some older siblings. One-year-olds usually stay to help raise the next generation, and some stay as long as five years!

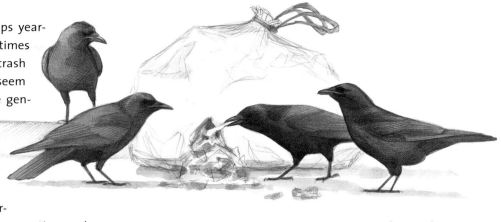

A group of crows foraging

■ Baby crows—with partially grown feathers, pale bill, and blue eyes—tend to leave the nest early, often before they can really fly. Humans who find these baby crows on the ground sometimes feel compelled to "rescue" them, taking them in and feeding them for a few weeks until they are fully independent, but it's best to leave them alone. Most likely the parents are nearby and will take care of their baby, and social contact with other crows is critically important at this stage. Crows are clever and inquisitive, and can be engaging and interesting pets, but they are wild animals and are severely handicapped by having humans as foster parents. One researcher tracked seven different crows raised by humans, and none of them survived in the wild more than a few months after fledging. In contrast, more than half of young crows raised in the wild survive through their first winter.

A juvenile American Crow

■ Crows are able to recognize us by our faces, and they associate each person with good or bad experiences. Furthermore, they can communicate that information to other crows. One researcher who had trapped crows was still recognized by crows that had never been trapped, nearly a mile away from the trapping site and five years later! We can't recognize individual crows, but as a start we can sometimes distinguish first-year birds from older. Adult crows have uniform glossy black feathers. Young crows have less glossy, matte black feathers, which become gradually more faded and brownish through the winter. Yearlings helping adults at the nest in the spring often look distinctly brownish next to the older birds.

A one-year-old (left) and adult (right) American Crow

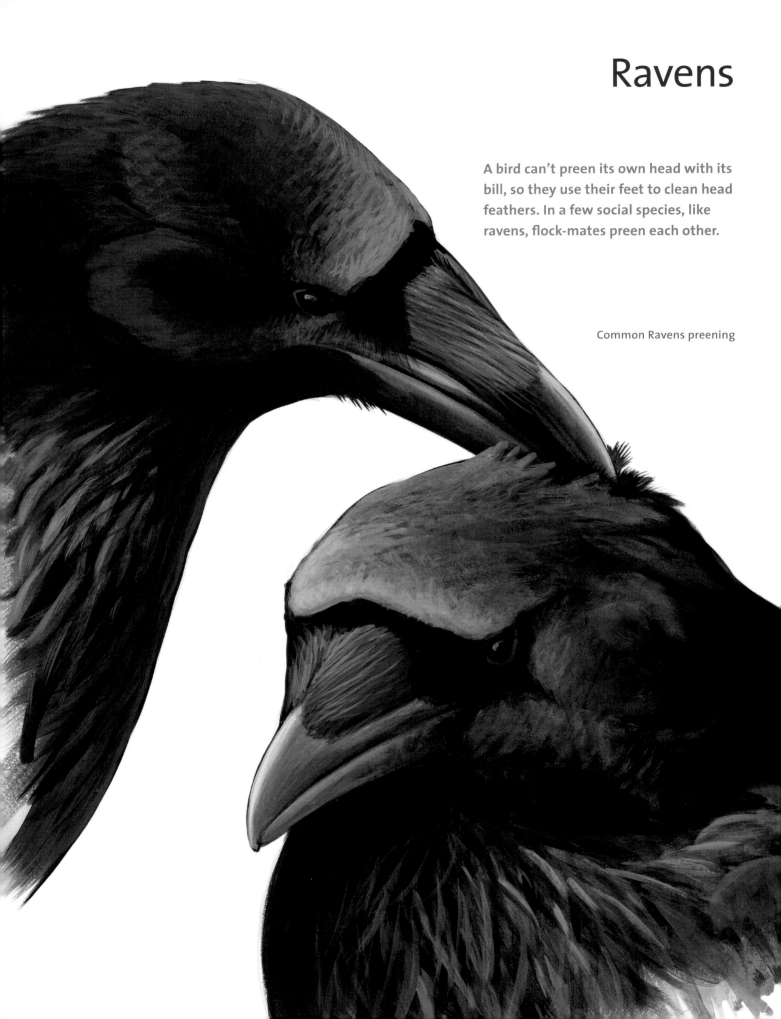

Ravens

A bird can't preen its own head with its bill, so they use their feet to clean head feathers. In a few social species, like ravens, flock-mates preen each other.

Common Ravens preening

■ One of Aesop's fables, "The Crow and the Pitcher," tells the story of a thirsty crow that finds a pitcher with some water, but the water is out of reach in the bottom. By dropping pebbles into the pitcher, the crow is able to raise the water level and get a drink. This has inspired modern experiments testing various species in the crow family. Presented with a tasty treat floating deep inside a tube, the birds were able to solve the problem. They understood the value of large rocks over small, understood the right number of stones, understood that a tube of sawdust would not react to stones, and so on. The most accomplished species—the New Caledonian Crow of the South Pacific—showed a level of understanding of this problem similar to that of a five- to seven-year-old human.

A raven solving the puzzle

Common Raven

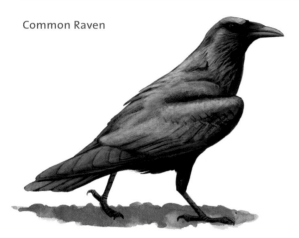

■ It seems counterintuitive that so many birds in hot climates are black, but studies have found that the advantages outweigh the disadvantages. Dark feathers do get hotter than white feathers, but because feathers provide such good insulation very little of that heat reaches the skin. In a light breeze, birds with black feathers actually stay cooler than white birds, because the dark feathers absorb light and heat at the surface, where it can easily radiate back to the air. White feathers allow light to penetrate into the feathers, closer to the skin, where heat is not so easily transferred back to the air. In addition, black feathers are more resistant to wear and help block UV radiation. Being black might also allow birds to be inconspicuous when resting in the shade, but conspicuous to their flock-mates when they are active.

■ Every bird is covered with feathers, and almost every feather on an individual bird is different, specialized in length, shape, and structure to match whatever function is needed at that position. Feathers around the head are all quite specialized, with tiny feathers around the eyes, feathers modified into bristles at the base of the bill, and longer feathers on the throat. Among the most specialized are the feathers that cover the ear opening. These must allow sound to pass through but also protect against debris and create a streamlined surface over the ear for air to flow across as smoothly and quietly as possible. The noise of air turbulence can reach 100 decibels in our ears at speeds as low as 25 miles per hour, the normal flight speed for most birds. That much noise makes it very difficult to hear anything else, and causes hearing damage in humans with long-term exposure. A smooth ear covering helps birds avoid both of those problems.

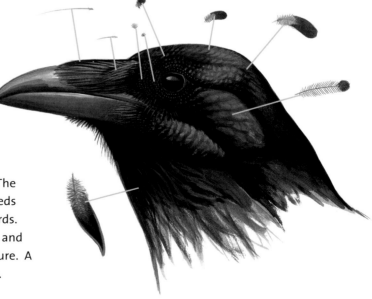

Some of the specialized feathers around the face; the ear covert feather is at the lower right.

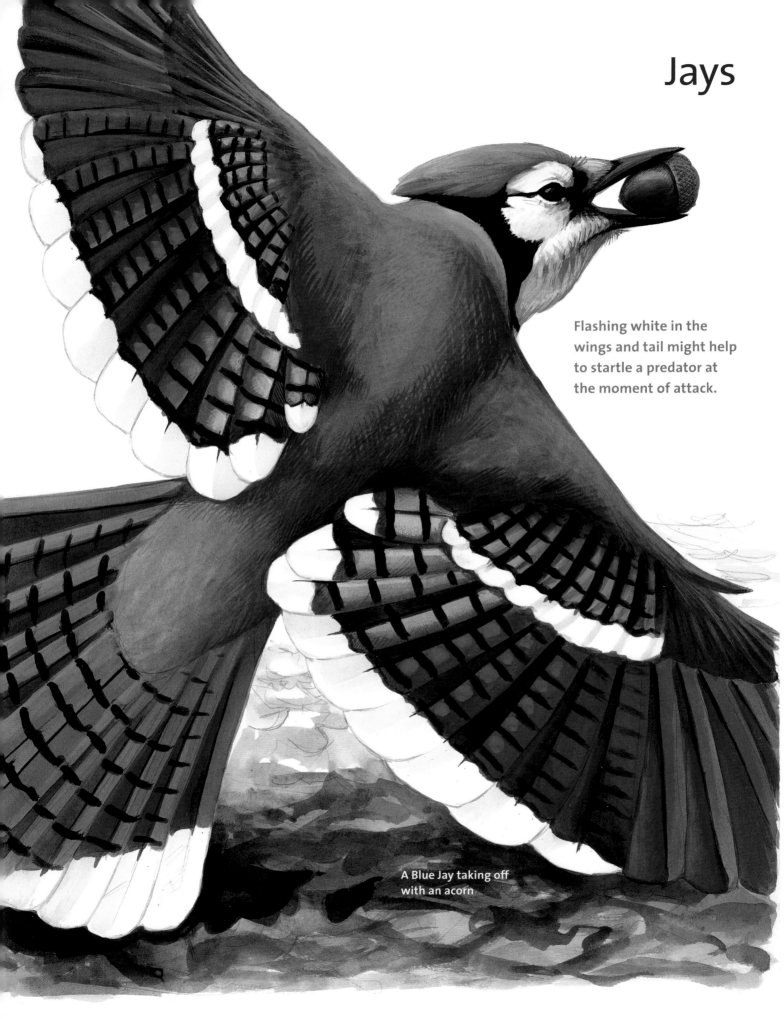

Jays

Flashing white in the wings and tail might help to startle a predator at the moment of attack.

A Blue Jay taking off with an acorn

■ Birds can be loud. For example, if a rooster crowed in your ear, the sound would be as loud as if you were standing two hundred feet from a jet engine. (Neither is recommended!) A lot of birds, like jays, make loud sounds, and a bird's ear is less than an inch away from its mouth. So how do birds avoid damaging their own hearing when they call? Several things can happen more or less automatically when a bird calls. As the jaw opens, the external ear canal closes to shut out sound; increased air pressure in the inner ear helps dampen vibration; and the movement of a jawbone connected to the ear relaxes tension on the eardrum. Birds also have the ability to restore damaged hearing by growing new hair cells inside their ear, something humans cannot do.

Steller's Jay calling

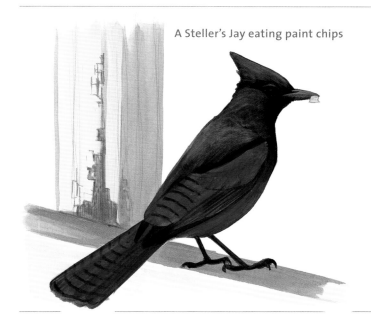

A Steller's Jay eating paint chips

■ Jays are sometimes seen knocking bits of light-colored paint off of houses and eating the paint chips. They are seeking calcium, which is an ingredient in most paint, and is especially important for female birds forming eggshells. Females of many species are known to select grit with higher calcium content in the spring when they are producing eggshells. This paint-chipping behavior is most prevalent in northeastern North America, where natural calcium is relatively scarce, partly because acid rain leaches calcium out of the soil. This behavior also occurs when there is deep snow cover, making any natural sources of calcium unavailable. You can help the jays (and stop them from chipping paint) by offering crushed eggshells, which are a better source of the calcium the birds need.

■ Sunning and anting are two different behaviors that are often confused. When *sunning,* a bird spreads its wings and fluffs its body feathers to bask in bright sunlight, especially on hot days. This is usually followed by a bout of preening. One likely benefit of sunning is that feather-degrading bacteria are inhibited by sunlight. Other possible reasons include converting vitamin D, and controlling feather lice (either by killing them or causing them to move, making it easier for birds to remove them by preening). In *anting* behavior, a bird sits among a swarm of ants in a contorted position, often with the tail bent under the body, grabs an ant in its bill, and wipes the ant along its feathers. Some evidence points to this being a kind of food preparation. The birds harass the ant to release its toxic formic acid, and once the acid is released the ant is edible. Formic acid does not have any known effect on feathers or feather parasites. But birds also wipe other acids such as lemon juice onto their feathers, so it is possible that acid has some still-unknown benefit.

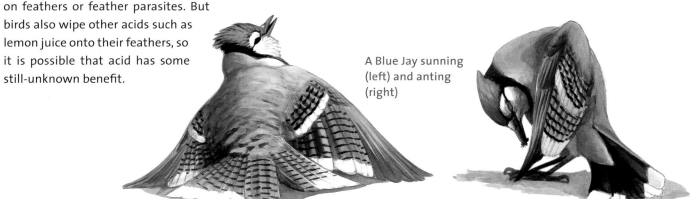

A Blue Jay sunning (left) and anting (right)

Scrub-Jays

**A brash visitor to bird feeders,
especially fond of peanuts**

California Scrub-Jay

■ Many jays rely on acorns for food, in particular the California Scrub-Jay, which can store up to five thousand acorns in the fall for use in the winter and spring. They have evolved a reinforced lower jaw for hammering hard objects—including acorns. They hit the acorn with the tip of the lower mandible to pierce the shell. Similar to woodpeckers, the lower jaw rather than the skull absorbs the force of impact. One significant challenge of eating acorns is that they have high levels of tannins, which bind with proteins and makes them unavailable. Acorns are high in fat and carbohydrates, but, eating acorns alone, jays lose weight rapidly because tannins lock up more protein than the birds get from the acorns. If a bird has access to other sources of protein—enough to make up for what the tannins remove—then acorns in moderation can be a valuable part of the diet.

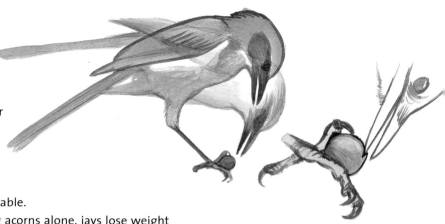

A California Scrub-Jay opening an acorn by hitting it with the tip of the lower mandible

■ Jays are experts at hiding food that they want to save for later. They usually hide food on the ground by digging a small hole, stuffing the food into it, then covering it with a leaf or small rock. Using their navigational abilities and extraordinary memory, they can keep track of thousands of different hidden items (see p. 113 bottom). Perishable things like insects are retrieved within days; long-lasting items like seeds can be left for months. Some jays spy on others and steal food after it has been cached. If a jay thinks it was observed while hiding food, it will return secretly a few minutes later to move the cached food to a new and better hiding place. This demonstrates a high level of intelligence, including an awareness of the intentions of other jays.

A California Scrub-Jay about to hide an acorn

■ A recent study in California found that many species of birds are already adapting to warming temperatures, nesting five to twelve days earlier than they did one hundred years ago. This change in timing matches the temperature shift over that time, and is probably both to avoid high summer temperatures and to synchronize with plant and insect cycles that have shifted earlier. Resident birds can sense the local conditions and make adjustments, but long-distance migrants face a more complicated challenge. Their return from remote wintering grounds is triggered largely by day length, but the timing of plant and insect cycles on their breeding grounds changes with the local climate. Birds are adjusting their arrival times in response to these changes, but there is evidence that, so far, many species are not adjusting quickly enough to keep pace. Time will tell whether the mismatch increases, or whether birds are flexible enough to adapt.

California Scrub-Jays

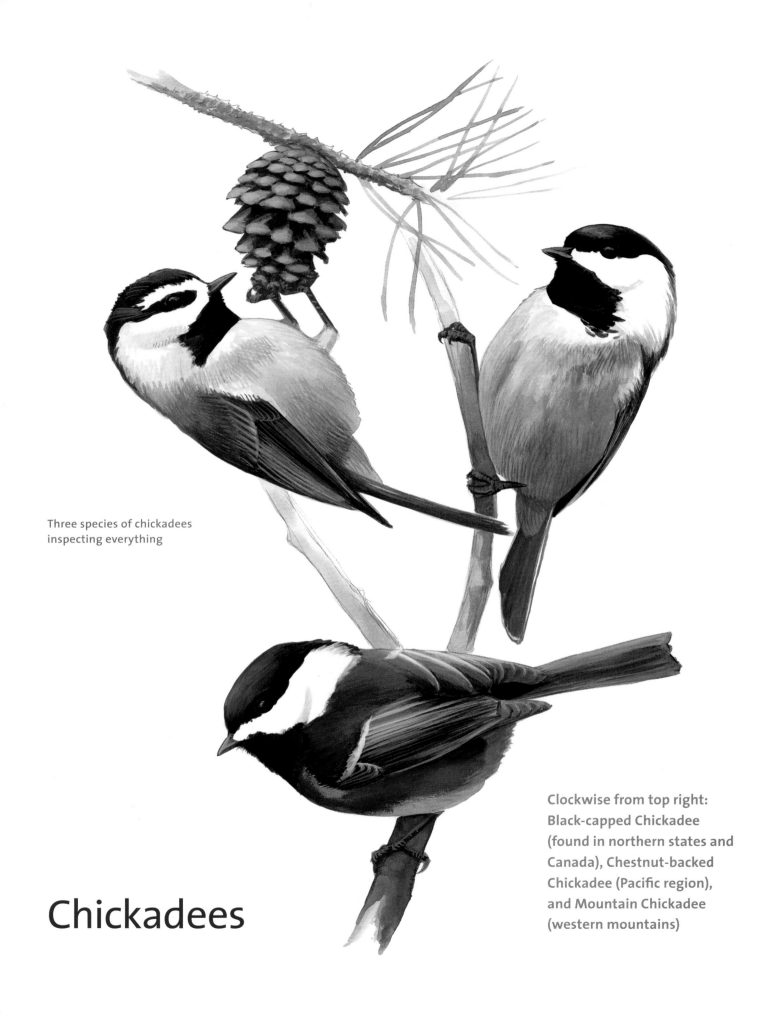

Three species of chickadees
inspecting everything

Chickadees

Clockwise from top right:
Black-capped Chickadee
(found in northern states and
Canada), Chestnut-backed
Chickadee (Pacific region),
and Mountain Chickadee
(western mountains)

■ Chickadees are the busybodies of the forest, peering into crevices, exploring tangles, studying twigs and pine cones, and constantly chattering about it. When they aren't nesting, chickadees are quite social, and travel in small groups of up to ten birds. Other songbirds understand the chickadees' calls and often join their roving groups. By relying on the chickadees to watch for danger, the other birds have more time to focus on foraging. This can be particularly helpful to migrants. A migrating warbler that has just landed in an unfamiliar woodland at dawn can take advantage of the experience of the local chickadees. Following them as they move through the forest will be relatively safe, and will lead to the best sources of food and water.

Black-capped Chickadees in action

■ Despite the fact that chickadees are reliable and consistent visitors to bird feeders (they especially like sunflower seeds), more than half of their diet year-round is animal prey. In the northern winter, they hunt for dormant tiny insects and spiders, including eggs and larvae, which are found in bark crevices and dead leaf clusters, along twigs, and in other such places. In the summer, they mostly bring small caterpillars to their nestlings (they can collect over a thousand in a day), but for the first week or so after hatching the adults make special efforts to seek out spiders to feed to their young. Spiders provide the nutrient taurine, which is essential for brain development and other functions (see p. 47 top).

A Black-capped Chickadee bringing a caterpillar to a fledgling

■ Chickadees that live in areas with harsh winters are very diligent about storing food for the winter, and a single chickadee can store up to a thousand seeds in a day, or eighty thousand in a season. This strategy is called scatter hoarding, as the birds simply tuck food away in any crevice where it will fit—in a cluster of spruce needles, in a bark crevice, and so on. Incredibly, the bird can remember where each item is stored, and at least some information about which ones are the best quality and which ones have been eaten already. The hippocampus—the part of the brain involved in spatial memory—is larger in birds that live in colder climates, where storing food is more important; it grows larger in the fall to accommodate multiple storage locations, and then shrinks again in the spring (see p. 111 middle).

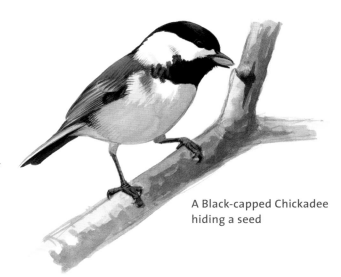

A Black-capped Chickadee hiding a seed

Titmice

Related to chickadees, the four species of titmice are all grayish with short crests.

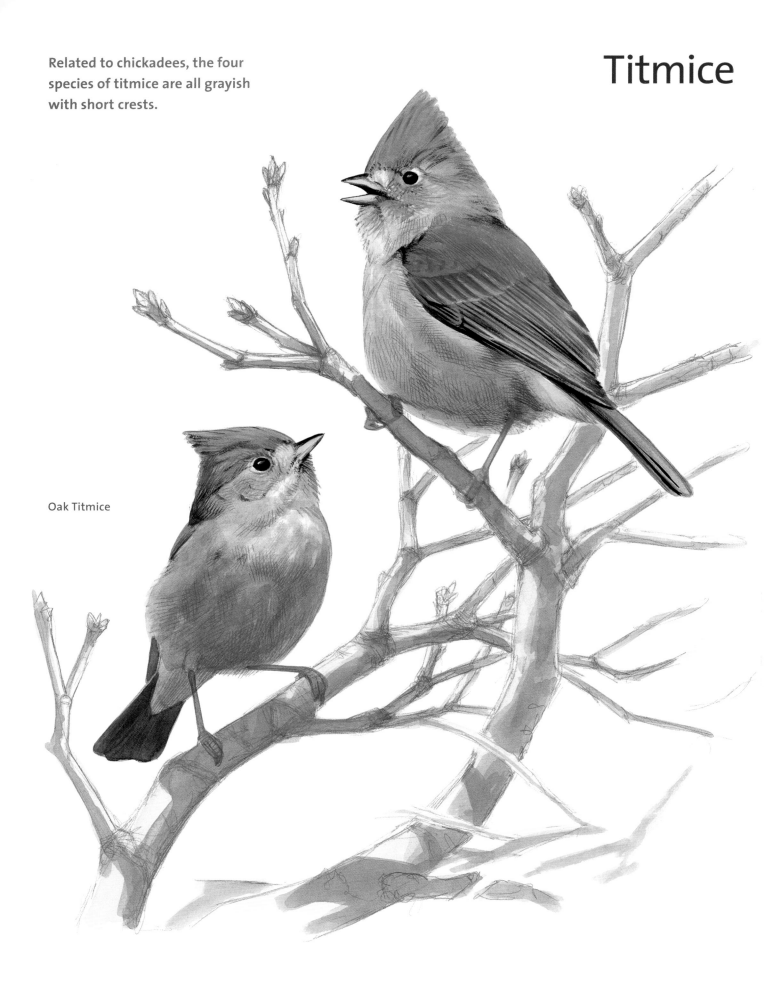

Oak Titmice

■ The theory of optimal foraging predicts that birds will modify their foraging behavior in a way that maximizes benefits while minimizing effort and risk. Confronted with seeds of four different sizes, you might expect this titmouse to grab the biggest one and head for the woods. But a larger seed is harder to carry, more conspicuous to anyone watching, and will take longer to break up and consume. All of this involves more effort and increases the risk of attack by thieves and predators. Small seeds usually offer less food value and might not be worth the effort, but if a small seed has high fat content and a lot of calories it could be the best choice. The optimal seed has just the right balance of benefits and costs. This multi-faceted decision-making is going on every time a titmouse visits a bird feeder, and there are plenty of times when the cost-benefit analysis leads a bird to choose the larger seed, but it is always a considered choice.

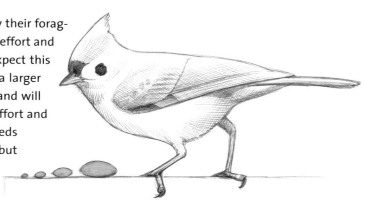

A Tufted Titmouse faced with a decision

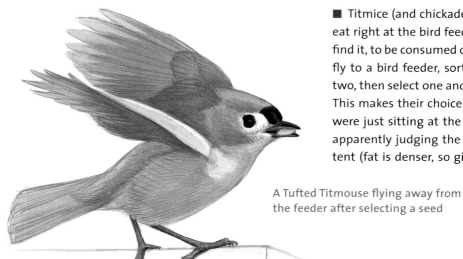

A Tufted Titmouse flying away from the feeder after selecting a seed

■ Titmice (and chickadees), unlike many other small birds, do not eat right at the bird feeder. They carry food away from where they find it, to be consumed on another perch. You will usually see them fly to a bird feeder, sort through the seeds there for a second or two, then select one and fly back into the woods to eat it or hide it. This makes their choice of seed a bit more important than if they were just sitting at the feeder and eating. While sorting they are apparently judging the weight, as a way of guessing the fat content (fat is denser, so given two similarly sized seeds, the heavier one is likely to have more fat). Once in the cover of woods, the titmouse holds the food item between its feet, and uses its bill to hammer and pry it apart for eating.

■ Songbirds typically lay four or five eggs, and begin incubating after the last egg has been laid so that all develop together and hatch close to the same time. In the Tufted Titmouse this incubation period averages thirteen days, and in the Eastern Phoebe sixteen days. Among other species the average time to hatching differs a lot. Why have these differences evolved? A recent review suggests that one of the most important factors is sibling rivalry. A young bird gains a selfish advantage by hatching sooner than its nest-mates, and this "race" to hatching leads to shorter incubation times. This is balanced, of course, by the need for the embryo to develop fully so it will grow into a successful adult. In species that lay a single egg, or with asynchronous hatching (see p. 53 bottom), the sibling hierarchy is predetermined and incubation times are relatively long.

Tufted Titmouse nestlings nearly ready to fledge

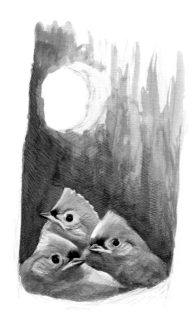

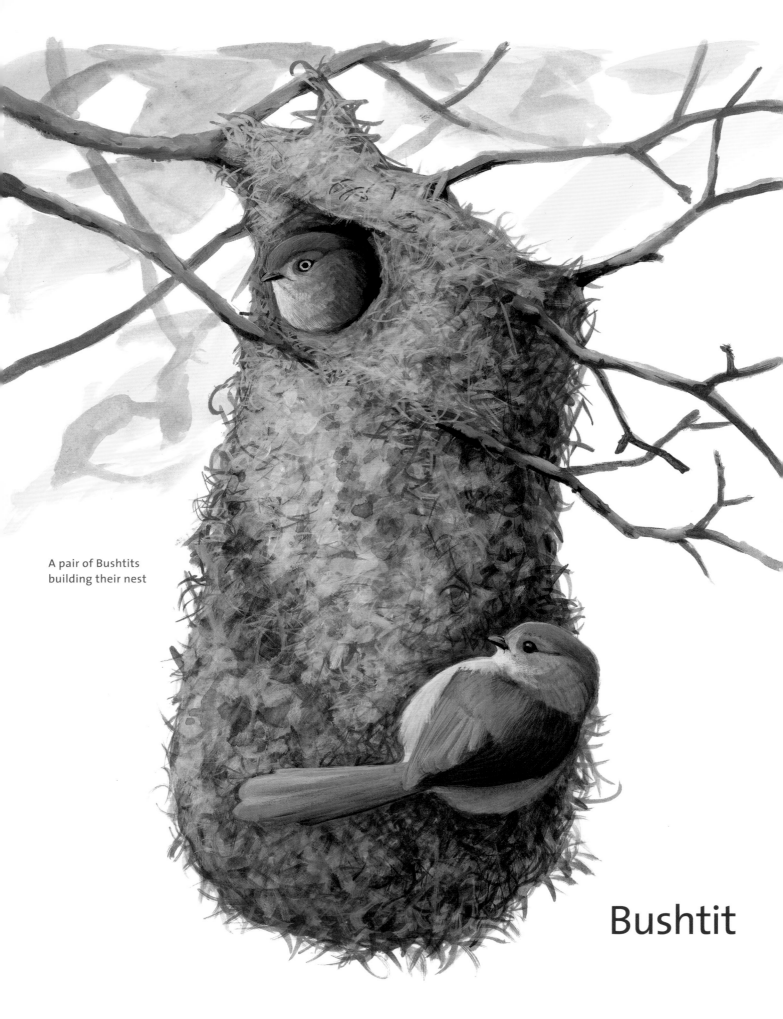

A pair of Bushtits
building their nest

Bushtit

Step 1: The nest always begins with a ring of spiderwebs and fibers creating the rim.

Step 2 can go either one of two ways:

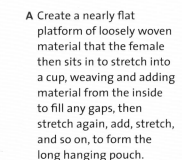

A Create a nearly flat platform of loosely woven material that the female then sits in to stretch into a cup, weaving and adding material from the inside to fill any gaps, then stretch again, add, stretch, and so on, to form the long hanging pouch.
B Quickly create a loosely woven pouch at nearly full size, then weave in material from both inside and outside to fill gaps and create a finished nest.

Nest type A is used more often early in the nesting season and in more open locations, takes longer to build, and is stronger. Nest type B is used more often later in the summer and in thicker vegetation, is completed more quickly, and is less durable.

In two to seven weeks the nest is finished; the hood over the nest opening is built last.

■ One important, but often over-looked, function of nests is as insulation. For a few weeks the eggs and young must be maintained at a constant temperature. The embryos and nestlings will die if they get too cold or too hot, and there is only so much the adults can do to change the temperature. Bushtit nests provide a lot of insulation. In one study in Arizona the interior of nests in full sun reached only 84°F when the outside of the nest was over 111°F. The nest also retains heat on cold nights. Because of their well-insulated nest, Bushtits average only 40 percent of each day incubating, allowing both members of a pair more time to forage. Other species tend to build nest walls thicker and with more insulating material in places where the temperature is colder, adjusting the nest to the conditions to provide more insulation for the eggs and young.

Bushtit nest in cross-section

■ Despite its tiny size, the Bushtit builds a very impressive nest—a woven hanging basket up to a foot long. All songbirds follow similar steps in nest building: create a foundation or framework, add material to form the structure, and then finish the inside with a soft insulating lining. All of this is instinctive, and birds require no instruction to build an intricate nest typical of their species. The Bushtit is one of the few species known to use two different approaches to nest building, depending on the setting and the time of year. So while nest building is instinctive, it also allows for the flexibility to adapt to local conditions and even choose to build different nest styles depending on various factors.

Nuthatches

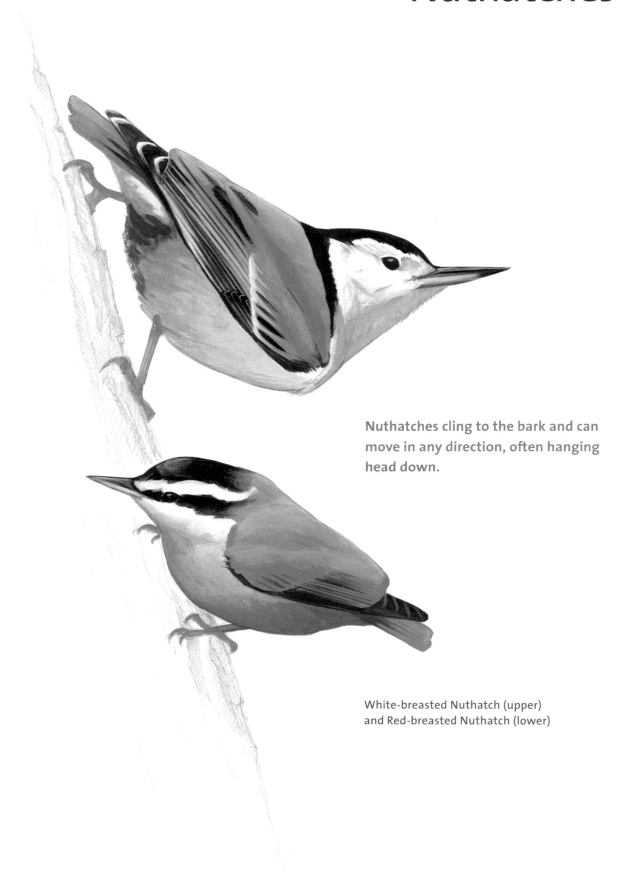

Nuthatches cling to the bark and can move in any direction, often hanging head down.

White-breasted Nuthatch (upper)
and Red-breasted Nuthatch (lower)

■ Both of these species nest in cavities in trees, but rarely use birdhouses. The female builds a grassy nest inside the cavity, and Red-breasted Nuthatches then "paint" the entrance hole with sap that they carry from pine, spruce, or fir trees using either their bill or a small bit of bark as a paintbrush. The nuthatches are expert at diving through the hole without getting stuck, but the sticky resin deters squirrels and other birds from entering. White-breasted Nuthatches engage in a similar behavior, sweeping or wiping the outside of the nest hole with bark strips, leaves, or crushed insects. Presumably these have a strong odor that either masks the birds' smell or repels predators, but the true function is unknown.

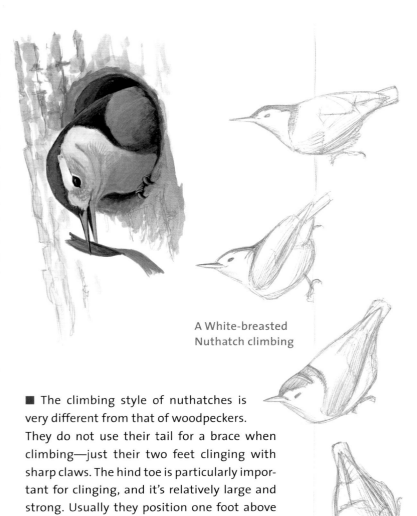

White-breasted Nuthatch applying scent to the entrance to its nest

A White-breasted Nuthatch climbing

Female (top) and male (bottom) White-breasted Nuthatch

■ Male and female White-breasted Nuthatches are quite similar in every way. Usually the only way we can tell them apart is by the color of the crown. The male has a shiny black crown, while the female's is gray.

■ The climbing style of nuthatches is very different from that of woodpeckers. They do not use their tail for a brace when climbing—just their two feet clinging with sharp claws. The hind toe is particularly important for clinging, and it's relatively large and strong. Usually they position one foot above the other so that the lower foot acts as a brace while the upper foot clings to the bark. This allows them to move easily up or down the trunk and at all angles on branches.

White-breasted Nuthatch threat display

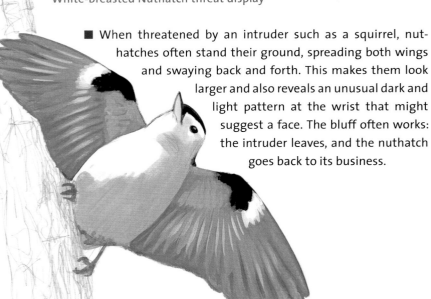

■ When threatened by an intruder such as a squirrel, nuthatches often stand their ground, spreading both wings and swaying back and forth. This makes them look larger and also reveals an unusual dark and light pattern at the wrist that might suggest a face. The bluff often works: the intruder leaves, and the nuthatch goes back to its business.

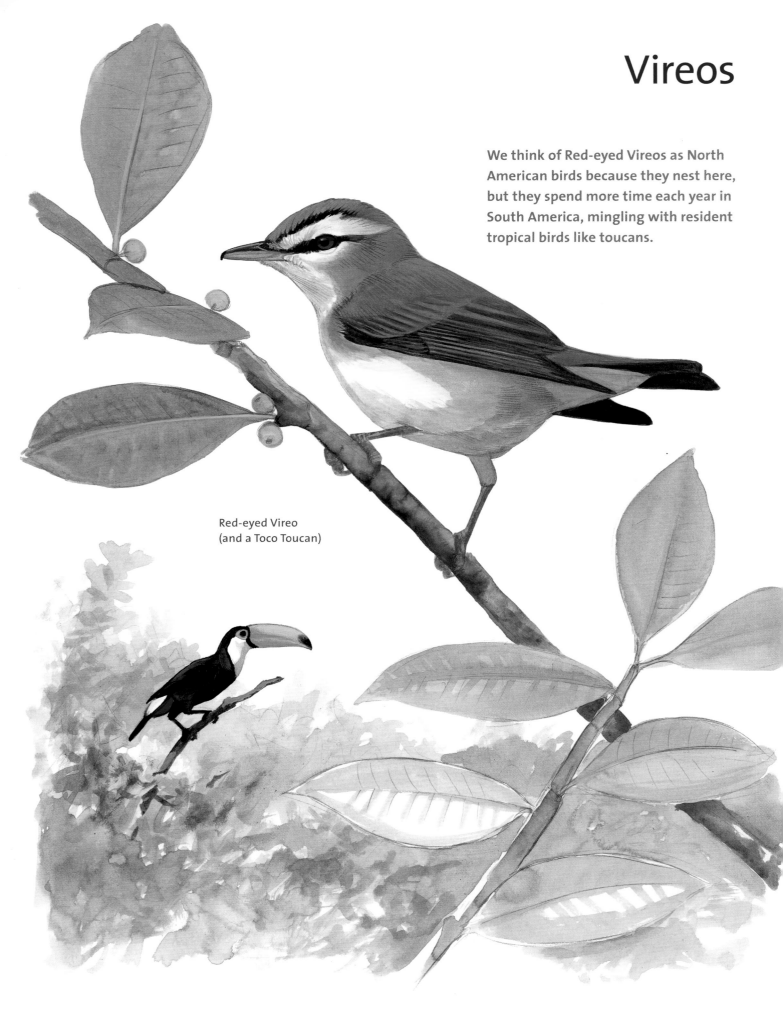

Vireos

We think of Red-eyed Vireos as North American birds because they nest here, but they spend more time each year in South America, mingling with resident tropical birds like toucans.

Red-eyed Vireo
(and a Toco Toucan)

A Red-eyed Vireo in active posture (left) and sleeping posture (right)

■ It has long been reported that birds have a system of tendons that "automatically" grips a branch when their legs are bent, but this is not true. A recent study found that there is no automatic perching mechanism, and that birds simply balance as they sleep. They sleep with their body shifted farther forward than when they are active, so their weight is balanced over the feet, with their toes loosely draped over the perch, not gripping tightly at all. The ability to balance on a slender, unsteady twig—while sleeping—is just something birds can do (see p. 149 top).

The toes and tendons of a typical songbird

■ Birds do have a tendon-locking mechanism in their toes, which works something like a plastic cable tie. In a bird's toes, a rough bumpy surface on each tendon (blue) matches angled ridges on the inside of the tendon sheath (red). When the tendon is pulled tight, the toe curls, the bumps on the tendon lock into the ridges on the sheath, and the toe stays tightly curled with almost no further muscular effort. Raptors use this system to hold their prey, clamping on with an unbreakable grip that requires very little effort. Clearly they can release their grip easily, but exactly how they do that is still unknown.

■ There is no green pigment in American birds. Much of what we perceive as greenish (on vireos, flycatchers, warblers, and others) is a combination of yellow and gray pigment. The three feathers here show the two pigments separately and combined. More intense green colors are produced by a combination of yellow pigment and blue structural color (see p. 85 top) or by structural color alone (see p. 77 middle).

Gray and yellow pigments combine in the middle feather to form a greenish color.

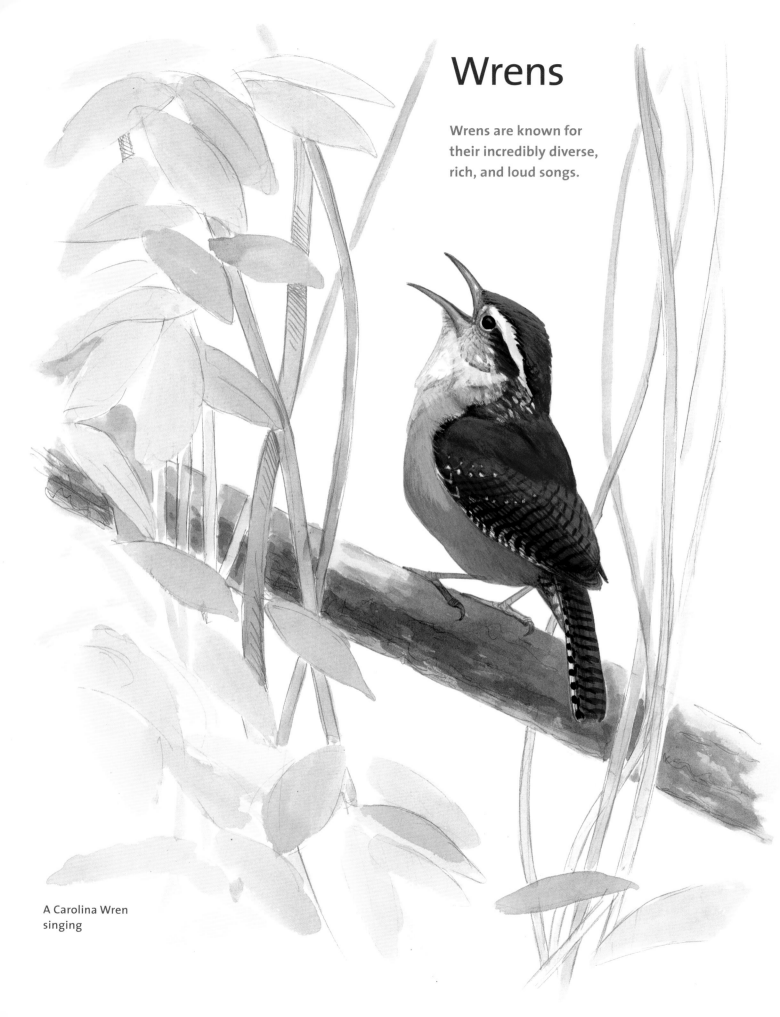

Wrens

Wrens are known for
their incredibly diverse,
rich, and loud songs.

A Carolina Wren
singing

■ Wrens are denizens of shadowy thickets, creeping through tangled vines and upturned tree stumps, probing crevices in search of insects and other invertebrates. Most species of wrens have a habit of holding their tail raised up, often flicking it or bouncing their whole body up and down when excited. This could involve both looming (see p. 135 middle) or alertness (see p. 95 top) signals. These movements and postures are characteristic of wrens, and allow birders to distinguish them from other small songbirds at a glance.

The typical movements of a House Wren

House Wren scolding

■ In the same way that kingbirds attack hawks (see p. 96), small songbirds will harass a predator in a behavior known as mobbing. Mobbing calls are directed at the predator, calls from one bird attract other birds, and soon there can be a small "mob" of many different species, gathered around and calling loudly. Bolder birds will even swoop in to peck at the predator's back. This has two benefits—it annoys the predator as the noise and swarming movement is distracting, and it alerts all of the potential prey in the area. Most predators rely on surprise to capture their prey, and announcing the presence of a predator takes away that advantage. Songbirds reserve their most aggressive mobbing tactics for the breeding season and near their nest. In the fall and winter a hawk, owl, or cat will be approached and scolded but not attacked. A birding technique known as "pishing" (making a *pshh-pshh-pshh* sound) mimics the call of a scolding wren or chickadee, and this often works to lure small birds into view.

Why don't we find dead birds?

Few birds die of old age. Many healthy birds are killed by predators or accidents, and if a bird slows down from age or disease they are even more vulnerable. Birds usually don't die in a way that leaves their body on the ground where we might find it. And if a bird does die and fall to the ground, its body is usually scavenged quickly by another animal. The causes that most often lead to a human encounter with a dead bird are all human related. It is not uncommon to find birds stunned or killed after flying into a glass window, or killed by house cats that are allowed outdoors, or dead along the roadside after being hit by a vehicle.

A deceased Carolina Wren

Kinglets

This tiny species can survive winters in the far north, but this requires a lot of food. The equivalent amount for us would be at least twenty-seven large pizzas every day. Do you eat like a bird?

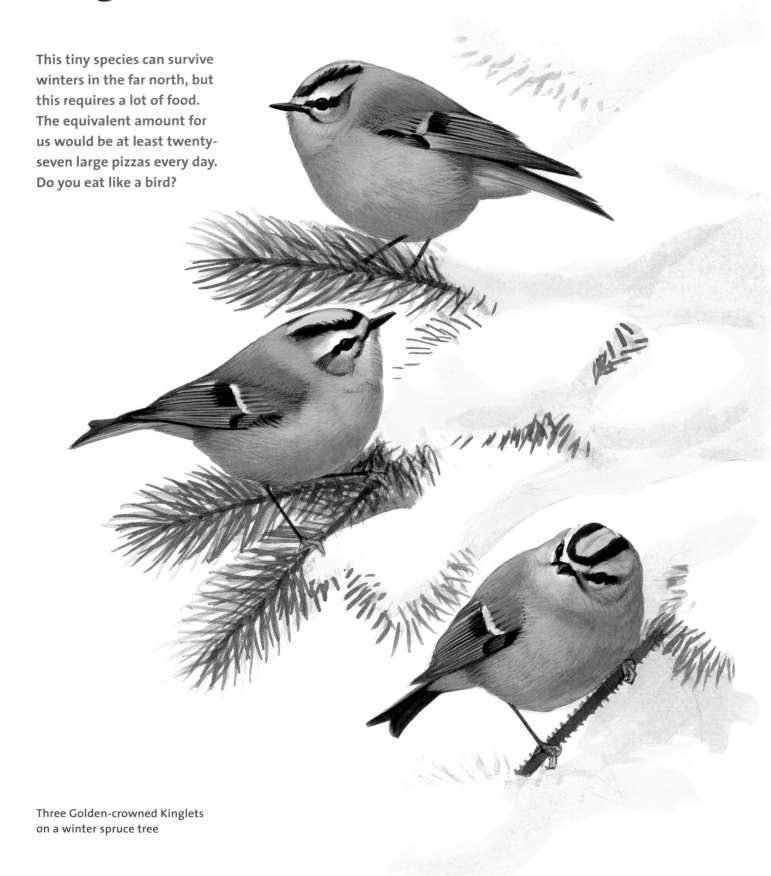

Three Golden-crowned Kinglets on a winter spruce tree

■ The circulatory system of birds is not dramatically different from ours. They have a four-chambered heart that pumps blood through arteries and veins, which carry fuel to the entire body and return waste products to be exhaled or excreted. There are differences in scale. A bird's heart is relatively large, about 2 percent of their body weight, compared to ours, which is about one-quarter that size, under one half of a percent of our body. And their heart beats much faster than ours. A bird as small as a Golden-crowned Kinglet has a resting heart rate of over six hundred beats per minute (ten per second), about ten times faster than the average human, and during activity the heart rate doubles to over twelve hundred beats per minute.

A Golden-crowned Kinglet, showing the size and position of the heart

■ Small birds lose about 10 percent of their body weight each night while they sleep. Half of that is by defecation and half is by burning fat and evaporating water. Imagine a hundred-pound human losing ten pounds overnight, and gaining it back the next day! This overnight weight loss in birds doesn't change very much with changing temperatures, and can be even higher on warm nights because of increased evaporation. On cold nights, birds become torpid (see p. 77 bottom), reduce their body temperature, and stay snuggled into their feathers, using them like a big sleeping bag. In extreme cold, a healthy bird will remain torpid longer, and actually reduce their daytime activity, starting later in the morning and ending earlier in the afternoon. They rely on their ability to conserve energy and wait for warmer weather. A bird can lose 30 percent of its body weight before suffering serious effects. In those conditions bird feeders can be a critical resource, allowing birds to refuel quickly and easily.

A sleeping Golden-crowned Kinglet

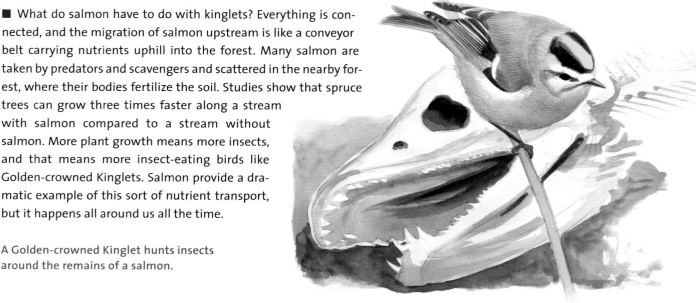

■ What do salmon have to do with kinglets? Everything is connected, and the migration of salmon upstream is like a conveyor belt carrying nutrients uphill into the forest. Many salmon are taken by predators and scavengers and scattered in the nearby forest, where their bodies fertilize the soil. Studies show that spruce trees can grow three times faster along a stream with salmon compared to a stream without salmon. More plant growth means more insects, and that means more insect-eating birds like Golden-crowned Kinglets. Salmon provide a dramatic example of this sort of nutrient transport, but it happens all around us all the time.

A Golden-crowned Kinglet hunts insects around the remains of a salmon.

American Robin

Early colonists in North America called this bird "robin" because it has a reddish breast like the European Robin they knew from home. The two species are not closely related.

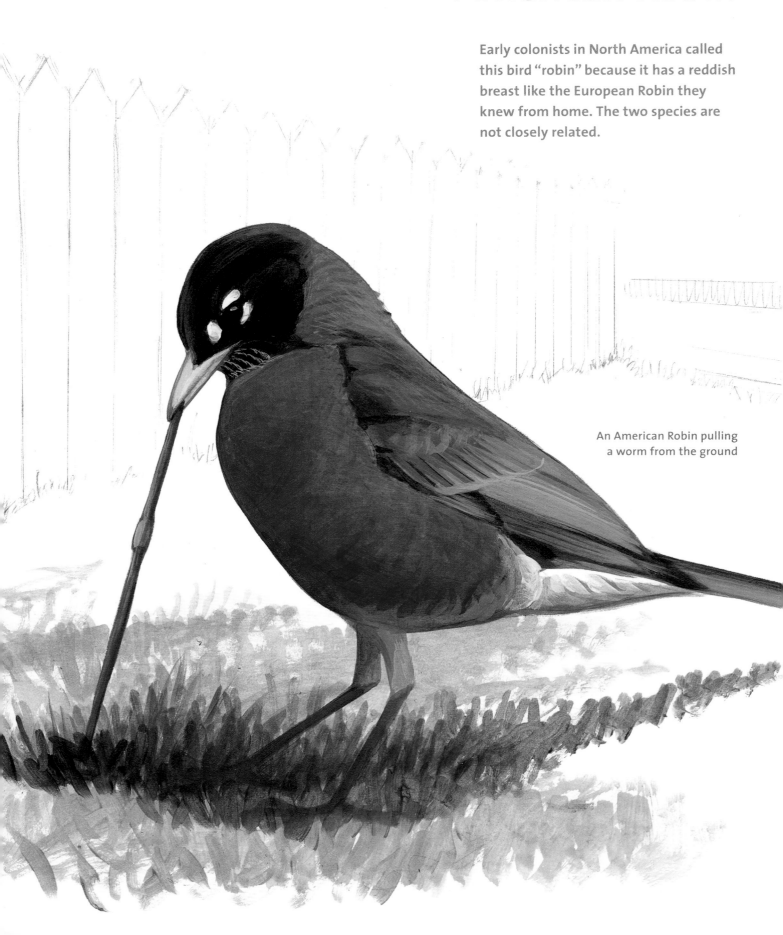

An American Robin pulling a worm from the ground

I thought robins were a sign of spring, but a flock just visited my yard in midwinter.

Robins depend on fruit in the winter and, like waxwings (see p. 138), their winter range is determined largely by the availability of food. The expansion of suburbs and widespread cultivation of exotic fruit trees, along with the recent spread of invasive berry-producing plants (like bittersweet and buckthorn) now means that robins can find winter food much farther north (and a warming climate helps). Robins have benefited from invasive species and human development of the landscape for at least two centuries. Their favorite summer food, the earthworm, was introduced to North America from Europe and thrives in lawns, and their primary winter food (fruit) is more common in the hedgerows and edge habitats we create.

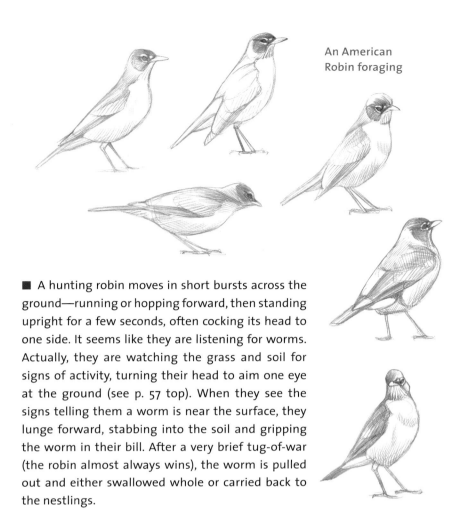

An American Robin foraging

■ A hunting robin moves in short bursts across the ground—running or hopping forward, then standing upright for a few seconds, often cocking its head to one side. It seems like they are listening for worms. Actually, they are watching the grass and soil for signs of activity, turning their head to aim one eye at the ground (see p. 57 top). When they see the signs telling them a worm is near the surface, they lunge forward, stabbing into the soil and gripping the worm in their bill. After a very brief tug-of-war (the robin almost always wins), the worm is pulled out and either swallowed whole or carried back to the nestlings.

American Robins eating sumac berries

■ The robin-like Varied Thrush is common in the moist evergreen forests of western North America, and rarely wanders east as far as the Atlantic coast. Even though it looks similar to a robin, the dark breastband and patterned wings are very distinctive. It finds insects and berries within the forest, only occasionally venturing out onto open lawns.

Varied Thrush

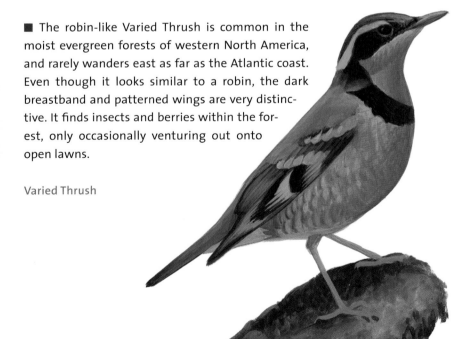

The Nesting Cycle of a Robin

Once a male and female are paired, and a nest site selected, the female builds the nest (the male may help by bringing some nesting material to her). The nest begins with a foundation of stouter twigs, then grasses cemented together with mud, ending with fine grass for the lining. Nest construction can take from four to seven days.

A bird has built a nest by my front door, what can I do?

Give the birds as much privacy as you can. Use the door as little as possible, and walk through calmly and quietly when you must. If possible, hanging something to block your activity from the direct sight of the nesting birds will reduce disturbance. You can't move the nest (if you do, the birds will most likely abandon it), and in the early stages of the nesting cycle even minor disturbances might cause the adults to abandon the nest. As days pass, the adults will become more invested in their offspring, and more accustomed to your presence. The entire nesting process will only take about four weeks, and it is fascinating to watch.

Three to four days after the nest is finished the female lays the first egg. Each egg amounts to about 8 percent of her body weight, but she will lay one a day until the clutch is complete at three to six eggs. The eggs of the American Robin are a beautiful greenish blue.

Incubation begins (and embryos begin to develop) after the second or third egg is laid. Only the female incubates. To help transfer heat to the eggs, a patch of bare skin on her belly, called a brood patch, develops extra blood vessels at this time. She spends about 75 percent of the day, and all night, sitting on the eggs. About once every hour she stands up, turns the eggs, and flies away to forage, drink, preen, and so on, for about fifteen minutes.

About twelve to fourteen days after hatching the young have well-developed wing feathers and strong legs. They are ready to leave the nest and take their first flight. But they will continue to depend on their parents for food for another twelve to fourteen days.

Many robin pairs will raise a second brood beginning about seven days after their first brood fledges. Rather than reuse the old nest, the female usually builds a new one (see p. 95 middle). While she builds, the male continues to tend the grown young from the earlier brood. Second broods often have fewer eggs, and may fail if the summer temperature is too high.

Once the young are about seven days old they have a full coat of feathers and can maintain their own body temperature for longer periods, allowing the female to join the male in the search for food. At this stage the nestlings are growing very quickly, and each one can consume its body weight in food each day, which means the adults have to bring food to the nest every five to ten minutes. The adults tend to perch on the same side of the nest each time they bring food, and the young compete for the best positions close to that spot.

After twelve to fourteen days of incubation, the eggs hatch within a few hours. The female carries the empty eggshells away and drops them far from the nest (see p. 133 bottom), or sometimes eats them, presumably for the calcium (see p. 109 middle). Newly hatched young are mostly naked, blind, and unable to use their legs, but they instinctively lift their heads and beg for food when stimulated by the shaking of the nest or by the calls of the adults. The female spends a lot of time in these early days sheltering the young and keeping them warm. At this stage the male does most of the work of bringing food to the young.

Only about one-third of all American Robin nests succeed in fledging one or more young, and only one-quarter of those fledged young will survive to November 1 (see p. 169 bottom).

Thrushes

Wood Thrush

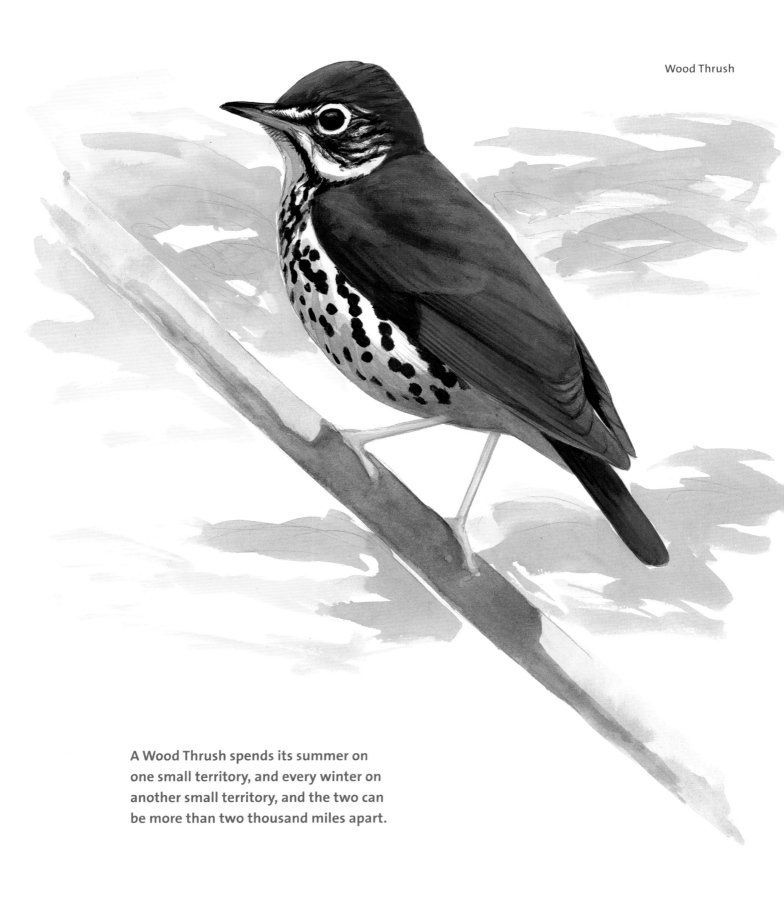

A Wood Thrush spends its summer on one small territory, and every winter on another small territory, and the two can be more than two thousand miles apart.

■ For millennia humans have enjoyed bird songs, and the songs of thrushes in particular. Even among the thrushes the Hermit Thrush is often singled out for praise. A recent study of Hermit Thrush songs found that they often use pitches that are mathematically related by simple ratios, and follow the same harmonic series as human music. The harmonic series is a fact of physics, and not a creation of human culture, so it should not be entirely surprising that other vocal animals use it. But this does show that the fundamentals of music are rooted in nature and have a very basic, even instinctive, appeal.

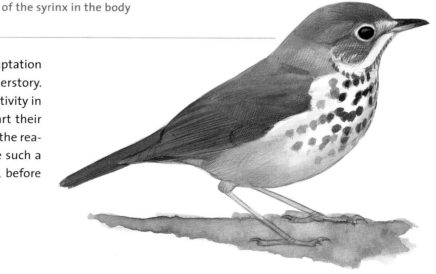

Hermit Thrush singing

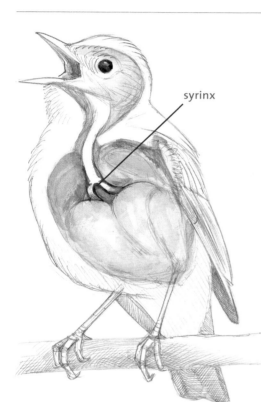

syrinx

■ Birds produce sound with the syrinx, which differs from our larynx by being made of two parts and located deeper in the respiratory tract at the point where the two airways from the left and right lungs and air sacs join to form the trachea. Two complex sets of tiny muscles control airflow through the two sides independently, allowing the birds to produce two different sounds at the same time. In many songbirds the two sides are slightly different. These species produce higher sounds with one side and lower sounds with the other. Sounds from the two sides often match up seamlessly, making it impossible to tell that they are from two different sources. In other cases, notably in the songs of thrushes, the two sides produce entirely different sounds simultaneously, creating an incredibly rich and complex sound. In effect, the thrush can harmonize with itself.

A thrush, showing the position of the syrinx in the body

■ Thrushes have unusually large eyes, an adaptation to their preferred habitat in the shady understory. Research has shown that eye size is linked to activity in low light, and birds with large eyes tend to start their day earlier and end it later. This could be one of the reasons that the melodious songs of thrushes are such a prominent part of the dawn and dusk chorus, before and after most other birds sing.

Hermit Thrush

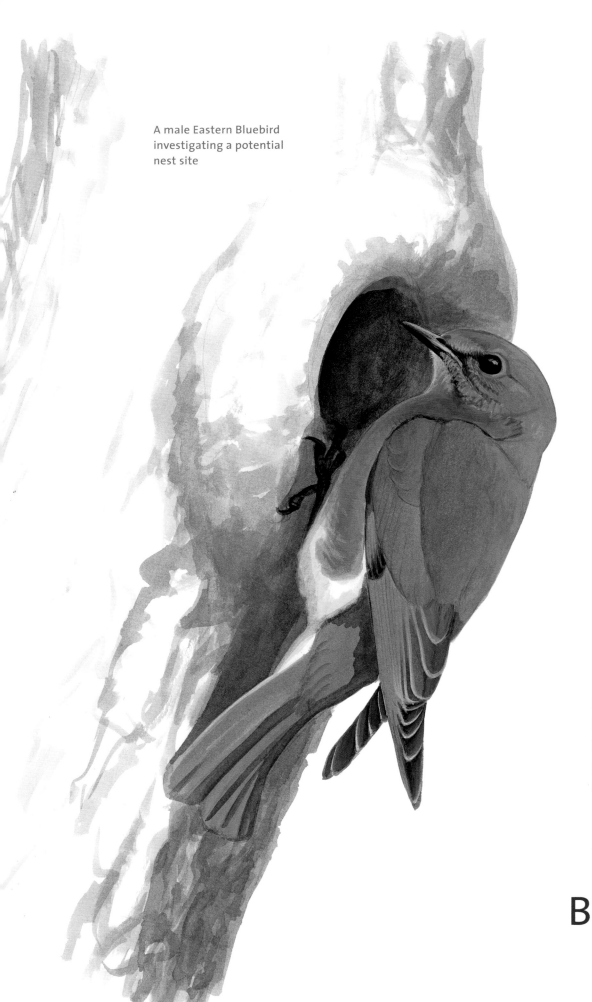

A male Eastern Bluebird investigating a potential nest site

Bluebird populations have increased greatly in the last fifty years, probably helped by nest boxes.

Bluebirds

■ There is no blue pigment in birds—all blue color is produced by the microscopic structure of the feathers. If you find a blue feather, you will notice that it is only blue on one side, and it looks drab brownish when light shines through it. The bluebird's color relies on the same physical principles as iridescent hummingbird feathers, in which a coherent scattering of light reinforces some wavelengths and diminishes others (see p. 77 middle), but the structure behind it is quite different. Instead of multiple flat layers of material to reflect light, bluebirds have a spongy layer filled with tiny air pockets and channels. These air pockets are all about the same size, and together they produce a patterned structure with the correct intervals to match the wavelength of blue light.

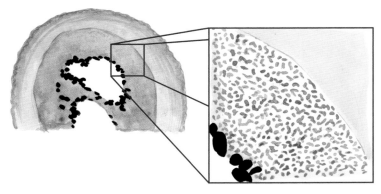

The solid surface of one barb (brown) with the spongy layer of tiny air channels (gray). The larger black dots are granules of melanin that capture any light that makes it through the spongy layer.

Waves of blue light scattered from one air pocket will be in phase with waves of blue light from some of the other air pockets. Light of other wavelengths will be out of phase and mostly invisible. Because the air pockets are evenly distributed throughout this spongy layer, the effects on light traveling in any direction are the same. Unlike the iridescent throat colors of hummingbirds, the blue color of a bluebird looks similar from all angles.

■ Bluebirds, like many other species, build their nest inside a cavity. This is usually an old woodpecker hole, but it's sometimes a rotted hollow branch, a crevice in a building, or a similar location. They rely on an abundance of standing dead trees and woodpeckers to provide nest sites, and if dead trees are removed, as they are in many urban and suburban settings, there are few places for bluebirds to nest. Fortunately, bluebirds are happy to accept birdhouses, and thousands of people across North America help to maintain "bluebird trails" that provide nest boxes along miles of country roads.

■ If you find a broken eggshell on the ground, the shape of the pieces can give some information about what happened. If an egg hatches normally, the chick chips away a ring around the widest part of the egg and the egg separates into two halves. The parents then carry the eggshells from the nest and scatter them some distance away. An eggshell cut straight across in this way is likely to be the result of successful hatching nearby. Eggshells in smaller pieces, fragmented or crushed, could be the result of an accident or predation. Given the opportunity, many species of birds and small mammals will eat the contents of an egg and leave the shell behind.

A broken egg on the ground (right) indicates predation or an accident; an egg neatly split in half (left) indicates hatching.

A male Eastern Bluebird on a nest box

Northern Mockingbird

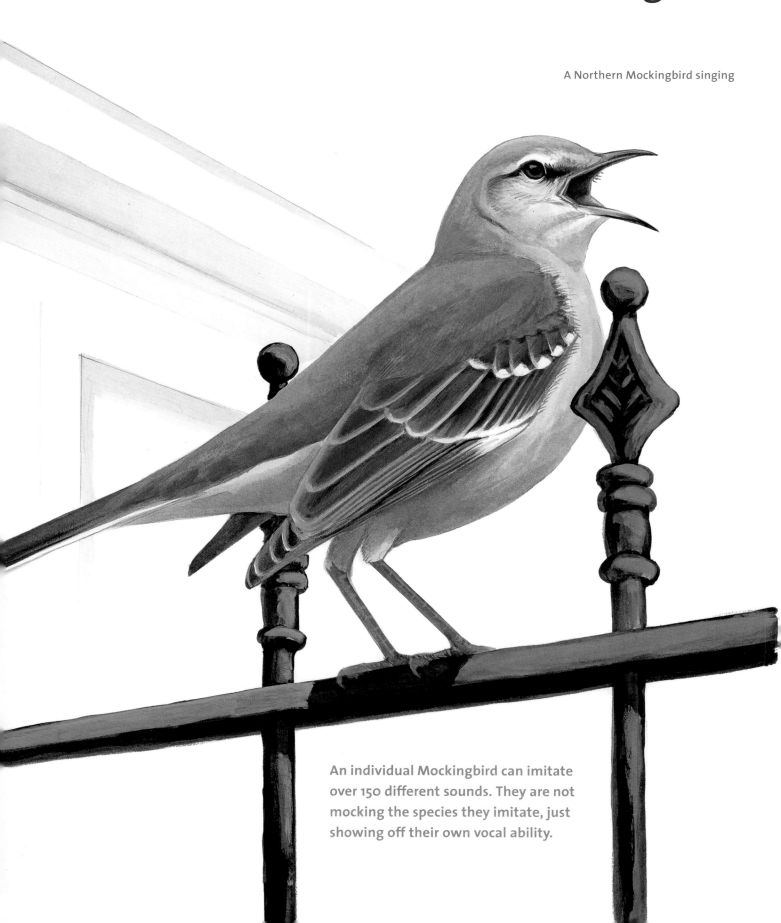

A Northern Mockingbird singing

An individual Mockingbird can imitate
over 150 different sounds. They are not
mocking the species they imitate, just
showing off their own vocal ability.

A bird is attacking me every time I walk through my yard!

Many species do this to defend their nest, and mockingbirds are particularly aggressive. They see humans as potential predators, and their attacks are not dangerous, but are meant primarily as an annoyance to encourage you to leave the area. This aggression peaks during the relatively brief period when eggs and young are in the nest, which lasts about three to four weeks for most songbirds. However, a single pair can raise two or three broods each summer, so there may be several periods of heightened nest defense. Like crows, Northern Mockingbirds can recognize individual humans, and humans that have actually disturbed the nest will be singled out for more aggressive attacks than those who simply walk past.

A Northern Mockingbird in attack mode

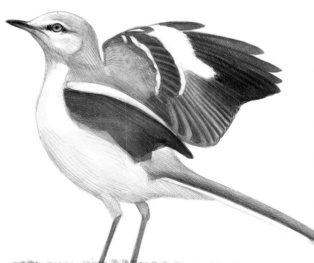

■ You might notice a mockingbird standing on the lawn and flicking its wings open above its back. This is known as wing flashing and is a trick the birds use to try to scare insects out of hiding. It takes advantage of a deeply instinctive behavior called the looming response. The "made you blink" games that kids play are really a test of the looming response in humans. All animals, including insects, react the same way. By lifting its wings suddenly, the Northern Mockingbird is making insects "blink." If an insect moves, even slightly, it reveals its location and the bird can try to catch it.

A Northern Mockingbird wing flashing to scare insects

■ One of the things mockingbirds are known for is singing at night, often loudly and incessantly, which usually makes them unpopular with their human neighbors. Research on other species has shown that birds in urban areas have increased their nighttime singing, and that this is at least partly a response to daytime noise. The birds are taking advantage of the quiet hours to broadcast their message without interference (see p. 159 top). The Northern Mockingbird has always been a night singer, and maybe they do it to avoid competition with other singers.

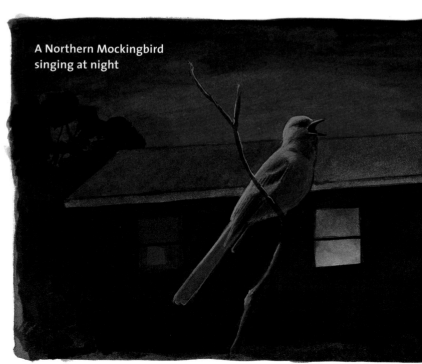

A Northern Mockingbird singing at night

European Starling

Starlings were introduced to North America from Europe, where they had adapted to living around humans, and spread across the continent in the early 1900s.

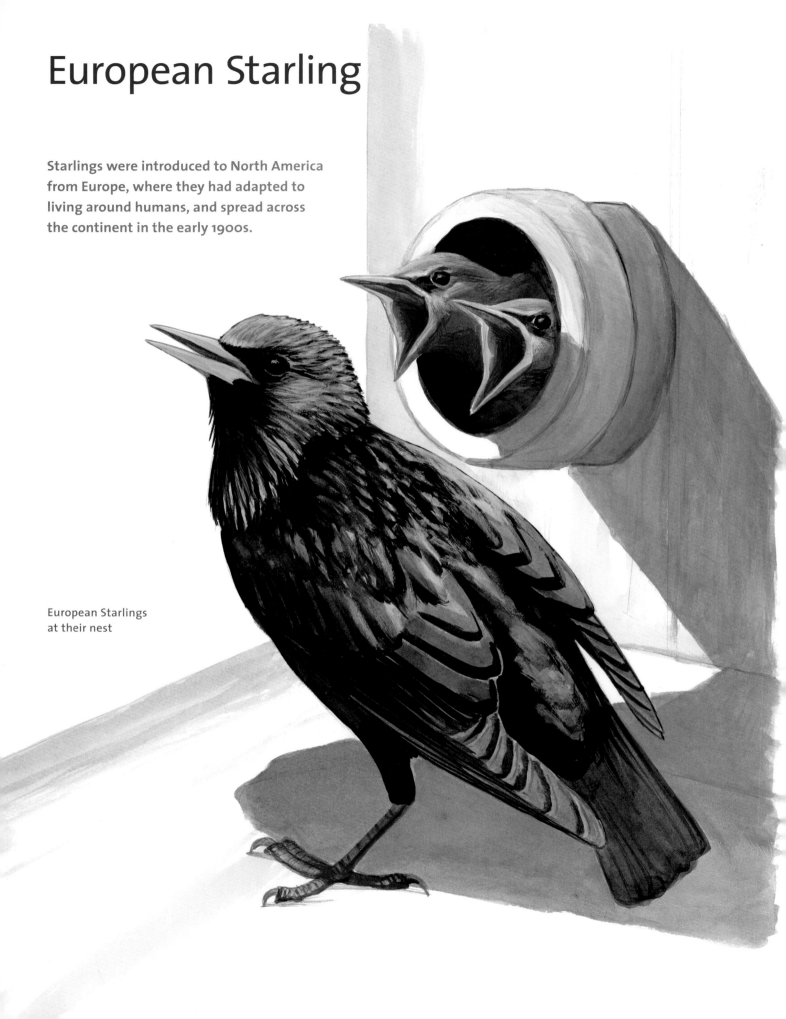

European Starlings at their nest

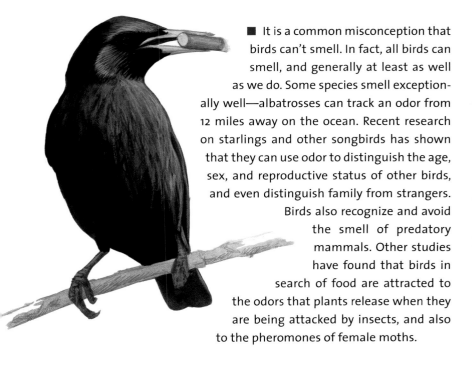

■ It is a common misconception that birds can't smell. In fact, all birds can smell, and generally at least as well as we do. Some species smell exceptionally well—albatrosses can track an odor from 12 miles away on the ocean. Recent research on starlings and other songbirds has shown that they can use odor to distinguish the age, sex, and reproductive status of other birds, and even distinguish family from strangers. Birds also recognize and avoid the smell of predatory mammals. Other studies have found that birds in search of food are attracted to the odors that plants release when they are being attacked by insects, and also to the pheromones of female moths.

Starlings use their sense of smell to decorate their nest with aromatic plants or other pungent items (like cigarette butts), which help repel insect pests from the nest.

■ The bill color of many species changes with the seasons. The European Starling undergoes one of the more dramatic changes from yellow in the summer to blackish in the winter. It has generally been assumed that this color change was used for social signaling, but recent work shows that melanin adds strength and increases the hardness of the bill. Like many species, starlings shift from eating mostly softer food like insects in the summer to harder food like seeds in the winter. A darker bill in the winter might be (at least partly) an adaptation to make the bill stronger. Melanin also strengthens feathers (see p. 47 middle) and dark spots on eggshells serve to strengthen the shell and reduce the need for scarce calcium.

A European Starling in winter colors (left) and summer colors (right)

Why do birds take baths?

Several possible reasons for bathing have been proposed, beside the obvious: that it helps to remove dirt from the feathers. The function that seems most important and is supported by research is that it helps to restore the shape of feathers. Like human hair (think bedhead), feathers can be bent and misshapen by everyday pressures. Simply wetting and drying the feathers restores their original shape. Birds always follow a bath with a session of intensive preening, putting all of their feathers in the proper alignment, the same way we follow a shower with brushing our hair. After being wet and then aligned, the feathers will dry into their proper original shape. One experiment found that starlings that were not allowed to bathe showed more anxiety about their ability to escape a predator, presumably knowing that their flight feathers were not in perfect condition.

A European Starling bathing

Waxwings

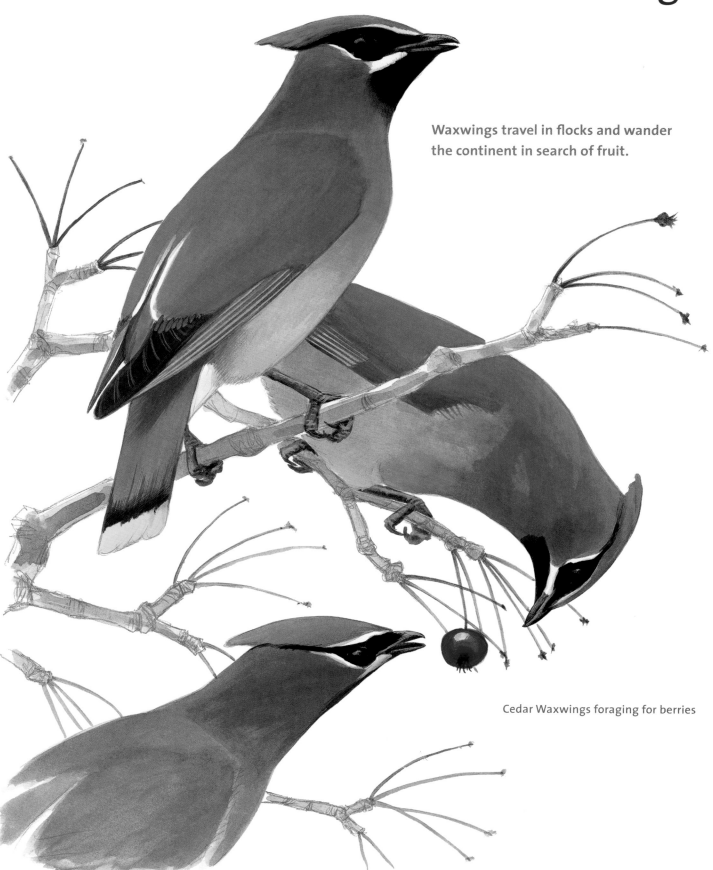

Waxwings travel in flocks and wander the continent in search of fruit.

Cedar Waxwings foraging for berries

■ The diet of waxwings is mainly fruit for much of the year, and they have several adaptations related to this. They have a relatively small bill, but it opens into an unusually wide mouth, allowing them to swallow large fruit whole. Their tongue has inward-facing barbs to help pull fruit into their throat. And they travel in flocks and wander widely in search of abundant fruit. Most songbirds in North America time their nesting efforts to coincide with the explosion of insect larvae on new plant growth early in the summer. Waxwings also feed their young a protein-rich diet of insects, but they delay their nesting until late in the summer so that the young fledge at a time when fruit is abundant.

A Cedar Waxwing swallowing a whole berry

A waxwing tail, showing orange tips, with one new feather replaced with the typical yellow tip

■ Carotenoid compounds are common in fruits and seeds, and birds' bodies use these carotenoids to produce the range of red to yellow colors in their plumage. There are many different carotenoids, and birds have evolved chemical processes to create the correct color from whatever food they are eating. An invasive Asian honeysuckle, however, provides a slightly different carotenoid that American birds are not used to, and when the birds process this chemical it produces a deeper orange color instead of the typical yellow. If waxwings eat the fruit of this honeysuckle in the late summer during the time when they are growing new tail feathers, those feathers develop orange tips rather than yellow, and will stay that way until new feathers grow a year later. So far this doesn't seem to cause any problems for the waxwings.

■ Most birds stay put for the entire breeding season, raising a brood of young (or several) in one place. A few species might be less tied to one spot. The Phainopepla, a distant relative of waxwings, is found in the southwestern U.S. and feeds mainly on mistletoe berries. They are known to use two distinct habitats for nesting. In the winter they are found in desert habitat at lower elevations, where nesting activity peaks in April. As temperatures climb and mistletoe berries become scarce they move to wooded riparian and foothill habitats, where smaller numbers nest in June and July. Recent studies suggest that this is a single population, and the same individuals nest early in desert habitat, then move to wooded areas and nest again in an entirely different place just a couple of months later. Even more remarkable, their breeding strategy changes from strictly territorial in the desert to loosely colonial in wooded habitats!

A male Phainopepla

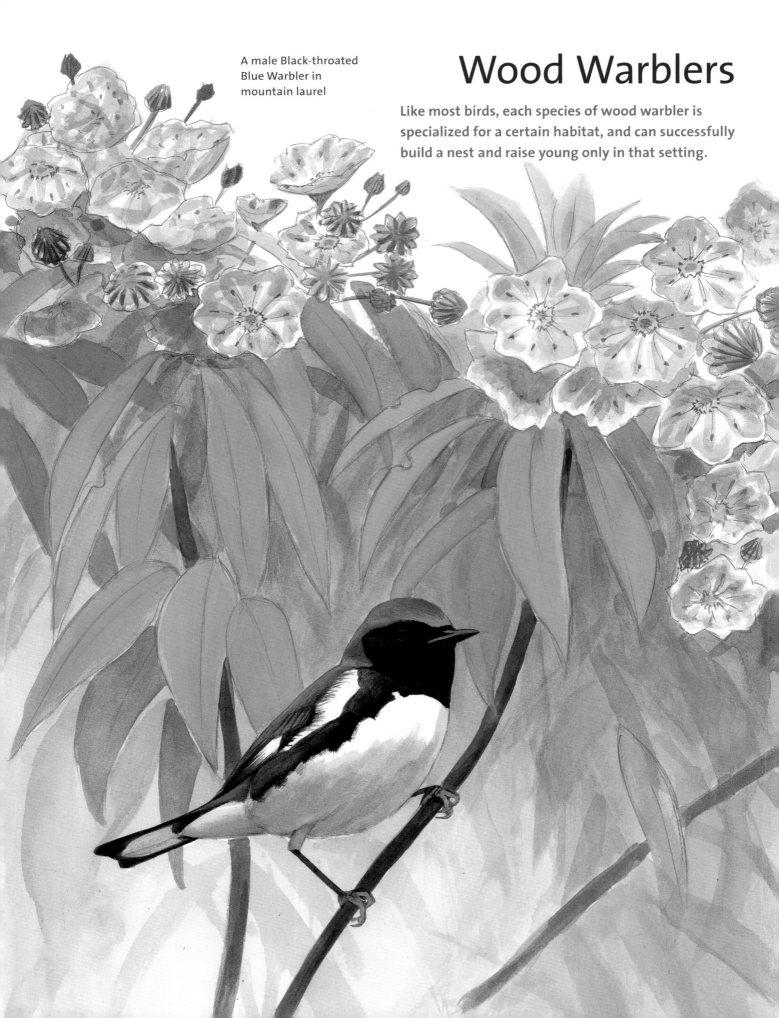

A male Black-throated Blue Warbler in mountain laurel

Wood Warblers

Like most birds, each species of wood warbler is specialized for a certain habitat, and can successfully build a nest and raise young only in that setting.

■ Scientists are still working to sort out the remarkable details of the magnetic sense of birds. There is evidence that songbirds have two different systems for detecting the orientation of the magnetic field as well as the slope of the field (which varies with latitude from horizontal at the equator to vertical at the poles). They can also detect polarized light, which gives valuable clues to the position of the sun even when the sun itself is not visible. All of these senses might be linked to the birds' vision, so it is possible that a songbird sees some sort of compass guide all the time. This information is critical for orientation during migration, but it could also be very useful for a bird navigating locally. Imagine seeing a compass reading all the time as you walked through your house or the supermarket. Birds could use this information as they navigate their own breeding territory, to help remember the locations of stored food, and more.

A Black-and-white Warbler with a totally hypothetical artist's rendering of what the bird might see in the sky: a blue band of polarized light, and a reddish band oriented with the magnetic field with a stronger dot showing the slope of the magnetic field

■ Filoplumes are a specialized kind of feather, tiny slender plumes growing in clusters around the base of most feathers. The follicle where they enter the skin is packed with nerve endings. Like telltales on a boat's sail, they apparently act as sensors to allow a bird to monitor the movements of individual feathers. Birds know when a feather is out of place, when two feathers are stuck together, when a fly has landed on a feather, etc. In flight filoplumes allow birds to sense lift, drag, turbulence, updrafts, downdrafts, and other forces over the entire wings and body. The birds can use this information to make the constant tiny adjustments of wing and tail position necessary for efficient flight.

Filoplumes growing next to a typical feather

■ One of the riskiest aspects of migration is the days off. Imagine flying all night and landing in an unfamiliar place at dawn. Finding water, shelter, and food while avoiding predators is a huge challenge, and even more so when much of the landscape is covered with human structures and lawns. In urban and suburban areas, especially, small parks and gardens can be a magnet for migrating birds. You can make your yard bird-friendly by planting native shrubs and trees and offering water. The biggest benefit of using native plants for birds is that those plants have evolved over millennia to coexist with a whole ecosystem of insects and other organisms. Exotic plants are not integrated with the local ecosystem, and fewer insects are able to use them. For example, in the eastern United States native oak trees host more than five hundred species of moth and butterfly larvae, exotic Norway Maples fewer than ten species. For insectivorous birds, obviously, an oak tree is much more attractive. Furthermore, if you want your yard to provide food for birds, you should not use insecticides. Let the birds control the insects.

A Black-throated Green Warbler foraging in a spring oak tree

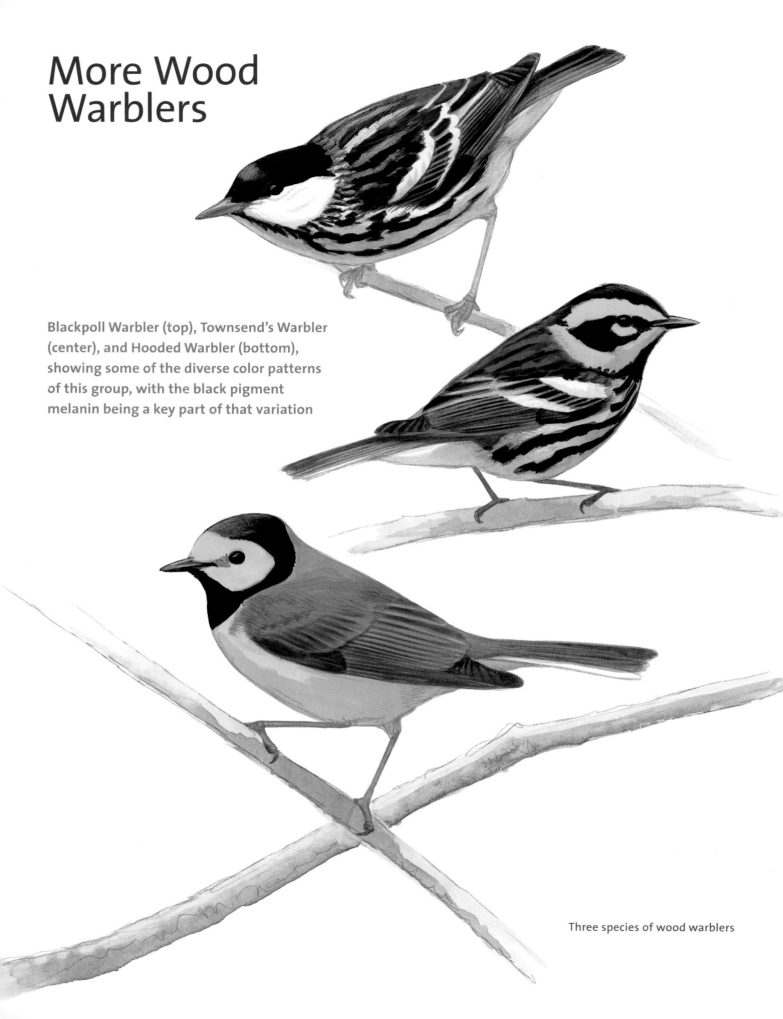

More Wood Warblers

Blackpoll Warbler (top), Townsend's Warbler (center), and Hooded Warbler (bottom), showing some of the diverse color patterns of this group, with the black pigment melanin being a key part of that variation

Three species of wood warblers

■ Almost all of the wood warblers are highly migratory, and the Blackpoll Warbler is the distance champion among them. Some individuals nest in northwestern Alaska and winter in central Brazil—more than 7,000 miles away. In the fall all Blackpoll Warblers gather along the northeastern coast from Nova Scotia to New Jersey, where they feed and rest, building up fat reserves. Their body weight doubles before the flight, from their normal weight of 11 grams to over 23 grams. This fat is the fuel that will carry them on a 2,500-mile nonstop flight, in about 72 hours, over the Atlantic Ocean to the coast of northeastern South America. By the time they land they will have lost their added weight and a little more. In the spring they travel north in shorter hops, flying across the Caribbean to Cuba and Florida, then over land to their nesting territories.

The annual migration cycle of the Blackpoll Warbler

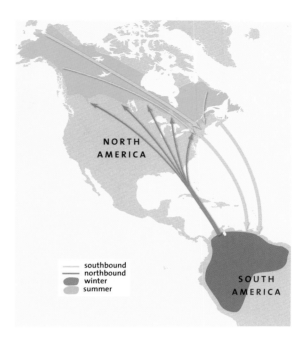

■ Birds' bodies operate at very high temperatures. They are also well insulated, and their muscles generate lots of extra heat during activities like flying. How do they cool down? They reduce their insulation layer by pressing feathers closer to the body and by exposing the parts of their bodies with fewer feathers, like the upper leg and the underside of the wing. And they pant. By opening their bill wide and expanding their throat to expose lots of moist skin, they can take in rapid puffs of air (triple their normal breathing rate) to evaporate water and cool the surfaces of their throat and air sacs. Ideally, they only do this when they have access to water to replenish what evaporates (see p. 153 bottom).

A female Common Yellowthroat panting

Why do birds sing?

Singing is a bird's way of advertising, announcing their presence and showing off for mates and rivals. Many species vary their performance depending on their audience—for example, a male might use one song type to impress a female, another song type to intimidate rival males, and casual "practice" songs when they have no audience. Many singing performances also include a visual display like flashes of bright color or acrobatic movements. A brightly colored throat is a feature shared by many species. When the bird sings it raises its bill and the throat expands, making the color very conspicuous, while in a normal posture the color is in shadow and less conspicuous.

A male Common Yellowthroat singing and not

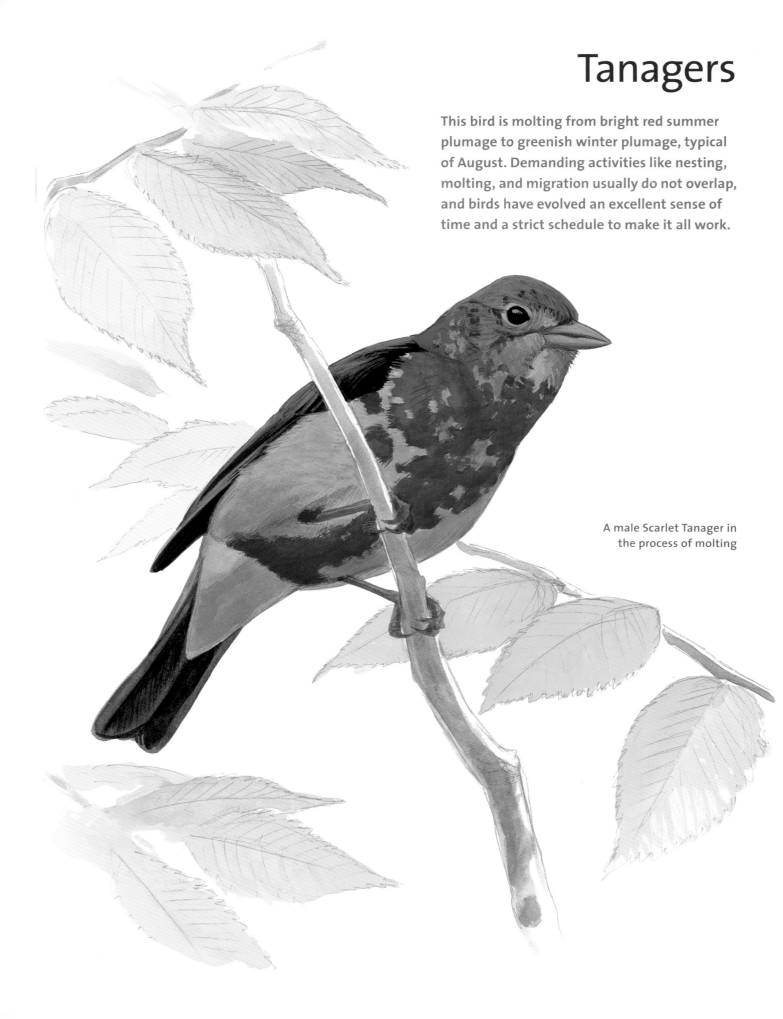

Tanagers

This bird is molting from bright red summer plumage to greenish winter plumage, typical of August. Demanding activities like nesting, molting, and migration usually do not overlap, and birds have evolved an excellent sense of time and a strict schedule to make it all work.

A male Scarlet Tanager in the process of molting

■ Consider how a tanager sees the world as it moves through a lattice of slender twigs suspended above the ground. The bird gives no thought to hopping from twig to twig eighty feet up in the air, then jumping into the open air to catch a passing insect, or flying across a fifty-foot gap to the next twig. Can birds be afraid of heights? Some fear of heights is instinctive and adaptive. Walking off a cliff would be bad, so most animals, including baby birds, instinctively avoid the edge. Once a bird can fly, the cliff poses little danger, and they are comfortable balancing on the edge or even stepping off, knowing that they can spread their wings and come right back. An adult bird must have some understanding of how bad a fall could be, but at the same time confidence that it won't fall.

A Western Tanager perched above the forest canopy

■ Preening is one of the most essential chores a bird has to do, and they spend a lot of time doing it. Typically they preen for about 10 percent of each day, but it can be over 20 percent. Some details of the bill shape of birds have evolved specifically for preening, and a few species have specialized claws for feather care. The main functions are to remove parasites and to clean and adjust the feathers. Birds have a gland at the base of their tail that produces an oil used for feather care. Preening typically involves reaching back to this preen gland, getting a little oil on the bill, and then using the bill to carefully tend to each body, wing, and tail feather from base to tip. This resets all of the barbs and straightens the feather, while also spreading oil across it. A session of preening often ends with the bird leaning forward, raising all of the feathers away from the body, and shaking like a wet dog, sending bits of dust and down floating away.

Typical preening motions

A Scarlet Tanager eating elderberries

■ Many birds eat fruit, and most fruit has adapted to be eaten and dispersed by birds. The nutritious outer layer of the fruit attracts birds, and fruit up to pea-sized or even larger is easily swallowed whole by birds. Once swallowed, the fleshy part of the fruit is digested, and the hard seeds are either regurgitated or excreted, intact, usually within a few hours. In this way birds disperse seeds widely across the landscape. One study found that birds migrating from Europe carry viable seeds to the Canary Islands, across several hundred miles of ocean.

Cardinals

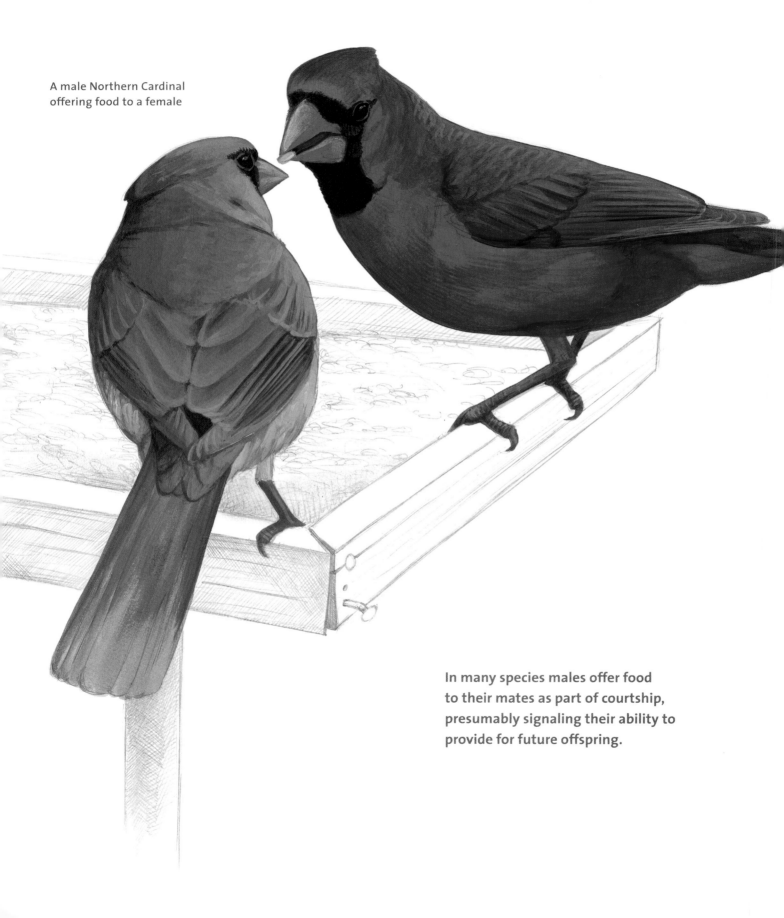

A male Northern Cardinal offering food to a female

In many species males offer food to their mates as part of courtship, presumably signaling their ability to provide for future offspring.

■ The pointed crest of a Northern Cardinal is strictly feathers. The shape of the featherless head can be seen on this page. Some extra-long feathers grow from the top of the head, and can be raised and lowered at will. When the feathers lie flat against the crown they form a point sticking out at the back of

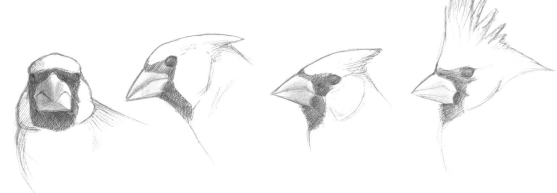

A Northern Cardinal with crest raised and lowered

the head. When the crest feathers are raised, they form a tall, shaggy triangle. Birds with crests use them to communicate, generally raising the feathers when they are excited or aggressive, and lowering the feathers when they are relaxed or submissive.

■ When it leaves the nest, a young Northern Cardinal has a dark bill without any bright color. A few weeks later the dark color will have faded and the bill becomes bright orange-red like the adults. The feathers on these juvenile birds are often relatively flimsy, having been grown quickly as part of a strategy to fledge from the nest as soon as possible. They will be replaced by more adult-like feathers within a few weeks, before the harsher weather of winter sets in.

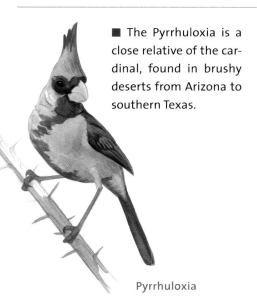

A young cardinal just a few days after leaving the nest

■ Normally when birds molt they do so gradually, looking a little ragged but fully feathered throughout. Occasionally, a cardinal loses all of its head feathers at once, revealing the dark gray skin and the ear opening. The feathers soon grow back, and there is little risk to being bald for a short time as long as the weather is not too cold or wet. This condition has been recorded mainly in a few suburban species in eastern North America. One Blue Jay kept in captivity molted all of its head feathers this way for eight years in a row, suggesting that this can be a normal strategy. But it's still not clear why it is triggered in some individuals.

A male Northern Cardinal with all of its head feathers missing

■ The Pyrrhuloxia is a close relative of the cardinal, found in brushy deserts from Arizona to southern Texas.

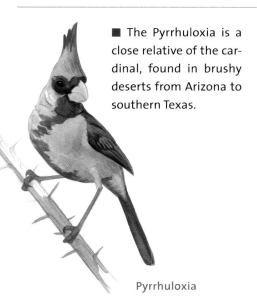

Pyrrhuloxia

■ Birds are very sensitive to day length, and changes in day length trigger hormonal changes. Male cardinals sing from conspicuous perches on treetops or wires beginning on the first sunny days after the winter solstice. This happens even when the air is cold and the ground covered with snow, and early observers were understandably encouraged by this brilliant red bird, singing as confirmation that the days were getting longer and spring was on the way. Descriptions of the song reflect this optimism, as the bird was thought to be saying *cheerily cheerily cheer, cheer, cheer, cheer* and other similar phrases.

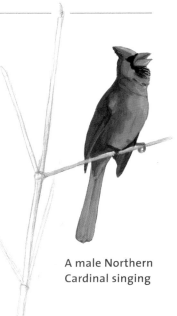

A male Northern Cardinal singing

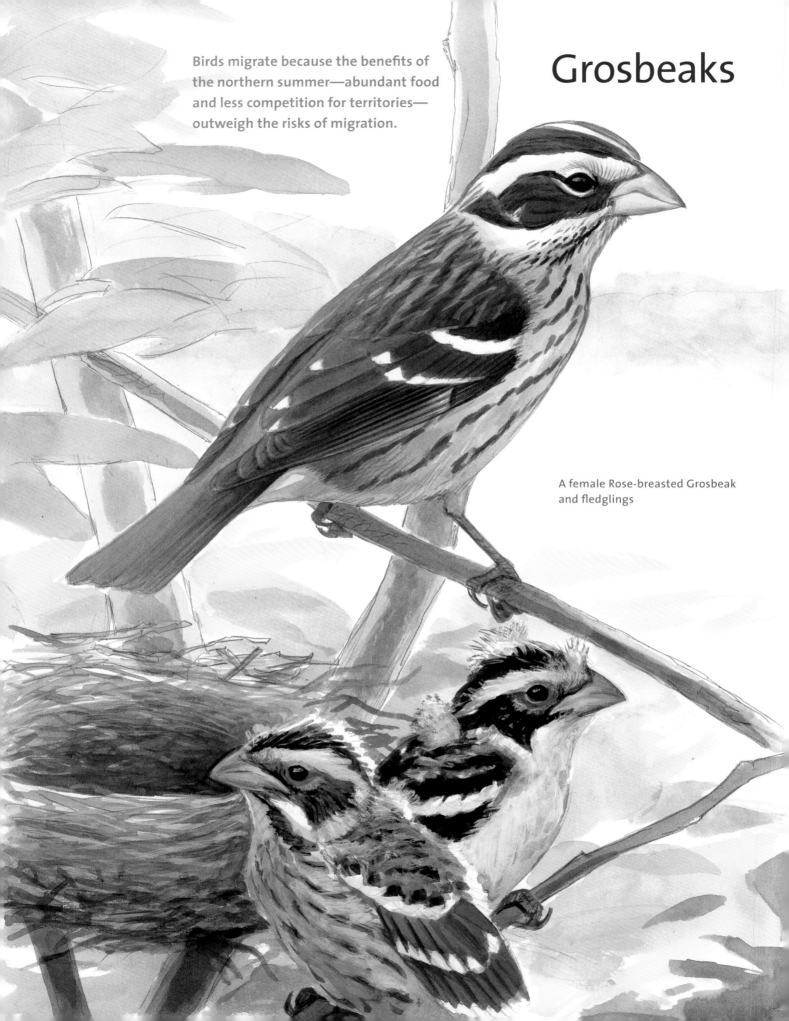

Birds migrate because the benefits of the northern summer—abundant food and less competition for territories—outweigh the risks of migration.

Grosbeaks

A female Rose-breasted Grosbeak and fledglings

■ Much of what birds do depends on an incredibly precise sense of body position, such as balancing on a tiny twig (see p. 121 top), standing on one leg (see p. 35 bottom), and negotiating the intricacies of flying (see p. 83 top). One reason this ability is beyond our comprehension is that birds do it with the help of an additional balance sensor, located in their pelvis! Having a motion sensor in the pelvis, along with one in the head (in the inner ear, much like ours), means they can keep track of the movement of two body parts independently. If their body is moving up and down because their perch is swaying, they can compensate for that while keeping their head stationary. Or if they spin their head around in rapid scanning or preening, it doesn't affect their ability to balance; they know that only their head is moving, not their body.

A Black-headed Grosbeak balancing on a twig with the help of an extra balance sensor in its pelvis

■ A large bill like a grosbeak's is designed for cracking large and hard seeds. The real key to being able to crack hard seeds is stronger jaw muscles. Larger and stronger muscles require a wider and stronger jaw, and also require a larger, reinforced bill to withstand the extra bite force generated by the larger muscles. The large bill is really a secondary adaptation made necessary by the more powerful jaw muscles. At bird feeders these species enjoy sunflower seeds, and are among the few birds that can crack and eat safflower seeds, which are too hard for most birds to open. In the wild their diet is 20 percent fruit, more than 50 percent insects, and only 30 percent seeds. It's not clear where or when their massive bill is necessary, but apparently they benefit from being able to crack hard seeds at some point during the year.

A Rose-breasted Grosbeak, showing large bill and wide jaw

■ Birds have a third eyelid called the nictitating membrane, a thin translucent or clear membrane that flicks across the eye from front to back to protect the eye while still allowing some vision. It's rarely seen in real life, because it moves so quickly and usually closes when the bird is engaged in some rapid action. It is probably used a lot in flight to guard against oncoming insects, dust, twigs, and other hazards. Flycatchers and other songbirds use it as they snap up an insect in flight. Woodpeckers close it as their bill hits wood. This grosbeak is closing it as the husk of a seed cracks. Grosbeaks open seeds by using the cutting edges at the side of their bill, positioning the seed lengthwise along the edge and biting down to split it open, then manipulating the shell and the seed with their tongue. Pieces of the shell are pushed away and dropped from the side of the bill, while the seed is saved.

A Rose-breasted Grosbeak with the nictitating membrane mostly closed

Buntings

Males and females of nonmigratory species generally share "household chores" and look similar. In migratory species like buntings, males take on more territorial defense and are more brightly colored, and females do more of the nesting chores where drab colors are an advantage.

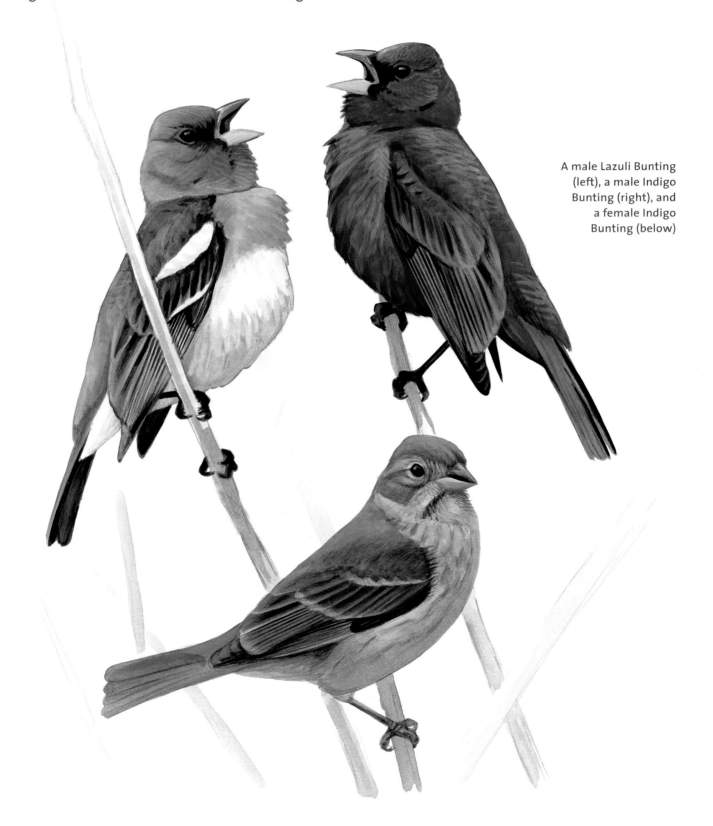

A male Lazuli Bunting (left), a male Indigo Bunting (right), and a female Indigo Bunting (below)

■ The bird respiratory system is fundamentally different from ours, and much more efficient. Instead of flexible lungs that expand and contract with each breath, birds have rigid lungs and air flows through continuously in one direction, back to front. Air flow and storage is managed by a system of air sacs, and breathing is controlled by the muscles of the rib cage. Because the lungs don't move, the membranes for gas exchange can be thinner than in our lungs. This also allows intertwined tiny air passages and blood vessels to be arranged with a countercurrent flow (see p. 15 top), which transfers a lot more oxygen to the blood than in human lungs. It is thought that this breathing system evolved in dinosaurs more than 200 million years ago, at a time when the earth had only half as much oxygen as today, and birds now reap the benefit. Birds are essentially never out of breath, and if you see a bird panting after exertion it is because of overheating (see p. 143 middle). In experiments, hummingbirds can still fly at an oxygen level equivalent to 43,000 feet elevation! That's 50 percent higher than Mount Everest.

The respiratory system of a bird: the air sacs occupy a large part of the body of a bird, and some air sacs extend into the larger bones (not shown).

■ One of the most colorful birds in the world, the Painted Bunting is found in the southeastern United States from South Carolina to Texas. The adult male is an incredible rainbow of brilliant colors; females and immatures are a much plainer olive overall. The population nesting along the Atlantic coast of the southeastern U.S. is declining: one reason is the species' popularity as a cage bird in Cuba, where they are trapped in the winter. Trapping them is illegal, but this is rarely enforced.

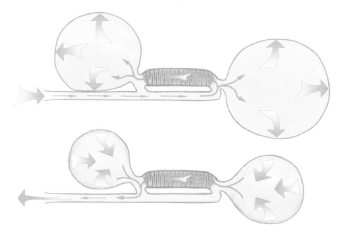

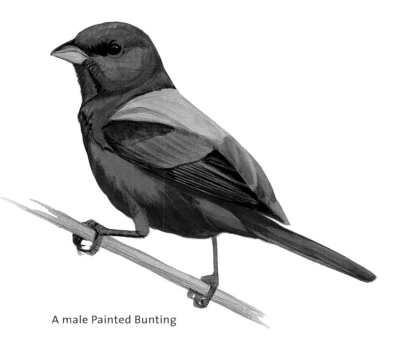

A male Painted Bunting

A greatly simplified schematic diagram of a bird's respiratory system, with air sacs in blue and lungs in purple. The air sacs expand to inhale (top) and contract to exhale (bottom), and fresh air always flows from back to front (right to left) through the lungs.

■ When the rib cage expands, air is pulled into the body. The expansion of the rear air sacs pulls fresh air in from outside, and the expansion of the front air sacs pulls fresh air forward through the lungs. When the rib cage contracts, air is forced out of the body. The front air sacs (holding "used" air) empty to the outside, while fresh air from the rear air sacs is pushed forward through the lungs. It is not known why air follows certain paths and not others. For example, inhaling causes the front air sacs to pull air through the lungs and not from outside. No evidence of physical valves has been found, and apparently it is simply the angles of connections in the airway that cause air to flow one way and not another.

Towhees

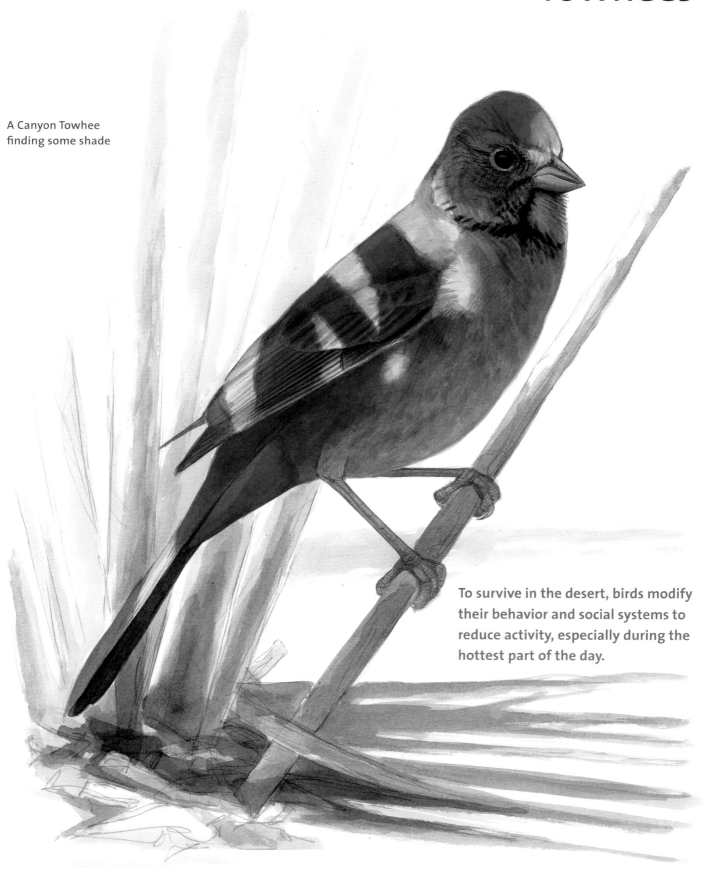

A Canyon Towhee finding some shade

To survive in the desert, birds modify their behavior and social systems to reduce activity, especially during the hottest part of the day.

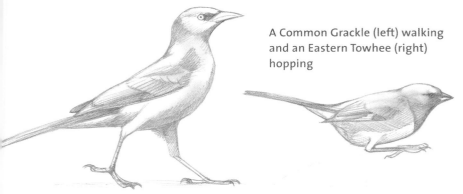

A Common Grackle (left) walking and an Eastern Towhee (right) hopping

■ Why do some birds walk and others hop? It's not clear. In general, larger species mostly walk while smaller species mostly hop (for example, crows walk, while jays and towhees hop). One potential advantage is that walking allows the chicken-like head-bobbing motion and maintains a more continuous view of the surroundings (see p. 75 top). Hopping may be more efficient for smaller species, with one hop carrying them farther than several steps, and hopping may be too much work or too much impact for heavier species. In reality the distinction is not clear, and a recent study examining video of a few species found that all of them, at all speeds, use both walking/running and hopping, and just as often use a variety of mixed gaits in between walking and hopping.

■ The double-scratch maneuver is designed to kick leaves and other debris backward, exposing potential food (see p. 7 middle). The bird simply jumps straight up, and while its body is in the air, the feet swing forward and then rake back across the ground, sending debris flying. Coming to rest in the typical standing position, the bird studies the ground around its feet to see what has been uncovered. The bird can also use the raking motion itself to push the body up each time, so a towhee can execute several double scratches without a break, bouncing up and down and sending leaves flying behind it, then pausing to examine the newly exposed ground.

■ Do birds need to drink? Yes, birds need water. They like to drink a lot of water (especially in hot weather), but they can get by with almost none if they need to. In one experiment, House Finches given access to unlimited water, and at a comfortable 68°F, drank an average of 22 percent of their body weight in water each day (for a one-hundred-pound person that would be almost three gallons of water!). At 102°F that amount doubled to nearly half of their body weight. Birds don't sweat. Instead they cool off by panting and evaporating water from their throat (see p. 143 middle). Even though they drink a lot when they can, most birds survive just fine without drinking as long as they have food with some water in it, like fruit or insects. Just like humans, birds reduce their water needs when necessary by reducing activity and staying cool.

The Eastern Towhee, like most birds, drinks by bowing down and scooping water into its mouth.

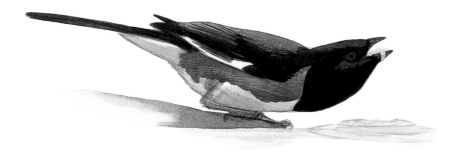

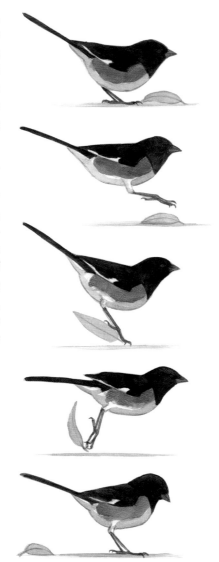

An Eastern Towhee showing the sequence of a double-scratch motion

153

Juncos

These three are all regional variations of the same species. The three subspecies shown here are known as Slate-colored Junco (top, found mainly north and east), Oregon Junco (middle, found across the west), and Gray-headed Junco (bottom, found in the southern Rocky Mountains).

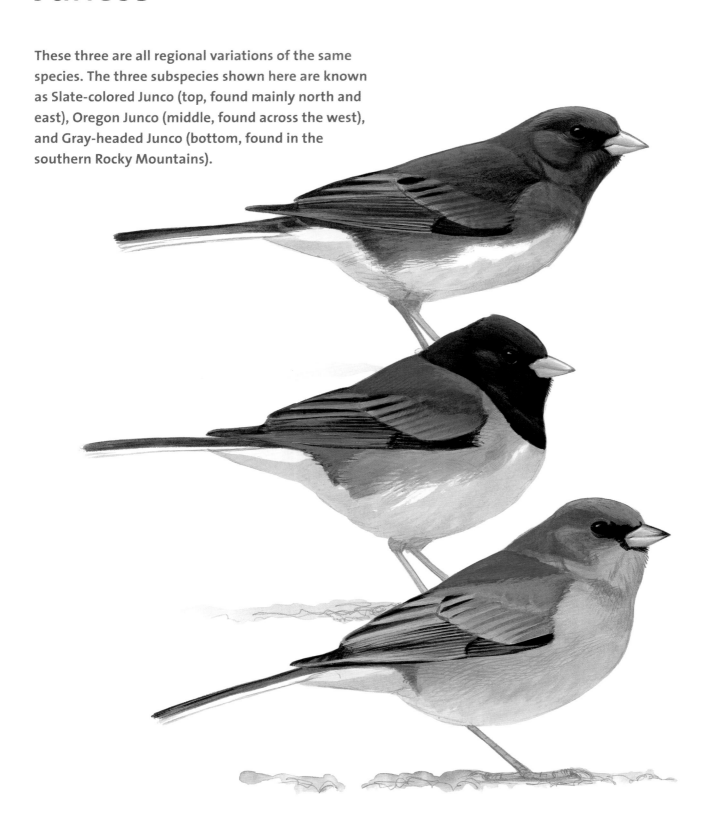

Three subspecies of Dark-eyed Junco

It's December—why are there almost no birds using my feeder?

The most likely answer is that they are finding plenty of natural food and simply don't need to supplement that with the bird feeder. Even if you are offering high-quality food in unlimited amounts, it probably requires some compromise or risk to reach it, like traveling across open areas (see p. 115 top). The birds may be more comfortable foraging all day in dense weedy thickets where they can stay hidden and find a diverse array of natural seeds and fruit, and even the occasional insect or snail. Once the winter weather closes in, and natural food supplies dwindle, bird feeders become the best option for many birds and you should see a normal number of birds making the trek to your feeder.

Dark-eyed Juncos

Is a bird feeder just providing easy pickings for predators?

No. Studies show that predation at feeders is lower than in more natural settings. This is presumably because there are more birds watching for danger and sounding the alarm for any nearby threat. Feeders do pose a threat by indirectly increasing nest predation in the summer. Populations of crows, grackles, cowbirds, chipmunks, and others increase when they have access to feeders in the winter, and those species then go after nests in the spring. Some studies have found that species like cardinals and robins raise almost no young in neighborhoods with feeders.

Is my bird feeder making birds lazy?

No. Studies show that even birds that have lived with feeders for generations still get at least half of their food from the wild and use the artificial food only as a supplement. They suffer no ill effects when the feeders are removed. Feeders help them get through extreme winter weather when natural food is hard to find (such as an ice storm) but otherwise have little impact on survival.

Will feeding birds keep them from migrating?

No. The decision to migrate is based on many different factors, including date, weather, and the bird's body condition and fat reserves. If anything, it's possible that feeders might prompt birds to leave *sooner*, by making it easier to "fill the tank" before a long flight.

■ Most songbirds spend the summer as a pair on a territory, raising one or two broods of young, then go their separate ways migrating to the wintering grounds. In the case of juncos, females tend to migrate farther than males, and first-winter birds farther than older birds. At the southern edge of the winter range you would see a higher percentage of immature females, and closer to the breeding grounds more adult males. Many other species of songbirds do not segregate by age or sex, and each individual will return to the same small winter territory each year, in the same way that they are faithful to a summer territory.

Dark-eyed Juncos tending their nest

Sparrows

Migration requires a lot of information, and birds weigh many different factors before they decide to launch into the night sky to fly hundreds of miles.

A White-crowned Sparrow beginning a night of migration

■ Much of what is known about song learning in birds is based on studies of White-crowned Sparrows. Young birds are genetically predisposed to learn the song of their own species, and to ignore the songs of other species. They memorize song patterns that they hear before they are three months old. Soon they begin to practice singing, gradually developing vocal control and refining their song until they can consistently reproduce the song model they memorized in their first few months. They will continue to sing this song, more or less unchanging, for the rest of their lives.

A White-crowned Sparrow singing

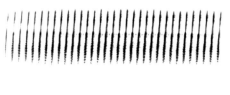

1 sec 2 sec 3 sec

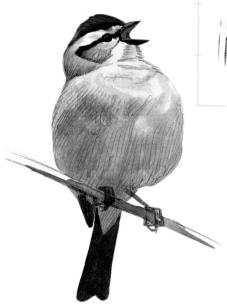

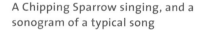

A Chipping Sparrow singing, and a sonogram of a typical song

■ The song of a male Chipping Sparrow sounds like a simple trill: one note repeated rapidly on the same pitch. To us they all sound pretty much alike, but the birds are a lot more discerning. Birds can process sounds at least twice as fast as we can, so to get closer to what a bird hears we should listen to a recording at half speed or slower. In this case a simple trill is a rapid series of upslurred notes—a vocal performance that depends on exacting control and synchronization of the muscles in the two-parted syrinx (see p. 131 middle). This has to be coordinated with breathing, bill position, and body movements to create a song that is precise and consistent. One study found that sparrows can sing notes with a wide range (from low to high), or notes repeated rapidly, but they can't maximize both in the same song. We could think of a bird's song as a kind of dance or gymnastics routine, a series of elaborate jumps, and the judges (potential mates and rivals) are looking for height and speed, along with precision and consistency.

Why do birds lay eggs?

One egg is a huge investment. The yolk builds up slowly, and after a fertilized yolk is released from the follicle it takes another twenty-four hours before the egg is laid. It begins in the oviduct, where albumin (egg white) is added (in about four hours); then to the uterus, where the shell is formed (fifteen hours); and finally any coloration is added to the shell (five hours). A complete egg can be anywhere from about 2 percent to 12 percent of a female's body weight; smaller birds and birds with precocial young produce relatively large eggs. The advantage of eggs is that the female can produce multiple eggs in a short time, and deposit them in a nest. The embryos grow and develop in the nest while the mother's mobility is not compromised. If she carried four or five developing embryos and gave birth to live young, flight would not be possible during that time.

A female Chipping Sparrow with one fully formed egg

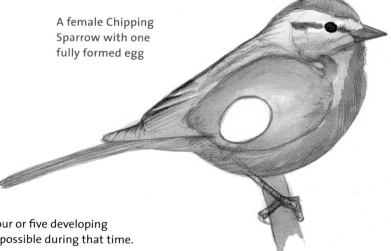

More Sparrows

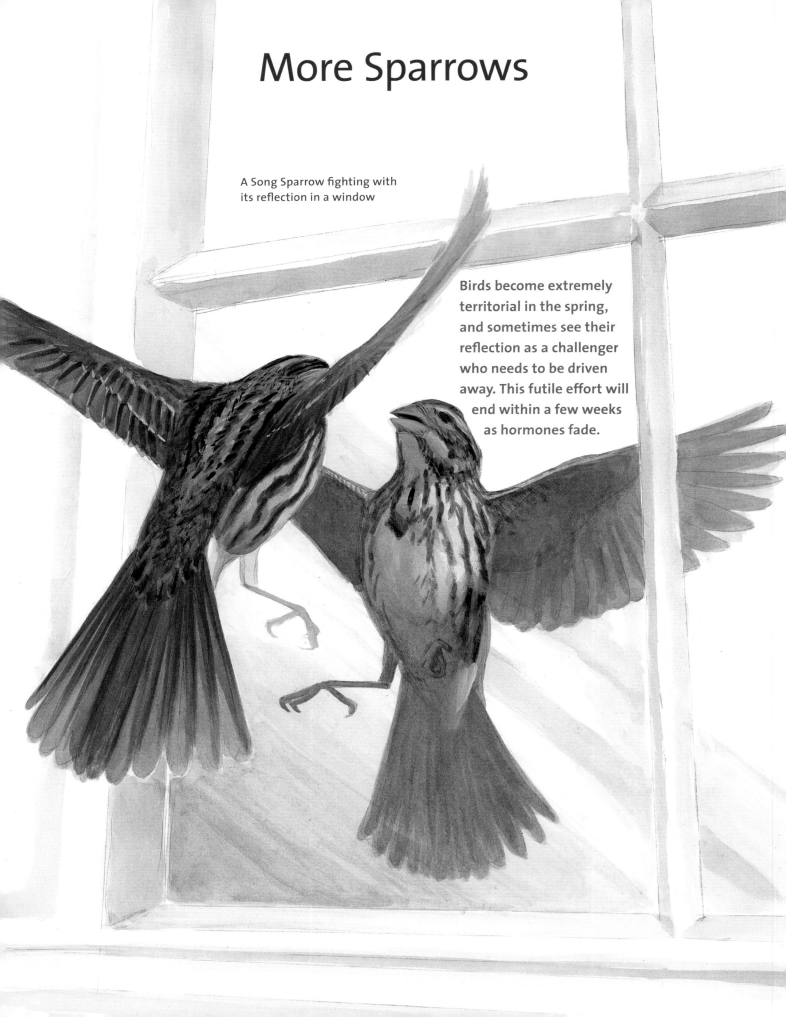

A Song Sparrow fighting with its reflection in a window

Birds become extremely territorial in the spring, and sometimes see their reflection as a challenger who needs to be driven away. This futile effort will end within a few weeks as hormones fade.

■ As humans transform the landscape we also transform the soundscape. The industrialized world is awash in low-frequency noise. Since sound is such an important means of communication for birds, any extra noise has a significant impact on them. Surveys find reduced populations of many species near roads, industrial sites, and other noisy environments, and much of this decline is attributed to noise. Some species (such as the Mourning Dove, with its low-pitched song) simply avoid nesting in noisy places. Birds that do live in noisy places are shifting the pitch of their songs higher, which helps to

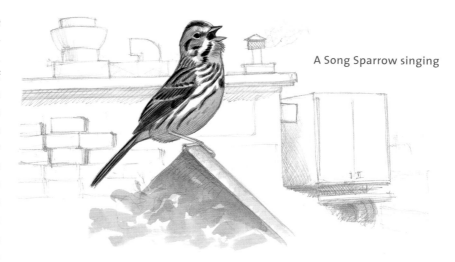

A Song Sparrow singing

differentiate their sounds from low-pitched noise. It's not clear whether songs are actually changing as a direct adaptation to communicate better through the noise, or whether birds simply try to sing louder in noisy places, and produce higher-pitched sounds when they "shout."

■ Wild birds face two competing risks every day—starvation and predation. They must eat without being eaten, and they have to find enough food every day to last through the long night. Finding food requires searching, often in the open, and eating adds weight that slows a bird down. They are constantly assessing the risks and the benefits of any potential food source. Experiments have shown that when birds know that predators are around, they delay feeding until later in the day. That way they stay light and agile through the afternoon, and put on weight just before they go to sleep.

A Song Sparrow foraging at sunset

■ Across its wide range, from Atlantic to Pacific and Mexico to Alaska, the Song Sparrow shows a lot of variation in size, shape, and color. Most of this variation follows some general patterns that are shared with other wide-ranging species. Birds living in more humid climates (like the Pacific Northwest) tend to be darker than those in drier climates. One obvious benefit is that those colors match the surroundings better; an additional benefit is that the dark pigment melanin helps protect the feathers from bacteria, which are more active in humid climates. Another broad trend is that birds in hotter climates have relatively large bills and feet. This helps them regulate their body temperature by allowing more heat to escape from those uninsulated parts. In cold climates smaller feet and bills help reduce heat loss.

Song Sparrows from hot and dry Arizona (left), and cool and humid British Columbia (right)

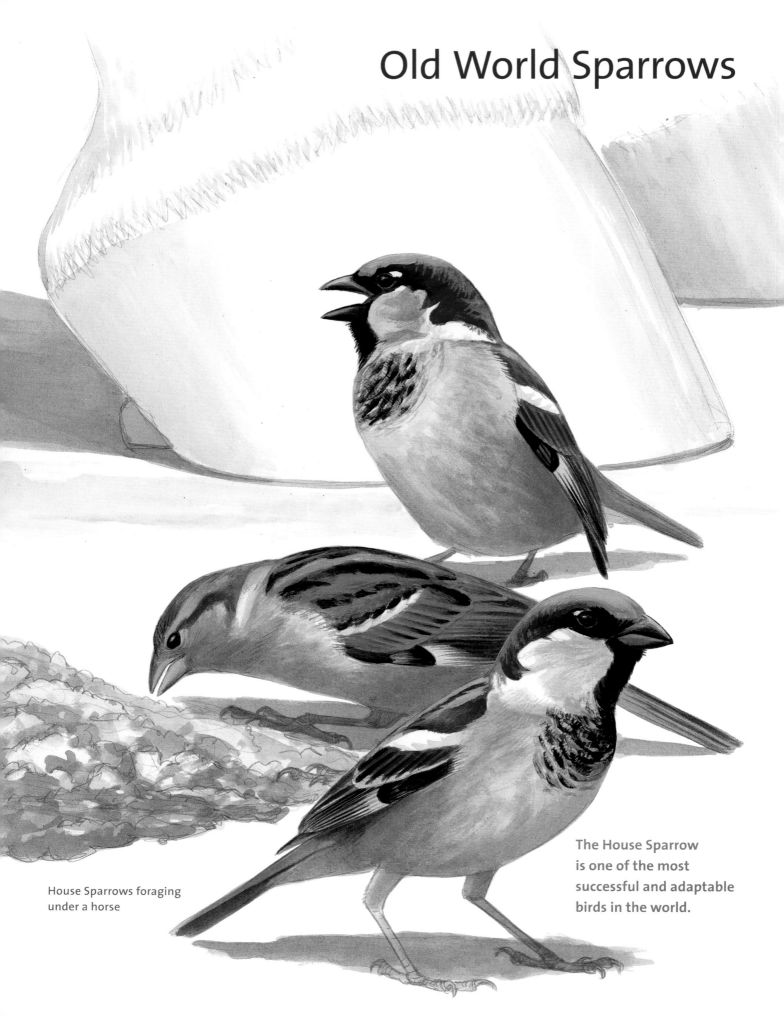

Old World Sparrows

House Sparrows foraging
under a horse

The House Sparrow
is one of the most
successful and adaptable
birds in the world.

■ House Sparrows thrive around people, and genetic studies have traced this to the beginning of human agriculture in the Middle East about ten thousand years ago. House Sparrows adapted by growing slightly larger bills to take advantage of the larger and harder grain being grown in large quantities by humans. As agriculture spread around the world, the human-adapted House Sparrows spread with it and continued to adapt. Before 1900, horse-drawn carriages and livestock were everywhere, offering plenty of spilled grain and other food. When House Sparrows were brought to North America in the mid-1800s, they had spent ten thousand years adapting to humans, and quickly spread throughout the farms and cities of this continent. Their populations have declined steadily over the last one hundred years, however, as farms and livestock have disappeared from large areas.

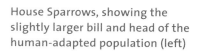

House Sparrows, showing the slightly larger bill and head of the human-adapted population (left)

A House Sparrow in flight, with all feathers outlined

How many feathers does a bird have?

Few attempts have been made to count all of the feathers on a bird, but enough to make some general statements. Small songbirds like House Sparrows have about 1,800 feathers in the summer:

 About 400 on the head
 600 on the underside of the body
 300 on top of the body
 400 on the wings (200 on each wing, mostly small coverts at the leading edge)
 100 on the legs
 12 in the tail

Songbirds in cold climates have more feathers in the winter—about 2,400 total—adding about 600 small downy feathers on the body. Larger land birds like crows have a few more feathers than small birds, but mostly they just have larger feathers. Water birds have a lot more feathers, particularly on the parts that are in contact with water (see p. 7 middle).

■ Dust bathing is a common behavior in certain species, such as the House Sparrow. You might find small bowl-shaped depressions in the ground where House Sparrows habitually take dust baths. The birds' motions are similar to a typical water bath, crouching into the dust and then shaking the wings to move dust up and over the body. The reason for dust baths is unknown, but one hypothesis is that the dust interacts with preen oil in some beneficial way. The right amount of preen oil helps waterproof and condition the feathers, inhibits bacteria, and so on. Too much oil could cause feather barbs to stick together, provide food for bacteria and parasites, and more. Dusting may be a way to control oil levels or change some of the oil's properties.

A female House Sparrow dust bathing

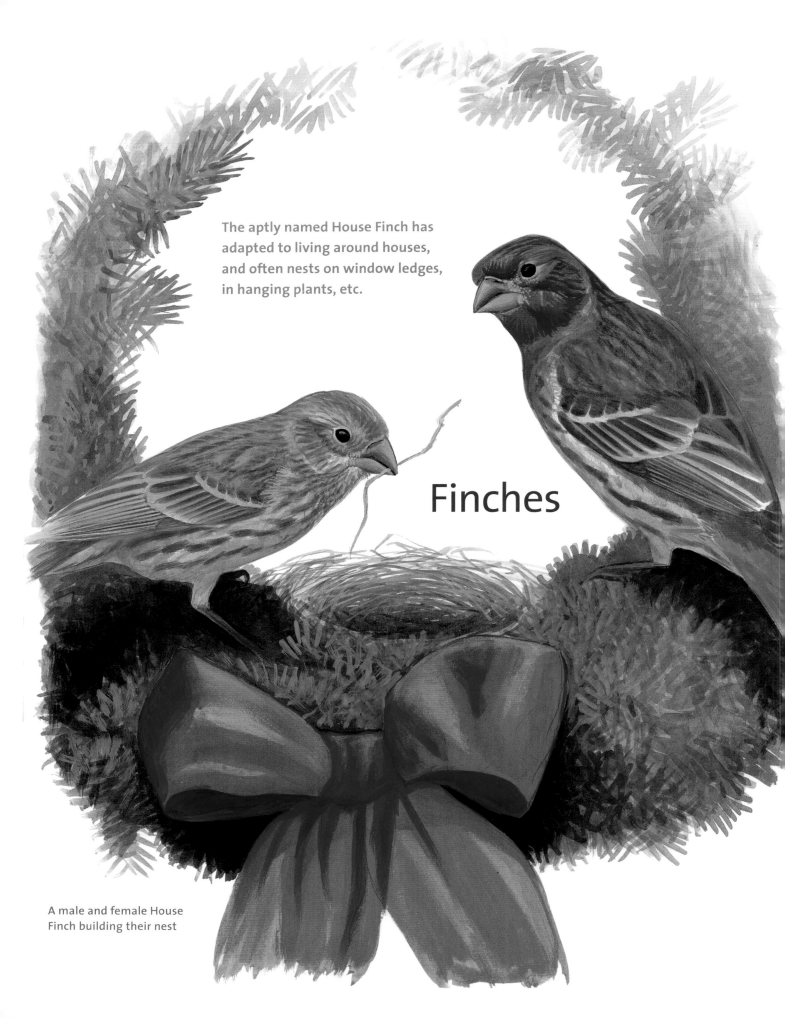

The aptly named House Finch has adapted to living around houses, and often nests on window ledges, in hanging plants, etc.

Finches

A male and female House Finch building their nest

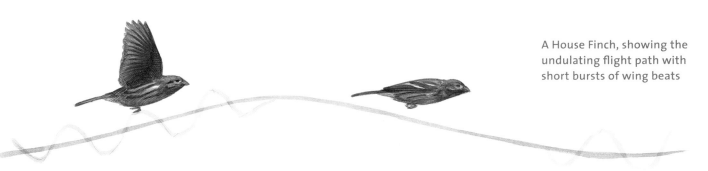

A House Finch, showing the undulating flight path with short bursts of wing beats

■ Almost all songbirds fly on an undulating path with alternating short bursts of wing beats and brief glides. In the glide phase the wings are folded tightly against the body, and the birds gain some lift from the body and tail, but are mainly just falling. Closing the wings creates a streamlined torpedo shape and reduces drag; at higher speeds this is more efficient and birds actually flap less and glide/fall more. At slower speeds calculations suggest that alternating flapping and falling is not the most efficient mode of travel, but so many birds do it that there must be other, still unknown, advantages. It's possible that intermittent flapping handles turbulence better, or that brief pauses allow the birds to rest and cool off, or that the birds are physically unable to position their wings any other way.

■ All red, orange, and yellow color in songbirds comes from carotenoid pigments, which must be acquired in their diet. These compounds create the red and yellow colors found in many fruits and vegetables, the colors of fall leaves, and much more. Birds' systems then modify the carotenoid molecules to produce a consistent shade of red to yellow color. Carotenoids are also essential for the immune system, so it has long been thought that bright color is a useful signal of health. If a bird is sick, it needs carotenoids to fight the disease and won't be able to spare much for feather color. Therefore, a bird with bright feathers must have been healthy when those feathers grew. In House Finches, males range from bright red to yellow and the link between color and health is unclear. The percentage of yellow males varies regionally—there are more in the Southwest, and many in Hawaii—and the color probably has more to do with the specific carotenoids available and how it was processed, and less to do with fitness.

A typical male House Finch with red color (left) and one with yellow instead

■ It's rare to see sick birds, because even a minor illness is a very serious risk. It makes a bird slower and less alert, and therefore much more vulnerable to predators. One disease that is sometimes seen at bird feeders is an eye infection called conjunctivitis. This is highly contagious and spreads through close contact such as at bird feeders. An epidemic of conjunctivitis spread across the eastern U.S. in the mid-1990s, affecting mainly House Finches. The disease is still present but less frequent now. Making sure your bird feeders and the areas around them are clean is one important way to reduce the chance of disease. If you do see any birds at your feeder with conjunctivitis, it is recommended to take all of the feeders down and clean them with bleach, and rake away any seeds and droppings underneath the feeders. This is all good bird feeder housekeeping and should be done regularly even if you don't see any signs of disease.

A male House Finch with conjunctivitis

Goldfinches

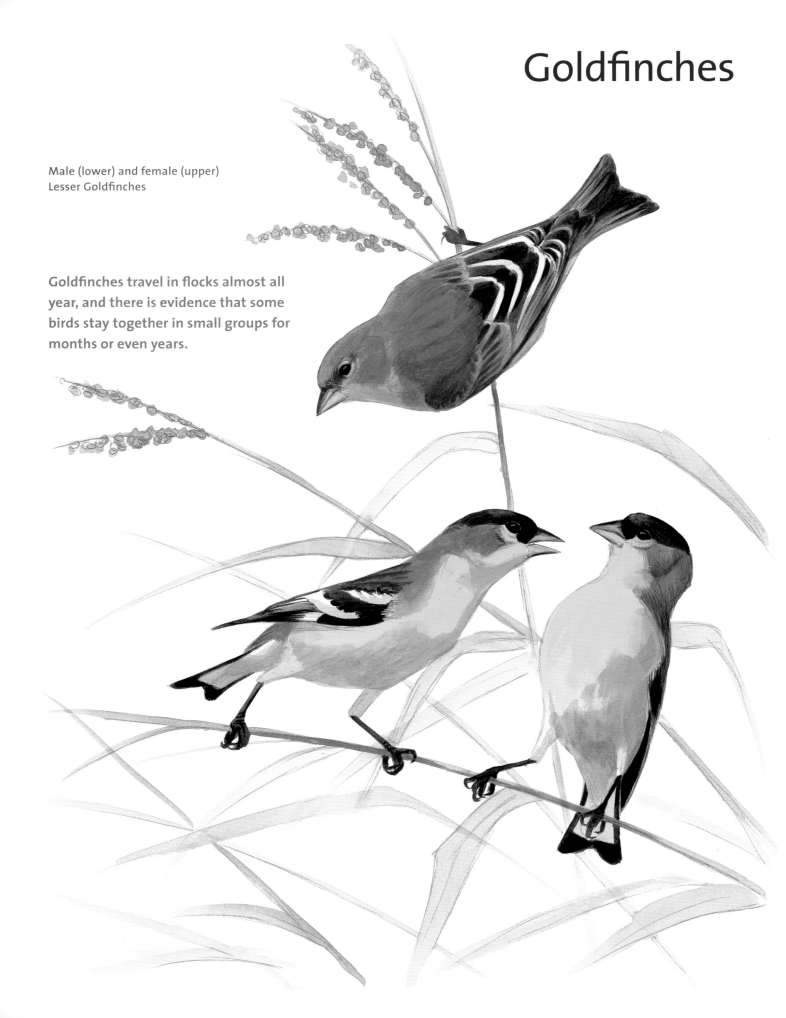

Male (lower) and female (upper)
Lesser Goldfinches

Goldfinches travel in flocks almost all
year, and there is evidence that some
birds stay together in small groups for
months or even years.

■ All birds molt (see pp. 5 middle and 95 top). Many birds molt once a year and simply replace their old feathers with a similar-looking set. Other species—such as the American Goldfinch—molt twice a year and change their appearance dramatically with the seasons. In terms of time and energy, it is "expensive" to grow a whole new set of feathers, so goldfinches (like many other species) undergo their complete molt of all body and wing feathers in the late summer. At

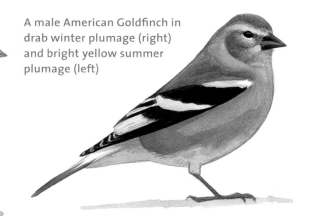

A male American Goldfinch in drab winter plumage (right) and bright yellow summer plumage (left)

this season they can expect mild weather and plenty of food, and molting fits in between nesting and migration. In the late summer the goldfinch grows drab feathers that help camouflage it through the winter. Six months later, in the early spring before nesting begins, goldfinches molt all of their body feathers again (but not the wing or tail feathers) and males transform into the showy yellow and black colors they need for courtship. Hormones control the switch that allows the same feather follicle to grow very different feathers at different seasons.

The body feathers of a male American Goldfinch, with a ray of light penetrating several layers and reflecting off each one

■ The brilliant yellow color of a male goldfinch requires more than just bright yellow pigment; there is a secret to the glowing quality of the color. A single feather is thin and translucent, so most light goes right through it, and a single feather does not reflect enough light to be very impressive. Goldfinch feathers are bright yellow at the tip (the part that is exposed) and bright white at the base. The way the feathers are arranged on the bird, the yellow tips of several feathers overlap. Some light reflects off the outer yellow surface of each feather, and light that passes through is reflected back out by the bright white of the feather bases. The feathers of a goldfinch essentially form a translucent yellow film with backlighting.

■ Several species of small finches live in the boreal forest across Canada and Alaska, and their life cycle is closely tied to the seed production of certain species of trees. The trees' strategy is to produce very few seeds for several years to reduce the population of seed eaters, then produce so many seeds in one year that there is no way they can all be eaten. Many conifers produce seeds about every seven years. The Common Redpoll is linked to birch trees, which tend to produce large crops of seeds every other year. With an abundant seed crop more redpolls survive the winter and raise more young, increasing the population, and the following year (when the birches produce few seeds) the redpolls move south in search of food. These unpredictable movements are called *irruptions*, and are always an exciting event for birdwatchers.

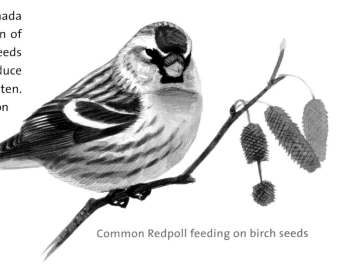

Common Redpoll feeding on birch seeds

Bobolinks and Meadowlarks

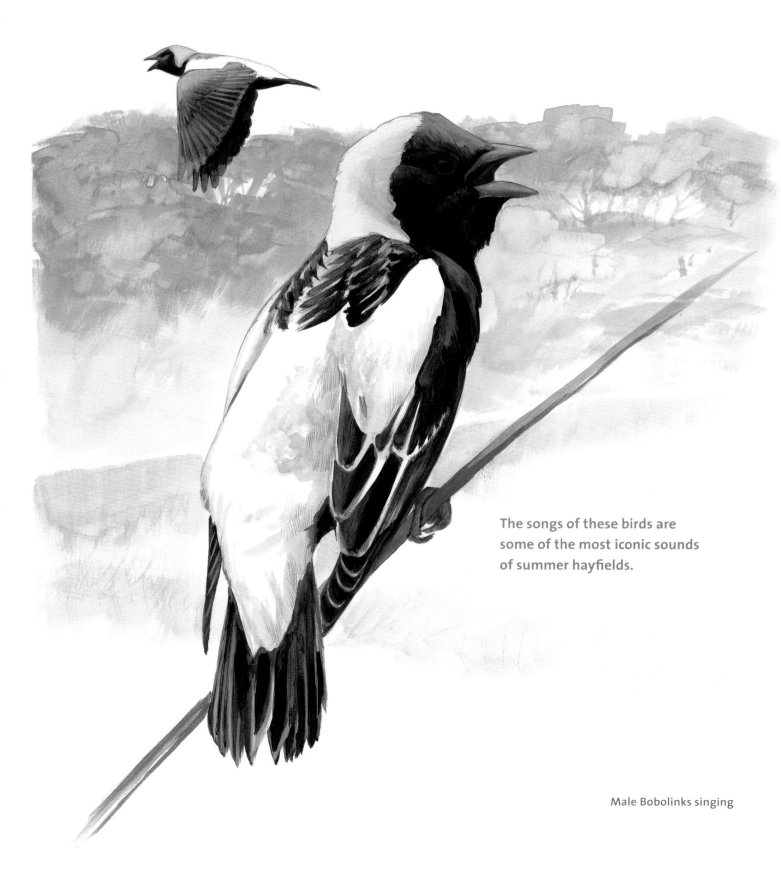

The songs of these birds are some of the most iconic sounds of summer hayfields.

Male Bobolinks singing

■ Male Bobolinks display by singing in flight, and females apparently prefer males with longer flight songs. Exercise such as flying generally requires steady breathing, but singing involves complex breath control. And the song of the Bobolink is extreme: it can be over ten seconds long with more than one hundred phrases. If we try to run and sing at the same time, we end up gasping for air, so how do birds balance these two activities? For one thing, their lungs are much more efficient than ours (see p. 151 bottom right). When we fill our lungs with air, the oxygen is rapidly absorbed. We can exhale to sing, but we won't get more oxygen until we inhale fresh air. A bird can store fresh air in its air sacs, and as that air is exhaled to produce song it also delivers fresh oxygen to the lungs. Singing in flight is still a remarkable feat, but getting enough oxygen could be one of the smaller issues.

A male Bobolink
singing in flight

■ Birds and farming have always had a complicated relationship. Farmers blame birds for damaging crops, but also appreciate the insect control that birds offer—birds consume more than 500 million tons of insects a year worldwide. Small family farms have provided lots of high-quality bird habitat in hedgerows, weedy edges, pastures, and other sites. As recently as the early 1900s much of the eastern United States was farmed, and species like the Eastern Meadowlark and Bobolink thrived, nesting on the ground in the open meadows and hayfields that were a part of every farm. With the decline of farming in many areas, and a more industrialized style of farming, most of this habitat is now gone. Even where hayfields still exist they are essentially traps: hay is cut multiple times in a season, and there is not enough time between cutting for birds to complete a nesting cycle.

A meadowlark singing
in a hay field

■ Meadowlarks are unusual in having their sharpest vision oriented slightly above the horizon. Since they spend most of their time on the ground in the open, this may be an adaptation for looking up for danger. Their vision is also oriented forward so they can see the tip of their bill—most birds can't—but this creates a larger blind spot behind the head, which means they have to turn their head more to scan their surroundings.

One of their foraging techniques is to stick their closed bill into matted grass and force the bill open. As the bill opens, the eyes automatically turn slightly forward and down. This gives them a view right between the open mandibles into the gap in the grass, so they can see and grab any potential food.

An Eastern Meadowlark, showing the
line of sight with bill open and closed

Orioles

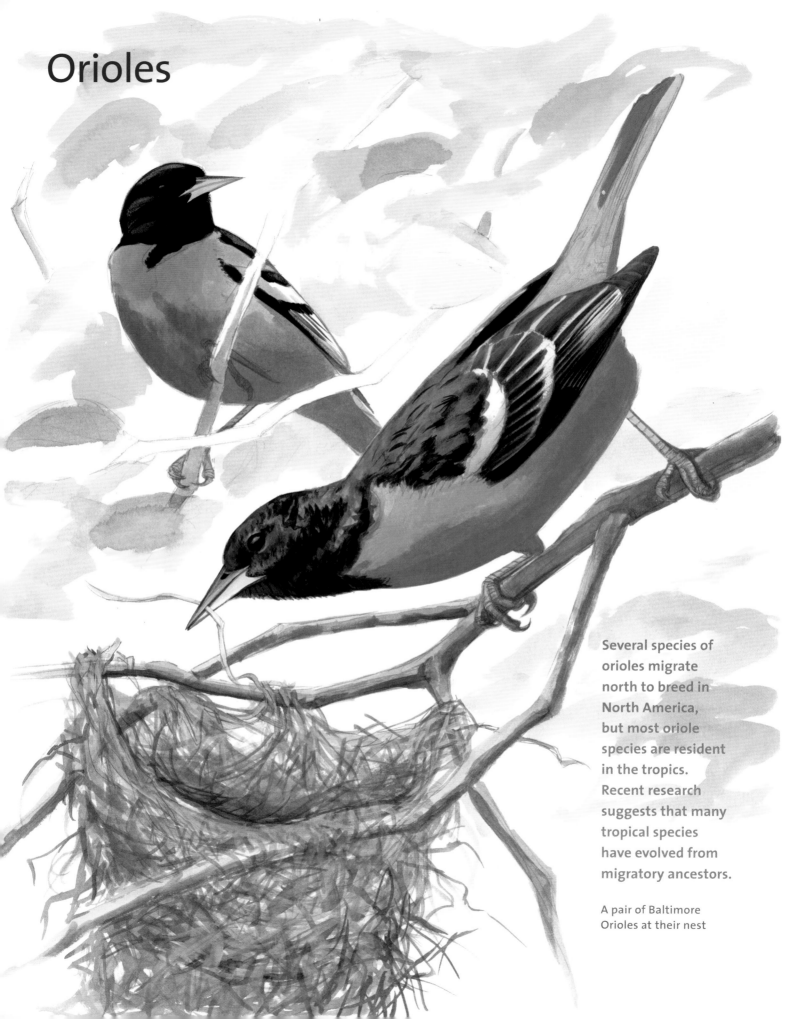

Several species of orioles migrate north to breed in North America, but most oriole species are resident in the tropics. Recent research suggests that many tropical species have evolved from migratory ancestors.

A pair of Baltimore Orioles at their nest

■ The shape of birds' eggs varies in different species from nearly round to more elongated. The non-round eggs can be either symmetrical (extended evenly into an ellipse) or asymmetrical (strongly pointed at one end). Many possible explanations for this variation have been proposed. A recent study comparing a large sample of eggs from fourteen hundred species found a surprising link between egg shape and flight habits. Species that spend more time flying, or are stronger fliers, tend to lay eggs that are less round. This suggests that egg shape has evolved, in part, in response to the requirements of flight, but the reason is still unknown. One possibility is that as birds' bodies evolved to be light and streamlined for efficient flight, round eggs no longer fit. An elongated egg can hold the same volume as a round egg while also being narrower, and might be required in species that are more committed to flight.

The Song Sparrow flies less and lays less pointed eggs (left) than the Baltimore Oriole (right).

Baltimore Oriole Population Chart

The chart below shows just over one year in the population cycle of the Baltimore Oriole (other songbirds are similar). In this chart a breeding population of thirty adults (in blue) produce 100 eggs (yellow). From those eggs fifteen birds return the next spring and join the fifteen surviving adults from the previous year to keep the breeding population at thirty and produce another 100 eggs.

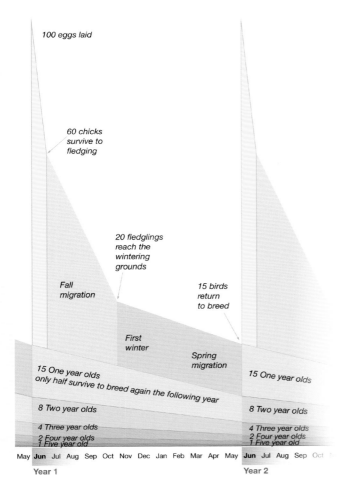

A population graph of Baltimore Orioles

Key points:

- Young birds outnumber adults during fall migration.

- Fully half of each year's breeding population is made up of first-time breeders.

- The entire system is extremely fragile. If no young are produced one year, the population drops by half, and tiny disturbances can nudge the percentages and make the difference between an increasing or declining population.

How long do birds live?

Most individuals live less than one year. If they make it to their first breeding season, songbirds generally have about a 50 percent chance of surviving each year. Given the 50:50 odds, about one songbird out of a thousand would make it to ten years and one in thirty-three thousand would live to fifteen years, but that might be beyond the potential lifespan. Banding records show that the oldest Baltimore Oriole known was twelve years old, and the oldest songbird was an American Robin, at just under fourteen years. Larger birds generally live longer. For example a Bald Eagle reached thirty-eight years. And seabirds are particularly long-lived, with one Laysan Albatross at least sixty-seven years old and counting. These are remarkably long life spans compared with similar-sized mammals, especially considering the high metabolism of birds.

Do birds mate for life?

In songbirds, the answer is "Yes, but . . ." In a Baltimore Oriole pair, if both survive the winter, they will most likely find their way back to the same territory, recognize each other, and make another nesting attempt together. But the male and female each have a 50 percent chance of surviving the year, leaving only a 25 percent chance that both will make it back. So yes, they generally mate for life—but in most cases that only lasts for a single breeding season.

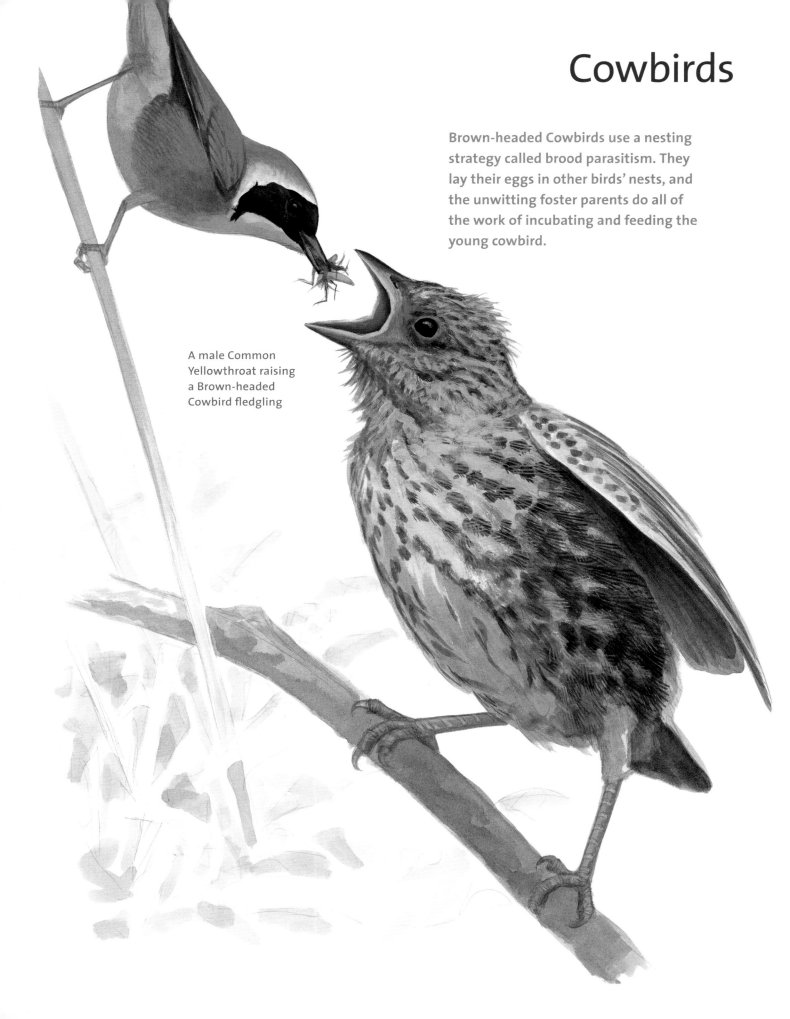

Cowbirds

Brown-headed Cowbirds use a nesting strategy called brood parasitism. They lay their eggs in other birds' nests, and the unwitting foster parents do all of the work of incubating and feeding the young cowbird.

A male Common Yellowthroat raising a Brown-headed Cowbird fledgling

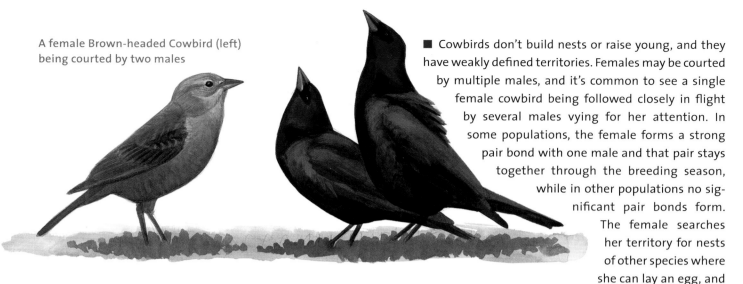

A female Brown-headed Cowbird (left) being courted by two males

■ Cowbirds don't build nests or raise young, and they have weakly defined territories. Females may be courted by multiple males, and it's common to see a single female cowbird being followed closely in flight by several males vying for her attention. In some populations, the female forms a strong pair bond with one male and that pair stays together through the breeding season, while in other populations no significant pair bonds form. The female searches her territory for nests of other species where she can lay an egg, and monitors those nests to determine the best time for adding her egg. She lays one egg in each suitable nest, and can lay dozens of eggs in a season. Most egg laying occurs in the morning, which is when most courtship behavior occurs, and in the afternoon the cowbirds relax.

■ Female cowbirds do not simply lay an egg and leave it; they actually monitor the progress of the egg and the young. If the cowbird finds that her egg has been removed by the host species, she often retaliates by destroying all of the eggs of the host. This slows the spread of anti-cowbird behavior by preventing those birds from reproducing, as well as potentially giving the cowbird another chance to add an egg if the host re-nests. Research suggests that female cowbirds remain in their territory until well after their young have hatched, and that baby cowbirds as young as six days old respond to the characteristic rattle call of female cowbirds. Baby cowbirds have to avoid imprinting (see p. 3 middle) on their foster parents, and the rattle call of the female cowbird may function as a kind of instinctive password that helps cowbirds recognize their own species after they fledge.

A female Brown-headed Cowbird at a nest

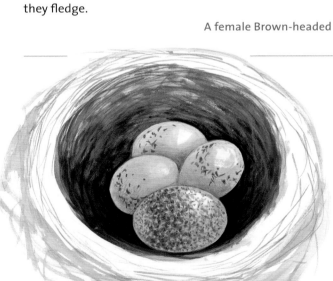

■ Cowbird eggs take fewer days to hatch than other species, so as long as a cowbird egg is added to a clutch before incubation has started, it will hatch before the host's eggs. The young cowbird either pushes the unhatched eggs out of the nest or, being larger and stronger, simply outcompetes the host chicks for food. If a female cowbird finds a nest where incubation has already begun, she may remove those eggs from the nest, presumably as a way to get the host to begin laying a new clutch where the cowbird can sneak in an egg.

A Common Yellowthroat nest with one (larger and more densely spotted) Brown-headed Cowbird egg

171

Grackles

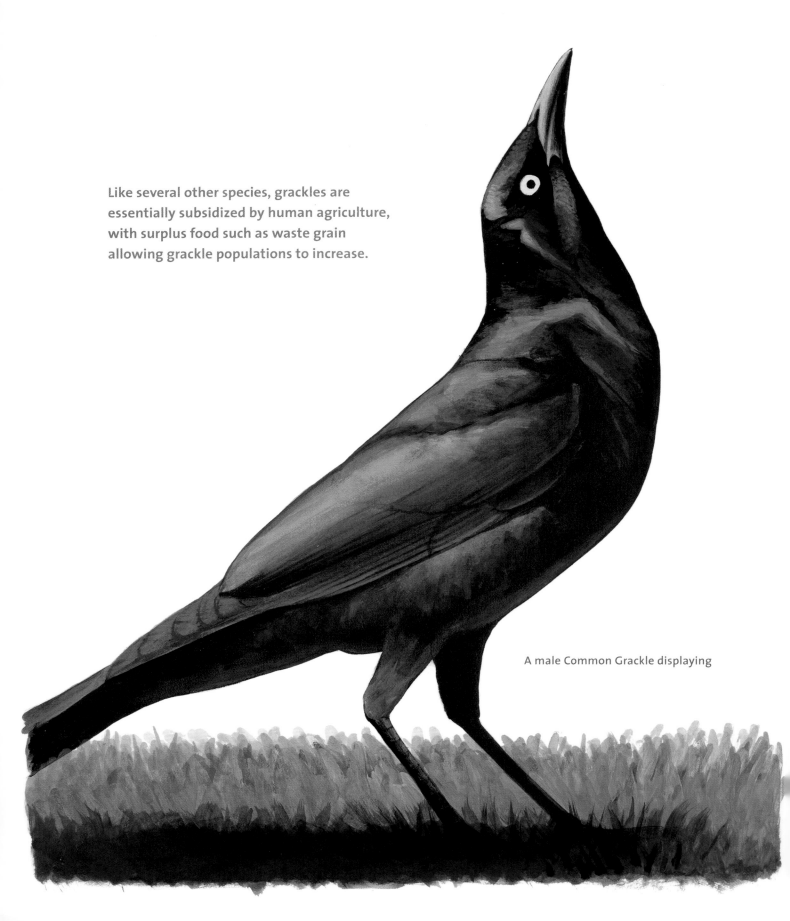

Like several other species, grackles are
essentially subsidized by human agriculture,
with surplus food such as waste grain
allowing grackle populations to increase.

A male Common Grackle displaying

■ Some birds, including grackles and blackbirds, form large flocks that travel and roost together, while chickadees, warblers, and others are more solitary or form loose groups. Similar to colonial nesting (see p. 49 top), flocking is determined partly by the kinds of food the birds exploit. For species such as grackles, the preferred food of grain is found in patches. Finding the food is a challenge, but once found there is plenty of it for all. Chickadees, warblers, and similar species are searching for food that is widely and sparsely distributed, and they don't want another bird near enough to be in competition for the same insect. Being in a flock is an advantage if you are wandering to find patches of food, and for eating steadily once food is found (many eyes can watch for predators and sound the alarm), but flocking is not an advantage when food is scarce and scattered.

A large flock of Common Grackles

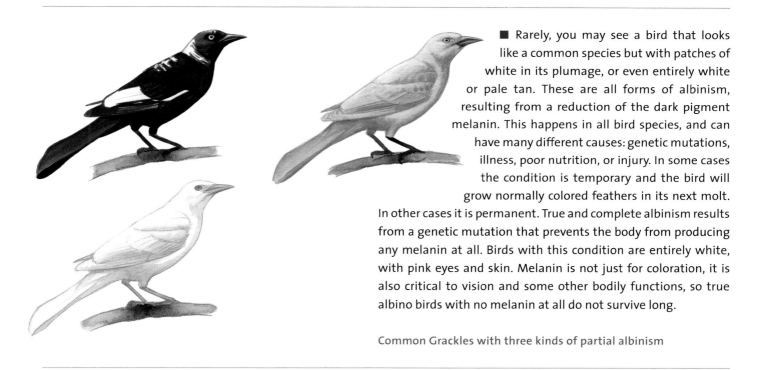

■ Rarely, you may see a bird that looks like a common species but with patches of white in its plumage, or even entirely white or pale tan. These are all forms of albinism, resulting from a reduction of the dark pigment melanin. This happens in all bird species, and can have many different causes: genetic mutations, illness, poor nutrition, or injury. In some cases the condition is temporary and the bird will grow normally colored feathers in its next molt. In other cases it is permanent. True and complete albinism results from a genetic mutation that prevents the body from producing any melanin at all. Birds with this condition are entirely white, with pink eyes and skin. Melanin is not just for coloration, it is also critical to vision and some other bodily functions, so true albino birds with no melanin at all do not survive long.

Common Grackles with three kinds of partial albinism

■ What's up with the white and black bird droppings? Metabolizing proteins creates a lot of nitrogen compounds, which need to be eliminated from the body because they are fairly toxic (ammonia, for example). Mammals convert these nitrogen compounds to less toxic urea, which is diluted with lots of water and stored in a bladder before being excreted from the body as urine. Because of the requirements of flight, however, birds can't afford to use that much water or carry that much weight, so they convert the nitrogen into a chalky precipitate, uric acid. This forms the white part of each dropping, while the dark part is undigested material that has passed through the intestines.

Two bird droppings

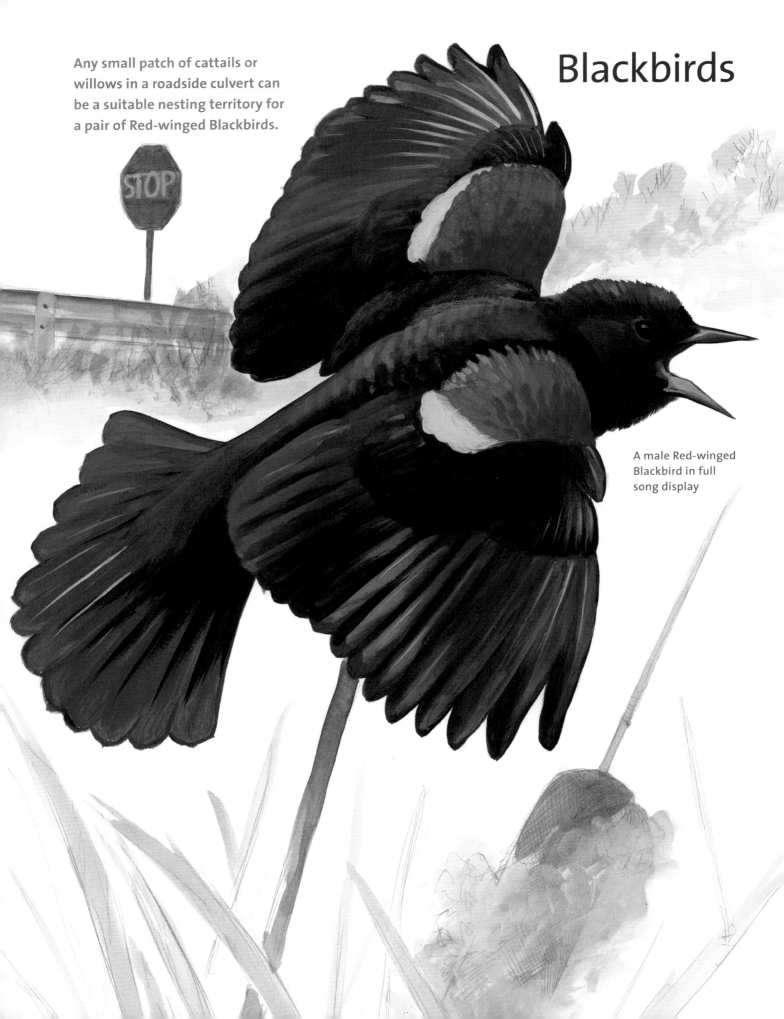

Any small patch of cattails or willows in a roadside culvert can be a suitable nesting territory for a pair of Red-winged Blackbirds.

Blackbirds

A male Red-winged Blackbird in full song display

■ The red shoulders of a male Red-winged Blackbird are a signal that can be displayed or concealed as needed. When a blackbird is relaxed and not advertising to a mate or a rival, the wings are folded tightly against the body and the black feathers from the back and the breast wrap around and cover the red shoulder almost entirely. When the black body feathers are pulled back, the red shoulder is exposed. The male's full song display involves spreading the wings out from the body, fluffing up the feathers on the shoulders to make the red patches even larger and more visible, and singing to draw attention to his display.

A Red-winged Blackbird with the red wing patch concealed by black body feathers (left) and exposed (right)

■ Sometimes when you get a very close look at a feather in the right light, you can see faint bars across the feather, created by a subtle difference in the sheen or darkness of the feather. These are growth bars—similar to tree rings, but instead of a year, each dark-light combination indicates a single twenty-four-hour period of growth. Darker bands grow during the day, and lighter bands at night. The rate of growth varies from one to seven millimeters a day depending on the species and the bird's health and nutrition, but is generally only two to three millimeters a day (about a tenth of an inch). This Red-winged Blackbird tail feather grew in about twenty days. Smaller species like wrens can grow their largest feathers in under ten days. Species like eagles and pelicans have much larger feathers, but those feathers still grow only a few millimeters a day, meaning that a single wing feather might take one hundred days or more to grow.

A tail feather of a Red-winged Blackbird, all black but showing the subtle shadings of growth bars

■ Millions of people feed hundreds of millions of pounds of birdseed to birds every year, and all of that bird food has to be grown somewhere. The challenge for farmers is to grow a crop that is inherently attractive to birds while preventing wild birds from eating it all in the fields before it is harvested. Breeders have developed sunflower plants that are shorter (providing less foliage for birds to hide in) and have flowers that droop to face the ground (making them less conspicuous and harder for birds to reach). Fields farther from wetlands are less vulnerable to blackbird attack, and various techniques are used to scare birds away from the fields. When most plants have matured the fields are sprayed with herbicide to kill the plants and speed the drying of the flower heads, then all are harvested at once.

Blackbirds flying over a field of bird food

Birds in this book

Canada Goose 2

With its dapper white chin and resonant honk, the Canada Goose is a familiar sight and sound on ponds and fields across North America. A few decades ago, the passage of geese in the spring and fall was a rare and celebrated occurrence. In the early 1900s, their numbers had been so reduced by hunting and disturbance that none were nesting in the eastern United States, and in most areas they were only seen migrating to or from their nesting grounds far to the north in Canada. Over the last half century, however, their numbers have increased so much that they are now considered a pest in many areas.

Snow Goose 4

The Snow Goose is a long-distance migrant, nesting in the High Arctic and wintering in huge numbers in a few places in the southern U.S. True migration involves the seasonal movements of whole populations of birds, and allows them to take advantage of regions that offer a wealth of resources for only part of the year. In some species migration operates on a strict schedule (see Scarlet Tanager, p. 186). The migration of geese is more loosely controlled by instinct. Geese have the ability to move throughout the year whenever conditions warrant. They might cover long distances nonstop, or interrupt their movement, or even reverse direction to take advantage of feeding opportunities. Plentiful food and mild weather will permit them to move farther north, while dwindling food supplies, a snowstorm, or severe cold will prompt an immediate retreat to the south. This strategy, known as *facultative migration,* is a way to exploit new and temporary food sources and react to weather. Along with a warming climate, this has allowed many geese to shift their primary wintering areas far to the north in just a few decades.

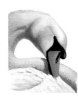

Mute Swan 6

With their all-white plumage, long necks, and aristocratic demeanor, swans have been admired for centuries. The Mute Swan is native to Britain and Europe, where it was associated with royalty and kept as an ornamental feature of ponds on large estates as early as the 1100s. Beginning in the mid-1800s, some were brought to the United States and released in parks. They thrived and spread, and are now common on sheltered waters from New England to the Great Lakes. Two species of swans, the Tundra Swan and the Trumpeter Swan, are native to North America. Biologists are concerned about the impact the nonnative Mute Swan is having on native waterfowl; they are extremely territorial, and once a pair settles on a pond they will chase off many other species of ducks and geese. They also eat large amounts of aquatic vegetation, and could potentially outcompete native species for food.

Muscovy Duck (top) and Mallard (bottom) 8

Only a few species of birds have been domesticated by humans, with two ducks—the Mallard (domesticated in Southeast Asia) and the Muscovy Duck (domesticated in Central America)—being among the most important. Shown here are just two of the countless varieties and crosses of these species that can be seen in parks and farmyards around the world. Other domesticated species of birds include two geese from Europe and Asia, the Wild Turkey from Mexico, guineafowl from Africa, the Rock Pigeon from Europe, and, of course, the chicken from Southeast Asia.

Mallard 10

The Mallard is the most widespread and familiar wild duck in North America, found in flocks on ponds and marshes across the continent. It has been domesticated, and many domestic varieties are found in city parks and farmyards. Water birds like ducks have many adaptations for an aquatic lifestyle. One of their primary challenges is getting to the food they want, since it is usually under the water. Several related species of ducks—including the Mallard—use a technique called "tipping up," or "dabbling." These "dabblers" simply tip forward while swimming, stretching their neck straight down underwater to reach their desired food. This only works when food is within reach and not moving, so these species forage in shallow water and feed mainly on plants.

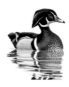

Wood Duck 14

One of the most extravagantly adorned birds, the male Wood Duck is the product of millions of years of evolution and female choice. Having precocial young (see Canada Goose, p. 3 top), the female can manage the entire nesting and chick-rearing process alone. This means she can select a mate based only on his beauty—showy plumage and intricate displays (looks and dance moves). In the same way that plant breeders select certain flower characteristics, females can drive the evolution of these traits simply by their selection of mates. The evolutionary logic is that if she chooses a beautiful and desirable mate, it increases the chance that her offspring will be beautiful and desirable, and more likely to find mates themselves. This will maximize the spread of her genes in future generations. The process is self-perpetuating, as male offspring inherit the looks of their father, and female offspring inherit their mother's preferences. Over millions of generations, as females continually choose males that stand out from the flock, the process can lead to strikingly beautiful birds like the Wood Duck.

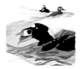

Surf Scoters 16

One of over twenty species of diving ducks in North America, the Surf Scoter nests on freshwater lakes in the far north and winters on open ocean. Unlike dabbling ducks (see Mallard, p. 177) scoters forage in deep water and dive to the bottom to find clams and other shellfish. Having no teeth, they simply swallow the clams whole. The powerful muscles of the gizzard pulverize the whole clam, including the shell, into pieces small enough to pass through the digestive tract. The shell fragments act as grit and help to grind up the food, so scoters, unlike geese and other birds (see p. 5 bottom), do not need to swallow rocks to provide a grinding surface.

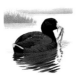

American Coot 18

Coots swim like ducks and are about the same size, but they are unrelated. In fact, coots are related to a group of marsh birds called *rails,* and are distantly related to cranes (see p. 36). Coots differ from ducks in having lobed toes rather than webbed, as well as in bill shape. The coot's sharp clucking and nasal whining sounds are very different from the quacks and whistles commonly heard from ducks. And their nesting habits are quite different, too; for example, adult coots provide food for the young.

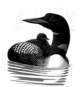

Common Loon 20

Its eerie wailing cries and sleek yet primitive looks make the Common Loon a charismatic and beloved symbol of the wild and pristine lakes of the North. A nesting pair requires a lake at least one-third of a mile across, with clear water (they hunt by sight). They also need a healthy population of small fish 3 to 6 inches long, as adults consume about 20 percent of their body weight in fish each day. Acid rain, pollution, algae blooms, and silt from soil erosion can all make a lake unsuitable for nesting loons. Discarded lead fishing weights can be swallowed by loons and cause lead poisoning, which is currently the largest source of human-caused mortality in the species, but they seem to be able to overcome all of these challenges and populations are currently stable or increasing.

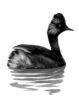

Eared Grebe 22

Grebes are water birds, generally smaller than ducks. Despite their similarity to loons, cormorants, and other water birds, recent DNA research shows that their closest relatives are flamingos! The Eared Grebe is a small species common across the West. They gather by the hundreds of thousands to feast on brine shrimp at a few alkaline lakes in the fall—Great Salt Lake in Utah and Mono Lake in California each host huge numbers. On cold, sunny mornings, the Eared Grebe sunbathes by facing away from the sun and raising its rump feathers, exposing dark underlying skin to the warm sunlight.

Atlantic Puffin 24

Puffins are in the Alcid family, a group of birds adapted to life on the ocean and coming to land only to nest in colonies on small islands or rocky sea cliffs. Alcids live in some of the coldest ocean water in the world, and spend the entire winter at sea without ever coming to land. They are the Northern Hemisphere equivalent of penguins, but their similarities are the result of convergent evolution. These two groups of birds have independently evolved similar solutions to the challenges of finding food in a frigid ocean.

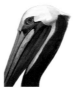

Double-crested Cormorant 26

Cormorants are fish-eating birds that are common around larger bodies of water worldwide. The Great Cormorant is said to be the most efficient marine predator in the world, catching more fish per unit of effort, on average, than any other animal. Cormorants have had a long association with humans, and a centuries-old practice in Asia uses captive cormorants to catch fish for their human handlers. In recent decades, a population increase of Double-crested Cormorants in the United States and Canada has brought them into conflict with human fishermen.

Brown Pelican 28

Two of the world's eight species of pelicans are found in North America—the Brown Pelican, in saltwater along our coasts, and the American White Pelican, mainly in freshwater and in the West. Both are instantly recognizable by their very large size and characteristic pelican pouch. They are among our largest birds; the American White Pelican is more than two thousand times as heavy as a hummingbird. That's equivalent to the difference between a human and a blue whale.

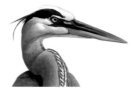

Great Blue Heron 30

They may appear graceful and elegant at a distance, but up close the large size and dagger-like bill of the Great Blue Heron make it a fearsome predator. That bill is usually aimed at fish, but frogs, crayfish, mice, and even small birds are on the menu if they come within striking range. At nearly four feet tall, it is the tallest bird that most people will see. They are often seen resting or standing patiently at the water's edge, just watching. If disturbed, the heron will fly up with a deep disgruntled croak, beating its wings slowly and deeply, and curling its neck back onto its shoulders after a few wing beats.

Snowy Egret 32

Egrets and herons differ only in name; they are all in the same family. Most egrets are white, and some species have very lacy plumes. The egret's delicate feathers were the height of fashion in women's hats in the late 1800s, and plume hunters destroyed nesting colonies and killed hundreds of thousands of birds every year to ship feathers to the major cities of the United States and Europe. By 1900, the populations of many species were dangerously low. Public outcry over the wanton killing of birds for nothing more than fashion led to the formation of the first Audubon Societies, the first laws to protect wild birds, and the establishment of the U.S. National Wildlife Refuge System. With protection, most species quickly recovered.

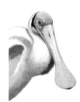

Roseate Spoonbill 34

The Roseate Spoonbill is one of the most remarkable birds in North America. Found along the southeast coast from Texas to Georgia, their pink color and spoon-shaped bill makes them instantly recognizable. They feed by swinging their bill back and forth in muddy water, slightly open so water passes through between the upper and lower mandibles. Tiny prey like shrimp or small fish can be felt, grabbed, and swallowed. Ibises are in the same family, but with downcurved bills.

Sandhill Cranes 36

There are fifteen species of cranes in the world, and only three of them have populations that are considered secure. One of those is the Sandhill Crane, found throughout most of North America and increasing in numbers. The other native species on this continent is the Whooping Crane. Never common or widespread, the Whooping Crane was reduced to a total population of only about twenty individuals in 1941, most of those migrating between northern Canada and Texas. The nesting grounds in Canada were not discovered until 1954. Since then, with the help of dedicated work by generations of biologists, the population has slowly increased and now numbers several hundred birds in the wild.

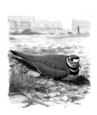

Killdeer 38

The first sign that a Killdeer has taken up residence nearby is the piercing "*kill-deer*" call repeated over and over from high in the air. This is the male, advertising to rivals and his mate, claiming a territory. Usually the territory is an open field with a bit of gravel—the edge of a parking lot, a gravel road, even a gravel rooftop can serve as a nesting site. Because they nest on open ground, these birds face some serious challenges in protecting their eggs and young from predators, and they have developed an impressive array of tricks and strategies to keep themselves and their eggs safe.

Long-billed Curlew 40

The Long-billed Curlew is one of the largest sandpipers in the world, and its bill is one of the longest relative to body size of any bird in the world. One might expect them to use their long bill to reach prey hidden deep in mud or burrows, but more often they do not. This species nests on dry short-grass prairie in the western U.S., where they eat mainly grasshoppers and other insects plucked out of the grass with the tip of their bill. Some spend the winter along coastal waterways, probing in mud for marine worms, fiddler crabs, and other prey. But many curlews winter in the dry grasslands of northern Mexico, where they continue to eat grasshoppers.

Sanderling 42

The Sanderling is commonly seen on wave-washed sand on both coasts. This is the sandpiper best adapted to sandy beaches, and therefore the one most often encountered by beach-going humans. They have evolved a foraging strategy that takes advantage of the food uncovered by wave action along the beach. An incoming wave rushes up the beach, stirring up the surface of the sand and sending the birds in a quick dash uphill to escape the rising water. As soon as the wave begins to recede they run downhill after it, watching for any invertebrates that have been dislodged by the movement of water and sand, and stopping to probe and to feed. A few seconds later the next wave forces them to dash uphill again. There are many other species of sandpipers, and most are found on mudflats where they can forage less frantically.

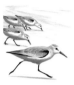

American Woodcock 44

The American Woodcock is a very unusual sandpiper that lives in the woods, hunting invertebrates in the soil by smell. Unlike most other sandpipers, they are solitary and secretive. The surest way to encounter one is to go out in the spring and listen for males displaying. After sunset, male woodcocks come out of the woods into nearby grassy fields to show off for any females who are watching. From the ground they give a nasal buzz, and then launch into an impressive display. Climbing several hundred feet into the twilight sky, they circle and then drop quickly down, all the time "singing" a complex, high-pitched twitter. Most, if not all, of the sound is produced by air rushing past their narrow outer wing feathers.

Ring-billed Gull 46

Gulls may be the most versatile birds in the world. In a bird triathlon—swim, run, fly—gulls would be among the favorites to win. Other birds may be faster swimmers, faster runners, and faster fliers, but no other bird does all three so well, and this versatility allows gulls to take advantage of a very wide range of feeding opportunities. The Ring-billed Gull is a medium-size gull common across the continent near any water. It often hangs around restaurant and shopping center parking lots hoping for food. Many other species of gulls occur especially along the ocean shores.

Common Tern 48

Terns are closely related to gulls, but they are much more elegant, with very graceful flight, slender wings, and long pointed bills. Most tern species eat small fish exclusively, which they catch by hovering and then diving headfirst into the water. Most species nest in colonies and are highly migratory, traveling far south to find their preferred prey in the winter.

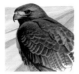

Red-tailed Hawk 50

If you see a large hawk perched along a road or field edge anywhere in North America, it's likely to be this species. The Red-tailed Hawk is a species in the genus *Buteo*—a group of large hawks with long, broad wings—and it thrives in the open woods and small fields that we create in suburbia, feeding mainly on squirrels and small rodents. One pair has even taken up residence (famously) in Central Park, in the middle of Manhattan. The evocative scream of the Red-tailed Hawk is familiar to millions of people from the soundtracks of desolate western scenes in movies and TV shows. Unfortunately, the accompanying footage usually shows a Bald Eagle or Turkey Vulture.

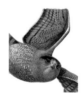

Cooper's Hawk 54

The hawks in the genus *Accipiter* specialize in hunting small birds. With long tails and relatively short, powerful wings, they are excellent fliers and can maneuver easily through tangled branches and around obstacles. Small birds sound the alarm and shelter in fear when an Accipiter shows up, and a hawk is often the reason for a sudden drop in bird feeder activity. It can be shocking to witness the capture of a small bird by one of these hawks, but it is important to remember the critical role that predators play in ecology. A recent study found that the mere suggestion of a predator causes smaller species to change their behavior, staying closer to shelter. This creates an opportunity for the prey of the smaller birds (insects, seeds, and so on) to survive in areas the birds are avoiding. Predators control the populations of their prey species, and also alter the behavior of survivors. All of this has far-reaching effects on the entire community.

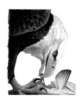

Bald Eagle 56

The national bird of the United States was nearly extinct in the 1970s, when its population was decimated by DDT poisoning. Thankfully, with protection, the species is again widespread and fairly numerous. It's now possible to see Bald Eagles in every state, but they still face numerous threats, including lead poisoning. Despite the fearsome appearance of their bill, eagles never use it as a weapon to attack or defend. They use their talons for that, and use their bill only to tear apart food. Bald Eagles are primarily scavengers, taking easy prey such as dead fish whenever they can, and congregating around dams and other open water in the winter. Ask at your local nature center or bird supply store—chances are there is a good eagle-viewing spot near you.

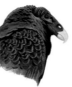

Turkey Vulture 58

The Turkey Vulture and its close relatives the Black Vulture and the California Condor are nature's cleanup crew. They patrol from the air to find dead animals, then drop down for a meal. Several adaptations help them do this: they have evolved the ability to ride updrafts and thermals with almost no effort so they can stay airborne for hours, a powerful sense of smell to find food sources from the air, featherless heads for easy cleanup, and a unique community of gut bacteria that would be toxic to most other animals. Vultures are often called "buzzards," but in Britain that name is used for hawks related to the Red-tailed Hawk.

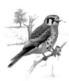

American Kestrel 60

The American Kestrel is one of the smallest falcons in the world, related to the Peregrine Falcon but a dainty eater of grasshoppers and mice. Formerly more numerous, often nesting in barns, the American Kestrel has been declining for decades, and its petulant *"killy killy killy"* call is no longer a familiar sound. Kestrels can still be seen in open country, often perched on wires or fenceposts along roadsides or hovering over fields as they hunt for grasshoppers and mice, but few people see them regularly. Reasons for the decline are still unknown, but it may be related to the loss of farmland habitat, or the increased use of insecticides on farms and lawns, or the loss of nest sites as fewer large dead trees are left standing.

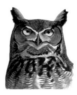

Great Horned Owl 62

Wherever you live, chances are there is a Great Horned Owl living within a few miles. This species has proven to be very adaptable and has taken advantage of the abundance of small mammals in suburbia, essentially taking the night shift where Red-tailed Hawks hunt in the day. It is a very opportunistic hunter. On average, 90 percent of its diet is mammals, but the diet of some individuals can be up to 90 percent birds, mainly waterfowl or medium-size birds roosting in the open, also nestlings (including raptors), and even smaller owls.

Eastern Screech-Owl 64

The Eastern Screech-Owl (and the very similar Western Screech-Owl) are common in woodland edges across the continent. Most owls are active at night and find a sheltered and secluded spot to rest through the whole day, often using the same perch every day. This makes them especially sensitive to disturbance at their daytime roost. Their cryptic colors and ear tufts provide camouflage and usually allow them to hide, but other birds or squirrels sometimes discover a roosting owl and mob it (see p. 123 lower left). If you find a roosting owl it is important to avoid disturbing it. Watch from a distance and don't stay in the area long. The velvety surface and soft edges of owl feathers are not as water repellent as typical feathers, so owls tend to get wet in the rain. This could be one reason why so many seek out sheltered daytime roost sites in hollow trees or dense vegetation.

Wild Turkey 66

No other North American bird has such a complex history with humans. The Wild Turkey is at the same time a symbol of the wild and bountiful forests of the New World and one of the most widely domesticated birds in the world. In 1621 the Pilgrims brought domestic turkeys with them from England, and then wrote about a "great store of Wild Turkies" in Massachusetts, but by 1672—only fifty years later—it was "rare to meet with a wild turkie," and by 1850 the species was completely gone from not only Massachusetts but much of the eastern U.S. It was more than one hundred years before the species returned, thanks to prolonged efforts by wildlife managers, the regeneration of forests, and a reduction of hunting. Wild Turkeys rebounded in the late 1900s, and are now a common sight even in suburban yards.

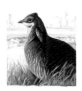

Greater Prairie-Chicken 68

The chicken-like birds in the grouse and pheasant family have been favorites of hunters for millennia. Many species are now very rare in the wild, and a few are extinct. In North America one population is extinct—the Heath Hen (considered a subspecies of the Greater Prairie-Chicken). It was found along the Atlantic coast from Boston to Washington, D.C., the same area that the first European colonists occupied, and by the 1830s it was almost exterminated. The last surviving population was on Martha's Vineyard, Massachusetts, where the last individual was seen in 1932.

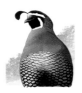

California Quail 70

Quail are related to chickens, grouse, and pheasants, but classified in a separate family. Several species of quail are common in the American Southwest from Texas to California. Small groups, called "coveys," are often seen foraging on the ground at the edge of brushy areas, or sprinting single file across roads or trails. Only one species—Northern Bobwhite—is found in the East, and it is now much less common than it was fifty years ago.

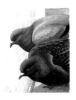

Rock Pigeon 72

The pigeon is surely the most familiar bird in North America, and it's not even native. Domesticated thousands of years ago in the Middle East and now completely adapted to city life, this bird is abundant, and both loved and hated, in cities worldwide. In the wild, Rock Pigeons roost and nest on cliff ledges, so adapting to the ledges of human structures like buildings and bridges was not hard for them.

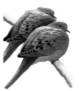

Mourning Dove 74

Pigeons and doves are closely related. Along with the American Robin, the Mourning Dove is one of the most widespread species in North America, found in virtually every backyard from British Columbia to Arizona to Maine. Their mournful hooting call is often mistaken for an owl's. One contributor to their success is the ability to nest almost year-round, even in northern climates. Most species in the northern states have a very limited nesting season of less than two months, but Mourning Doves stretch their nesting season to over six months, from March to October, and even longer in the South.

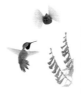

Rufous Hummingbird 76

Several species of hummingbirds (including the Rufous Hummingbird) are common in western North America. In the East only the Ruby-throated Hummingbird is expected. Hummingbirds and flowers have evolved together, and the flowers that are pollinated by hummingbirds are often perennial, red, tubular, and without strong odor. Hummers can smell, but they find the flowers by sight and remember the locations of perennials to return to them every year. A narrow tube helps ensure that only hummingbirds can reach the nectar. Flowers also adjust their nectar content to lure hummingbirds back for repeated visits, which increases the chance of pollination.

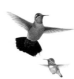

Blue-throated Mountain-Gem and Calliope Hummingbird 78

The Calliope Hummingbird is found in the western mountains, while Blue-throated Mountain-gem is one of several species that range just north of the Mexican border into the southwestern states. Hummingbirds are extreme. They have the longest bill and shortest legs relative to body size, and are unable to walk or hop—every movement requires flying. This painting shows the largest hummingbird found north of Mexico and the smallest. There are larger species in South America (up to the Giant Hummingbird, which is about as heavy as a Song Sparrow) and a couple of smaller species (the smallest is the Bee Hummingbird of Cuba). The smaller species (including Rufous Hummingbird) beat their wings over seventy times a second. That adds up to over 250,000 wing beats per hour, and over a million wing beats in just four hours of flying. In a year a single bird beats its wings well over half a billion times!

Greater Roadrunner 80

The roadrunner is one of the most iconic species of the American desert Southwest. In the cuckoo family, they spend most of their time on the ground, fly only reluctantly, and eat almost anything they can catch, from beetles and lizards to snakes and birds. Contrary to the classic cartoon, they are not at war with coyotes.

Belted Kingfisher 82

The kingfisher family includes more than three hundred species, but only six species are found in the Americas. The name kingfisher originated in England, where only one species occurs. That species, and the six found in the Western Hemisphere, do eat mainly fish. The other three-hundred-plus species are found in Asia, Australia, and Africa, and most of them do not eat fish. They are found in forests and brushy areas, where they eat insects and other small animals. The well-known kookaburra is a member of the kingfisher family.

Monk Parakeet 84

The Monk Parakeet comes from temperate South America and can survive as far north as Boston and Chicago. Many parrot species around the world are threatened with extinction. Nests are sought and raided so that the young parrots can be brought to market and sold as pets. This has a devastating impact on the overall population. Many species have escaped from captivity and now survive in the wild in cities in the southern U.S. Ironically and tragically, there are now more Red-crowned Parrots escaped from captivity and living wild in the southern U.S. than in the species' native range in Mexico. Only one species of parrot was native to the United States—the Carolina Parakeet, now extinct.

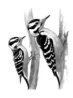

Downy Woodpecker and Hairy Woodpecker 86

These two species are common in woodlands almost everywhere in the United States and Canada, and they often visit feeders, making this a frequent identification challenge for backyard birders. The appearance of the Downy Woodpecker might be evolving to match the appearance of the Hairy Woodpecker. Recent research supports the idea that a smaller species (in this case, Downy Woodpecker) can benefit when other birds mistake it for a larger species (Hairy Woodpecker). In other words, the Downy Woodpecker fools the other birds and gets a higher position in the pecking order by pretending to be a Hairy Woodpecker.

Yellow-bellied Sapsucker 88

Yes, the Yellow-bellied Sapsucker is a real bird. There are four species of sapsuckers in the world, all in North America. Their name comes from a distinctive habit of drilling rows of shallow holes in trees, and returning regularly to drink the sap and to eat any insects that have been attracted. They drill two different kinds of sap wells: shallower rectangular holes and deeper, smaller, round holes. These tap into different layers of the tree tissue, which carry more or less nutritious sap at different seasons. These sap wells make the sap available to any other birds and animals in the area, and this leads ecologists to call sapsuckers a keystone species. Like the keystone at the top of an arch, removing

sapsuckers from an ecological community could cause the whole system to collapse.

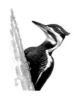

Pileated Woodpecker 90

This crow-sized woodpecker has experienced a population surge in recent years, with the recovery of large areas of forest in many states. Still, it occurs at low density, with only about six pairs per square mile even in the best habitat, so birders are always excited to encounter one. It usually doesn't visit bird feeders, but individual birds or family groups may learn to come for suet in some locations. No other living North American woodpecker is this large, and the bright red crest and flashing white wing patches identify it. Only the Ivory-billed Woodpecker (now presumed extinct) was larger.

Northern Flicker 92

The most un-woodpecker-like woodpecker, flickers are often seen hopping around on lawns or in gardens, searching for their favorite food—ants. With their odd habits and bold markings, many people never suspect flickers are woodpeckers. They are noisy in the spring and summer, giving a loud, clear *keew* and a long series of *wik-wik-wik-wik* notes. Flickers are much less common now than they were several decades ago, perhaps because there are fewer large dead trees for nesting, fewer ants, or more pesticides, but the actual cause is unknown. By excavating nesting cavities in large dead trees, flickers provide future nest sites for many other species, such as the American Kestrel. The decline of flickers may therefore influence populations of other species.

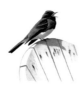

Black Phoebe 94

Most species of flycatchers are inconspicuous denizens of forest, swamps, and dense brush. A few species are found in the open and around buildings, and these include the phoebes. The three species of phoebes are small flycatchers that build nests on man-made structures such as porches and barns. All three have the habit of dipping their tails gently when they are perched, and all have soft whistled songs that say their name—*FEE-bee*—and variations.

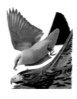

Western Kingbird 96

Kingbirds are larger, bolder, and more colorful flycatchers found in wide open spaces. They are known for their fearless and aggressive defense of their territory and nest against all intruders. The kingbird is quicker and more agile in flight than larger birds, and attacks any passing hawk from above and behind, often pecking at the back of the hawk's head as shown here. Kingbirds choose conspicuous perches in open country—fences, telephone wires, etc.—and watch for large flying insects.

Chimney Swift 98

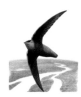

The high, sharp twittering of Chimney Swifts is a common sound over eastern towns in the spring and summer, but you will never see one perched. These remarkable birds spend the entire day high in the air, and spend the night clinging to the walls inside a chimney. Before the advent of chimneys, they roosted and nested in large, hollow trees, or even on the bark of large trees protected by an overhanging limb. Exactly how they spend their winters is not known. Once they start migrating in September to their wintering grounds in South America, it's possible that they stay in the air for the entire time, until they return to their nesting chimney the following April. Recent research has documented that some other species of swifts stay airborne, flying continuously, for up to ten months. How and when they sleep is still unknown, but a study of frigatebirds showed them flying continuously for weeks at a time, and that the time spent sleeping each day during continuous flight was only 6 percent of the daily sleep they get when they can perch. Like other birds (see Mourning Doves, p. 75 middle), they can sleep one side of their brain while the other side is still alert, but flying frigatebirds actually spend about one-quarter of their sleep time with both sides of the brain asleep!

Barn Swallow 100

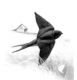

The summer hayfield buzzes with activity, and swallows skim the tops of the grasses from one end to the other, nabbing insects just above the field. Virtually every barn in North America has swallows nesting in it, and it is rare to find a Barn Swallow nest that is *not* in a building. This species adapted to nesting in barns almost as soon as the structures were first erected in the U.S., and the rapid spread of humans and barns in the 1800s probably allowed the Barn Swallow to greatly expand its nesting range.

Tree Swallow 102

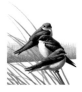

Tree Swallows, like all swallow species, eat mainly insects that they capture in flight. This requires an abundance of small insects in the air, and that requires good weather. When the air is too cold or damp for insects to be flying (a chilly early morning or during a storm, for example), large numbers of swallows will rest together in reeds or bushes. They use torpor to conserve energy (see p. 77 lower left). They can survive for a few days with no food, but longer stretches of cold and damp weather can be a serious challenge.

American Crow 104

Several species of crows are found in different regions across the continent, and they are among the most intelligent of all birds. Intelligence is difficult to define, and difficult to test in birds. One indirect measure of intelligence is the ability to adapt and thrive in many different environments—to innovate—and ravens and crows are certainly some of the most innovative birds. They also understand the concept of trading, and have a sense of fair trade. In one study, human experimenters traded with ravens. Some humans were "fair" and traded items of equal value, while others were "unfair," giving a lower-quality item in exchange. The birds learned the tendency of each individual human and preferred to trade with the fair ones.

Common Raven 106

Ravens are very closely related to crows, and share the crows' intelligence and rich social life. Birds use their bills for feather care, preening regularly to keep their feathers properly aligned and clean, but they can't preen their head with their own bill. For that they must use their feet, to scratch away any debris and to rearrange feathers. Some species have specialized claws with comb-like structures that allow better feather care. Ravens and some other species engage in mutual preening, which is presumably the best way to keep head feathers clean and straight.

Blue Jay 108

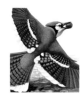

This colorful and boldly marked species is common in wooded areas, including suburbs and city parks, and a frequent visitor to birdfeeders throughout the East. Its close relative the Steller's Jay is similarly common in the West. When theories of protective coloration were first being debated around 1900, birds like the Blue Jay were a puzzle. It was difficult to imagine how such flashy colors could be helpful for concealment. Now we know that color patterns evolve for many reasons, not just camouflage. The head pattern of the Blue Jay is probably to disrupt the perceived shape of the head, making it harder for a predator to recognize the bird and to tell what direction it is looking. The bright white flashes in wings and tail probably help by startling a predator in the moments before an attack. One experiment found that fast movement by prey would cause a predator to hesitate, and even more so if the fast movement is accompanied by a sudden flash of color. A panicked Blue Jay taking off in a burst of movement and flashes of white could cause a predator to flinch, and that might allow the jay to escape.

California Scrub-Jay 110

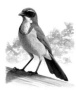

Several closely related species of scrub-jays are found in the western and southern U.S., where they are among the most brash and fearless visitors to bird feeders. They are especially fond of peanuts. Like other jays, they seem to be particularly susceptible to West Nile Virus, which arrived in North America in 1999 and spread quickly across the continent like other invasive species (see p. 185, European Starling), becoming a serious threat to birds as well as a major human health issue. Birds are the host of the virus, which is transmitted by mosquitoes. Initially, populations of jays and many other species declined sharply. While some species recovered quickly, recent surveys show that populations of other species are still reduced.

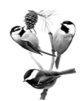

Black-capped, Mountain, and Chestnut-backed Chickadees 112

Inquisitive, bold, and social, chickadees are among the most popular and well-known birds wherever they occur. They are among the most reliable customers at bird feeders, and are often the first to discover a new feeder. Named for their *chick-a-DEE-DEE-DEE* call, their scolding *dee-dee-dee* calls announce the presence of predators or any other newsworthy event. Like many other birds (and unlike humans), chickadees can see ultraviolet light—a whole range of color beyond purple. Male and female chickadees look alike to us, with white cheeks, but they look quite different to each other, as males have a much stronger ultraviolet reflection on their cheeks.

Oak Titmouse 114

Titmice are closely related to chickadees, and the four species in North America all have drab grayish color and short crests. As early as the 1300s the name *titmose* was in use in England, by combining the Middle English words *tit* (meaning "small") and *mose* (meaning "small bird")—literally "small small bird." After a century or two, this became *titmouse*, and in another century or two was shortened to *tit*, which is still used today for Eurasian species such as the Blue Tit. The name *chickadee* is uniquely American, and refers to the birds' distinctive calls. Early Europeans in North America used the name *titmouse* for chickadees as well—for example, in 1840 Audubon wrote about the Black-capt Titmouse.

Bushtit 116

Bushtits are the smallest non-hummingbird birds in North America, slightly smaller than the Golden-crowned Kinglet. Five of them together weigh one ounce. They are found in the western states in open brush and gardens. They almost always travel in flocks of up to several dozen, constantly flitting and chattering through the foliage of shrubs and trees. Despite their similarity to chickadees they are not closely related. Their nearest relatives are in Europe and Asia.

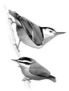

White-breasted Nuthatch and Red-breasted Nuthatch 118

Nuthatches spend a lot of time clinging to the bark of trees, like woodpeckers, but the similarities end there. They cling to the bark with just their feet and can move in any direction around a tree trunk. They do not chisel into wood with their bills, instead mostly gleaning food from the bark. When visiting bird feeders, they quickly grab a seed and fly back into a tree. Wedging the seed into a bark crevice, they pound it open with their bill. This is apparently the origin of their name—they are really nut hackers. White-breasted Nuthatches are resident and defend their territories year-round, but many Red-breasted Nuthatches nest in the far north. In years when the numbers of spruce and pine seeds in the northern forests are low, Red-breasted Nuthatches move south in huge numbers.

Red-eyed Vireo 120

Vireos are small and inconspicuous songbirds, generally found in dense leafy vegetation and more noticeable for their voice than for their appearance. They are not related to toucans, but the Red-eyed Vireos that spend the summer in the U.S. and southern Canada migrate south to winter in the Amazon basin in South America, and they have all seen toucans.

Carolina Wren 122

The wrens are a Neotropical family, with only one species in the Old World, and only a few north of Mexico. Most species are nonmigratory, and mainly insectivorous, which limits their range to warm climates. Among the most remarkable features of wrens are their songs, which are loud, rich, and varied. Each male Carolina Wren knows a repertoire of up to fifty different song phrases, which it uses in various performances to impress mates or rivals. Males from the western population of the Marsh Wren have an even more diverse repertoire of up to 220 different songs!

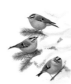

Golden-crowned Kinglet 124

The Golden-crowned Kinglet is one of the smallest birds in North America, smaller than some hummingbirds. They weigh about as much as a U.S. nickel, and still manage to survive the winter as far north as Canada. Most of the day—up to 85 percent of daylight hours—is devoted to searching for food. At night they find a sheltered spot, huddle with up to ten or so other kinglets, and enter torpor to conserve energy. Like other birds, their metabolism increases in the winter, essentially revving the engine to produce more heat, even though this uses more fuel. They eat insects, which in the winter means mainly insect eggs and larvae gleaned from twigs and bark. Kinglets in the winter probably need at least eight calories a day, which doesn't sound like much, but if we ate at the same rate, a hundred-pound person would need about sixty-seven thousand calories, which is about twenty-six pounds of peanuts, or twenty-seven large pizzas, every day. Do you "eat like a bird"?

American Robin 126

One of the most familiar and beloved birds in North America, the American Robin is equally at home in the foothills of California, the shelterbelts of Nebraska, and the suburbs of Boston. No matter where your backyard is, if you have a grassy lawn, chances are you will see robins there hunting earthworms. It has been calculated that a single robin can eat 14 feet of earthworms in a day. When early British colonists noticed this bird's red breast, it reminded them of the robin they knew from gardens in Britain, and they named this bird to match, but the two species are only distantly related, and the American Robin is much larger.

Wood Thrush 130

The Wood Thrush and several similar species are related to the American Robin but are retiring denizens of shaded forest. All have extraordinary songs. Many birds defend a nesting territory in the summer. This is essentially a bit of private property, and the nesting pair that has claimed it will defend their territory against others of their species. Ideally their "property" will provide everything that is needed to successfully nest and raise young. They defend as much space as they need, so territories tend to be small in very productive areas and larger elsewhere. A few species of long-distance migrants (including thrushes) also defend winter territories, but as individuals, not in pairs. In both winter and summer birds are very faithful to their territory and return each year. A Wood Thrush might spend its whole life on the same few acres each summer and winter, with a 1,500-mile commute in between.

Eastern Bluebird 132

With their gentle demeanor and pleasing colors, bluebirds are among the most beloved birds in North America. They are classified in the thrush family, related to the American Robin and the Wood Thrush. Besides their color, they differ from other thrushes in their choice of habitat (open fields and orchards), nesting site (in a cavity), and in their social system (traveling in small groups of five to ten birds). They eat mainly insects and fruit, but in recent years some bluebirds have begun to frequent bird feeders, where they eat softer foods like suet, sunflower hearts, and mealworms.

Northern Mockingbird 134

The mockingbird gets its name from its habit of mimicking the sounds of other species in its song. They are not "mocking" these other species, of course. Most likely the sounds have no particular meaning (although there is evidence that mockingbirds know the source of their material). The birds are simply using the variety of sounds to show off their vocal prowess. Copying sounds that they hear is an easy way to expand their repertoire, and could also allow other mockingbirds to judge the quality of the copy. On average each male knows about 150 different sounds, and mixes them up in every singing bout.

European Starling 136

Native to Europe, starlings were introduced in New York City in 1890, and quickly multiplied, spreading to the Pacific coast by the 1950s and becoming one of the most abundant birds on the continent. As their numbers increased, they usurped the nesting cavities of native species like the Eastern Bluebird and the Red-headed Woodpecker, contributing to the declines of those species. In North America, starlings are considered an invasive species—a nonnative species that spreads and causes economic or environmental damage. But starlings are not malicious; they have simply adapted to, and thrive in, the environment created by humans (see p. 161 top). The North American continent had been altered by other invasive species well before starlings arrived here. Earthworms are nonnative, and they fundamentally alter plant communities by changing the chemistry and structure of the soil. Most of the backyard and roadside plants that we see every day were also introduced from elsewhere: dandelion, buckthorn, most honeysuckle, kudzu, knapweed, and others, as well as hundreds of species of insects including the honeybee and the cabbage white butterfly. And humans are, of course, the ultimate invasive species. Starling populations in the U.S. have declined dramatically since the 1960s, presumably due to changes in farming practices, and their impact is now greatly reduced.

Cedar Waxwing 138

Waxwings get their name from the small red tips on the feathers of their inner wing, which reminded early naturalists of the red sealing wax used on important letters. The birds' red markings are not wax, of course, but keratin (the same substance as the rest of the feather) formed into a solid flat tip and decorated with red pigment. Waxwings eat mainly fruit, and live an itinerant life, moving continuously through the winter. They spend most of the year in small flocks simply wandering in search of fruit. They will stay in an area only as long as the fruit lasts, then wander again in search of the next meal. For example, birds tagged in Saskatchewan were found later in California, Louisiana, and Illinois. One bird wandered from Ontario to Oregon, another from Iowa to British Columbia.

Black-throated Blue Warbler 140

The wood warblers are the most numerous, conspicuous, and diverse of the Neotropical migrants—species that nest in North America and winter in the subtropics and tropics. Their arrival each spring in the North is eagerly anticipated by birders, especially in the eastern part of the continent, where a "fallout" of migrants can include twenty or more species of brilliantly colored warblers. The fact that most species weigh under 10 grams (about a third of an ounce) makes their intercontinental journeys even more remarkable. The Black-throated Blue Warbler is typically found in moist leafy understory—the kind of situation created by a stand of mountain laurel or rhododendron. Most species have similarly narrow preferences for habitat, and this makes them vulnerable as even small shifts in climate lead to changes in plant communities.

Blackpoll, Townsend's, and Hooded Warblers 142

Over fifty species of wood warblers in North America show an incredible diversity of colors and patterns, with the black pigment melanin a key to that variation. Wood warblers are known for their intense colors and high energy—the late ornithologist Frank Chapman once called them the "dainty, fascinating sprites of the tree-tops." We tend to focus on the brilliant yellow to red carotenoid pigments, and the brightness of these colors might be an indication of the health of the bird (see p. 163 middle). The black feathers also contribute to the appearance of most species of warblers. Patches of deep black are striking, and bright yellow and orange seem even more brilliant when set off against black. Recent research has found that healthier birds produce blacker feathers, not because of more pigment, but because of the microstructure of the feathers themselves. More barbules and a more consistent feather structure create a deeper black appearance. In this way, differences in melanin-based markings might be an important signal of the condition of the bird.

Scarlet Tanager 144

The brightly colored tanagers live mainly in the forest canopy. Larger than warblers, with stout bills, they are actually related to cardinals. The lives of highly migratory species like the Scarlet Tanager have to run on a strict schedule. Spring migration leads immediately into nesting, and in the few weeks between nesting and fall migration they need to complete a molt of all of their feathers. Birds have an excellent sense of time and a complex relationship with time. Certain genes are known to be associated with time cycles, and multiple light sensors synchronize annual and daily cycles according to day length. This allows birds to begin and end migration on time, and also, for example, to adjust their migration direction and urgency to date and latitude. A sense of time is also critical to singing and many other daily activities.

Northern Cardinal 146

Named for its bright red color, like the robes of the cardinals of the Roman Catholic Church, this is one of the most recognizable birds in North America. In the breeding season (spring and summer) it is common to see a male cardinal feeding an adult female. The males are signaling their fitness in their ability to find enough food to share with their mate. This is one of the species that has benefited most from suburbanization over the last century. Cardinals thrive in the suburban landscape of open lawns with scattered shrubs and trees and plentiful bird feeders. In 1950 they were found north only to southern Illinois and New Jersey; now they are a conspicuous visitor to bird feeders year-round as far north as southern Canada.

Rose-breasted Grosbeak 148

Related to cardinals, the grosbeaks are highly migratory, nesting across the U.S. and southern Canada, and wintering in Central America. Why migrate? There are many downsides to migration: it's dangerous and energy intensive, and it requires extreme adaptations. Even brain size is linked to migratory habits. Large brains require a lot of energy, making them incompatible with long-distance flights, so migratory species average smaller brains. But about 19 percent of the world's bird species, and huge numbers of birds, migrate every year. Migrants are able to nest in areas with reduced competition and a burst of abundant food. Basically, they are traveling farther to get cheap food and lodging. The trip is not easy but the deals are so good it's worth the extra distance. The energy used to travel is paid back by the energy gained in the northern summer.

Lazuli Bunting and Indigo Bunting 150

Related to cardinals and grosbeaks, buntings are small finch-like birds of hedgerows and brushy edges. Buntings are strongly sexually dimorphic—the males and females look different—and recent studies show that this is linked to migration. More than three-quarters of migratory species are dimorphic, while over three-quarters of sedentary species are not. In sedentary populations pairs remain together on a small territory all year and usually share the work of defending that territory and raising young. With migration, sexual roles diverge. Males arrive on the breeding grounds first and establish a territory, females come a few days later and select a mate. The most attractive males are more likely to be chosen, and more quickly, which drives the evolution of more showy plumage. As the female's responsibilities shift away from territorial defense into the work of raising a family, drabber plumage is an advantage. It provides better camouflage and is less costly to produce, leaving her with more resources for the combined demands of migrating and producing eggs.

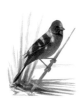

Canyon Towhee 152

Several species of towhees (which are basically oversized sparrows) are found in different regions across North America. Two plain brownish species are often seen in suburban yards in the southwest and in California. Birds that live in the desert have evolved and adapted to stay cool and conserve water. They can get by with little water, but they do need some. During the hottest part of the day, birds reduce their activities overall and try to relax in the shade. Foraging activities and trips to water occur mainly early and late in the day. Many species have long-term pair bonds and maintain year-round territories, reducing the need for energetic displays. Fighting is relatively rare. And there are many mechanisms to shelter eggs and chicks from the heat, and to provide water. Even with all of this, life in the desert

is challenging. A recent study of future climate suggests that many songbirds (especially smaller species) will not be able to survive the predicted higher temperatures in the desert.

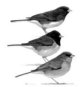

Dark-eyed Junco 154

Almost every winter bird feeder in the United States and southern Canada is visited by Dark-eyed Juncos, but the juncos that show up can look very different depending on where you live. The birds shown here are all males of the same species—Dark-eyed Junco—but represent distinct regional variations or subspecies. Slate-colored Junco (upper) is found mainly east of the Rocky Mountains. Oregon (middle) is found in the west, and Gray-headed (lower) is found in the southern Rocky Mountains. Evolution is an ongoing process continuing all the time, and populations in different regions can diverge (evolve different features) because of different selective pressures. With enough time and divergence they can become different species. In the case of the Dark-eyed Junco, all the differences we see have evolved since the last ice age, about fifteen thousand years ago. These populations look quite different, but they sound the same, act the same, and (most important) seem to recognize each other as the same species and interbreed wherever their ranges meet. Regional populations that we can distinguish, but that don't seem to be recognized by the birds, are classified as subspecies (see p. 159 bottom).

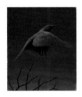

White-crowned Sparrow 156

This species is the the most familiar sparrow in the West, found in large winter flocks in weedy areas. There are many other species of sparrows, almost all of them brownish and streaked and found on or near the ground. Most small songbirds migrate at night, which makes their journeys even more remarkable and mysterious. The potential advantages of flying at night include: less turbulent air; cooler temperatures that mean less water lost to panting; fewer predators; stars more visible for navigation; and the daytime can be spent on refueling. After sunset birds launch into flight, climb to several thousand feet, and fly for hours. How they decide which night to fly is complex. In the big picture, changes in day length trigger hormones, which lead to physiological changes that increase the bird's urge and ability to migrate. Even captive birds display this migratory restlessness in the spring and fall—fidgeting, nocturnal activity, and other actions. Each night a bird might check its body condition, fat reserves, the current temperature and trend, wind direction and speed, changes in barometric pressure, approaching weather, date, current location, and more. A complex appraisal of all of these factors leads to a decision to take off or to wait. Launching into the night with an unknown destination is risky, but waiting might be even more risky (see p. 23 top).

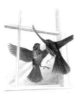

Song Sparrow 158

This is the familiar sparrow of gardens and hedgerows, especially in the East. In the spring and early summer many people find that a bird is attacking their windows. The bird is not just flying into the glass randomly, or trying to get into the house—it is attacking its reflection in the glass. The bird sees itself in the reflective surface (a car's side-view mirror is also a common target) and with breeding-season hormones making it more aggressive and territorial, the sight of a potential rival triggers the need to defend its territory and a relentless but futile effort to drive off the intruder. You can eliminate the reflection by covering the glass (on the outside), but the bird will usually just move to another window and continue its attacks there. If you just want to stop it from attacking a bedroom window and waking you up, for example, then covering one or two windows might be enough. The activity should taper off in a few weeks, as the breeding season ends and the territorial drive fades.

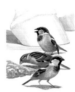

House Sparrow 160

The House Sparrow, native to Eurasia, is not closely related to the sparrows native to North America. It is one of the most successful bird species in the world, colonizing cities on every continent except Antarctica. Like crows and starlings, this species has proven to be extremely adaptable, and has spread by taking advantage of opportunities that other birds do not. They live in small groups all year, and one of the secrets of their success may be the fact that groups are better at problem solving. This effect has been shown in many animals, from humans to birds. When faced with a puzzle, such as an inaccessible food source, a group of birds might each try a slightly different approach. If one bird solves the problem, the rest of the group learns from that and all have access to the food. One study found that groups of six sparrows solved problems seven times faster than groups of two, and that urban sparrows were better at problem solving than country sparrows. For all of their success, however, House Sparrow populations have been declining worldwide for many decades. This is presumably related to the decline of small farms and livestock, including the shift from horses to cars for transportation.

House Finch 162

These small streaked finches are regular visitors to bird feeders and—true to their name—they are often seen around houses. If you have small finches nesting on a windowsill, porch ledge, or Christmas wreath, they are undoubtedly House Finches. Adult males are bright red on the head and breast, while females are brownish and streaked, without red. The House Finch is native to the western United States and only recently colonized the East. It is said that in 1939, a pet store owner on Long Island, New York, released a small number of House Finches when he learned that it was illegal to keep native birds. From that small group they spread throughout the eastern U.S., and have now met and merged with the expanding western population.

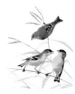

Lesser Goldfinch 164

Known to many—appropriately—as "Wild Canaries," goldfinches are among the most conspicuous bright yellow birds. The American Goldfinch is found continent-wide, and the Lesser Goldfinch only in the West. All are frequent visitors to bird feeders, and a flock will often sit calmly for minutes at a time, occupying all of the perches on a feeder and nibbling seeds. Most migratory birds travel as individuals, but goldfinches travel in flocks during the nonbreeding season, and there is some evidence that groups can stay together for years. A European study of tagged siskins (close relatives of goldfinches) found multiple records of birds that were recaptured together a month later, with maximum records of birds still together after more than three years and over 800 miles.

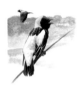

Bobolink 166

The Bobolink and the meadowlarks are all related to blackbirds and orioles. They are found in open meadows and pastures, and their songs are some of the most iconic sounds of summer hayfields. For nesting these birds require a large open field with tall grass, and little disturbance (for example, free of dog walkers). Fields meeting those requirements have become scarce in many areas, and Bobolinks and meadowlarks have correspondingly become scarce. They are still common in the Great Plains and other areas with large hay fields. When they leave the breeding grounds, Bobolinks migrate in flocks to the grasslands of southern South America—one of the longest migrations of any songbird.

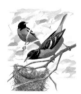

Baltimore Oriole 168

Several species of orioles migrate north to breed in North America, but most oriole species are resident in Central and South America. Migratory habits can adapt quickly, and even within a species there can be wide variation in both migratory and sedentary populations. It has long been assumed that migratory behavior is the more recent trait, with sedentary tropical ancestors gradually increasing seasonal shifts to the north. A recent study suggests that migratory behavior appeared and disappeared multiple times as different species evolved, and that many songbirds now resident in the American tropics evolved from migratory species. In this scenario, some individuals of a species nesting in North America and wintering in the tropics would simply not migrate all the way back to the north, and remain in or near the tropics to breed. Then, being isolated from the migratory population, the new tropical group would evolve into a distinct species.

Brown-headed Cowbird 170

Brown-headed Cowbirds (in the blackbird family) use a nesting strategy called brood parasitism. They lay their eggs in other birds' nests, and the unwitting foster parents do all of the work of incubating and feeding the young cowbird. The foster parents continue to care for the baby cowbird even if it grows much larger than them. It's tempting to criticize the cowbird, and some of their behavior can seem cruel and downright criminal, but we have to guard against the tendency to project our own values on the natural world. The female cowbird does not choose to lay her eggs in the nests of other birds—that's just the way cowbirds have evolved, and she seeks every advantage for her own offspring. It's a remarkable system, and for the cowbirds it works remarkably well.

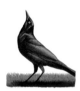

Common Grackle 172

The Common Grackle is truly common in suburban and rural habitats across the eastern two-thirds of the continent. They are large, strong, and opportunistic, and can prey on the eggs and young of smaller songbirds. Like some other species, such as crows and Brown-headed Cowbirds, grackles feed on corn and other crops, and are essentially subsidized by human agriculture. This allows their population to increase, which leads to greater impacts on the species around them. It's not their fault, and doesn't have to detract from their iridescent splendor.

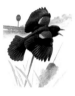

Red-winged Blackbird 174

Wherever there is water and dense reeds or brush, you can find the Red-winged Blackbird. A small patch of cattails or willows in a roadside culvert makes a suitable nesting territory, and in more extensive marshes hundreds nest in close proximity. One of the harbingers of spring, males return and start advertising on their territories as early as the first warm days in February, even in New England.

What to do if . . .

A BIRD HITS A WINDOW

If, despite your best efforts to prevent it, a bird is stunned by hitting a window, pick it up gently and place it in a small cardboard box or a paper bag. Make sure the box or bag is closed and secured. Put that in a quiet warm place where the bird can rest in the dark. Many birds will recover within an hour. Don't open the box inside the house, not even for a peek (or see below "What to do if a live bird is in your house").

If you hear scratching and fluttering noises inside the box/bag this indicates that the bird is probably ready to go. Carry the box outside and open it up— hopefully the bird will fly right out. If it doesn't, then leave it a while longer in the dark. There is no immediate need for food or water, so the bird will be fine for several hours. If the bird needs more care you should look for a licensed wildlife rehabilitator in your area, and if it doesn't recover please see the below section, "If you find a dead bird."

A BIRD IS FLYING REPEATEDLY AGAINST A WINDOW

This is an entirely separate issue from window collisions (see above) and is generally harmless. Birds sometimes see their own reflection as a potential rival and make a futile effort to drive off the "intruder" [p. 187, Song Sparrow].

A WOODPECKER IS ATTACKING YOUR HOUSE

First, figure out what the woodpecker is doing [p. 87 right]. If it is foraging you might need to call an expert to find out if you have insects in your walls. If it is drumming or excavating, this behavior should taper off after a few weeks. In the meantime you can try hanging something to deter the woodpecker: a tarp to prevent it from reaching the wood, foil strips or CDs to scare it off, etc. Woodpeckers usually attack houses with natural siding colors, and one solution in extreme cases is to paint the house a different color.

A BIRD HAS BUILT A NEST ON YOUR PORCH

A few species of birds will nest on a porch, windowsill, etc. Give the birds as much privacy as you can, especially early in the process, and enjoy the opportunity to watch an entire nesting cycle [p. 128 middle].

A LIVE BIRD IS IN YOUR HOUSE

A bird inside a building will look for an exit and fly toward daylight, fluttering against (or crashing into) windows. If you stand in the room, especially between the bird and an exit, it might fly close to you, but you are in no danger. The bird is not attacking you, only looking for a way out.

Move slowly and calmly to avoid startling the bird. First close doors to keep the bird in the room it's in and prevent it from entering other parts of the house. Then open all available exterior windows and doors in that room to provide an easy exit. Open windows at the top if possible. Close the curtains or shades on windows that can't be opened, leaving daylight only in open windows and doors.

If you approach the bird it will probably fly, so always try to approach in a way that will "herd" it toward an exit and won't block its escape. Making yourself larger by spreading your arms above your head will help to prevent the bird from flying past you, but do this, like everything else, slowly and calmly. If the bird is fluttering against a window and you are able to pick it up, hold it gently but firmly and move immediately to an opening to release it outside.

YOU FIND A DEAD BIRD

Dead birds are most often seen as the result of human-related causes: hitting a window, hit by a car, or killed by a pet cat. It's unlikely that any dead bird you find is diseased, but handle it carefully and wash your hands.

The law: it is generally illegal to possess a native bird, or any parts such as feathers, without the proper permits.

In most cases you should simply dispose of the body: bury it or put it in the trash. If you know that an official institution like a museum or university is interested in the bird as a specimen for study, follow these steps: Roll it carefully into a paper towel or a sheet of newspaper. Wrap that tightly in a plastic bag and be sure to include a note about where, when and how you found the bird. Put it in the freezer. Wash your hands.

YOU FIND A BABY BIRD

Two key points before going any further:

🖋 Most baby birds do not need any help, and the best thing you can do is leave them alone, almost every time. Baby birds generally do not need to be rescued. [p. 105 middle]

🖋 It is illegal to keep native birds, and they do not make good pets. Only specially trained and licensed wildlife rehabilitators are allowed to keep injured or orphaned birds.

Assess the situation

If the baby bird looks something like this:

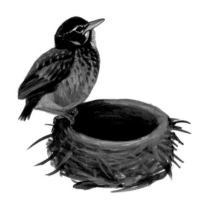

This is a fledgling and it is normal for birds this age to leave the nest. The parents are probably nearby, and the young bird should be left alone. If you hear a sharp, repeated call while you are close to the baby bird, or see an adult bird actively flying around close to you, that is likely to be a parent defending its young. You should move away and let them take over. Do not put food and water near the fledgling; it won't help and it might attract predators.

Only a few situations will benefit from your intervention:

🖋 *If a fledgling is in imminent danger* from cats, dogs, cars, etc. If you are convinced that it is in danger, simply shoo it toward safety, or gently pick it up and move it into a safer location such as a shrub or tree.

🖋 *If a fledgling is clearly injured,* (for example, if it has been brought to you by a cat or dog). If the injuries are minor and the bird can sit and hop, it probably has its best chance in the wild with its parents. Take it outside and set it on a relatively high and hidden perch in a bush or small tree where the parents can find it. If its injuries are more severe, call your local wildlife rehabilitator.

🖋 *If a fledgling is lost or orphaned.* First, it is unlikely that you have found an orphaned bird. The parents are probably close by. The first step is to find out if the parents are still around. Watch for at least two hours from a location where you can be sure your presence is not keeping the parents away (for example, from inside your house), and watch constantly. The parents will be stealthy when they visit and it takes only a few seconds to deliver food to a fledgling. If you are certain that the young bird is an orphan, call your local wildlife rehabilitator.

If the baby bird looks more like this:

This is a very young bird (unable to sit up) that has fallen from its nest. If you can find and reach the nest, put the baby bird back. If you can't find a nest or can't put the bird back, make a substitute nest and attach it as close to the old nest as you can. For a temporary nest a small box or bowl (e.g. a berry basket) lined with a paper towel should work. Put the baby bird in it and watch from a distance to see if the parents return.

If, after all that, you are sure that a baby bird needs your help, keep it warm and dry and call your local wildlife rehabilitator.

Becoming a birder

To get started in birding, all you need is curiosity. Traditionally, a guide to identification and a pair of binoculars are considered the basic requirements—and as your birding hobby expands these items will become essential. But in the twenty-first century, you can find information and helpful discussion groups online, and many people now start birding with a digital camera instead of binoculars.

You will learn faster if you can be an active observer—draw sketches, take notes, write poetry, take photos—whatever will make you look a little more carefully and a little longer. One of the best approaches is to ask yourself questions: Why is that bird acting that way? How does the bill shape of one species compare to others? The more you notice the more you will learn.

It's a good birding habit to try to limit the impact you have on the birds' behavior. Owls are especially sensitive to disturbance [p. 180, Eastern Screech-Owl], but we should try to disturb all birds as little as possible.

BIRD IDENTIFICATION

One of the keys to successful bird identification is noticing differences and similarities [p. 37 top]. Pay attention to shape (especially bill shape) and habits, as well as color, and learn which species are related.

Browsing this book will give you a sense of the wide variety of bill shapes. Thinking about the birds' feeding habits, you will quickly notice patterns in how each bill shape is used [pp. 41 top and 149 middle].

Pay attention to all aspects of a bird's shape. For example the presence of a crest [p. 147 top] or different shapes of wings [p. 99 middle].

The habits of birds are other powerful clues for distinguishing species. For example, the tilting flight of a Turkey Vulture is distinctive [p. 59 bottom] and very different from the undulating flight of most songbirds [p. 163 top] or the smooth, graceful flight of a swallow [p. 101 middle]. Wrens can often be identified by a characteristic habit of raising their tails [p. 123 top], and a phoebes have a habit of wagging their tails [p. 95 top].

Color is often one of the easiest clues for distinguishing similar species. The Pyrrhuloxia is very closely related to the Northern Cardinal, even though it is colored quite differently [p. 147 left bottom]. Three species of chickadees differ mainly in color patterns [p. 112]. The Varied Thrush is in the same family as the American Robin and shares a similar orange and gray color, but differs in many details of color pattern [127 bottom].

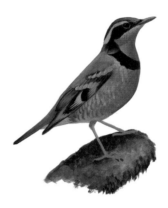

Groups of related species always share fundamental similarities. For example, all woodpeckers climb trees using their stiff tail as a brace [p. 91 top]. Nuthatches climb trees but without using their tail [p. 118]. In some cases unrelated species evolve similar solutions to the same challenge. Brown Creepers have evolved the same modified tail and the same climbing method as woodpeckers, but they are not related [p. 89 bottom].

Acknowledgments

This book relies heavily on the constantly growing body of published scientific research, and it would not have been possible without the curiosity and dedication of all of the people who work to advance our knowledge of birds and the natural world. Some of those people are listed as authors of the papers in the Sources section. Many thousands of others have also contributed to our current understanding of birds through those studies and countless more. I owe thanks to them all.

Thanks to the following people who helped directly with this book by answering questions, providing references, reading drafts, etc: Kate Davis, Frank Gallo, Lorna Gibson, Jerry Liguori, Klara Nordern, Danny Price, Jeff Podos, Richard Prum, Peter Pyle, J. Michael Reed, Marj Rines, Margaret Rubega, Mary Stoddard, Luke Tyrrell, and Joan Walsh.

Special thanks to these three people who put in extra time with research help, reading, rereading, and general consulting at various stages of the project: Chris Elphick, Lindall Kidd, and Tooey Rogers.

Thanks to my agent, Russell Galen, for being excellent at his job, so I could focus on mine.

Thanks to the publishing team at Alfred A. Knopf for their patience as this project slowly developed, and then for expertly weaving it all together into a real book.

Thanks to my wife, Joan, and my sons, Evan and Joel, for making sure I had just enough time to get this done.

Sources

The sources listed for each essay in the following pages are specific and technical references. A few general sources were also critical to the research for this book. These provided useful information for many of the essays, and make a good starting point for further reading:

Gill et al 2019. *Ornithology*. 4th ed. New York: W. H. Freeman.
Scanes, ed. 2014. *Sturkie's Avian Physiology*. 6th ed. Cambridge, MA: Academic Press.
Proctor and Lynch 1998. *Manual of Ornithology: Avian Structure and Function*. New Haven: Yale University Press.
Rodewald, ed. 2015. *The Birds of North America*. Cornell Laboratory of Ornithology, Ithaca, NY. https://birdsna.org

3 Geese, like ducks, sandpipers, and chickens:
Starck and Ricklefs 1998. "Patterns of Development: The Altricial-Precocial Spectrum." In J. M. Starck and R. E. Ricklefs, eds., *Avian Growth and Development. Evolution Within the Altricial Precocial Spectrum.* New York: Oxford University Press.

3 Young geese instinctively form an attachment:
Lorenz 1952. *King Solomon's Ring.* New York: Methuen.
Hess 1958. "Imprinting in animals." *Scientific American* 198: 81–90.

3 Male and female geese are identical in appearance:
Caithamer et al 1993. "Field identification of age and sex of interior Canada geese." *Wildlife Society Bulletin* 21: 480–487.

5 Flying in a V formation:
Portugal et al 2014. "Upwash exploitation and downwash avoidance by flap phasing in ibis formation flight." *Nature* 505: 399–402.
Weimerskirch et al 2001. "Energy saving in flight formation." *Nature* 413: 697–698.

5 Feathers wear out:
Howell 2010. *Molt in North American Birds.* New York: Houghton Mifflin Harcourt.
Gates et al 1993. "The annual molt cycle of *Branta canadensis interior* in relation to nutrient reserve dynamics." *The Condor* 95: 680–693.
Tonra and Reudink 2018. "Expanding the traditional definition of molt-migration." *The Auk* 135: 1123–1132.

5 Birds have no teeth:
Gionfriddo and Best 1999. "Grit use by birds." In V. Nolan, E. D. Ketterson, C. F. Thompson, eds., *Current Ornithology, Volume 15.* Boston: Springer.

7 Swans and geese have long slender necks:
Ammann 1937. "Number of contour feathers of *Cygnus* and *Xanthocephalus*."
The Auk 54: 201–202.

9 Along with using wing feathers for pens:
Hanson 2011. *Feathers.* New York: Basic Books.

11 Taking off from water presents special challenges:
Queeny 1947. *Prairie Wings: Pen and Camera Flight Studies.* New York: Lippincott.

11 All birds have feathers:
Wang and Meyers 2016. "Light like a feather: a fibrous natural composite with a shape changing from round to square." *Advanced Science* 4: 1600360.

12 The female alone builds a nest:
Bailey et al 2015. "Birds build camouflaged nests." *The Auk* 132: 11–15.

12 A nesting attempt:
Kirby and Cowardin 1986. "Spring and summer survival of female Mallards from north central Minnesota." *Journal of Wildlife Management* 50: 38–43.
Arnold et al 2012. "Costs of reproduction in breeding female Mallards: predation risk during incubation drives annual mortality." *Avian Conservation and Ecology* 7(1): 1.

15 Birds are well insulated on their bodies:
Midtgard 1981. "The rete tibiotarsale and arteriovenous association in the hind limb of birds: a comparative morphological study on counter-current heat exchange systems." *Acta Zoologica* 62: 67–87.
Midtgard 1989. "Circulatory adaptations to cold in birds." In C. Bech, R. E. Reinertsen, eds., *Physiology of Cold Adaptation in Birds.* NATO ASI Series (Series A: Life Sciences), vol. 173. Boston: Springer.
Kilgore and Schmidt-Nielsen 1975. "Heat loss from ducks' feet immersed in cold water." *The Condor* 77: 475–517.

15 Female choice may control the appearance of males:
Prum 2017. *The Evolution of Beauty: How Darwin's Forgotten Theory of Mate Choice Shapes the Animal World—and Us.* New York: Doubleday.

15 The variety and complexity of colors:
Chen et al 2015. "Development, regeneration, and evolution of feathers." *Annual Review of Animal Bioscience* 3: 169–195.

17 We rely on our kidneys:
Bokenes and Mercer 1995. "Salt gland function in the common eider duck (*Somateria mollissima*)." *Journal of Comparative Physiology B* 165: 255–267.

17 Feathers are waterproof:
Rijke and Jesser 2011. "The water penetration and repellency of feathers revisited." *The Condor* 113: 245–254.
Srinivasan et al 2014. "Quantification of feather structure, wettability and resistance to liquid penetration." *Journal of the Royal Society Interface* 11.
Bormashenko et al 2007. "Why do pigeon feathers repel water? Hydrophobicity of pennae, Cassie-Baxter wetting hypothesis and Cassie-Wenzel capillarity-induced wetting transition." *Journal of Colloid and Interface Science* 311: 212–216.

19 Birds have a well developed sense of taste:
Rowland et al 2015. "Comparative Taste Biology with Special Focus on Birds and Reptiles." In R. L. Doty, ed., *Handbook of Olfaction and Gustation,* 3rd ed. New York: Wiley-Liss.
Clark et al 2014. "The Chemical Senses in Birds." In C. Scanes, ed., *Sturkie's Avian Physiology.* Cambridge: Academic Press.
Wang and Zhao 2015. "Birds generally carry a small repertoire of bitter taste receptor genes." *Genome Biology and Evolution* 7: 2705–2715.
Skelhorn and Rowe 2010. "Birds learn to use distastefulness as a signal of toxicity." *Proceedings of the Royal Society B: Biological Sciences* 277.

21 Loon chicks can swim within hours after hatching:
Evers et al 2010. "Common Loon (*Gavia immer*). Version 2.0." In A. F. Poole, ed., *The Birds of North America.* Ithaca: Cornell Lab of Ornithology.

23 Eared Grebes spend most of the year:
Roberts et al 2013. "Population fluctuations and distribution of staging Eared Grebes (*Podiceps nigricollis*) in North America." *Canadian Journal of Zoology* 91: 906–913.

Jehl et al 2003. "Optimizing Migration in a Reluctant and Inefficient Flier: The Eared Grebe." In P. Berthold, E. Gwinner, E. Sonnenschein, eds., *Avian Migration*. Springer Berlin / Heidelberg.

23 Diving birds have some ability:
Casler 1973. "The air-sac systems and buoyancy of the Anhinga and Double-Crested Cormorant." *The Auk* 90: 324–340.
Stephenson 1995. "Respiratory and plumage gas volumes in unrestrained diving ducks (*Aythya affinis*)." *Respiration Physiology* 100: 129–137.

23 An amazing communication occurs:
Brua 1993. "Incubation behavior and embryonic vocalizations of Eared Grebes." Master's thesis, North Dakota State Univ., Fargo.

25 Colonies of nesting seabirds:
Croft et al 2016. "Contribution of Arctic seabird-colony ammonia to atmospheric particles and cloud-albedo radiative effect." *Nature Communications* 7: 13444.
Otero et al 2018. "Seabird colonies as important global drivers in the nitrogen and phosphorus cycles." *Nature Communications* 9: 246.

25 The large colorful bill of a puffin:
Tattersall et al 2009. "Heat exchange from the Toucan bill reveals a controllable vascular thermal radiator." *Science* 24: 468–470.

25 Murres, related to puffins:
Croll et al 1992. "Foraging behavior and physiological adaptation for diving in Thick-Billed Murres." *Ecology* 73: 344–356.
Martin 2017. *The Sensory Ecology of Birds*. Oxford: Oxford University Press.
Regular et al 2011. "Fishing in the dark: a pursuit-diving seabird modifies foraging behaviour in response to nocturnal light levels." *PLOS One* 6: e26763.
Regular et al 2010. "Crepuscular foraging by a pursuit-diving seabird: tactics of common murres in response to the diel vertical migration of capelin." *Marine Ecology Progress Series* 415: 295–304.
Gremillet et al 2005. "Cormorants dive through the polar night." *Biology Letters* 1: 469–471.

27 It is often reported that cormorants' feathers:
Srinivasan et al 2014. "Quantification of feather structure, wettability and resistance to liquid penetration." *Journal of the Royal Society Interface* 11.
Gremillet et al 2005. "Unusual feather structure allows partial plumage wettability in diving Great Cormorants *Phalacrocorax carbo*." *Journal of Avian Biology* 36: 57–63.
Ribak et al 2005. "Water retention in the plumage of diving Great Cormorants *Phalacrocorax carbo sinensis*." *Journal of Avian Biology* 36: 89–95.
Quintana et al 2007. "Dive depth and plumage air in wettable birds: the extraordinary case of the Imperial Cormorant." *Marine Ecology Progress Series* 334: 299–310.

27 My vision is blurry underwater:
Cronin 2012. "Visual optics: accommodation in a splash." *Current Biology* 22: R871–R873.
Martin 2017. *The Sensory Ecology of Birds*. Oxford: Oxford University Press.

31 Great Blue Herons are very patient hunters:
Katzir et al 1989. "Stationary underwater prey missed by reef herons, *Egretta gularis*: head position and light refraction at the moment of strike." *Journal of Comparative Physiology A* 165: 573–576.

33 Refraction:
Lotem et al 1991. "Capture of submerged prey by little egrets, *Egretta garzetta garzetta*: strike depth, strike angle and the problem of light refraction." *Animal Behaviour* 42: 341–346.
Katzir and Intrator 1987. "Striking of underwater prey by a reef heron, *Egretta gularis schistacea*." *Journal of Comparative Physiology A* 160: 517–523.

33 The evolution of feathers:
Prum and Brush 2002. "The evolutionary origin and diversification of feathers." *The Quarterly Review of Biology* 77: 261–295.

33 Herons and egrets have developed:
Lovell 1958. "Baiting of fish by a Green Heron." *Wilson Bulletin* 70: 280–281.
Gavin and Solomon 2009. "Active and passive bait-fishing by Black-Crowned Night Herons." *The Wilson Journal of Ornithology* 121: 844–845.

35 Why do birds stand on one leg?:
Chang and Ting 2017. "Mechanical evidence that flamingos can support their body on one leg with little active muscular force." *Biology Letters* 13: 20160948.

39 Eggs that are simply laid on open ground:
Reneerkens et al 2005. "Switch to diester preen waxes may reduce avian nest predation by mammalian predators using olfactory cues." *Journal of Experimental Biology* 208: 4199–4202.
Kolattukudy et al 1987. "Diesters of 3-hydroxy fatty acids produced by the uropygial glands of female Mallards uniquely during the mating season." *Journal of Lipid Research* 28: 582–588.

41 These four species of shorebirds:
Dumont et al 2011. "Morphological innovation, diversification and invasion of a new adaptive zone." *Proceedings of the Royal Society B: Biological Sciences* 279: 1734.

43 The swerving movements of a tight flock of sandpipers:
Attanasi et al 2014. "Information transfer and behavioural inertia in starling flocks." *Nature Physics* 10: 691–696.
Attanasi et al 2015. "Emergence of collective changes in travel direction of starling flocks from individual birds' fluctuations." *Journal of the Royal Society Interface* 12.
Potts 1984. "The chorus-line hypothesis of manoeuvre coordination in avian flocks." *Nature* 309: 344–345.

43 The tip of a sandpiper's bill:
Piersma et al 1998. "A new pressure sensory mechanism for prey detection in birds: the use of principles of seabed dynamics?" *Proceedings of the Royal Society of London B: Biological Sciences* 265.

43 Observing a flock of sandpipers:
Rubega and Obst 1993. "Surface-tension feeding in Phalaropes: discovery of a novel feeding mechanism." *The Auk* 110: 169–178.

45 To impress mates and rivals:
van Casteren et al 2010. "Sonation in the male common snipe (*Capella gallinago gallinago* L.) is achieved by a flag-like fluttering of their tail feathers and consequent vortex shedding." *Journal of Experimental Biology* 213: 1602–1608.
Clark et al 2013. "Hummingbird feather sounds are produced by aeroelastic flutter, not vortex-induced vibration." *Journal of Experimental Biology* 216: 3395–3403.
Clark and Feo 2008. "The Anna's Hummingbird chirps with its tail: a new mechanism of sonation in birds." *Proceedings of the Royal Society B: Biological Sciences* 275: 955–962.

45 Birds generally have excellent eyesight:
Martin 2007. "Visual fields and their functions in birds." *Journal of Ornithology* 148: 547–562.

47 Gulls are notorious for eating junk:
Annett and Pierotti 1989. "Chick hatching as a trigger for dietary switches in Western Gulls." *Colonial Waterbirds* 12: 4–11.
Alonso et al 2015. "Temporal and age-related dietary variations in a large population of yellow-legged gulls *Larus michahellis*: implications for management and conservation." *European Journal of Wildlife Research* 61: 819–829.

47 If you find a gull feather on the beach:
Butler and Johnson 2004. "Are melanized feather barbs stronger?" *Journal of Experimental Biology* 207: 285–293.
Bonser 1995. "Melanin and the abrasion resistance of feathers." *The Condor* 97: 590–591.

47 What do birds do in a hurricane?:
Breuner et al 2013. "Environment, behavior and physiology: do birds use barometric pressure to predict storms?" *Journal of Experimental Biology* 216: 1982–1990.

49 Why do some birds nest in colonies?:
Rolland et al 1998. "The evolution of coloniality in birds in relation to food, habitat, predation, and life-history traits: a comparative analysis." *The American Naturalist* 151: 514–529.
Varela et al 2007. "Does predation select for or against avian coloniality? A comparative analysis." *Journal of Evolutionary Biology* 20: 1490–1503.

49 Terns are exquisitely adapted for flight:
Egevang et al 2010. "Tracking of Arctic terns *Sterna paradisaea* reveals longest animal migration." *Proceedings of the National Academy of Sciences* 107: 2078–2081.
Weimerskirch et al 2014. "Lifetime foraging patterns of the wandering albatross: life on the move!" *Journal of Experimental Marine Biology and Ecology* 450: 68–78.
Weimerskirch et al 2015. "Extreme variation in migration strategies between and within wandering albatross populations during their sabbatical year, and their fitness consequences." *Scientific Reports* 5: 8853.

51 The overall color of birds:
Amar et al 2013. "Plumage polymorphism in a newly colonized Black Sparrowhawk population: classification, temporal stability and inheritance patterns." *Journal of Zoology* 289: 60–67.
Tate and Amar 2017. "Morph specific foraging behavior by a polymorphic raptor under variable light conditions." *Scientific Reports* 7: 9161.
Tate et al 2016. "Differential foraging success across a light level spectrum explains the maintenance and spatial structure of colour morphs in a polymorphic bird." *Ecology Letters* 19: 679–686.
Tate et al 2016. "Pair complementarity influences reproductive output in the polymorphic Black Sparrowhawk *Accipiter melanoleucus*." *Journal of Avian Biology* 48: 387–398.

51 The females and males of most species:
Kruger 2005. "The evolution of reversed sexual size dimorphism in hawks, falcons and owls: a comparative study." *Evolutionary Ecology* 19: 467–486.

55 Cooper's and Sharp-shinned Hawks:
Fisher 1893. "Hawks and owls as related to the farmer." *Yearbook of the USDA*: 215–232.

55 Along with their very sharp eyesight:
Bostrom et al 2016. "Ultra-rapid vision in birds." *PLOS One* 11: e0151099.
Healy et al 2013. "Metabolic rate and body size are linked with perception of temporal information." *Animal Behaviour* 86: 685–696.

57 We call someone "eagle-eyed":
Ruggeri et al 2010. "Retinal structure of birds of prey revealed by ultra–high resolution spectral-domain optical coherence tomography." *Investigative Ophthalmology & Visual Science* 51: 5789-5795.
O'Rourke et al 2010. "Hawk eyes I: diurnal raptors differ in visual fields and degree of eye movement." *PLOS One* 5: e12802.

57 Look at a single word in this sentence:
Potier et al 2017. "Eye size, fovea, and foraging ecology in Accipitriform raptors." *Brain Behavior and Evolution* 90: 232-242.
Tucker 2000. "The deep fovea, sideways vision and spiral flight paths in raptors." *Journal of Experimental Biology* 203: 3745-3754.

57 One of the most serious threats:
Haig et al 2014. "The persistent problem of lead poisoning in birds from ammunition and fishing tackle." *The Condor* 116: 408–428.
Yaw et al 2017. "Lead poisoning in Bald Eagles admitted to wildlife rehabilitation facilities in Iowa, 2004–2014." *Journal of Fish and Wildlife Management* 8: 465-473.
University of Minnesota Website: https://www.raptor.umn.edu/our-research/lead-poisoning

59 Vultures spend the night roosting:
Clark and Ohmart 1985. "Spread-winged posture of Turkey Vultures: single or multiple function?" *The Condor* 87: 350–355.

59 You might have heard that birds cannot smell:
Grigg et al 2017. "Anatomical evidence for scent guided foraging in the Turkey Vulture." *Scientific Reports* 7: 17408.
Smith and Paselk 1986. "Olfactory sensitivity of the Turkey Vulture (*Cathartes aura*) to three carrion-associated odorants." *The Auk* 103: 586–592.
Krause et al 2018. "Olfaction in the Zebra Finch (*Taeniopygia guttata*): what is known and further perspectives." *Advances in the Study of Behavior* 50: 37–85.

59 The flight of Turkey Vultures:
Mallon et al 2016. "In-flight turbulence benefits soaring birds." *The Auk* 133: 79–85.
Sachs and Moelyadi 2010. "CFD-based determination of aerodynamic effects on birds with extremely large dihedral." *Journal of Bionic Engineering* 7: 95–101.
Klein Heerenbrink et al 2017. "Multi-cored vortices support function of slotted wing tips of birds in gliding and flapping flight." *Journal of the Royal Society Interface* 14.

61 The intricate color pattern:
Clay 1953. "Protective coloration in the American Sparrow Hawk." *Wilson Bulletin* 65: 129–134.
Cooper 1998. "Conditions favoring anticipatory and reactive displays deflecting predatory attack." *Behavioral Ecology* 9: 598–604.

61 The Peregrine Falcon is the fastest:
Tucker 1998. "Gliding flight: speed and acceleration of ideal falcons during diving and pull out." *Journal of Experimental Biology* 201: 403–414.

61 Birds use many techniques to save energy:
Williams et al 2018. "Social eavesdropping allows for a more risky gliding strategy by thermal-soaring birds." *Journal of the Royal Society Interface* 15.

63 The "horns" of Great Horned Owl:
Perrone 1981. "Adaptive significance of ear tufts in owls." *The Condor* 83: 383–384.
Santillan et al 2008. "Ear tufts in Ferruginous Pygmy-Owl (*Glaucidium brasilianum*) as alarm response." *Journal of Raptor Research* 42: 153–154.
Catling 1972. "A behavioral attitude of Saw-Whet and Boreal Owls." *The Auk* 89: 194–196.
Holt et al 1990. "A description of 'tufts' and concealing posture in Northern Pygmy-Owls." *Journal of Raptor Research* 24: 59–63.

63 There's a common myth that owls can spin their heads:
Krings et al 2017. "Barn Owls maximize head rotations by a combination of yawing and rolling in functionally diverse regions of the neck." *Journal of Anatomy* 231: 12–22.
de Kok-Mercado et al 2013. "Adaptations of the owl's cervical & cephalic arteries in relation to extreme neck rotation." *Science* 339: 514–515.

63 Owls are supposed to be nocturnal:
Penteriani and Delgado 2009. "The dusk chorus from an owl perspective: Eagle Owls vocalize when their white throat badge contrasts most." *PLOS One* 4: e4960.

65 Owls have extremely sensitive hearing:
Knudsen and Konishi 1979. "Mechanisms of sound localization in the Barn Owl (*Tyto alba*). *Journal of Comparative Physiology* 133: 13–21.
Takahashi 2010. "How the owl tracks its prey—II." *Journal of Experimental Biology* 213: 3399–3408.

65 Owls' wing feathers:
Bachmann et al 2007. "Morphometric characterisation of wing feathers of the Barn Owl *Tyto alba pratincola* and the pigeon *Columba livia*." *Frontiers in Zoology* 4: 23.

65 Even with their excellent hearing:
Payne 1971. "Acoustic location of prey by Barn Owls (*Tyto alba*)." *Journal of Experimental Biology* 54: 535–573.
Hausmann et al 2009. "In-flight corrections in free-flying Barn Owls (*Tyto alba*) during sound localization tasks." *Journal of Experimental Biology* 211: 2976–2988.
Fux and Eilam 2009. "The trigger for Barn Owl (*Tyto alba*) attack is the onset of stopping or progressing of prey." *Behavioural Processes* 81: 140–143.

69 What's the most common bird in North America?:
USDA data

71 The Northern Bobwhite is named for the male's call:
Phillips 1928. "Wild birds introduced or transplanted in North America." U.S. Department of Agriculture Technical Bulletin 61.

73 Birdbrain, silly goose, dodo:
Watanabe 2001. "Van Gogh, Chagall and pigeons: picture discrimination in pigeons and humans." *Animal Cognition* 4: 147–151.
Levenson et al 2015. "Pigeons (*Columba livia*) as trainable observers of pathology and radiology breast cancer images." *PLOS One* 10: e0141357.
Toda and Watanabe 2008. "Discrimination of moving video images of self by pigeons (*Columba livia*)." *Animal Cognition* 11: 699–705.
Emery 2005. "Cognitive ornithology: the evolution of avian intelligence." *Philosophical Transactions of the Royal Society B Biological Sciences* 361: 23-43.
Prior et al 2008. "Mirror-induced behavior in the Magpie (*Pica pica*): evidence of self-recognition." *PLOS Biology* 6: e202.

73 With their remarkable navigational abilities:
Blechman 2007. *Pigeons: The Fascinating Saga of the World's Most Revered and Reviled Bird*, New York: Open Road and Grove/Atlantic.
Guilford and Biro 2014. "Route following and the pigeon's familiar area map." *Journal of Experimental Biology* 217: 169–179.

75 Many birds bob their heads back and forth as they walk:
Friedman 1975. "Visual control of head movements during avian locomotion." *Nature* 255: 67–69.
Frost 1978. "The optokinetic basis of head-bobbing in the pigeon." *Journal of Experimental Biology* 74: 187–195.

75 Can birds really sleep with one eye open?:
Mascetti 2016. "Unihemispheric sleep and asymmetrical sleep: behavioral, neurophysiological, and functional perspectives." *Nature and Science of Sleep* 8: 221–238.

75 Why do the wings of Mourning Doves make a whistling sound:
Hingee and Magrath 2009. "Flights of fear: a mechanical wing whistle sounds the alarm in a flocking bird." *Proceedings of the Royal Society of London B: Biological Sciences* 276: 4173–4179.
Coleman 2008. "Mourning Dove (*Zenaida macroura*) wing-whistles may contain threat-related information for con- and heterospecifics." *Naturwissenschaften* 95: 981–986.
Magrath et al 2007. "A mutual understanding? Interspecific responses by birds to each other's aerial alarm calls." *Behavioral Ecology* 18: 944–951.

77 The glittering colors of a hummingbird's throat:
Prum 2006. "Anatomy, Physics, and Evolution of Structural Colors." In Hill and McGraw, eds., *Bird Coloration Vol 1: Mechanisms and Measurements*. Cambridge: Harvard University Press.
Greenewalt et al 1960. "Iridescent colors of hummingbird feathers." *Journal of the Optical Society of America* 50: 1005–1013.

77 Many species of birds have iridescent colors:
Doucet and Meadows 2009. "Iridescence: a functional perspective." *Journal of the Royal Society Interface* 6.
Meadows 2012. "The costs and consequences of iridescent coloration in Anna's Hummingbirds (*Calypte anna*)." PhD Dissertation, Arizona State University.

77 It takes a lot of fuel:
Hiebert 1993. "Seasonal changes in body mass and use of torpor in a migratory hummingbird." *The Auk* 110: 787–797.
Shankar et al 2019. "Hummingbirds budget energy flexibly in response to changing resources." *Functional Ecology* 33: 1904-1916.
Carpenter and Hixon 1988. "A new function for torpor: fat conservation in a wild migrant hummingbird." *The Condor* 90: 373–378.

78 The largest hummingbird found north of Mexico, and the smallest:
Bertin 1982. "Floral biology, hummingbird pollination and fruit production of Trumpet Creeper (*Campsis radicans*, Bignoniaceae)." *American Journal of Botany* 69: 122–134.

79 Feeding hummingbirds is simple:
Williamson 2001. *A Field Guide to Hummingbirds of North America*. New York: Houghton Mifflin Harcourt.

79 Hummingbirds can hover in place:
Sapir and Dudley 2012. "Backward flight in hummingbirds employs unique kinematic adjustments and entails low metabolic cost." *Journal of Experimental Biology* 215: 3603–3611.
Tobalske 2010. "Hovering and intermittent flight in birds." *Bioinspiration & Biomimetics* 5: 045004.

Warrick et al 2005. "Aerodynamics of the hovering hummingbird." *Nature* 435: 1094–1097.

79 Hummingbirds feed by dipping:
Rico-Guevara and Rubega 2011. "The hummingbird tongue is a fluid trap, not a capillary tube." *PNAS* 108: 9356–9360.
Rico-Guevara et al 2015. "Hummingbird tongues are elastic micropumps." *Proceedings of the Royal Society B: Biological Sciences* 282.

81 At the time of the meteor impact:
Longrich et al 2011. "Mass extinction of birds at the Cretaceous-Paleogene (K-Pg) boundary." *Proceedings of the National Academy of Sciences USA* 108: 15253–15257.
Field et al 2018. "Early evolution of modern birds structured by global forest collapse at the end-Cretaceous mass extinction." *Current Biology* 28: 1825–1831.
Claramunt and Cracraft 2015. "A new time tree reveals Earth history's imprint on the evolution of modern birds." *Science Advances* 1 (11): e1501005

81 For more than a century the link:
Li et al 2010. "Plumage color patterns of an extinct dinosaur." *Science* 327: 1369–1372.
Liu et al 2012. "Timing of the earliest known feathered dinosaurs and transitional pterosaurs older than the Jehol Biota." *Palaeogeography, Palaeoclimatology, Palaeoecology* 323–325: 1–12.

83 Kingfishers catch fish by hovering:
Videler et al 1983. "Intermittent gliding in the hunting flight of the Kestrel, *Falco tinnunculus L.*" *Journal of Experimental Biology* 102: 1–12.
Frost 2009. "Bird head stabilization." *Current Biology* 19: PR315–R316.
Necker 2005. "The structure and development of avian lumbosacral specializations of the vertebral canal and the spinal cord with special reference to a possible function as a sense organ of equilibrium." *Anatomy and Embryology (Berl)* 210: 59–74.

85 The brilliant green color:
Stradi et al 2001. "The chemical structure of the pigments in *Ara macao* plumage." *Comparative Biochemistry and Physiology Part B: Biochemistry and Molecular Biology* 130: 57–63.
McGraw and Nogare 2005. "Distribution of unique red feather pigments in parrots." *Biology Letters* 1: 38–43.
Burtt et al 2011. "Colourful parrot feathers resist bacterial degradation." *Biology Letters* 7: 214–216.

85 Without hands, most birds birds use their bill:
Friedmann and Davis 1938. "'Left-handedness' in parrots." *The Auk* 55: 478–480.
Brown and Magat 2011/a. "Cerebral lateralization determines hand preferences in Australian parrots." *Biology Letters* 7: 496-498.
Brown and Magat 2011/b. "The evolution of lateralized foot use in parrots: a phylogenetic approach." *Behavioral Ecology* 22: 1201–1208.

85 A bird's tongue is a very important food-handling appendage:
Beckers et al 2004. "Vocal-tract filtering by lingual articulation in a parrot." *Current Biology* 14: 1592–1597.
Ohms et al 2012. "Vocal tract articulation revisited: the case of the monk parakeet." *Journal of Experimental Biology* 215: 85–92.

86 These two similar species:
Weibel and Moore 2005. "Plumage convergence in *Picoides* woodpeckers based on a molecular phylogeny, with emphasis on convergence in Downy and Hairy Woodpeckers." *The Condor* 107: 797–809.

Miller et al 2017. "Fighting over food unites the birds of North America in a continental dominance hierarchy." *Behavioral Ecology* 28: 1454–1463.
Leighton et al 2018. "The hairy-downy game revisited: an empirical test of the interspecific social dominance mimicry hypothesis." *Animal Behaviour* 137: 141–148.
Rainey and Grether 2007. "Competitive mimicry: synthesis of a neglected class of mimetic relationships." *Ecology* 88: 2440–2448.
Prum and Samuelson 2012. "The hairy-downy game: a model of interspecific social dominance mimicry." *Journal of Theoretical Biology* 313: 42–60.

87 Woodpeckers engage in three very distinct activities:
https://www.allaboutbirds.org/can-woodpecker-deterrents-safeguard-my-house

87 Why don't woodpeckers get concussions?:
Wang et al 2011. "Why do woodpeckers resist head impact injury: a biomechanical investigation." *PLOS One* 6: e26490.
Farah et al 2018. "Tau accumulations in the brains of woodpeckers." *PLOS One* 13: e0191526.
Gibson 2006. "Woodpecker pecking: how woodpeckers avoid brain injury." *Journal of Zoology* 270: 462–465.
May et al 1976. "Woodpeckers and head injury." *The Lancet* 307: 1347–1348.

89 The Acorn Woodpecker:
Koenig and Mumme 1987. *Population Ecology of the Cooperatively Breeding Acorn Woodpecker.* Princeton: Princeton University Press.
Koenig et al 2011. "Variable helper effects, ecological conditions, and the evolution of cooperative rreeding in the Acorn Woodpecker." *The American Naturalist* 178: 145–158.

91 The extendable tongue of woodpeckers:
Bock 1999. "Functional and evolutionary morphology of woodpeckers." *Ostrich: Journal of African Ornithology* 70: 23–31.
Jung et al 2016. "Structural analysis of the tongue and hyoid apparatus in a woodpecker." *Acta Biomaterialia* 37: 1–13.

95 Many unrelated species of birds:
Avellis 2011. "Tail pumping by the Black Phoebe." *The Wilson Journal of Ornithology* 123: 766–771.
Randler 2007. "Observational and experimental evidence for the function of tail flicking in Eurasian Moorhen *Gallinula chloropus.*" *Ethology* 113: 629–639.

95 Phoebes like to build their nest:
Rendell and Verbeek 1996. "Old nest material in nest boxes of Tree Swallows: effects on nest-site choice and nest building." *The Auk* 113: 319–328.
Davis et al 1994. "Eastern Bluebirds prefer boxes containing old nests." *Journal of Field Ornithology* 65: 250–253.
Pacejka and Thompson 1996. "Does removal of old nests from nest-boxes by researchers affect mite populations in subsequent nests of house wrens?" *Journal of Field Ornithology* 67: 558–564.
Stanback and Dervan 2001. "Within-season nest-site fidelity in Eastern Bluebirds: disentangling effects of nest success and parasite avoidance." *The Auk* 118: 743.

95 Like most birds, phoebes generally:
Wang et al 2009. "Pellet casting by non-raptorial birds of Singapore." *Nature in Singapore* 2: 97–106.
Ford 2010. "Raptor gastroenterology." *Journal of Exotic Pet Medicine* 19: 140–150.
Duke et al 1976. "Meal to pellet intervals in 14 species of captive rap-

tors." *Comparative Biochemistry and Physiology Part A: Physiology* 53: 1–6.

97 All birds have extraordinary vision:
Tyrrell and Fernandez-Juricic 2016. "The eyes of flycatchers: a new and unique cell type confers exceptional motion detection ability." Presented at NAOC Conference, August 2016.

97 Rictal bristles:
Lederer 1972. "The role of avian rictal bristles." *Wilson Bulletin* 84: 193–197.

97 The Scissor-tailed Flycatcher:
Fitzpatrick 2008. "Tail length in birds in relation to tail shape, general flight ecology and sexual selection." *Journal of Evolutionary Biology* 12: 49–60.
Thomas 1996. "Why do birds have tails? The tail as a drag reducing flap, and trim control." *Journal of Theoretical Biology* 183: 247–253.
Evans and Thomas 1997. "Testing the functional significance of tail streamers." *Proceedings of the Royal Society B: Biological Sciences* 264: 211–217.

101 Swallows fly for hours at a time:
Hallmann et al 2017. "More than 75 percent decline over 27 years in total flying insect biomass in protected areas." *PLOS One* 12: e0185809.
Smith et al 2015. "Change points in the population trends of aerial-insectivorous birds in North America: synchronized in time across species and regions." *PLOS One* 10: e0130768.
Nebel et al 2010. "Declines of aerial insectivores in North America follow a geographic gradient." *Avian Conservation and Ecology* 5: 1.

101 In order to fly:
Dumont 2010. "Bone density and the lightweight skeletons of birds." *Proceedings of the Royal Society B: Biological Sciences* 277: 2193–2198.

103 Will the same individual birds return:
Winkler et al 2005. "The natal dispersal of Tree Swallows in a continuous mainland environment." *Journal of Animal Ecology* 74: 1080–1090.

103 All baby songbirds:
Bennett and Harvey 1985. "Brain size, development and metabolism in birds and mammals." *Journal of Zoology* 207: 491–509.
Chiappa et al 2018. "The degree of altriciality and performance in a cognitive task show correlated evolution." *PLOS One* 13: e0205128.

103 The details of an individual wing feather:
Lingham-Soliar 2017. "Microstructural tissue-engineering in the rachis and barbs of bird feathers." *Scientific Reports* 7: 45162.
Laurent et al 2014. "Nanomechanical properties of bird feather rachises: exploring naturally occurring fibre reinforced laminar composites." *Journal of the Royal Society Interface* 11.
Sullivan et al 2017. "Extreme lightweight structures: avian feathers and bones." *Materials Today* 20: 377–391.
Bachmann et al 2012. "Flexural stiffness of feather shafts: geometry rules over material properties." *Journal of Experimental Biology* 215: 405–415.

105 Baby crows:
http://www.birds.cornell.edu/crows/babycrow.htm

105 Crows are able to recognize us:
Cornell et al 2011. "Social learning spreads knowledge about dangerous humans among American Crows." *Proceedings of the Royal Society B: Biological Sciences* 279.

107 One of Aesop's Fables:
Bird and Emery 2009. "Rooks use stones to raise the water level to reach a floating worm." *Current Biology* 19: 1410–1414.
Jelbert et al 2014. "Using the Aesop's fable paradigm to investigate causal understanding of water displacement by New Caledonian Crows." *PLOS One* 9: e92895.
Muller et al 2017. "Ravens remember the nature of a single reciprocal interaction sequence over 2 days and even after a month." *Animal Behaviour* 129: 69–78.

107 It seems counterintuitive:
Ward et al 2002. "The adaptive significance of dark plumage for birds in desert environments." *Ardea* 90: 311–323.
Ellis 1980. "Metabolism and solar radiation in dark and white herons in hot climates." *Physiological Zoology* 53: 358–372.

109 Birds can be loud:
Muyshondt et al 2017. "Sound attenuation in the ear of domestic chickens (*Gallus gallus domesticus*) as a result of beak opening." *Royal Society Open Science* 4.

109 Jays are sometimes seen knocking:
Hames et al 2002. "Adverse effects of acid rain on the distribution of the Wood Thrush *Hylocichla mustelina* in North America." *Proceedings of the National Academy of Sciences* 99: 11235–11240.
Pahl et al 1997. "Songbirds do not create long-term stores of calcium in their legs prior to laying: results from high-resolution radiography." *Proceedings of the Royal Society B: Biological Sciences* 264: 1379.

109 Sunning and anting:
Saranathan and Burtt 2007. "Sunlight on feathers inhibits feather-degrading bacteria." *The Wilson Journal of Ornithology* 119: 239–245.
Eisner and Aneshansley 2008. "Anting in Blue Jays: evidence in support of a food-preparatory function." *Chemoecology* 18: 197–203.
Potter and Hauser 1974. "Relationship of anting and sunbathing to molting in wild birds." *The Auk* 91: 537–563.
Koop et al 2012. "Does sunlight enhance the effectiveness of avian preening for ectoparasite control?" *Journal of Parasitology* 98.

111 Many jays rely on acorns for food:
Koenig and Heck 1988. "Ability of two species of oak woodland birds to subsist on acorns." *The Condor* 90: 705–708.
Koenig and Faeth 1998. "Effects of storage on tannin and protein content of cached acorns." *The Southwestern Naturalist* 43: 170–175.
Dixon et al 1997. "Effects of caching on acorn tannin levels and Blue Jay dietary performance." *The Condor* 99: 756–764.

111 Jays are experts at hiding food:
Clayton et al 2007. "Social cognition by food-caching corvids. The western scrub-jay as a natural psychologist." *Philosophical Transactions of the Royal Society B: Biological Sciences* 362: 507–522.
Clayton and Dickinson 1999. "Memory for the content of caches by scrub jays (*Aphelocoma coerulescens*)." *Journal of Experimental Psychology: Animal Behavior Processes* 25: 82–91.

111 A recent study:
Socolar et al 2017. "Phenological shifts conserve thermal niches in North American birds and reshape expectations for climate-driven range shifts." *Proceedings of the National Academy of Sciences USA* 114: 12976–12981.
Cotton 2003. "Avian migration phenology and global climate change." *Proceedings of the National Academy of Sciences USA* 100: 12219–12222.
Mayor et al 2017. "Increasing phenological asynchrony between spring green-up and arrival of migratory birds." *Scientific Reports* 7: 1902.

Stephens et al 2016. "Consistent response of bird populations to climate change on two continents." *Science* 352: 84–87.

Moller et al 2008. "Populations of migratory bird species that did not show a phenological response to climate change are declining." *Proceedings of the National Academy of Sciences USA* 105: 16195–16200.

113 Chickadees are the busybodies:

Krebs 1973. "Social learning and the significance of mixed-species flocks of chickadees (*Parus spp.*)." *Canadian Journal of Zoology* 51: 1275–1288.

Dolby and Grubb 1998. "Benefits to satellite members in mixed-species foraging groups: an experimental analysis." *Animal Behaviour* 56: 501–509.

Sridhar et al 2009. "Why do birds participate in mixed-species foraging flocks? A large-scale synthesis." *Animal Behaviour* 78: 337–347.

113 Despite the fact that chickadees are reliable:

Arnold et al 2007. "Parental prey selection affects risk-taking behaviour and spatial learning in avian offspring." *Proceedings of the Royal Society B: Biological Sciences* 274: 2563–2569.

113 Chickadees that live in areas with harsh winters:

Brodin 2010. "The history of scatter hoarding studies." *Philosophical Transactions of the Royal Society B: Biological Sciences* 365: 869–881.

Clayton 1998. "Memory and the hippocampus in food-storing birds: a comparative approach." *Neuropharmacology* 37: 441–452.

Grodzinski and Clayton 2010. "Problems faced by food-caching corvids and the evolution of cognitive solutions." *Philosophical Transactions of The Royal Society B: Biological Sciences* 365: 977–987.

Roth et al 2012. "Variation in memory and the hippocampus across populations from different climates: a common garden approach." *Proceedings of the Royal Society B: Biological Sciences* 279: 402–410.

115 The theory of optimal foraging:

Zwarts and Blomert 1992. "Why knot *Calidris canutus* take medium-sized *Macoma balthica* when six prey species are available." *Marine Ecology Progress Series* 83: 113–128.

115 Songbirds typically lay four or five eggs:

Ricklefs et al 2017. "The adaptive significance of variation in avian incubation periods." *The Auk* 134: 542–550.

117 One important, but often overlooked, function:

Akresh et al 2017. "Effect of nest characteristics on thermal properties, clutch size, and reproductive performance for an open-cup nesting songbird." *Avian Biology Research* 10: 107–118.

Mainwaring et al 2014. "The design and function of birds' nests." *Ecology and Evolution* 4: 3909–3928.

Sloane 1996. "Incidence and origins of supernumeraries at Bushtit (*Psaltriparus minimus*) nests." *The Auk* 113: 757–770.

117 Despite its tiny size:

Addicott 1938. "Behavior of the Bush-tit in the breeding season." *The Condor* 40: 49–63.

121 It has long been reported:

Galton and Shepherd 2012. "Experimental analysis of perching in the European Starling (*Sturnus vulgaris*: Passeriformes; Passeres), and the automatic perching mechanism of birds." *Journal of Experimental Zoology Part A: Ecological Genetics and Physiology* 317: 205–215.

121 Birds do have a tendon–locking mechanism:

Einoder and Richardson 2007. "The digital tendon locking mechanism of owls: variation in the structure and arrangement of the mechanism and functional implications." *Emu* 107: 223–230.

125 Small birds lose about 10 percent of their body weight:

Ketterson and Nolan 1978. "Overnight weight loss in Dark-eyed Juncos (*Junco hyemalis*)." *The Auk* 95: 755–758.

125 What do salmon have to do with kinglets?:

Helfield and Naiman 2001. "Effects of salmon-derived nitrogen on riparian forest growth and implications for stream productivity." *Ecology* 82: 2403–2409.

Post 2008. "Why fish need trees and trees need fish." *Alaska Fish & Wildlife News* November 2008.

129 Many robin pairs:

Cooper et al 2006. "Geographical and seasonal gradients in hatching failure in Eastern Bluebirds *Sialia sialis* reinforce clutch size trends." *Ibis* 148: 221–230.

131 For millennia humans have enjoyed bird songs:

Doolittle et al 2014. "Overtone-based pitch selection in hermit thrush song: unexpected convergence with scale construction in human music." *Proceedings of the National Academy of Sciences USA* 111: 16616–16621.

Chiandetti and Vallortigara 2011. "Chicks like consonant music." *Psychological Science* 22: 1270–1273.

131 Birds produce sound with the syrinx:

Goller and Larsen 1997. "A new mechanism of sound generation in songbirds." *Proceedings of the National Academy of Sciences USA* 94: 14787–14791.

Podos et al 2004. "Bird song: the interface of evolution and mechanism." *Annual Review of Ecolology, Evolultion, and Systematics* 35: 55–87.

131 Thrushes have unusually large eyes:

Thomas et al 2002. "Eye size in birds and the timing of song at dawn." *Proceedings of the Royal Society B: Biological Sciences* 269: 831–837.

133 There is no blue pigment in birds:

Prum 2006. "Anatomy, Physics, and Evolution of Structural Colors." In Hill and McGraw, eds., *Bird Coloration Vol 1: Mechanisms and Measurements*. Cambridge: Harvard University Press.

Prum et al 2003. "Coherent scattering of ultraviolet light by avian feather barbs." *The Auk* 120: 163–170.

Prum et al 1998. "Coherent light scattering by blue feather barbs." *Nature* 396: 28–29.

135 A bird is attacking me every time I walk through my yard!:

Levey et al 2009. "Urban mockingbirds quickly learn to identify individual humans." *Proceedings of the National Academy of Sciences USA* 106: 8959–8962.

135 You might notice a mockingbird standing:

Mumme 2002. "Scare tactics in a neotropical warbler: white tail feathers enhance flush-pursuit foraging performance in the Slate-throated Redstart (*Myioborus miniatus*). *The Auk* 119: 1024–1036.

Mumme 2014. "White tail spots and tail-flicking behavior enhance foraging performance in the Hooded Warbler." *The Auk* 131: 141–149.

Jablonski and Strausfeld 2000. "Exploitation of an ancient escape circuit by an avian predator: prey sensitivity to model predator display in the field." *Brain, Behavior and Evolution* 56: 94–106.

135 One of the things Mockingbirds are known for:

Fuller et al 2007. "Daytime noise predicts nocturnal singing in urban robins." *Biology Letters* 3: 368–370.

La 2012. "Diurnal and nocturnal birds vocalize at night: a review." *The Condor* 114: 245–257.

Gil et al 2015. "Birds living near airports advance their dawn chorus and reduce overlap with aircraft noise." *Behavioral Ecology* 26: 435–443.

136 Starlings were introduced to North America:
Simberloff and Rejmanek 2010. "Invasiveness." In *Encyclopedia of Biological Invasions*. Berkeley: University of California Press.

137 Why do birds take baths?:
Slessers 1970. "Bathing behavior of land birds." *The Auk* 87: 91–99.
Brilot et al 2009. "Water bathing alters the speed-accuracy trade-off of escape flights in European Starlings." *Animal Behaviour* 78: 801–807.
Brilot and Bateson 2012. "Water bathing alters threat perception in starlings." *Biology Letters* 8: 379–381.
Van Rhijn 1977. "Processes in feathers caused by bathing in water." *Ardea* 65: 126–147.

137 It is a common misconception that birds can't smell:
Amo et al 2012. "Sex recognition by odour and variation in the uropygial gland secretion in starlings." *Journal of Animal Ecology* 81: 605–613.
Hiltpold and Shriver 2018. "Birds bug on indirect plant defenses to locate insect prey." *Journal of Chemical Ecology* 44: 576–579.
Nevitt et al 2004. "Testing olfactory foraging strategies in an Antarctic seabird assemblage." *Journal of Experimental Biology* 207: 3537–3544.
Goldsmith and Goldsmith 1982. "Sense of smell in the Black-chinned Hummingbird." *The Condor* 84: 237–238.
Mihailova et al 2014. "Odour-based discrimination of subspecies, species and sexes in an avian species complex, the Crimson Rosella." *Animal Behaviour* 95: 155–164.

137 The bill color of many species:
Bonser and Witter 1993. "Indentation hardness of the bill keratin of the European Starling." *The Condor* 95: 736–738.
Bulla et al 2012. "Eggshell spotting does not predict male incubation but marks thinner areas of a shorebird's shells." *The Auk* 129: 26–35.

139 Carotenoid compounds are common in fruits and seeds:
McGraw et al 2001. "The influence of carotenoid acquisition and utilization on the maintenance of species-typical plumage pigmentation in male American Goldfinches (*Carduelis tristis*) and Northern Cardinals (*Cardinalis cardinalis*). *Physiological and Biochemical Zoology: Ecological and Evolutionary Approaches* 74: 843–852.
Hudon and Brush 1989. "Probable dietary basis of a color variant of the Cedar Waxwing." *Journal of Field Ornithology* 60: 361–368.
Hudon and Mulvihill 2017. "Diet-induced plumage erythrism as a result of the spread of alien shrubs in North America." *North American Bird Bander* 42: 95–103.
Witmer 1996. "Consequences of an alien shrub on the plumage coloration and ecology of Cedar Waxwings." *The Auk* 113: 735–743.

139 Most birds stay put for the entire breeding season:
Chu 1999. Ecology and breeding biology of Phainopeplas (*Phainopepla nitens*) in the desert and coastal woodlands of southern California. Ph.D. dissertation, University of California, Berkeley.
Robbins 2015. "Intra-summer movement and probable dual breeding of the Eastern Marsh Wren (*Cistothorus p. palustris*); a *Cistothorus* ancestral trait?" *The Wilson Journal of Ornithology* 127: 494–498.
Walsberg 1977. "Ecology and energetics of contrasting social systems in *Phainopepla nitens* (Aves: Ptilogonatidae)." *University of California Publications in Zoology* 108: 1–63.
Chu et al 2002. "Social and genetic monogamy in territorial and loosely colonial populations of Phainopepla (*Phainopepla nitens*). *The Auk* 119: 770–777.

141 Filoplumes are a specialized kind of feather:
Necker 1985/a. "Receptors in the skin of the wing of pigeons and their possible role in bird flight." *Biona Report* 3. New York: Fischer.
Necker 1985/b. "Observations on the function of a slowly adapting mechanoreceptor associated with filoplumes in the feathered skin of pigeons." *Journal of Comparative Physiology A* 156: 391–394.
Brown and Fedde 1993. "Airflow sensors in the avian wing." *Journal of Experimental Biology* 179: 13–30.

141 One of the riskiest aspects of migration:
Tallamy and Shropshire 2009. "Ranking lepidopteran use of native versus introduced plants." *Conservation Biology* 23: 941–947.
Tallamy 2009. *Bringing Nature Home: How You Can Sustain Wildlife with Native Plants*. Portland, OR: Timber Press.
Narango et al 2017. "Native plants improve breeding and foraging habitat for an insectivorous bird." *Biological Conservation* 213: 42–50.

141 Scientists are just beginning to sort out:
Muheim et al 2016. "Polarized light modulates light-dependent magnetic compass orientation in birds." *Proceedings of the National Academy of Sciences* 113: 1654–1659.
Wiltschko et al 2009. "Directional orientation of birds by the magnetic field under different light conditions." *Journal of the Royal Society Interface* 7.
Heyers et al 2017. "The magnetic map sense and its use in fine-tuning the migration programme of birds." *Journal of Comparative Physiology A* 203: 491–497.
Phillips et al 2010. "A behavioral perspective on the biophysics of the light-dependent magnetic compass: a link between directional and spatial perception?" *Journal of Experimental Biology* 213: 3247–3255.
Mouritsen 2015. "Magnetoreception in Birds and Its Use for Long-Distance Migration." In *Sturkie's Avian Physiology*, 6th ed. Amsterdam: Elsevier.
Chernetsov et al 2017. "Migratory Eurasian Reed Warblers can use magnetic declination to solve the longitude problem." *Current Biology* 27: 2647–2651.

143 Almost all of the wood warblers:
DeLuca et al 2015. "Transoceanic migration by a 12 g songbird." *Biology Letters* 11: 20141045.
Holberton et al 2015. "Isotopic (δ2Hf) evidence of 'loop migration' and use of the Gulf of Maine Flyway by both western and eastern breeding populations of Blackpoll Warblers." *Journal of Field Ornithology* 86: 213–228.

143 Birds' bodies operate at very high temperatures:
Martineau and Larochelle 1988. "The cooling power of pigeon legs." *Journal of Experimental Biology* 136: 193–208.

145 Preening is one of the most essential chores:
Cotgreave and Clayton 1994. "Comparative analysis of time spent grooming by birds in relation to parasite load." *Behaviour* 131: 171–187.
Singh 2004. "Ecology and biology of cormorants *Phalacrocorax* spp. with special reference to *P. carbo* and *P. niger* in and around Aligarh." PhD thesis, Aligarh Muslim University, Aligarh, India.
Clayton et al 2005. "Adaptive significance of avian beak morphology for ectoparasite control." *Proceedings of the Royal Society B: Biological Sciences* 272: 811–817.
Moyer et al 2002. "Influence of bill shape on ectoparasite load in western scrub-jays." *The Condor* 104: 675–678.

145 Many birds eat fruit:
Viana et al 2016. "Overseas seed dispersal by migratory birds." *Proceedings of the Royal Society B: Biological Sciences* 283: 20152406.

Green and Sanchez 2006. "Passive internal dispersal of insect larvae by migratory birds." *Biology Letters* 2.

Kleyheeg and van Leeuwen 2015. "Regurgitation by waterfowl: an overlooked mechanism for long-distance dispersal of wetland plant seeds." *Aquatic Botany* 127: 1–5.

147 Normally when birds molt:

https://blog.lauraerickson.com/2017/06/of-bald-and-toupee -wearing-birds.html

149 Much of what birds do:

Urbina-Melendez et al 2018. "A physical model suggests that hip-localized balance sense in birds improves state estimation in perching: implications for bipedal robots." *Frontiers in Robotics and AI* 5: 38.

Necker 2005. "The structure and development of avian lumbosacral specializations of the vertebral canal and the spinal cord with special reference to a possible function as a sense organ of equilibrium." *Anatomy and Embryology (Berl)* 210: 59–74.

Necker 1999. "Specializations in the lumbosacral spinal cord of birds: morphological and behavioural evidence for a sense of equilibrium." *European Journal of Morphology* 37: 211–214.

149 A large bill like a grosbeak's:

Herrel et al 2005. "Evolution of bite force in Darwin's finches: a key role for head width." *Journal of Evolutionary Biology* 18: 669–675.

van der Meij and Bout 2008. "The relationship between shape of the skull and bite force in finches." *Journal of Experimental Biology* 211: 1668–1680.

151 The bird respiratory system:

Maina 2017. "Pivotal debates and controversies on the structure and function of the avian respiratory system: setting the record straight." *Biological Reviews of the Cambridge Philosophical Society* 92: 1475–1504.

Lambertz et al 2018. "Bone histological correlates for air sacs and their implications for understanding the origin of the dinosaurian respiratory system." *Biology Letters* 14.

Projecto-Garcia et al 2013. "Repeated elevational transitions in hemoglobin function during the evolution of Andean hummingbirds." *Proceedings of the National Academy of Sciences USA* 110: 20669–20674.

151 When the rib cage expands:

Brown et al 1997. "The avian respiratory system: a unique model for studies of respiratory toxicosis and for monitoring air quality." *Environmental Health Perspectives* 105: 188–200.

Harvey and Ben-Tal 2016. "Robust unidirectional airflow through avian lungs: new insights from a piecewise linear mathematical model." *PLOS Computational Biology* 12: e1004637.

Wang et al 1992. "An aerodynamic valve in the avian primary bronchus." *Journal of Experimental Zoology* 262: 441–445.

153 Why do some birds walk and others hop?:

Andrada et al 2015. "Mixed gaits in small avian terrestrial locomotion." *Scientific Reports* 5: 13636.

153 Do birds need to drink?:

Bartholomew and Cade 1956. "Water consumption of House Finches." *The Condor* 58: 406–412.

Weathers and Nagy 1980. "Simultaneous doubly labeled water (3hh18o) and time-budget estimates of daily energy expenditure in *Phainopepla nitens*." *The Auk* 97: 861–867.

Nudds and Bryant 2000. "The Energetic Cost of Short Flights in Birds." *The Journal of Experimental Biology* 203: 1561–1572

155 It's December, why are there almost no birds using my feeder?:

Brittingham and Temple 1992. "Does winter bird feeding promote dependency?" *Journal of Field Ornithology* 63: 190–194

Brittingham and Temple 1988. "Impacts of supplemental feeding on survival rates of Black-capped Chickadees." *Ecology* 69: 581–589.

Teachout et al 2017. "A preliminary investigation on supplemental food and predation by birds." *BIOS* 88: 175–180.

Crates et al 2016. "Individual variation in winter supplementary food consumption and its consequences for reproduction in wild birds." *Journal of Avian Biology* 47: 678–689.

155 Will feeding birds keep them from migrating?:

Malpass et al 2017. "Species-dependent effects of bird feeders on nest predators and nest survival of urban American Robins and Northern Cardinals." *The Condor* 119: 1–16.

157 The song of a male Chipping Sparrow:

Lahti et al 2011. "Tradeoff between accuracy and performance in bird song learning." *Ethology* 117: 802–811.

Byers et al 2010. "Female mate choice based upon male motor performance." *Animal Behaviour* 79: 771–778.

Konishi 1969. "Time resolution by single auditory neurones in birds." *Nature* 222: 566–567.

Dooling et al 2002. "Auditory temporal resolution in birds: discrimination of harmonic complexes." *The Journal of the Acoustical Society of America* 112: 748.

Lachlan et al 2014. "Typical versions of learned Swamp Sparrow song types are more effective signals than are less typical versions." *Proceedings of the Royal Society B: Biological Sciences* 281: 20140252.

157 Why do birds lay eggs?:

Amadon 1943. "Bird weights and egg weights." *The Auk* 60: 221–234.

Huxley 1927. "On the relation between egg-weight and body-weight in birds." *Zoological Journal of the Linnaean Society* 36: 457–466.

159 As humans transform the landscape:

McClure et al 2013. "An experimental investigation into the effects of traffic noise on distributions of birds: avoiding the phantom road." *Proceedings of the Royal Society B: Biological Sciences* 280: 20132290.

Francis et al 2009. "Noise pollution changes avian communities and species interactions." *Current Biology* 19: 1415–1419.

Ortega 2012. "Effects of noise pollution on birds: a brief review of our knowledge." *Ornithological Monographs* 74.

Guo et al 2016. "Low frequency dove coos vary across noise gradients in an urbanized environment." *Behavioural Processes* 129.

159 Wild birds face two competing risks:

Lind 2004. "What determines probability of surviving predator attacks in bird migration?: the relative importance of vigilance and fuel load." *Journal of Theoretical Biology* 231: 223–227.

Bednekoff 1996. "Translating mass dependent flight performance into predation risk: an extension of Metcalfe & Ure." *Proceedings of the Royal Society B: Biological Sciences* 263: 887–889.

159 Across its wide range, from Atlantic to Pacific:

Tattersall et al 2016. "The evolution of the avian bill as a thermoregulatory organ." *Biological Reviews* 92: 1630–1656.

Peele et al 2009. "Dark color of the Coastal Plain Swamp Sparrow (*Melospiza georgiana nigrescens*) may be an evolutionary response to occurrence and abundance of salt-tolerant feather-degrading bacilli in its plumage." *The Auk* 126: 531–535.

Danner and Greenberg 2014. "A critical season approach to Allen's rule: bill size declines with winter temperature in a cold temperate environment." *Journal of Biogeography* 42: 114–120.

160 The House Sparrow is one of the most successful:

Liker and Bokony 2009. "Larger groups are more successful in innovative problem solving in House Sparrows." *Proceedings of the National Academy of Sciences USA* 106: 7893–7898.

Sol et al 2002. "Behavioural flexibility and invasion success in birds." *Animal Behaviour* 64: 516.

Audet et al 2016. "The town bird and the country bird: problem solving and immunocompetence vary with urbanization." *Behavioral Ecology* 27: 637–644.

161 The House Sparrow is fully adapted:

Saetre et al 2012. "Single origin of human commensalism in the House Sparrow." *Journal of Evolutionary Biology* 25: 788–796.

Riyahi et al 2013. "Beak and skull shapes of human commensal and non-commensal House Sparrows *Passer domesticus*." *BMC Evolutionary Biology* 13: 200.

Ravinet et al 2018. "Signatures of human-commensalism in the House Sparrow genome." *Proceedings of the Royal Society B: Biological Sciences* 285: 20181246.

161 How many feathers does a bird have?

Wetmore 1936. "The number of contour feathers in passeriform and related birds." *The Auk* 53: 159–169.

Osvath et al 2017. "How feathered are birds? Environment predicts both the mass and density of body feathers." *Functional Ecology* 32.

Peacock 2016. How many feathers does a Canary have? Blog post at faansiepeacock.com

161 Dust bathing is a common behavior:

Olsson and Keeling 2005. "Why in earth? Dustbathing behaviour in jungle and domestic fowl reviewed from a Tinbergian and animal welfare perspective." *Applied Animal Behaviour Science* 93: 259–282.

161 Almost all songbirds fly:

Tobalske 2007. "Biomechanics of bird flight." *The Journal of Experimental Biology* 210: 3135–3146.

Tobalske 2010. "Hovering and intermittent flight in birds." *Bioinspiration & Biomimetics* 5: 045004.

Tobalske et al 1999. "Kinematics of flap-bounding flight in the Zebra Finch over a wide range of speeds." *Journal of Experimental Biology* 202: 1725–1739.

Rayner et al 2001. "Aerodynamics and energetics of intermittent flight in birds." *Integrative and Comparative Biology* 41: 188–204.

163 All red, orange, and yellow color:

Inouye et al 2001. "Carotenoid pigments in male House Finch plumage in relation to age, subspecies, and ornamental coloration." *The Auk* 118: 900–915.

McGraw and Hill 2000. "Carotenoid-based ornamentation and status signaling in the House Finch." *Behavioral Ecology* 11: 520–527.

163 It's rare to see sick birds:

https://feederwatch.org/learn/house–finch–eye–disease/

165 All birds molt:

Saino et al 2014. "A trade-off between reproduction and feather growth in the Barn Swallow (*Hirundo rustica*)." *PLOS One* 9: e96428.

165 The brilliant yellow color:

Scott and MacFarland 2010. *Bird Feathers: A Guide to North American Species*. Mechanicsburg, PA: Stackpole.

165 Several species of small finches:

Kennard 1976. "A biennial rhythm in the winter distribution of the Common Redpoll." *Bird-Banding* 47: 231–237.

Erskine and McManus 2003. "Supposed periodicity of Redpoll, *Carduelis* sp., visitations in Atlantic Canada." *Canadian Field-Naturalist* 117: 611–620.

167 Male Bobolinks display by singing in flight:

Mather and Robertson 1992. "Honest advertisement in flight displays of Bobolinks (*Dolichonyx oryzivorus*)." *The Auk* 109: 869–873.

Oberweger and Goller 2001. "The metabolic cost of birdsong production." *Journal of Experimental Biology* 204: 3379–3388.

167 Birds and farming:

Askins et al 2007. "Conservation of grassland birds in North America: understanding ecological processes in different regions." *Ornithological Monographs* 64.

Nyffeler et al 2018. "Insectivorous birds consume an estimated 400–500 million tons of prey annually." *Naturwissenschaften* 105: 47.

167 Meadowlarks are unusual:

Tyrrell et al 2013. "Looking above the prairie: localized and upward acute vision in a native grassland bird." *Scientific Reports* 3: 3231.

Moore et al 2012. "Oblique color vision in an open-habitat bird: spectral sensitivity, photoreceptor distribution and behavioral implications." *Journal of Experimental Biology* 215: 3442–3452.

Martin 2017. "What drives bird vision? Bill control and predator detection overshadow flight." *Frontiers in Neuroscience* 11: 619.

Moore et al 2013. "Interspecific differences in the visual system and scanning behavior of three forest passerines that form heterospecific flocks." *Journal of Comparative Physiology A* 199: 263–277.

Moore et al 2017. "Does retinal configuration make the head and eyes of foveate birds move?" *Scientific Reports* 7: 38406.

169 The shape of birds' eggs varies:

Stoddard et al 2017. "Avian egg shape: form, function, and evolution." *Science* 356: 1249–1254.

169 How long do birds live?:

Holmes and Ottinger 2003. "Birds as long-lived animal models for the study of aging." *Experimental Gerontology* 38: 1365–1375.

Faaborg et al 2010. "Recent advances in understanding migration systems of New World land birds." *Ecological Monographs* 80: 3–48.

https://www.pwrc.usgs.gov/BBL/longevity/Longevity_main.cfm

171 Female cowbirds do not simply lay an egg and leave it:

Lynch et al 2017. "A neural basis for password-based species recognition in an avian brood parasite." *Journal of Experimental Biology* 220: 2345–2353.

Colombelli-Negrel et al 2012. "Embryonic learning of vocal passwords in Superb Fairy-Wrens reveals intruder cuckoo nestlings." *Current Biology* 22: 2155–2160.

173 Rarely, you might see a bird that looks like a common species:

Grouw 2013. "What colour is that bird? The causes and recognition of common colour aberrations in birds." *British Birds* 106: 17–29.

http://learn.genetics.utah.edu/content/pigeons/dilute/

175 Sometimes when you get a very close look:

Grubb 1989. "Ptilochronology: feather growth bars as indicators of nutritional status." *The Auk* 106: 314–320.

Wood 1950. "Growth bars in feathers." *The Auk* 67: 486–491.

Terrill 2018. "Feather growth rate increases with latitude in four species of widespread resident Neotropical birds." *The Auk* 135: 1055–1063.

180 Cooper's Hawk:

Suraci et al 2016. "Fear of large carnivores causes a trophic cascade." *Nature Communications* 7: 10698.

180 Turkey Vulture:
Roggenbuck et al 2014. "The microbiome of New World vultures." *Nature Communications* 5: 5498.

182 Monk Parakeet:
Burgio et al 2017. "Lazarus ecology: recovering the distribution and migratory patterns of the extinct Carolina Parakeet." *Ecology and Evolution* 7: 5467–5475.

183 Chimney Swift:
Liechti et al 2013. "First evidence of a 200-day non-stop flight in a bird." *Nature Communications* 4: 2554.
Hedenstrom et al 2016. "Annual 10-month aerial life phase in the Common Swift *Apus apus*." *Current Biology* 26: 1–5.
Rattenborg et al 2016. "Evidence that birds sleep in mid-flight." *Nature Communications* 7: 12468.

183 Blue Jay:
Kingsland 1978. "Abbott Thayer and the Protective Coloration Debate." *Journal of the History of Biology* 11: 223–244
Merilaita et al 2017. "How camouflage works." *Philosophical Transactions of The Royal Society B Biological Sciences* 372: 1724
Holmes et al 2018. "Testing the feasibility of the startle-first route to deimatism." *Scientific Reports* 8: 10737
Umbers et al 2017. "Deimatism: a neglected component of antipredator defence." *Biology Letters* 13: 20160936

183 California Scrub-Jay:
George et al 2015. "Persistent impacts of West Nile virus on North American bird populations." *Proceedings of the National Academy of Science* 112: 14290–14294
Chapin et al 2000. "Consequences of changing biodiversity." *Nature* 405: 234–242
Rahbek 2007. "The silence of the robins." *Nature* 447: 652–653
LaDeau et al 2007. "West Nile virus emergence and large-scale declines of North American bird populations". *Nature* 447: 710–713

185 Cedar Waxwings:
Brewer et al 2006. *Canadian Atlas of Bird Banding. Volume 1: Doves, Cuckoos, and Hummingbirds Through Passerines, 1921–1995*, rev. ed. Ottawa: Canadian Wildlife Service.
Brugger et al 1994. "Migration patterns of Cedar Waxwings in the eastern United States." *Journal of Field Ornithology* 65: 381–387.

186 Blackpoll Warbler, etc.:
D'Alba et al 2014. "Melanin-based color of plumage: role of condition and of feathers' microstructure." *Integrative and Comparative Biology* 54: 633–644.
Moreno-Rueda 2016. "Uropygial gland and bib colouration in the house sparrow." *PeerJ* 4: e2102.
Wiebe and Vitousek 2015. "Melanin plumage ornaments in both sexes of Northern Flicker are associated with body condition and predict reproductive output independent of age." *The Auk* 132: 507–517.
Galvan et al 2017. "Complex plumage patterns can be produced only with the contribution of melanins." *Physiological and Biochemical Zoology* 90: 600–604.
Jawor and Breitwisch 2003. "Melanin ornaments, honesty, and sexual selection." *The Auk* 120: 249–265.

186 Scarlet Tanager:
Bazzi et al 2015. "Clock gene polymorphism and scheduling of migration: a geolocator study of the Barn Swallow *Hirundo rustica*." *Scientific Reports* 5: 12443.

Gwinner 2003. "Circannual rhythms in birds." *Current Opinion in Neurobiology* 13: 770–778.
Akesson et al 2017. "Timing avian long-distance migration: from internal clock mechanisms to global flights." *Philosophical Transactions of the Royal Society B: Biological Sciences* 372: 1734.

186 Rose-breasted Grosbeak:
Somveille et al 2018. "Energy efficiency drives the global seasonal distribution of birds." *Nature Ecology & Evolution* 2: 962–969.
Winger et al 2014. "Temperate origins of long-distance seasonal migration in New World songbirds." *Proceedings of the National Academy of Sciences USA* 111: 12115–12120.
Hargreaves et al 2019. "Seed predation increases from the Arctic to the Equator and from high to low elevations." *Science Advances* 5: eaau4403.

186 Lazuli Bunting and Indigo Bunting:
Simpson et al 2015. "Migration and the evolution of sexual dichromatism: evolutionary loss of female coloration with migration among wood-warblers." *Proceedings of the Royal Society B: Biological Sciences* 282: 20150375.

186 Canyon Towhee:
Davies 1982. "Behavioural adaptations of birds to environments where evaporation is high and water is in short supply." *Comparative Biochemistry and Physiology Part A: Physiology* 71: 557–566.
Albright et al 2017. "Mapping evaporative water loss in desert passerines reveals an expanding threat of lethal dehydration." *Proceedings of the National Academy of Sciences USA* 114: 2283–2288.

187 White-crowned Sparrow:
Cassone and Westneat 2012. "The bird of time: cognition and the avian biological clock." *Frontiers in Molecular Neuroscience* 5: 32.
Van Doren et al 2017. "Programmed and flexible: long-term 'Zugunruhe' data highlight the many axes of variation in avian migratory behaviour." *Avian Biology* 48: 155–172.

187 House Finch:
Elliot and Arbib 1953. "Origin and status of the House Finch in the eastern United States." *The Auk* 70: 31–37.

188 Lesser Goldfinch:
Senar et al 2015. "Do Siskins have friends? An analysis of movements of Siskins in groups based on EURING recoveries." *Bird Study* 62: 566–568.
Arizaga et al 2015. "Following year-round movements in Barn Swallows using geolocators: could breeding pairs remain together during the winter?" *Bird Study* 62: 141–145.
Pardo et al 2018. "Wild Acorn Woodpeckers recognize associations between individuals in other groups." *Proceedings of the Royal Society B: Biological Sciences* 285: 1882.

188 Baltimore Oriole:
Winger et al 2012. "Ancestry and evolution of seasonal migration in the Parulidae." *Proceedings of the Royal Society B: Biological Sciences* 279: 610–618.
Winger et al 2014. "Temperate origins of long-distance seasonal migration in New World songbirds." *Proceedings of the National Academy of Sciences USA* 111: 12115–12120.

ABOUT THE AUTHOR

David Allen Sibley is the author and illustrator of the series of successful guides to nature that bear his name, including *The Sibley Guide to Birds*. He has contributed to *Smithsonian*, *Science*, *The Wilson Journal of Ornithology*, *Birding*, *Bird-Watching*, and *North American Birds*, as well as to *The New York Times*. He is the recipient of the Roger Tory Peterson Award for Lifetime Achievement from the American Birding Association and the Linnaean Society of New York's Eisenmann Medal.

A NOTE ON THE TYPE

This book was set in TheSans, a member of the Thesis type family created by the Dutch designer Lucas de Groot (born 1963) and released in 1994 by the FontFabrik foundry in Berlin. Originally known as Parenthesis, the Thesis family of fonts is unusual in including a serif font, a sans serif font, and a "mixed" font which all strive to harmonize the traditionally disparate styles.

COMPOSED BY NORTH MARKET STREET GRAPHICS, LANCASTER, PENNSYLVANIA

PRINTED AND BOUND BY C&C OFFSET PRINTING COMPANY, CHINA

DESIGNED BY MAGGIE HINDERS WITH MADELINE BRUBAKER